Digital Painting and Rendering for Theatrical Design

Digital Painting and Rendering for Theatrical Design explores the tools and techniques for creating dazzling, atmospheric, and evocative digitally painted renderings for scenic, costume, and projection/integrated media design.

By focusing on technique rather than the structure of a particular software, this book trains theatrical designers to think and paint digitally, regardless of the software or hardware they choose. The text begins with the construction of the artist's physical and digital workspace, then delves into an explanation of tool functionality, technique-building exercises, and examples from professional theatrical designers to help contextualize the concepts presented. Each chapter gradually progresses in complexity through skill-building exercises and advanced tool functionality, covering concepts like brush construction, various forms of masking, and layer interaction. The book explores various methods of constructing a digital rendering, including producing digital paintings that look like traditional media and photo bashing – the practice of using extant photographs to create a collaged image. Concepts are contextualized throughout the text using illustrations, quotes, and interviews with working professional designers.

This beautifully illustrated guide is written for professional theatrical artists, students of theatrical design, and other visual artists looking to broaden their digital painting skillset.

Jen Gillette (she/her) is a freelance costume designer and Assistant Professor of Costume Design at Florida State University. She has worked with The Kennedy Center, The Glimmerglass Festival, Manhattan School of Music, The Washington Ballet, Taffety Punk, Atlanta Opera, Krewe du Resistance, the New Orleans Shakespeare Festival, Triad Stage, and Hattiloo Theatre. Jen received an MFA from the University of North Carolina School of the Arts.

Digital Painting and Rendering for Theatrical Design

Using Digital Tools to Create Scenic, Costume, and Media Renderings

Jen Gillette

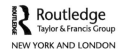

Routledge
Taylor & Francis Group

NEW YORK AND LONDON

Designed cover image: Tao Wang

First published 2024
by Routledge
605 Third Avenue, New York, NY 10158

and by Routledge
4 Park Square, Milton Park, Abingdon, Oxon, OX14 4RN

*Routledge is an imprint of the Taylor & Francis Group, an informa
business*

Library of Congress Cataloguing-in-Publication Data
Names: Gillette, Jen, author.
Title: Digital painting and rendering for theatrical design : using
digital tools to create scenic, costume, and media renderings /
Jen Gillette.
Description: New York, NY : Routledge, 2024. | Includes index.
Identifiers: LCCN 2023036091 (print) | LCCN 2023036092 (ebook)
| ISBN 9781032077017 (hardback) | ISBN 9781032076928
(paperback) | ISBN 9781003212836 (ebook)
Subjects: LCSH: Painting--Digital techniques. | Theaters--Stage-
setting and scenery. | Costume design.
Classification: LCC T385 .G529 2024 (print) | LCC T385 (ebook) |
DDC 006.6--dc23/eng/20231208
LC record available at https://lccn.loc.gov/2023036091
LC ebook record available at https://lccn.loc.gov/2023036092

ISBN: 978-1-032-07701-7 (hbk)
ISBN: 978-1-032-07692-8 (pbk)
ISBN: 978-1-003-21283-6 (ebk)

DOI: 10.4324/9781003212836

Typeset in ITC Officina Sans
by MPS Limited, Dehradun

This book is dedicated to my amazing Mom, who encouraged my love of painting and drawing from an extremely early age, showed me how to forge my way in the world, and never worried about whether or not I could make a life doing what I love.

Contents

Acknowledgments ix

CHAPTER 1 **Why We Paint** 1
 Introduction 1
 Why We Paint 2
 How to Use This Text 3

CHAPTER 2 **Your Studio** 5
 Your Studio Workspace 5
 Hardware 10
 Software 16

CHAPTER 3 **Configuring Your Digital Workspace** 20
 Configuring Software for Digital Painting 20
 Common File Types 24
 Presets and Templates 26
 Menus and Palettes 27
 Additional Settings 28
 Saving Your Work 29

CHAPTER 4 **Working with Layers** 32
 The Concept of Layers 32
 Setting Up and Using Layers 33
 Layers and Collaboration 44
 Applied Skills Tutorial: Cel-Shaded Paintings 44
 Applied Skills Tutorial: Let It Glow 46
 Applied Skills Tutorial: Painting Directional Light 48

CHAPTER 5 **Digital Art Supplies** 50
 Digital Brush Mechanics 50
 Applied Skills Tutorial: Limited Variable Still Life 51
 Traditional Media With Digital Tools 61
 Applied Skills Tutorial: Timed Gesture Drawings 65
 Applied Skills Tutorial: Traditional Watercolor Exercises 70
 Applied Skills Tutorial: Alpine Composition in Gouache 72
 Career Highlight Interview: Jean Gillmore 75

Contents

CHAPTER 6 **Building a Design Rendering** 77
Building a Painting 77
Perspective in Digital Painting 83
The Human Figure in Digital Painting 84
Applied Skills Tutorial: Re-Posing a Figure 89
Coloring Costume Renderings 94
Creating Surfaces 98
Applied Skills Tutorial: Fabric Studies 100
Applied Skills Tutorial: Drawing Fullness 102
Applied Skills Tutorial: Creating a Tree Stamp 105
Applied Skills Tutorial: Creating Lumber 105
Career Highlight Interview: Oakley Billions 110

CHAPTER 7 **Digital Painting in Production** 113
Editing Research 113
Applications of Digital Painting in Scenic Design 113
Applications of Digital Painting in Costume Design 118
Career Highlight Interview: Ali Filipovich 125
Digital Painting in Production Processes 129
Applied Skills Tutorial: Creating and Cutting Digital Yardage 130
Theatrical Documentation 131
Screen to Page 137
Shared Drives and Collaboration 139
Career Highlight Interview: Erik Teague 141

CHAPTER 8 **Photo Bashing** 146
What Is Photo Bashing? 146
Photo Bashing Tools 147
Selection Tools and Masking 150
Filters and Adjustments 153
Macros, Actions, and Batch Processing 154
Photo Bashing Techniques 155
Applied Skills Tutorial: Creating a Desert Drop 159
Applied Skills Tutorial: Creating a Photomontage Costume Rendering 162

CHAPTER 9 **Living with Digital Painting** 165
Advantages and Disadvantages of Digital Painting 165
The Future of Digital Painting 167
Further Resources 168
Troubleshooting 169

Index 170

Acknowledgments

To my family, without whom I would not have the courage or support to live my life in a creative industry: to David, for literally keeping me alive (mentally and physically) while I worked on this book; to Mom, Grandma, Grandpa, Jillian, Paul, Steve, Miho, Ricky, Teresa, Tyler, and the rest of the Sanders clan; to the two fiercest, funniest girls I know, Lavender and Jasmine; to all of the official and unofficial in-laws; and all of our dogs. Thank you all for the love, joy, and inspiration.

Thank you to a long line of important educators who have shaped my pedagogy and creative practice: Bill Brewer, Kyle Webster, Dina Perez, Cassandra Paine, Sean Foley, Cindy Foley, Joanne Miles, Bruce Brown, and Mr. Donahue. Thank you all.

Thank you to my friends who help to keep me sane in my scant downtime. Thanks for the trips, the shop talk, the D&D games, the adventures, the drinks, the tarot card readings, the care packages, the meals, and the memes.

Every day, I get to go to work and be surrounded by a community of mentors, colleagues, and students who support, inspire, champion, and challenge me. Thank you to all of my former colleagues and students at the University of Memphis and to my new colleagues and students at Florida State University.

Thank you to all of the *incredible* artists who shared their work with this text: Jean, Oakley, Ali, Erik, Ethan, Kimberly, Brian, Keyon, Jenni, Maki, Aidan, Logan, Gigi, Alyssa, Austin, M.K., Melissa, Sarah, Tyler, Tao, Clare, Newman, Loryn, and Aubrey. I appreciate and deeply admire all of you.

CHAPTER 1

Why We Paint

Introduction

Digital painting has been a tool available to artists since the mid-1980s with the arrival of a revolutionary piece of software called MacPaint. MacPaint allowed users to create images by dragging a mouse around a digital blank canvas, depositing black pixels using a small range of tools. Though the software for digital painting has evolved tremendously, the DNA of MacPaint is still visible in the layout of most digital rendering software available today: a menu bar sits horizontally across the top of the screen, the tool bar stacked vertically on the left, and the editable canvas is in the center. Even some of the icons established by MacPaint are still the visual vocabulary used by state-of-the-art digital painting software today. Go hunting online and you can see screenshots of MacPaint; the architecture of that software will be familiar to anyone who has opened modern digital rendering software like Photoshop or Procreate.

Since the 1980s, software development has surged forward, constantly seeking verisimilitude to natural media, an expansive vocabulary of tools, and support for increasingly large and complex images. Books and classes have sought to keep up with this constant flow of increasingly powerful tools, but users often find themselves up-ended by a software update or bored by a technical approach to an artistic medium. The error in teaching digital painting has been to approach it via software instead of treating it like any other art medium. Art students aren't taught to memorize the specific color names and chemical formulas of Windsor-Newton paints; students are taught techniques that apply broadly to all watercolor work. This book aims to approach digital painting as a medium, not as a piece of software.

The language of digital rendering software has consistent functionality and frameworks, no matter the specific software you chose. Whether you choose Adobe Photoshop, Adobe Fresco, Procreate, Corel Painter, Clip Studio, or any number of applications, there are core methodologies to creating and manipulating digital art works. There are certainly specialty tools and features available on specific pieces of software, but the structure is relatively the same. By creating an approach to digital painting and rendering that focuses on its conceptual components, this book will help artists to see past software layout, updates, menus, and brands, making a wider array of digital platforms comprehensible to the artist. Digital training cannot become obsolete when the artist understands the foundations of the digital painting studio.

In theater, artists are trained with first-hand experience, and learning often takes place through direct mentorship and apprenticeship. Mentors pass along what their mentors taught them, blending and tempering time-honored wisdom with their own professional experience. Apprentices and young theater practitioners bring fresh approaches to their own work in the field, filtering new information through the teachings of their mentors. Digital rendering has come to represent a break in this model because many seasoned mentors have not had the opportunity to learn digital tools.

Attitudes toward digital rendering in theater vary wildly, from deep devotion to skeptical disdain. Practitioners of digital painting will agree that digital image creation is no easier than traditional media rendering, but it is infinitely more flexible. Digital rendering requires drawing skills and an understanding of the elements of design: line, shape, form, space, color, value, texture. There are no shortcuts for the foundations of a good image. What digital painting *does* offer is the ability to redraw a hand until you've got it right without destroying the paper; the chance to show the director several different colorways of a custom wallpaper while sitting in a design meeting; the opportunity to tweak costume sketches to accurately reflect the various physicalities and identities of a cast without repainting the clothing. Digital tools are non-destructive and allow the user access to an entire art supply store worth of supplies. Artists are no longer bound to a physical studio in order to work on a set of show renderings. Paintings can be finished on airplanes, couches, dorm room bunk beds, and sitting at the edge of the Grand Canyon.

DOI: 10.4324/9781003212836-1

Figure 1.1 Lighting and scenic designer Jenni Propst practicing digital painting in the wild. (Jenni Propst)

Why We Paint

Theatrical designers are in a unique position in the art world. In everyday conversation, we might use the terms "artist" or "designer" interchangeably, but these are two different roles. In broad strokes, the term "artist" might refer to a solitary creator who makes art in order to illuminate an idea. By contrast, designers often work in teams in order to create solutions. Getting into the finer philosophical points in the field of aesthetics is beyond the scope of this book, but let us agree for the moment that a theatrical designer *is* an artist. However, we are in a unique class of artists because we are collaborators in creating a larger piece of art: the production on stage in front of an audience.

As designers, we use our skills to communicate the design intention with our collaborators on the design and artistic team, our collaborators in the production shops, and with our collaborators in the full company. These acts of communication require theatrical designers to generate different forms of design documentation in order to share a visual idea of the production. Theatrical designers produce costume sketches, paint elevations, renderings, or other imagery. These documents are interpreted by the production shops and executed in the

physical world. This book, then, is concerned with the skills of digitally painting and rendering to serve these goals:

1. **To ideate:** using the medium to generate ideas.
2. **To iterate:** using the medium to develop these ideas in a collaborative process.
3. **To communicate:** using the medium to convey to production partners how the design should be executed.

Of course, theatrical renderings aren't just spreadsheets or supply lists. It is their primary purpose to support communication, but they can also inspire and excite your collaborators. Directors will develop staging ideas based on the moody directional lighting in a scenic rendering. Choreographers will work with performers to show off the contrasting petticoats showcased in the costume renderings. Performers will learn about the physicality of a show's world from what they see in early projection media mockups. Artisans in the shops will understand the precision, scale, and style of the designer's vision. Our design documents are usually never seen by the audience, but they are essential to executing the design and creating the final product on stage. Digital painting can help us to make these communications both precise and inspiring.

Figure 1.2 University students gather around digital renderings during a design presentation. (Author's own)

However, we have a variety of means to ideate, iterate, explore possibilities, and express our visual intent to our collaborators. Scenic designers may build physical or digital models of a set. Costume designers may eschew rendering sketches in favor of research collages. So why, then, do we paint? Why do we not use another method to express our design intent?

Here are a few reasons:

- **To express ourselves precisely:** The pieces which make up the design may not already exist in the world. Perhaps they

exist in piecemeal, or not in a style that is easily applicable to this particular visual story. In these cases, we paint to accurately describe something which no one else can see. Painting performs a miracle of telepathy: we can share what exists only in our minds with our peers.

- **To evoke rather than perfectly describe:** As we work to bring new and unseen visual ideas into the world, sometimes a certain amount of vagueness or abstraction helps open our minds up to generate new ideas as we revisit and interpret what we see. Also, we can evoke shapes and objects without fully defining them, knowing that the human brain can make the necessary inferences to understand the artist's intent. This level of ambiguity can save us time as well.
- **To be in joyful conversation with the medium:** You have probably heard artists speak of happy accidents that occur while creating work. These are those moments where the unpredictability and imperfections of media lead to joyful discovery of new possibilities in the work. Some artists think with their hands, developing ideas visually as they draw. It is as though the medium is suggesting changes to our work as we paint, which can enhance our creative process.
- **To work quickly:** Rendering in two dimensions can be orders of magnitude faster than working in three dimensions. However, this is not always the case.

The list above broadly explores why we, as theatrical artists, feel compelled to use painted images to communicate our design ideas, but it doesn't address why theatrical artists may become devotees of digital painting. There are additional reasons why one might paint digitally, and why this medium is worth dedicated practice. Here are some features offered by digital painting:

- **Absolute precision of color choice:** Digital painting allows the artist to sample an exact Pantone color, an exact fabric swatch, an exact historically significant uniform color. The level of precision available to the digital painter is unparalleled by traditional mediums.
- **Unusual possibilities of mixed media:** Digital painting is sometimes perceived as being too controlled and too perfect for generating images that feel untouched by human hands. Strong digital painting technique can create paintings that are just as moody, evocative, and messy as those created in traditional media, but with editability and flexibility built in. Further, it's the only way that an artist could ever hope to use watercolors over an oil-painted base.
- **Non-destructive editing:** Any artist who has ever gone a step too far in adding watercolor to a rendering, or slipped with an exacto blade while trimming an image, or spilled their India ink all over a nearly finished painting will understand why an undo button is a life-saver. Being able to step forwards and backwards in your image construction, saving parts of your

image as independently editable components, and being able to jump back to an earlier version of your document is freeing.

- **Creative flexibility:** The needs of a theatrical production are constantly in flux. Anything can change during a show's design or production process: concept, cast, venue, budget, labor, timelines, etc. Being able to respond visually to the shifting needs of a production without annihilating your own hourly rate is critical for all working theatrical designers. Digital rendering allows for quick, adaptive changes without re-rendering entire plates.
- **Nothing's precious:** It's easy to get precious about a traditionally painted rendering. It's the only one of its kind in the world, and if it gets splashed with coffee, dye, or wood glue, it can damage communication for other teams. A digital rendering can be printed infinitely without any loss in quality. An artist can return to an earlier version of a sketch. Shops can notate the renderings, stage management can have excellent images for the rehearsal room, and the designer can share the documents freely without worrying about compromising their portfolio.
- **Additional tools for great designers who aren't great visual artists:** Not all great theatrical designers have great visual art skills; it's possible for the two to be mutually exclusive. Artists who struggle with perspective drawing and life drawing are better able to communicate their ideas using digital tools. While strong drawing skills will only make a designer a more effective collaborator, a theatrical artist's developing drawing skills can be supported more readily in the digital realm.
- **Portability:** If you are able to digitally render and paint with a small tablet and stylus, you will have the opportunity to be creative no matter where you are. Digital painting lets you leave behind your messy and difficult-to-transport traditional media paints or your heavy toolbox of model making supplies. Depending on the hardware you choose, you may be able to keep your entire art studio as part of your everyday carry.
- **Always advancing technology:** Watercolor isn't going to reinvent itself any time soon, which is probably why some people love it. Digital rendering software is always on the move, evolving to include new capabilities that offer theatrical designers exciting new avenues for creative work. The constant influx of new features is exciting.

How to Use This Text

Whether you are a skeptic, a beginner, a seasoned pro, or someone who missed the chance at digital training in their own schooling, welcome to this incredible medium. This text will meet you where you are, whether that means walking you into the digital painting workspace, restructuring the way you approach digital image creation, or giving you access to advanced techniques tutorials.

This book will address digital painting as a medium, not as a specific software tutorial. To use this book effectively, you may have to do the work of understanding where to find a specific feature or menu within the most current version of your own software. For instance, if this text were to include a screenshot of how to navigate a set of windows in today's version of Adobe Photoshop, this text might become irrelevant next week when the software updates. Books about watercolor paint discuss the proportion of water to pigment, how to layer color into the image, and how the weight of the artist's hand impacts the final image; this book approaches the tools of digital painting the same way. If you ever find yourself at an understanding gap between the software you're using and the instructions in this text, know that all the software recommended here has active online communities and resources for further learning. These resources include company FAQs, message boards, Reddit communities, Facebook groups, Twitch streamers, Discord servers, LinkedIn Learning resources through your public library, and YouTube channels. These outlets can provide software-specific answers. For more information about pursuing these resources, please read Chapter 9.

It's also important to remember that no two artists use a medium the same way, and this is also true for digital rendering. For every desired outcome, there are numerous paths to get to a finished image. This book can lead you from point A to point B, but it can also present a broad variety of options for how to paint digitally. If you are new to the medium, try moving through this text in a linear fashion in order to start with and build upon preliminary concepts. If you've been digitally rendering for a while, you might try jumping into new workflows and methods right away. The enormity of this medium means it isn't possible to cover every approach to digital painting in this text, but every effort is made to show you how diverse the paths are to creating finished digital paintings.

A common question from those new to digital painting is, "Do I need to learn traditional media painting first?" The answer to this is conditional. Great digital painting looks its best when it emulates the unpredictability of traditional media. Digital painting that is too perfect is less appealing; this is a point you will see reiterated throughout this text. Beautiful digital painting takes into account the pressure, speed, and sensitivity of the artist's hand. If you do not have a lot of experience with

traditional media, you may not know how to control the flow of a watercolor line as you move from the belly to the tip of the brush, or how to build layers of color using markers. These are skills that require translation because they don't work the same way digitally as they do on paper, but understanding the aesthetic goals of your media can be helpful.

Traditional media also take thoughtful planning. Without an undo command, you have to plan the order of your marks on the page in order to build a successful image. This understanding of planning can help you to break down a digital process and organize your layers successfully. Knowing at least a little about making work in analog media can inform and improve your digital painting. That being said, digital drawing feels very one-to-one with traditional drawing processes. Using pencils, charcoal, and ink media functions almost identically, requiring little translation from analog to digital mark-making. The only major difference you'll notice is the cleanliness of your workspace. Making digital paintings that look like they were painted with traditional materials requires a little more knowledge of how those materials work. For instance, digital watercolor uses pen pressure and load to control the amount of 'water' in the paint. An artist who knows how to manipulate watercolor's opacity and relative wetness will better understand how to manipulate digital painting brushes to get the same results.

You can dive in and experience this text in a linear way, starting at page 1 and moving through it chapter by chapter, or you can jump around to the material you feel is most helpful to you. Here are some suggestions based on your learning style:

1. I learn through **systems**. Start me at square one so that I can move through this book in order. [Start with Chapter 2 and build your knowledge sequentially.]
2. I learn by **doing**. Take me to some techniques I can try right now. [Start with an Applied Skills Tutorial in Chapters 4 or 5.]
3. I am motivated by **practicality**. Show me how these tools will shift my design workflow. [Start with Chapter 7 and learn about how painting impacts production workflows.]
4. I am motivated by **inspiration**. Show me the work of other artists. [Flip through the illustrations or jump to the Career Highlight Interviews.]

CHAPTER 2
Your Studio

Your Studio Workspace

It is important to choose the tools that work best for you as you build your digital painting practice. This chapter covers setting up your physical studio, the advantages and disadvantages of different hardware tools, and digital painting software.

For the moment, let's set aside hardware and software to consider your actual studio. The digital painting workspace has two main functions:

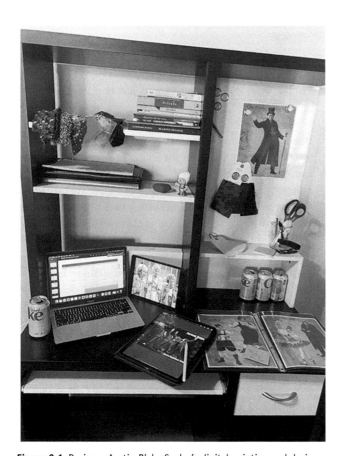

Figure 2.1 Designer Austin Blake Conlee's digital painting and design studio. (Austin Blake Conlee)

- To provide an inspiring workspace.
- To promote productivity and health through good ergonomic choices.

What constitutes an inspiring space will be unique for every artist. Some artists prefer clean, minimal spaces with no distractions, while others prefer richly curated clutter as a constant means of visual stimulation. While this text cannot provide insight as to what style of space may inspire you, it will address the basics of setting up a productive workspace that is comfortable, safe, and which promotes long-term health.

Building a Productive Workspace

Everyone's preferences will vary, but here are some factors to consider in setting up your studio to be a productive workspace.

- **Privacy**: A good studio will allow you to screen out distractions external to work and focus on the tasks you need to accomplish. If your studio is at home, having a door to the studio that can close, or at least some kind of divider to separate your workspace from your personal life, is essential. Physical separation is also important to creating positive work–life boundaries. You will also want to be able to control the noise level in your studio. If square footage is limited, a good last resort for this is a pair of quality noise-canceling headphones.
- **Light**: If possible, it is ideal to have access to both natural light and to several options for artificial light.
- **Work surfaces**: It is ideal to have a large desk or other work surface to use while working. This can be as unfussy as a hollow core door set on top of two filing cabinets or low sawhorses to give a cheap but enormous workspace. A good desk doesn't have to be expensive, but it should be the correct height for you so that when you are seated, your forearms do not tilt up or down to reach your tools.

DOI: 10.4324/9781003212836-2

- **Storage and organization:** This could be storage for show binders or other paperwork (if they aren't already digital), computer hardware storage (extra peripherals, cables, and devices that you aren't currently using), pens, pencils, paper, and more. The easier it is to access the storage, the more frequently you will use it and the less cluttered your life will be.

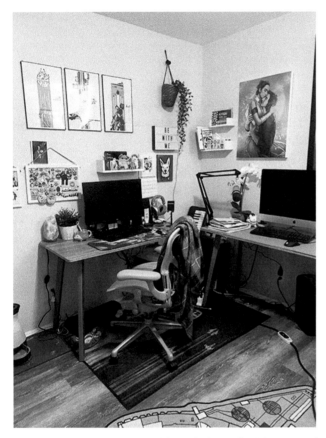

Figure 2.2 Designer Alyssa Homan's home design studio. (Alyssa Homan)

After you select your studio space, you may find some of the following items and tools useful.

- **Music/sound devices:** This could be your computer, phone, or a dedicated music device. Some people like to work to music, others prefer to work in silence, and some like to put TV shows/movies on in the background while they work. It is my professional opinion that anything you choose to have on while you work should be strictly non-visual. Anything that your eyes need to see will sap away valuable visual and creative energy, or worse, cloud your vision with another designer's ideas. If you prefer to work in silence, consider getting some noise-canceling headphones or ear plugs. They can make a dramatic difference in your ability to focus.

Listen While You Work

I have a few approaches to music:

- I'll curate an immersive mood for myself by listening to music from the period of the show or a playlist that feels like the world I'm building. For instance, when I'm working on a fantasy piece, I love listening to epic film scores or original fantasy music on YouTube.
- If I'm working on a musical or opera, I usually listen to recorded versions of the show while I work. I find listening to show music while I'm drawing helps me to remember the characters, mood, and moments as I'm making choices for the production.
- If I need an energy correction to get into the work, music can be a great help. I get excited when I put on Lizzo, hits from the 1980s, David Bowie, Metric, or Rebirth Brass Band. I sink into a moodier place with Florence and the Machine, 1990s trip hop, and Billie Holiday.
- If I'm on my feet doing costume technology or crafts work, I listen to podcasts to help soften my focus and pass the time. I'm a huge fan of actual-play D&D podcasts. I love audiobooks and podcasts, but find them too distracting to listen to while designing a show.

- **Printer:** When it comes time to print your work, it helps if your printer is wireless, loaded with ink and paper, and close at hand. Factors like paper choice and color matching will be covered later on. You may also choose to outsource all of your printing if you don't have the room for the printer you need and live close enough to a reliable print shop. Outsourcing printing is an especially viable option if your space or budget are limited.
- **Cutting mat, metal ruler, and cutting tools:** You will need to tidy documents after printing in order to trim away borders. You will want the appropriate cutting surface and tools to trim any excess paper.
- **Trash can/recycle bin:** There is always something at hand that needs to be discarded. It is easier to have a dedicated bin for the purpose in your studio and within arm's reach.
- **Clock:** This item can be controversial. The truth is that you can't afford to fall into a time-free creative flow; because designers are paid in flat fees, every minute spent on a project reduces your hourly wage. Learning to use a clock to increase productivity and manage your time effectively is important to being able to make a living as a designer.
- **Timer:** This is an item that you may choose to do without, but setting timers can be a great way to effectively manage your time and set internal deadlines for yourself. If you are likely to

get distracted by picking up your phone, try using an inexpensive kitchen timer.

Time Management in the Studio

Let's face it, trying to create your best work under tight deadlines is difficult. Time management is critical in this industry. Time management does not mean "choose work over fun" or "work every waking second"; smart time management uses boundaries, planning, and timers to make the most of your productive hours without bleeding your energy dry. There are many different strategies to manage time and stay productive over the course of your career. Below are a few strategies you may find helpful.

- **Pomodoro Technique**: Francesco Cirillo created the Pomodoro Technique as a time management tool to increase productivity. There are many different versions, but the most common version suggests that you use a kitchen timer to work without distraction for a period of 25 minutes, followed by a five-minute break. After four sessions, you take a longer 20-minute break. Try telling yourself, "I can do anything for 25 minutes," which can help to give you the mental stamina to dive into a task you have been avoiding. The five-minute break offers a chance to refresh creatively, get water, and stretch. You can also use these breaks to remind you to do stretches and exercises that will help you prevent stress or strain. Feel free to experiment with different intervals to find something that works for you.
- **Pretending to work**: This one may sound crazy, but it works. In order to jump-start working on a project, ask yourself, "What would it look like if I was working on this project?" then try to make it look like you are working by doing that. Within a few moments, pretending to work usually turns into actually working.
- **Calendaring projects**: Maintain a detailed calendar for all projects, set up by working backwards from a due date to create a series of internal deadlines. This also helps to visualize how badly the project will snowball if you fall behind.
- **Making lists**: Large, hand-written bullet lists of project components and subcomponents can be enormously helpful in organizing thoughts around a project. Making a beautifully hand-written bullet list, then systematically crossing items off the list, is a ritualistically satisfying part of a process. For an in-depth exploration of list-making and productivity, check out Adam Savage's book *Every Tool's a Hammer* (2020).
- **Setting limits**: It's very important to cap the time spent on a project. Try to give yourself time allotments for specific tasks because if you work with an open-ended timeline, you may continue to fuss and re-paint until something is absolutely perfect. This is unsustainable in design work, as it has the potential to destroy an hourly rate; every minute spent on a design project reduces your hourly rate when you

are being paid a flat design fee. As costumer for television and film Andja Budincich is fond of saying, "Done is beautiful."

- **Smart scheduling**: Different parts of the day are best for different types of work. For instance, I'm best at open-ended creative work like drawing rough sketches early in the morning, but I can do repetitive or organizational tasks, like building piece lists, late at night. Knowing when I will have the bandwidth to engage in different parts of my work helps me organize time and prioritize.
- **Time off**: Time off is an underrated and crucial element of time management. Exhausted, burned-out artists cannot produce their best work, and you work more slowly when you are tired. Schedule your time off and be inflexible with yourself about making sure you take a certain amount of time off each week. It can be helpful to plug it into your calendar of choice as a meeting. Do not feel the need to explain this conflict to collaborators; simply declare that you have a conflict and leave it at that.

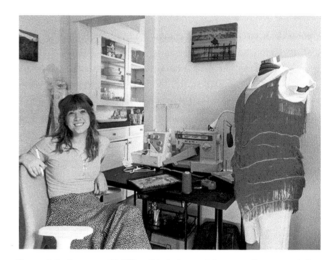

Figure 2.3 Costumer Ali Filipovich in her multi-use studio space. (Ali Filipovich)

Ergonomics and Arranging Your Studio

Like any physical activity that requires a great deal of practice, digital painting and rendering can be tough on the body. Long periods of sedentary painting at poorly set up workstations can lead to repetitive stress injuries and slow, cumulative damage to the artist's eyes, wrists, and back. While many expensive tech accessories are sold as ergonomic essentials, it is more important to practice good habits and use an ergonomic workspace which will alleviate strain and reduce the possibility of injuries.

Work Posture

It's important to adjust all of your equipment and furniture to the correct height for your body. Start with your feet: your feet should be able to rest on the floor with your lower legs running in a

perpendicular angle to the floor. Knees should bend at a 90-degree angle or be angled slightly toward the ground. Think of your body as a set of stairs moving toward the seat of your chair. Some artists may choose to use a footrest with their chair to give them the proper work posture.

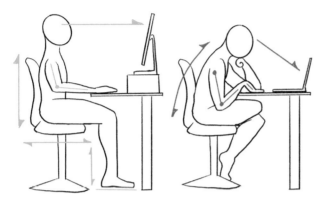

Figure 2.4 A well-aligned working posture (left). A working posture that will slowly destroy you (right). (Author's own)

A good chair provides lumbar support and promotes upright posture. Arms should be able to rest on the desk parallel to the floor, without angling up. It's best if your display is at eye height and does not require you to tilt your head up or down. Notebook computers can be problematic for ergonomic use, as it's impossible to have both the keyboard and the monitor at the ideal heights at the same time. Fortunately, there are many stands and risers which can alleviate the eye-level issue, although you may need to use a separate keyboard to maintain the correct posture.

Digital rendering hours can be long, and it's tempting to slouch, draw your legs up into your chair, or slide down in your chair. All of these habits can lead to repetitive stress injuries that will seriously slow your work, and it is worth checking in on your posture frequently. If you find yourself doing something often, try to adjust your setup to prevent that action. For instance, if you are craning your head forward, try making the text on your monitor larger or zooming in to the work. If you find yourself looking down, try propping your notebook computer up on a few books and using an external keyboard. Cultivate a sense of body awareness when you work, and pay attention to all of the little messages your body sends you. If you take a moment now to address what seems to be a minor inconvenience, it will save you hours of discomfort and lost productivity. You might also discover that you do better work when you are set up for success.

Repetitive Stress Injury

Like most tasks, there is a risk of repetitive stress injury from long hours spent at a digital painting workspace. If you plan on

spending your career painting, it can be helpful to talk to your doctor about what you can do to protect yourself against injury. While doing your own research online is easy, consulting with a medical professional is the safest practice.

The best protection against repetitive stress injury is interruption. Frequent stretches, both at and away from the computer workstation, will help to promote circulation and prevent fatigue. There are websites with video demonstrations of exercises that can help during the workday. Many of these exercises are performed at or next to one's computer work area. It's a good idea to have a running timer or alarm that reminds you to stand up and stretch or move every 30 minutes for at least two minutes. This may feel difficult when you're pressed with deadlines or deep in a creative flow, but it will be less of an interruption than recovery from injury.

A good general exercise regimen has many well-documented benefits. Not only will it keep your body strong for digital painting, it will also promote good mental health and regular sleep. Anecdotally, attending to one's physical and mental wellness creates the necessary space for new ideas, fresh solutions, and getting past artistic blocks during challenging projects. No matter where you are in your career, challenge yourself to building good self-care habits and modeling them for the other creatives in your life.

Don't forget that activities that you do outside of the studio can also add to stress injury, which will affect your time in the studio. Smartphones put a lot of stress on our wrists and thumbs, especially when we are also working in our studios all day. Other hand-intensive hobbies, like gaming or even yoga, can compound any stress placed on your hands in the studio. A useful strategy to deal with these stresses is to balance the hours per day you are using your hands during large rendering projects. Listen to your body and remember how much of your career depends on keeping your most important tools in good working order.

Eye Strain

Eye strain is a common complaint for those who spend much of their day working at computers. While blue blocking lenses may provide some protection against eye strain and sleep disruption, practicing frequent breaks is strongly recommended. Practice the 20-20-20 method cited by the American Optometric Association: every 20 or 25 minutes of work, look away from the screen for at least 20 seconds, focusing on something that is at least 20 feet away. If your workspace is smaller than 20 feet, try looking out a window or down a hallway. It is also helpful to use lubricating eye drops periodically, as we tend to blink less when staring at screens, leading to dry and irritated eyes.

Dark Mode

Most computers, mobile devices, and software programs now have the option to enable dark mode or choose a color theme for the user interface that makes the majority of the screen dark, with text being shown in white. This feature is essential on long-haul projects and in tech rehearsal. It is important to select the right mode for your ambient lighting.

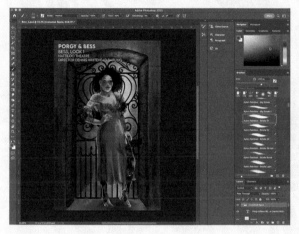

Figure 2.5 Screenshot of Adobe Photoshop working in dark mode. (Author's own)

Studio Lighting

Light is an important consideration when setting up your physical studio. Natural light is the best option, with full-spectrum fluorescent light favored in many institutional settings. Be aware that both natural and fluorescent light contain ultraviolet (UV) rays. UV light, which is harmful to your eyes, can pass through glass that is not specially designed to filter it out. In regard to interior lighting, a frequently cited study from the American Public Health Association posits that the UV light from many fluorescent light sources "causes irreparable damage over time to the human retina, especially in young children." They recommend using "warm-white tubes or incandescent bulbs of lower color temperature and longer wavelength light rather than fluorescent lamps." They recommend that when choosing interior lighting, we should use "incandescent and warm-white lamps instead of cool-white fluorescent lamps." (Walls et al. pp. 2222–2225) From a practical standpoint, having warm and cool lighting in place can help you check that your printed color is what you really want prior to leaving your studio with the wrong colors in hand.

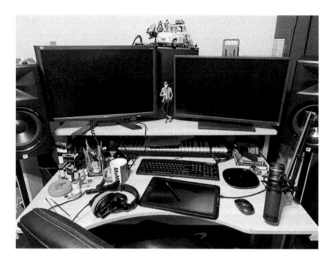

Figure 2.6 Designer Gigi Casperson's digital painting setup. (Gigi Casperson)

Setting up your studio lighting is more than just selecting the correct color temperatures. The way that you arrange your lighting is also important. If your office has a window, think carefully about where your desk and displays will be in relation to that light source. If your desk will face the window, we would strongly recommend getting yourself some adjustable curtains, with both a "blackout" curtain layer, and a light diffusion layer. It may seem extravagant to buy two sets of curtains, but remember that your productivity will be directly affected by how long you can work comfortably in that space. If your desk will face directly away from the window, curtains will also help with glare on your displays. Even if you don't have a window, a strong light source can create glare and eye strain. Make sure your display is in a place where you're not shifting your body to see around glare. If this isn't possible due to space or power limitations, consider putting an anti-glare monitor cover in place.

The ambient light of your studio should balance with your display's brightness. Working in a darkened room will strain and overwhelm your eyes as you stare into your monitor, but working in a sun-drenched, bright environment may have you squinting as your computer monitor cannot compete with your ambient light. Soft, indirect lighting that is level to your monitor's output is best for visibility and for your eye protection. Remember that if you have a window, the light levels will change throughout the workday.

Many computers have their own software or specific modes to correct for times of day or lighting conditions. Your computer may be reading the white balance or color

temperature of your room and subtly adjusting the display to make colors appear more consistent despite changes in ambient lighting. Many display devices (including phones) offer to schedule a night shift, or reduce contrast and blue tones after a certain time of day. You will notice the night-shifted display to be more yellow than usual, and usually the display will feature white text on black backgrounds. It is important to note that while reducing blue light in the hours before bed may promote better sleep, you should remember that night-shifting your display can radically shift your perception of the color in your documents.

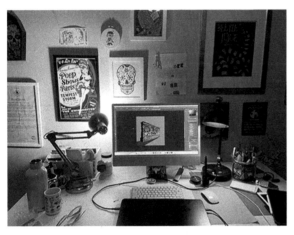

Figure 2.7 Photograph of the author's digital painting workstation. (Author's own)

Hardware

Digital painting requires specialized hardware. At a minimum, you need a device that runs the painting software and an input device for painting, usually a stylus and tablet. (Sometimes, the device and the input are collapsed into one machine, which will be discussed at length below.) Having a keyboard handy for shortcut keys is useful too. This book expects users will paint using a stylus and tablet rather than a mouse, a trackpad, or a finger. Only the stylus/tablet equips the artist with the combination of pressure sensitivity, tilt sensitivity, and technical precision required to excel in digital painting.

Imagine drawing with a soft-leaded 6B pencil. Lightly dragging the tip of the pencil across the paper produces thin, light lines. Bear down on the paper and the lines become heavy and dark. This is pressure sensitivity, and a good digital drawing surface will produce the same effects when drawing with a stylus. Now imagine you're using the side of a pencil to apply broad shading to a drawing; this is tilt sensitivity. The device will read the relationship between the stylus and the surface and adjust the

line on the screen to reflect it. While it is possible to eke out a rendering without a tablet and stylus, the grindingly slow speed, lack of delicate control, and general awkwardness of the tools make it unappealing.

Figure 2.8 Digital painting offers a wide variety of brushes that respond to pen pressure. (Author's own)

Let's start by looking at the specialized input devices that make digital painting possible. Technology is constantly being updated, so the following offers broad guidance rather than pointing you to specific makes and models of devices. The following is meant to help you choose the device best for your practice and your budget.

Selecting Your Input Device: Connected Drawing Tablets Versus Standalone Drawing Tablets

You have a very basic choice to make when you choose digital painting hardware: do you want to be tethered to a computer, or do you want the device to be standalone? It isn't necessarily as straightforward as you might think. There are two broad

categories of devices, despite the ways in which technological innovations have blurred the lines between these categories: connected drawing tablets and standalone drawing tablets.

Connected drawing tablets are what we are calling any drawing tablet that relies on a connection to a computer in order to function. Connected devices feature a drawing surface (tablet), drawing tool (stylus), and means of connecting to computers (device-specific cables or Bluetooth technology). Connected drawing tablets require the installation of drivers, an important consideration for people using shared computers, like those in a university lab setting. Common examples of connected tablets are Wacom and Huion graphics tablets.

Standalone tablets, as the term implies, do not need to be connected to any other computer in order to function as digital painting input devices, as they have their own built-in display, processor, memory, hard drive, power source, etc. Standalone devices are touchscreen devices like Apple's iPad, Android tablets, touchscreen computers like Microsoft Surface, or a newer category of devices called pen computers produced by the manufacturers of connected drawing tablets.

Each category of devices has strengths and weaknesses to consider.

Connected Drawing Tablets

Connected tablets come in two broad categories as well. There are pen tablets, which are drawing tablets that do not contain any display capability. Some painters find these initially awkward to use, as you must look at your computer screen while you use your stylus to draw on a blank surface that corresponds to the computer screen. Most users are able to adapt to this disconnect quickly, but there is a slight learning curve. These are quite sturdy, portable, and they are also usually the least expensive option to get started with high-quality pressure- and tilt-sensitive digital painting. A decent pen tablet, bundled with a stylus, can be purchased for around $50.

Pen displays are drawing tablets that contain a display within the drawing surface, which provides the most natural and immediate way to see your painting process. They mirror or extend your computer's display, allowing you to draw directly on the screen with your stylus. Pen displays are more delicate, heavier, and less long-lived than pen tablets. They also come with a heftier price tag and require a powerful computer to run them without lag. The trade-off for all of these conditions is the immediacy of interacting directly with your digital painting and software. Wacom's Cintiq ruled the pen display industry for some time, but challengers like XPPen and Huion are offering competitive products at attractive price points.

Figure 2.9 Pen display tablets mirror your computer's monitor, allowing you to interact directly with the image. (CCO Public Domain)

If you aren't sure how you're going to feel about digital painting, a pen tablet is a great, low-risk place to start. If you decide a pen display is the right choice for you, budget for a display that is at least 16 inches. Whatever you do, be certain that the tablet you purchase is pressure sensitive. Quality pressure sensitivity is the number one factor in how natural the painting process will feel. Tilt sensitivity is a good feature, but not absolutely essential, especially for beginners. Touchscreen functionality is not an essential feature; it can be useful, but it can also be frustrating when the side of your hand activates a touch function while you are painting with the stylus. To combat this, some digital painters wear thin half-gloves that cover the side of their dominant hand while resting it on the screen.

Connected Drawing Tablet Advantages

- **Processing power and memory**: A drawing tablet that is connected to a computer has the potential to be more powerful than its standalone siblings, but it is reliant on the power of the computer to which it is tethered. You can also upgrade your main computer at any time, and migrate your connected tablet from device to device. This means that you can use more powerful software, and work on larger and more complex paintings. Your connected tablet will be only as powerful as the computer that it is connected to. Depending on your computer, this may be an advantage or a disadvantage.
- **Size**: Connected tablets come in a great range of screen or drawing surface sizes, with some offering truly impressive drawing areas to work with.
- **Life span**: Because a connected tablet relies on your computer's power and software, it doesn't become obsolete as quickly as a device with its own processing power and operating system. A connected pen tablet will usually last you as long as the company that makes it continues to provide driver support.

- **Cost:** Connected drawing tablets are often a very inexpensive way to explore the world of digital rendering. You can get a great connected device at a very friendly price point.

Connected Drawing Tablet Disadvantages

- **Portability:** Although connected tablets are certainly portable, the plethora of special cables and connectors make them more difficult to move from place to place. You are far less likely to find serendipitous moments to paint on a subway car, or while visiting a friend, with a connected device. If you get your best work done in a studio with minimal distractions, you might not mind this trade-off. The larger pen displays are heavy, but the smaller pen tablet versions are quite portable (as long as you bring your computer).
- **Immediacy:** Many connected drawing tablets, especially the most affordable options, are pen tablets. There is a learning curve to looking up at the screen while drawing on another surface.

Standalone Drawing Tablet Hardware: iPads, Android Tablets, Pen Computers, Windows Surface Tablets, and Other Touchscreen Devices

Many artists choose a standalone touchscreen device as their primary means of digital painting. Rather than running input to a separate computer, as with a pen or display tablet, these devices are capable of running digital painting software and allowing the artist to interact directly with the display. The advantages are clear: less or no cable management, no drivers to install, no device interactivity issues, an uncluttered workspace, and a rendering tool that travels easily. It can also be financially beneficial to bundle the cost of your digital painting tool into a single device, especially if you work with shared computers or your computer isn't powerful enough to run digital painting software.

There are drawbacks to consider, as these devices come with their own limitations: the number of data ports are likely limited compared to what you'd find on a desktop or notebook computer, app-specific file formats may not be compatible when exported across software platforms, and in some cases, the touchscreen was not designed with digital painting in mind and may lack the responsiveness of a dedicated device. Some devices work like larger mobile devices (Android tablets, iPad, etc.), allowing users to select applications from operating system-specific app stores (Google Play, Apple's App Store, etc.). Others are more like notebook computers with touchscreens (Windows Surface, Lenovo Flex, etc.) and can run the same digital rendering software as desktop or notebook computers. Wacom also offers two different pen computer devices at the time of writing, which are portable computers with full Wacom technology built into the screen.

The price points of these devices vary with quality and capacity: simple, low-capacity Android tablets are very affordable, but may lack the necessary sensitivity for digital painting. Wacom pen computers, Windows Surface Pro, and iPad Pro devices are comparably priced to computers because of their extended capacities, and because they were built with the sensitivity and muscle required for digital painting applications. They are also fabulous multitaskers and are great for taking notes, mobile videoconferencing, reading and annotating scripts, searching for research, and building show paperwork. These devices have broad applicability for theater designers beyond digital painting.

Test driving a device to see how it responds to your particular hand is always recommended. When testing a device, you're getting a feel of the weight, materials, and shapes of the device. Does the stylus feel comfortable in your hand? Does the operating system make intuitive sense to you? Open a document to your usual size specifications, pick out a big brush, and check for lag, or the amount of time between your hand drawing a stroke and the stroke appearing on the screen. This should appear as simultaneous as it does in traditional media, even when working in large document formats.

Standalone Drawing Tablet Advantages

- **Portability:** As you might expect, standalone devices are easy to transport, offering maximum options for painting in your free moments. You can also take breaks from your desk chair and render on the couch.
- **Immediacy:** Most standalone tablets use a touchscreen display. Many artists prefer interacting with the image directly.
- **Lower learning curve:** If you're new to the digital realm, the minimal device management offered by standalone tablets is less intimidating. Also, digital painting apps like Procreate and Fresco are very intuitive for new painters.

Standalone Drawing Tablet Disadvantages

- **Processing power and memory:** Standalone devices are getting more powerful all the time, but for the moment, mobile standalone devices aren't as powerful as computers. Also, if your tablet and computer are combined into one device, you will find yourself greatly limited in the customizations you can choose for your device hardware. There are limited options for pen computer devices. While connected tablets come in a wider range of options, computers are infinitely more configurable.
- **Size:** Unsurprisingly, you will find that even the largest standalone device cannot compete in the work area offered by connected tablet options.
- **Cost:** Because they're essentially computers, standalone devices are often much more expensive than a connected device. Often, you're paying for a high-quality display and processing power, two things connected tablets don't need.
- **Life span:** Because you cannot upgrade the processor or memory on a standalone drawing tablet, and because

operating systems favor newer devices, standalone tablets have shorter lifespans than the decade-plus promise of a connected device.

The Stylus and the Surface

The different technologies tablets use to communicate with their respective styli should also be a factor in your selection. If at all possible, test drive these devices to feel the weight of the stylus in your hand and the feel of its tip on the surface of the tablet. Also consider whether you want a powered stylus like the Apple Pencil or an EMR stylus like those provided by Wacom and Huion. EMR stands for electromagnetic waves, and this type of stylus is powered by the tablet; an EMR stylus does not require charging. A battery-powered stylus like the Apple Pencil has to be charged periodically, but recent technological advancements have drastically shortened charging times for many products. The battery in a powered stylus uses Bluetooth technology to communicate with the tablet.

An important factor in choosing your device is the feel of the stylus on the drawing surface. Wacom offers a range of different nibs made from plastic and felt of various hardnesses and with various levels of flexibility, allowing you to choose a nib that feels like your favorite traditional media. Other products, like the Apple Pencil, do not have different nib styles. If you don't like the feeling of the Apple Pencil nib on glass, there are paper-feel screen protectors for the iPad screen that create a toothy feel to the drawing experience. All stylus nibs will eventually wear out and need to be replaced periodically, but this is far less expensive than replacing the stylus. There are also grip adjusters that will help any stylus fit more comfortably in your hand.

Selecting Your Computer

If you already own a computer, it is important to determine whether or not it is capable of running digital painting software and hardware prior to investing in new devices. If you plan on using a connected tablet, there are certain hardware requirements that will ensure you get better performance. As a rule of thumb, if a computer that already runs graphically demanding software (like Adobe Photoshop) is marketed as a video editing computer, or is a gaming computer, you probably have adequate hardware to add a stylus and tablet to your digital painting studio. If your computer struggles with graphically demanding tasks, it may also struggle to keep up with digital painting.

If you have the luxury of selecting a computer before you select your input device, a shortcut to researching which components you'll need to upgrade is to purchase a computer rated for gaming. They often have great specs, run cooler, and they come at a variety of price points. Prices for powerful computers fluctuate as certain materials become scarce, leading to periods where you might pay exorbitant prices for your processor or your graphics card. Before you spend on a new machine, spend a few weeks following tech blogs to get a feel for the market and to determine what you might expect to pay for a computer powerful enough to support your practice.

If you are shopping for or building out a computer, consult the hardware requirements for the software you want to use the most and the hardware requirements listed for the tablet you are interested in. Minimum specifications are usually available on the software company's website. To get the best of everything, you could buy a computer with the latest and most advanced versions of every component, but that gets very expensive. Understanding more about your computer's internal components can help you prioritize spending. The internet is flush with information about these parts, but the aim of the following list is to help you understand how each of them will impact your computer's performance specifically while painting. Here are some broad guidelines on what to look for in a computer:

- **Hard drive**: Having a large hard drive allows you to store multiple versions of your files, and work with large files easily. Later on, you will see how important it is to save multiple versions of your files as you iterate and develop your work. When building out a computer, you might have a choice between a traditional magnetic platter-style hard drive and a solid state drive (SSD), or a combination of the two. Magnetic disk drives are slower, but provide much more space for less money. SSD drives are significantly faster, better for working with large files, and are more rugged, but they are more expensive. If you have both types of drives, store your less frequently used files and programs on your larger magnetic drive and your frequently accessed files on your SSD. Files stored on a SSD can be opened and edited more rapidly. Magnetic platter drives are also delicate and dislike being jostled, which can be a real issue in a notebook computer that will be on the road a lot. SSDs are more durable and don't mind movement at all.

Cloud Storage

Cloud storage is a tremendous boon to collaborators working across distance or artists working on more than one device, but it isn't a complete replacement for hard drive space. A significant disadvantage to storing files on the cloud is that you need access to the cloud to edit your files. It is frustrating to sit down to get work done on a project only to find that the file you need is inaccessible because you don't have a solid internet connection. Using a solid state external hard drive for your backup and archival needs is a good complementary solution to cloud storage. Because most cloud storage is subscription based, you also want backups of your own files that cannot vanish due to a missed payment.

- **System memory (RAM):** The more memory your computer has, the more it can do. Memory, in this context, isn't the same as storage space. Think of RAM as your computer's ability to multitask. With a lot of RAM, your computer can run several processes at the same time, such as painting large-scale images without lag while you're listening to streamed music and you have several browser windows open with reference images.
- **Dedicated video card, graphics card, or GPU:** For the very best possible performance on a Windows device, your computer should have a dedicated graphics card rather than integrated graphics. A dedicated graphics card is a card that is used solely for video tasks. Less expensive computers use integrated graphics, which means that the main processor or a subprocessor on the motherboard processes all of the graphics. Dedicated graphics cards are specially designed to be faster and more efficient. They have their own processor that can often be just as fast or faster than your main CPU, and often have their own cooling fan. At the time of writing, the latest generation of Apple devices are upgrading to the M2 chipset that features integrated graphics chips which are said to provide the same processing power as other advanced systems with dedicated graphics cards while using far less electricity. The size of the documents you are creating should also factor into your choices here. Whether the graphics are processed using an integrated or dedicated chipset, you want your device to have lots of video memory (VRAM).
- **Video memory (VRAM):** More is better. Often having more VRAM goes farther than more regular memory. Everything said above for system RAM goes double for video memory. This is essential. At the time of publishing, 8GB is a good minimum.
- **Display:** Get a large display that has a high resolution (4K) and a fast refresh rate, 60 hertz or better. The higher the refresh rate, the less strain there is on your eyes. Some designers swear by wider monitors that have a slight curve to them, which is supposed to help limit how much you turn your head while working. These can be especially useful to scenic and projection designers.

Using Multiple Monitors

Even if you are using a tablet that has a built-in display, consider adding an additional monitor to your studio. It can be very useful to have your painting on your tablet, reference material on a large secondary monitor above your display tablet, and notes or even floating tool palettes on your primary display device. If you're working primarily with notebook computers and tablets, consider that monitors are more easily set up at the correct height for ergonomic

viewing, which reduces strain on your neck and back. If you're using multiple Apple devices, like a desktop computer and an iPad, the iPad can pair with the desktop via Sidecar to act as a second monitor.

- **Ports:** If your design area requires video output, having at least one additional video port is essential. Having a good number of peripheral ports (USB-A, USB-C) is very important. Some manufacturers limit the number of built-in peripheral ports and will require a special dongle or dock device to connect peripherals. Purchasing these devices can be an added expense. If you are only exporting smaller renderings from your device via the cloud, onboard ports might not be as crucial to your work. If you need to send large video files, onboard ports for various cables will save you time.

Specific Considerations for Portable Computers
- **Size and weight:** Even if you don't think that you will be moving your notebook around a lot for your work, size and weight matter. A notebook computer or tablet may feel light in your hands, but once you add protective cases, peripherals, and cables to your bag, the weight can feel significant when worn on your back or shoulder. You may also consider whether your new device will fit in the bag you like to carry or whether you will need to source a new bag to fit the device. Striking a balance between the size monitor you need and the weight of the device can be difficult, so you should think about how much you'll be toting the device with you on shopping trips, to meetings, and to rehearsals.
- **Screen size:** Please see the notes above regarding displays in general, but for notebook computers, screen size is directly related to weight and the overall dimensions of the device. You can certainly work on smaller screens, but the bigger your screen, the easier it will be to work fluidly.
- **Battery life:** If your device won't turn on, you can't get any work done. There have been steady improvements in notebook computer battery life, so expecting six to eight hours of battery life is perfectly reasonable. Some devices claim they can go 10–18 hours on a charge, but that may not be true when using graphically intensive programs. Many devices will throttle performance to increase battery life by default, so to get your best productivity, you will want to plug in, or manually disable that power management feature.
- **Heat management:** Sometimes, you won't know how your notebook computer handles heat until after you've purchased it. If you can't test drive your machine, look at forums and online communities and listen to what current users say about running the notebook computer. Graphics-intensive use and multitasking are all likely to make your machine run hotter and heat can dramatically shorten the lifespan of your machine.

Does It Matter What Operating System I Use?

If you are looking to buy a computer, you are probably considering a computer that runs either the Microsoft Windows operating system (OS for short) or the Apple MacOS. If you are looking for a standalone tablet, you are probably considering a Google Android or Apple iOS device. The operating system is the ecosystem of your machine which will run all of your software. These days, most consumers own more than one device, and you might find that there are advantages and disadvantages to having all of your devices in a single ecosystem. Phones, smart watches, tablets, and computers running the same OS often offer expanded features compared with devices using different ecosystems. You should think carefully about which operating system is a better fit for your computer fluency, budget, and organizational needs.

This is further complicated by the fact that each device and each OS has its own die-hard fan base. Do your best to separate marketing hype from the actual operating system: talk to users of any system that you are interested in, and if possible, spend some time working with the system yourself. What's important is what works for *you* as a designer, not subscribing to any sort of brand loyalty.

Selecting Hardware Based on Software System Requirements

All digital painting programs will have a recommended minimal system hardware posted with the software information page on the company website. These are only the minimum requirements for the software to work, so any specs above these minimum ratings will improve performance. Many of the more powerful graphics cards come with a multitude of options for how to maximize performance with your program of choice. Visit the website of your graphics card manufacturer to see what settings will work best for your hardware.

Here are a few strategies to research what kind of hardware you need for your software.

- As mentioned above, it is a pretty safe bet that a computer which is rated well for demanding video games will perform well with digital painting software.
- Research what major computer builders are using to make systems for highly demanding graphics applications. Puget Systems, for instance, publishes all of the relevant

information on the hardware they use for their systems. You could choose to buy directly from them (or a competitor like Falcon Northwest or Origin PC), or you could research what they are using and use that information to make informed decisions.
- Read reviews on tech publications like *The Wirecutter*, *PC Mag*, *MacWorld*, or *MacRumors* to see what their staff have to say about the products. It's important to glean information from informed third-party sources, not from the manufacturer.

Maintenance

After you have selected your device, you can extend the life of your hardware significantly with regular maintenance. Here are some methods that we recommend:

- **Regular external cleaning**: Research and follow the manufacturer's guidelines on the proper methods of keeping the exterior of your devices and peripherals clean.
- **Regular updates**: Keep your OS, drivers, and software packages up to date with regular automatic patches and security updates. Operating systems get regular security patches, software gets feature improvements, and video card drivers get regular performance upgrades. These are just a few examples of important updates you will want to watch for on a regular basis. Some will automatically prompt you to update periodically, but not all will!
- **Protection from malicious software**: Install and keep your antivirus and firewall software up to date. Especially if you are newer to using a computer, research how to avoid accidentally downloading malicious software and files. A good rule of thumb is to only install software and download files from trusted sources.
- **Clear your cache(s)**: There are many places that temporary files like to hide on your system. This will vary from installation to installation and depends on your OS, but keep an eye out for places that files like to accumulate. The more junk files you have on your computer, the slower it will be.
- **Check your storage**: Your computer will slow down if the hard drive is within one or two gigabytes of being full. If you notice your hard drive is full, consider backing up archived files to an external device and the cloud before removing them from your main computer.
- **Regular backups**: You will always need to keep backups of your files, and fortunately storage keeps getting cheaper and cheaper even as files get larger and larger. For maximum safety, use a Two-Plus-One backup method. Keep two identical separate physical backups on external hard drives and one cloud backup. If possible, keep the two physical backup drives in different places, in case one is stolen or destroyed. There are lots of free and paid options for scheduling regular physical backups and keeping them in sync. Some OS have regularly scheduled cloud backup options that are a great

safety net. Similarly, there are many free and paid options for storing data on the cloud. While it isn't recommended to store financially or personally sensitive data on the cloud, show archives should be just fine. High-quality paper prints on archival paper of your most highly valued work could last longer than any electronic storage method.

- **System refresh/factory reset**: Over time, every device, no matter how carefully you take care of it, will accumulate broken files, bugs, and even malicious software. It has gotten dramatically easier to reset your computer to its factory-fresh state, and periodic system refreshes can substantially improve performance. If you choose to refresh your system, make certain that you have externally backed up all of your important files and made a list of all of the software that you will want to re-install once your device is wiped clean.

Knowing When to Replace Your Device

Even the most expensive, high-end computer or standalone device will eventually be outpaced by advancements in software and hardware, but it can be difficult to know when it's time to consider purchasing a new one. Think through the following questions to help guide this decision:

- Are any of the components in your device replaceable? Upgrading your graphics card or adding RAM can extend the life of a machine by years. A custom-built tower-style CPU can last for decades if you continue to upgrade components as needed. It is also more eco-conscious to improve your current machine rather than just tossing it and buying something new.
- Is your device struggling with heat issues? Overheating can be a signal that your computer may soon fail catastrophically. Consider consulting a professional about your computer's heat issues, but make sure you're backed up and ready for the worst case scenario.
- After performing your regular maintenance, is your device's slow speed adding to your design time? If you're experiencing serious lag, struggling to run large documents, or waiting through excruciating load times, you may be reducing your hourly wage in the slowdown. Every minute you spend on a freelance project reduces your rate, so it's best to think about whether investing in a new machine (or repairing your current machine) would make financial sense.

A computer that's outlived its usefulness for you may still be a valuable resource for someone else. After wiping or, for extra safety, replacing your hard drive, consider selling or donating your used computer to someone who might make use of it. If you can't find anyone who wants it, check your local recycling programs and make sure your computer's components aren't going into a landfill. Many big box retailers offer computer recycling and some companies will pay you for a functional trade-in computer or provide purchase credit toward a new machine.

Software

Selecting the right hardware is only a part of setting up your digital painting studio. Software is where smart choices in hardware will give significant advantages when you put a stylus to your tablet. When selecting digital painting software, it is important to understand what each specific platform offers, what it is best at, what its limitations are, and what special features it offers that are not shared by any of its competitors. Further, some software choices require specific hardware, so it's great to have an idea of what software you want before shopping for a device. This list will likely change quickly and often, so asking experienced digital rendering practitioners for their latest recommendations may be a great supplement to what is discussed here. What follows is a general overview of some of the most common and established software tools for digital painting.

Adobe Photoshop

Adobe Photoshop is the reigning diamond-standard digital painting application. Photoshop pioneered the idea of working in layers, an idea core to all digital painting software, and Photoshop continues to update and upgrade its tool to make it the most powerful, feature-rich software on the market. Photoshop is also complex and can be opaque to new users because it has so many menus, controls, and features. Starting with Photoshop before learning other digital software platforms is recommended because most of the others have based their layout and functionality on Photoshop; if you understand Photoshop, you can learn almost any other digital painting software quickly and easily. It doesn't work so easily in the other direction. Because it is the diamond-standard painting application, understanding this software is usually required for those seeking work as assistants or illustrators.

Figure 2.10 Adobe Photoshop user interface, pictured in dark mode. (Author's own)

Photoshop has a lot to recommend it. The only limit to file size is the capacity of the user's computer, meaning designers can prepare large-scale fabric for custom printing or cyclorama-sized drops for digital printing. Selection tools are varied, sensitive, and smart, allowing for unparalleled image manipulation. Because Photoshop was originally conceived of as a photography manipulation platform, users have the choice between bringing in assets for manipulation, creating original painted content, or blending the two. Color can be manipulated in countless ways through direct application, blending modes, opacity, jitter controls, filters, and adjustment menus. The list goes on, and its subscription-based model means Adobe is constantly adding small patches, fixes, tweaks, and new features without overhauling the software in the form of new versions.

Other than its breadth of features, Photoshop's most powerful draw is the inclusion of digital artist Kyle Webster's excellent brush sets. Once sold separately by the artist, these brushes are now free to all Adobe Creative Cloud subscribers, including seasonal brush pack updates. Kyle's brushes beautifully mimic natural media by producing the same irregularities and happy accidents as natural media: a bit of your last paint color is left on your brush as you switch colors, markers can run dry after a few strokes, colors pool to the edge of a watercolor stroke, HB pencils make irregular marks indistinguishable from their analog cousins. Kyle's brushes, available on both Photoshop and Adobe Fresco, are powerful and beautiful.

Adobe Fresco

Adobe Fresco was developed by Adobe specifically as a tool for digital painters working on tablet devices. Originally debuting for the iPad and the Apple Pencil, Fresco uses the structural language of Photoshop but with streamlined features selected for their relevance to digital painting. The interface is clean, intuitive, and will be instantly familiar to Photoshop users.

Figure 2.11 Adobe Fresco user interface, pictured on a 2021 iPad Pro. (Author's own)

In addition to including Kyle's brushes, Fresco has a unique brush feature not matched by other software: live brushes. Fresco's live watercolor and oil brushes maintain wet edges after the stylus is lifted from the screen, allowing for a new and powerful range of natural media effects. Fresco users can drop color onto the canvas, then paint using the digital equivalent of clean water, allowing the concentrated color to bleed and pool on the surface exactly like watercolor on paper, but with all of the flexibility and forgiveness of digital tools. At the time of this writing, Fresco is still developing its software and has some limitations that may prove challenging for certain theatrical applications. Fresco updates regularly, adding new features and functionality. It is only available to Adobe Creative Cloud subscribers.

Procreate

Procreate is an application exclusive to the iPad. Its layout and functionality are similar to that of Adobe products, but with a sleek, minimal interface and simplified features. While Procreate cannot do everything Photoshop can do, it is an extremely powerful piece of software with a very approachable price tag and an intuitive design. It can create large documents, it harnesses the responsiveness of the Apple Pencil to create beautiful drawings and paintings, and it can export files that are compatible with Photoshop. If you are new to digital rendering and intimidated by complex software, Procreate has a gentle learning curve and is a great place to start. It's also becoming the preferred software of film and television illustrators, at least on the West Coast.

Figure 2.12 Procreate user interface, pictured on a 2021 iPad Pro. (Author's own)

Procreate isn't without drawbacks. If you're working with a lower-powered iPad like an iPad Air, Procreate will be frustrating. You will find Procreate limits the number of layers you can create in an image and you may experience lag or reduced sensitivity. Procreate includes selection and text tools, but they are much

more rudimentary than those Photoshop offers. At the time of publication, Procreate does not offer any sync options to create backups of your work. iCloud can be asked to do this, but the information is still stored in the Procreate app in the proprietary Procreate format. If you accidentally delete your images or if you need to switch to a new device without an iCloud backup, you will not be able to recover your Procreate files. If you choose to use Procreate regularly, it's a good idea to manually export your files in.PSD for archival purposes. If these warnings sound like they're coming from experience, it is because they are!

One of Procreate's unique features (shared by Clip Studio) is the assisted perspective drawing tool. Users have the ability to set up a horizon line and define vanishing points, then quickly sketch in a space that doesn't allow "wrong" lines. Using this tool, users can rapidly set up iterative scenic sketches without laboring over perspective grids. The assisted drawing feature can be toggled on and off, allowing for the designer to switch between structural lines and architectural detail.

Clip Studio

Though not as well known as the Adobe line of products, Clip Studio is a powerful and affordable software option. Because Clip Studio is geared toward comic artists, there are tools for both perspective grids and character poses, making it a great tool for scenic and costume designers. The perspective grid tool allows you to set up your horizon line and vanishing points before creating a locked-line drawing environment. This means when new lines are drawn, they are automatically locked to the perspective grid, making it impossible to "break" the perspective with an incorrectly angled line. This feature can be toggled on and off, allowing the designer to add organic and purposefully incorrect lines as needed.

Figure 2.13 Clip Studio user interface. (Author's own)

Clip Studio also has the ability to use 3D objects as assets. It comes pre-loaded with a few basic 3D bodies, and these bodies can be posed, have their proportions manipulated, or dramatically repositioned in relation to both the ground plane and the viewer.

This is an incredible resource for costume designers, as they are able to customize both the body and the pose, then use that figure as a reference layer when drawing.

Corel Painter

Corel Painter has a long and rich history of its own in the digital painting space, and Corel has been a major player in the graphics world for decades. Many artists prefer Corel Painter as a digital painting tool. It features a powerful brush engine, an ever-growing selection of brushes, dedicated painter's tools to review your compositions, and more. It is a mature and serious contender for the best digital painting software for your computer, though it is used less widely than Adobe Photoshop. This can lead to issues with collaborator compatibility.

Other Software

There are many other digital painting programs that will not be covered here, including SAI, Gimp, FireAplaca, SketchBook, Artweaver, Rebelle, and many more. Their exclusion from this list is not a judgment on their quality, but it is a comment on the frequency with which they are encountered in theatrical design settings. All software choices have pros and cons, and include a balance between cost and features. Talk to artists you know or artists you admire in your network or on social media to help find the software that will best fit your needs.

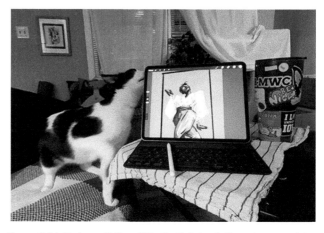

Figure 2.14 Designer Melissa Gilbert's digital painting setup, complete with helpful assistant. (Melissa Gilbert)

Further Resources

www.aoa.org/healthy-eyes/eye-and-vision-conditions/computer-vision-syndrome?sso=y

www.aoa.org/AOA/Images/Patients/Eye%20Conditions/20-20-20-rule.pdf

www.ehs.pitt.edu/workplace/ergonomics/computer-users

https://francescocirillo.com/pages/pomodoro-technique

https://health.clevelandclinic.org/do-blue-light-blocking-glasses-actually-work/

www.osha.gov/etools/computer-workstations

https://uhs.berkeley.edu/facstaff/ergonomics/computer-ergonomics

https://uhs.princeton.edu/health-resources/ergonomics-computer-use

https://uhs.umich.edu/computerergonomics

References

Savage, Adam. *Every Tool's a Hammer*. New York: Atria Books, 2020.

Walls, Helen L., Kelvin L. Walls, and Geza Benke. "Eye disease resulting from increased use of fluorescent lighting as a climate change mitigation strategy." *American Journal of Public Health* vol. 101, no. 12, 2011: pp. 2222–2225. doi: 10.2105/AJPH.2011.300246

CHAPTER 3
Configuring Your Digital Workspace

Configuring Software for Digital Painting

Digital painting software has its own consistent language. Learning to recognize this language in order to parse interfaces, icons, jargon, and acronyms will make you conversant in several software platforms. This chapter will address good practices to follow when you set up your files, and how you can customize your digital workspace, just as you customize your physical studio.

Formatting Your Digital Painting File

Setting up files correctly for your intended final product is critically important. Even veteran digital painters make mistakes here, and mistakes at this early stage can lead to

Paper Sizes and Resolution

Before you paint, you need to decide what size paper or canvas you will work on. Most digital painting software refers to your file as a canvas, but these documents are often created to be printed, so it's important to consider the final outcome when setting up your document. There are standard sizes of papers in the USA, and different artists prefer different sizes for specific uses. Note that not all printers can print at all of the sizes listed in Table 3.1. Standard office printers and copiers handle a limited range of paper sizes. Plotters have the most range and flexibility, but if you are investing in your first printer for professional use, having a printer that can print and scan color 11" x 17" pages is a great start. Some standard sizes used often in theater are listed below, with additional notes on what different disciplines might use each paper size for:

Table 3.1 US Standard Paper Sizes for Design Documentation

Names	Size (in)	Size (mm)	AR	Theatrical Uses
Arch C, Arch 3	18 × 24	457 × 620	4:3	Scenic renderings, scenic drafting, and projection/integrated media design renderings
Arch D, Arch 4	24 × 36	610 × 914	3:2	Scenic renderings, scenic drafting, and projection/integrated media design renderings
Letter	8.5 × 11	216 × 279	1.29	Scenic, costume, and projection/integrated media design renderings (office printer friendly)
Tabloid/ledger	11 × 17	279 × 432	.65	Scenic, costume, and projection/integrated media design renderings (office printer friendly)
Super B	13 × 19	330 × 483	1: 1.46	Scenic, costume, and projection/integrated media design renderings (available at many print shops)

major problems with the document when it comes to editing, printing, and sharing it. Many configuration decisions cannot be reversed once the document is created; by the time you discover that you've made an error, your only choice will be to start over from the beginning. Learning the intricacies of these menus sets you up for success and allows you to create time-saving templates for your work, preventing future errors in document setup.

Now that you have picked your paper size, you will need to set your document's resolution. Resolution is a term for describing how much detail can be shown in a certain area. It is described in dots per inch (DPI) or pixels per inch (PPI). The two terms are not really the same, but they are often used interchangeably. In digital painting for theater, we are often painting something that will eventually be printed and sent to a production shop for color matching and reference. Therefore, anything that you

DOI: 10.4324/9781003212836-3

paint for this purpose should be at 300 PPI or higher. If you choose a low PPI when you first create your document, there is no way to increase the quality of the image afterwards. This means that when you go to print your document at the full size you intended, it may look pixelated. Some software will claim it can increase the PPI after document creation, but keep in mind the software is making an intelligent guess as to how it should fill the missing pixels. The best solution is preventing the problem with correct document setup.

Figure 3.2 Document setup interface in Procreate. (Author's own)

Figure 3.1 Compare the pixel size between these two documents: the document on the left is a 300 PPI document and the document on the right is a 100 PPI document. The smaller pixel size of the 300 PPI document means the viewer is less likely to spot the pixels in the final image. (Author's own)

If you are a projection or integrated media designer creating media for a production then you are not necessarily concerned with choosing a paper size, so much as selecting a standard video resolution. In this case, your resolution is your canvas size, and vice versa. There is also a one-to-one correlation between the resolution and what you will see on the display device, so PPI and DPI are irrelevant. Discussing all of the different resolutions and video signal types is beyond the scope of this book, but projection designers painting media for productions should consider this rule of thumb: paint at twice the resolution you expect your video display device to require. This way, if you want to be able to zoom in and crop in the future, you have given yourself extra pixels to work with.

Choosing a high PPI will impact your computer's speed and performance. You may notice lag or other glitches when selecting high PPI combined with a large canvas. Depending on the power of your computer, you may have to sacrifice quality or size in order to paint effectively. This is especially true when working on tablet computers.

Unless you're working with a professional print shop, you will likely have to consider that any printers you're using do not have the option of page bleed. Page bleed is when the graphics on a page go all the way to the edge of the paper. This is not possible on most home or office printers. Consider that any material within a quarter inch of the page edge will be "clipped" or eliminated. Some printers will ask you to choose between clipping the image or resizing the image based on the printable area of the page. Resizing can lead to distortions and lost information, so it's better to just keep it in mind from the beginning and leave yourself a quarter inch border around the perimeter of your page. Photoshop will allow you to set up guidelines that won't appear in the saved or printed image, but will help remind you where the printable area of your page is. Once the page is printed, you can trim the paper to create the appearance of a page bleed.

Digital Color Theory

In the analog world, painters and lighting designers think about light very differently because pigment colors become darker when blended, while light becomes brighter when blended. Digital painters need to think about both of these modes when creating in a digital space, which is inherently misleading because all computer displays are backlit. A computer display can add light to a color, producing a backlit effect that cannot be reproduced on the printed page. Neon, highly saturated colors, or low contrast colors viewed on the computer display will print duller or darker than intended. Understanding digital color theory and software settings can help to prevent disappointment.

Figure 3.3 The color wells in Adobe Photoshop, Procreate, Adobe Fresco, and Clip Studio (clockwise from top left). (Author's own)

In the digital environment, you will switch tubes of paint for the color well. The color well (see Figure 3.3) is common to all digital rendering software, and it features a window or menu with a display of all available colors. It can be overwhelming, as the user has access to every possible hue, saturation, shade, and tint of every visible color. This section will discuss how to navigate digital color choices and how to set yourself up for successfully printing digital paintings by choosing the correct selections during setup and image creation. What follows is a bit technical, and it's fine to return to it later when you have more working knowledge of your software's interface.

RGB and CMYK Color Modes
During document setup in most digital painting software, you will be asked to choose whether you want to work in RGB or CMYK color mode. Let's unpack what these modes mean and why you may want to choose one over the other, depending on your project.

RGB stands for Red Green Blue color mode, and it is an additive color system meant for use on backlit screens. RGB gives you the most color freedom, but not all of the colors produced by RGB color mode painting can be printed. RGB assumes all colors begin at darkness until RGB lights are added to the darkness to create colors. Adobe Photoshop uses a large, numbered range to assign incremental intensity and saturation to each hue, resulting in millions of color possibilities. Think of it like an enormous grid where the x-axis contains all of the possible hues, and the y-axis contains all the possible values of each hue; this is very much what you see when you look at your color picker. The color range is based on what a display or monitor can produce. Eventually, when all the colors are lit over one another with adequate brightness, they blend to create white. This is referred to as *additive* mixing because the addition of more color creates more lightness. This color mode is perfect for digital paintings and design that will be seen online, or for working in a creative space without limitations.

Photoshop has a built-in warning system that alerts you to non-printable color selections. When you're selecting your color, watch out for the little triangle with an exclamation point in its center. When this icon appears in the color window, it means you've chosen a non-printable color. Photoshop will provide a small swatch of the nearest looka-like printable color (see Figure 3.4). If you click on the small square under the warning icon, it will automatically load the printable version of your color as your foreground color.

Figure 3.4 Photoshop will alert you if you've chosen an unprintable color by showing this exclamation point icon and offering you a swatch of the nearest printable version of the color. (Author's own)

CMYK stands for Cyan Magenta Yellow Black color mode, and this color range is based on the percentages of ink needed to produce a given color, assuming a white paper background. This color lineup likely sounds familiar because these are the standard colors for printer toner and ink. CMYK assumes that you're starting at white paper and adding layers of color. If the colors are layered together in equal proportion, they produce black. CMYK is a *subtractive* color process because it removes lightness in order to create color and imagery. This is the color mode intended for print pieces, and it will only allow you to work with printable colors. While CMYK used to be required for most commercial printing, new workflows are allowing printers to make use of RGB files without file conversion. Not all RGB colors can be printed, but new developments are allowing printers to make conversion choices instead of asking the human artist to make the necessary adjustments. If you're planning on having something professionally printed, like a printed fabric or digitally printed scenic drop, it's best to learn your printer's preferences before creating the document in order to save yourself the extra work (or cost) of performing a color conversion.

Some software will offer you additional color modes. A few examples are:

- **Bitmap:** Bitmap color mode only uses two values: black and white. When you paint in Bitmap mode, you cannot access

color or grayscale. Instead, each pixel will be either black or white, creating a truly monotone image.
- **Lab color:** One of the newest color modes available, lab color is touted as being the first non-device-specific color mode. While RGB is based on monitor capacity and CMYK is based on how printing works, lab uses the science of how human eyes perceive color to generate colors that will appear alike to people across viewing media.
- **Grayscale:** Grayscale color doesn't allow for the inclusion of any hues. It uses a range of colorless grays, true black, and true white. You will notice that many painting options aren't available to you if you choose to work in grayscale mode. For theatrical design purposes, where we're rarely working in black and white, it's usually a better idea to create your image in RGB color mode and desaturate in order to convert to grayscale if necessary. Keep in mind that converting to grayscale will remove any color undertone from your grays, so your grays will not be able to lean warm or cool.

These modes have specific uses that are generally outside the purview of digital media production for theatrical design, but it's always a good idea to have a sense of what different menu options mean so you know why you're choosing one option over another.

Color Conversion and Soft Proofing

Because of its range of features and options, most artists choose to render in RGB color mode. Some printers still require a document formatted in CMYK mode. If you create your work in RGB mode and later learn that the printer needs it in CMYK, it is possible to run a conversion. How to do this depends on the software you're using. Adobe products allow you to convert to CMYK within the software; other programs may default to RGB and will require a third-party app or website to convert your image to CMYK. Many third-party converters will also require that your image be flattened, or that all of your layers are merged. Before you flatten your image, make sure to save a duplicate copy with the layers intact, just in case. A flattened image will lose most or all of its editability.

Some software can convert between RGB and CMYK modes in order to accommodate a flexible digital workspace. If you're designing for backlit and onscreen viewing, like projection design, you can begin and end your process in RGB color mode. If there's any chance your work will be printed, it's a good idea to keep printable colors in mind while rendering. Photoshop has the option to constantly print-check your work using "soft proofing." Soft proofing allows you to work in an RGB document but toggle a CMYK view in order to check for printable color issues. Of course, monitors are still not the same as seeing the work on a printed page, no matter how well you calibrate your monitor for print work. If you plan on printing, it's always a good idea to leave enough time for test printing and color adjustments.

Photoshop has additional proof setup presets that allow you to view the image as it would appear to people with red–green color blindness, allowing you to adjust the image for maximum accessibility. (See Figure 3.5.)

Figure 3.5 Photoshop offers soft proofing for both protanopia-type and deuteranopia-type color blindness. (Author's own)

If color calibration is seriously important to your work, you may want to consider investing in a monitor calibration tool and a Pantone swatch book. A calibration tool will look at the display output on your computer, correct your white balance, and calibrate all of your displays. A Pantone swatch book will allow you to call up specific colors on Photoshop according to their Pantone number and communicate those numbers to your collaborators. While the color may look different on your screen than it does in the swatch book, the swatch books are identical and provide great color objectivity, even when collaborating across great distances. Neither of these solutions is inexpensive, and unless you're working with printed material more often than not, they are probably more than you'll need to be successful with digital rendering.

Common File Types

You will encounter many different file types as a digital artist depending on what software you use. What follows below is not an exhaustive list of image file formats, but rather a list of formats that you will use and encounter regularly as a digital painter.

1. **Joint Photographic Experts Group: JPG or JPEG files**
 Ninety-nine percent of the images you encounter digitally in your daily life are in this file format. This is a raster image format, and every time you save the file, it is recompressed. JPG uses lossy compression, so every time the image is saved, the image loses quality. Lossy compression removes information from the file that probably won't be noticed by the casual viewer, with the benefit of much smaller file sizes. The format is also flat and doesn't support layers or other tools

for non-destructive editing. Do not use this file format as your working file. JPG files are useful for exploiting and sharing with your collaborators, as your working painting files will be too big or in a proprietary file format. JPG is good for sharing (but not archiving) finished work, and just about every computer in the world can open a JPG file.

2. **Portable Network Graphics: PNG files**
 PNG is a common image file format. These are also raster files, and the image is recompressed every time you save it, but in contrast to JPG files, the compression is not lossy, so the image is not degraded over time. PNG files can display more colors than JPG files (depending on the file specifications), but they are also limited to RGB color, not CMYK. However, in terms of overall image quality, PNG files outperform JPG files, while still being compressed to a reasonable, shareable size. Also, PNG files support translucency, which makes them great for sharing logos or other free-floating assets. PNG files are also flat, so this is not a good format for a working painting file, but it is a reasonable way to archive imagery. While PNG files are often larger than JPGs, this file type has the same use as JPGS with the added benefits of higher image quality, greater range of colors, and translucency support.

3. **Tag Image File Format: TIFF or TIF files**
 This format offers the ability to store raster or vector image data, and offers lossless compression, high quality, a large color space in CMYK or RGB, and layer functionality. This format is favored for high-quality images when file size is not an issue.

4. **Photoshop Document: PSD, PSB, or PSDT files**
 This format is copyrighted by Adobe. This format can store raster or vector image data and uses lossless compression. There are a wide variety of color spaces and bit-depths available in PSD files, including CMYK and RGB. PSD files were also one of the first image formats to support layers, and layers are essential to non-destructive editing and painting processes. As an Adobe product, these files are broadly compatible with software included in the Creative Cloud. Despite being a copyrighted file format, these files can be opened and edited by programs such as GIMP, Procreate, Corel Draw, Corel Paintshop Pro, Corel Paint, and Affinity Photo. This format is the established standard of digital painting. There is a special version of PSD files called PSB, which stands for Photoshop Big; the primary function of PSB files is to allow creation of really large files. PSDT files are Photoshop template files, which open a user-generated saved template titled "New Document." If you work in Photoshop, you should save all of your working documents in the Photoshop format.

5. **Portable Document Format: PDF files**
 This format is less common for creating working documents in digital painting, but is still a valuable option with other purposes. It is copyrighted by Adobe as well, and therefore

Table 3.2 Digital Rendering File Types

File Type	Pros	Cons	Best Uses
PSD	Preserves layers and history, no compression, preserves vectors	Enormous file size, can't be opened without compatible software	Working documents
JPG	Easy-to-share small files, opens universally	Lossy compression, flattens image, rasterizes vectors	Quick sharing, web use
PNG	Supports translucency, less compression than JPG	Large file size, can't be opened universally, flattens image, rasterizes vectors	High-quality sharing, archiving
TIFF	Preserves layers, preserves vectors	Large file size, proprietary file types or features	Saving high-quality images
PDF	Easy to share, preserves layers, opens universally, great for printing, preserves vectors, can open fonts even if they're not owned by the user	Large file size, sometimes glitches appear when moving files between software	Printing, sharing with collaborators who may need to edit or print the work
PRO	None	Proprietary for Procreate only, export as .PSD or .PDF to archive	Working documents in Procreate, best to convert before sharing

broadly compatible across the Creative Cloud. The PDF file format was developed to provide a reliable way of storing image and text information for layout in print spaces using real-world dimensions (imperial or metric units). Because of this history as a print format, PDF can store both raster and vector imagery. There are a wide variety of color spaces and bit-depths available, including CMYK and RGB, and curiously, each element in a PDF document can use a different color space. PDF files support layers, like PSD files. There are a number of additional features in the PDF format, including hyperlinks, the ability to embed multimedia content, signature/form functionality, and 3D objects. However, these additional features are not generally much use in the painting process. Photoshop seems to treat PDFs essentially the same as PSD files, and you can open and edit PDFs with ease in Photoshop. All of this said, generally, PSD files are preferable over PDF as working files in digital painting. The best uses of the PDF format are sharing and printing. The PDF preserves not only layers and vectors, but it also allows users to view fonts not installed on the computer. This will allow you to create a rendering with a title block, share with a collaborator, and the collaborator will not need to convert fonts to view your text. This is a unique feature of the PDF file type that makes it very useful for theatrical design. Warning: PDF files can be huge if the layer structure of the working document is uncompressed.

6. **Procreate: PRO files**
Usually just called a "Procreate file," this format is copyrighted by Savage Interactive and not broadly compatible with other software. Procreate files are raster based and use RGB color space. These files also support layers and layer groups. One interesting additional feature of Procreate files is that each file stores a time lapse video of the painting being created. These time lapse videos are terrific for social media and instructional use. The starting point of the time lapse

videos can be unpredictable; sometimes time lapse only plays from the last time the document was opened, sometimes it plays from the origin of the document. If you plan on making use of the time lapse feature, it's better to export the video each time you work on your image. While other software cannot use PRO files, Procreate can export files as PSD, PDF, JPG, and other formats for use in other applications. The files you make in Procreate cannot be easily accessed outside of Procreate on your iPad, so backing up is difficult. It's best to export your Procreate work as PSD files to your favorite backup locations.

Here is a quick-reference table for your use so you can quickly decide which file type is best for you.

What Are Raster and Vector Images, and Why Is It Important to Know the Difference?

The quick answer is this: raster images are made of pixels arranged in a grid and vector images are made of math. To create a vector-based image, anchor points are dropped and a line appears between them. Drafting software like AutoCAD and Vectorworks also use vector-based systems. A vector line can be manipulated to create curves, but the user can't draw freely unless they're using vector-based brushes in select digital painting software (Adobe Fresco has this feature). The calculation that moves the line from one point to another keeps the line crisp no matter the scale, making a vector-based image infinitely scalable. The construction of

a raster-based image uses individually colored pixels, the density of which is determined by the PPI that you selected. If you try to force a new size on a raster-based image, it will either increase or decrease the size of the pixels. Making pixel-based images smaller is fine, but it doesn't look good if you try and make the pixels larger to fill more space. A raster-based image has a lot more flexibility and feels more like working in natural media: you can draw with sketchy pencil lines, smudge and half-erase your lines, and let your paint colors pool together. Raster images are allowed to be a little messy, and a little mess is what brings the natural media verisimilitude to digital work. By the nature of what it is, a vector-based image will always be clean and sharp.

Text will almost always generate as vector-based, and digital painting will almost always generate as raster-based. You can and should use both formats in the same document because most theatrical documentation requires both images and text. When using both raster and vector, be sure to choose a file format (PSD, PDF) that supports both so that your text doesn't convert to raster and print poorly.

A word of caution: some devices and software will automatically use proprietary file types that are not readable by other devices. One example of this is the HEIC type used by Apple devices, especially when AirDropping. This file type is not supported across operating systems and should not be used for sharing with collaborators. Even PSD files are proprietary to Photoshop and cannot be previewed by some computers, or accessed by people without Photoshop. While Photoshop is industry standard for many, it is advisable to double-save PSD documents as another file type before uploading to a shared folder so all collaborators can access this information.

Presets and Templates

Creating presets and templates is a great way to save time and to foolproof your document settings. The words "preset" and "template" are used in specific ways within the Adobe ecosystem, and to help you differentiate between the terms, the uses here will reflect that structure. Though some specific settings described below may not be universally available in digital rendering software, the concepts are still applicable in many contexts. The difference between a template and a preset is the content being controlled: in a preset, you're presetting the options provided by the software and in a template, you're setting up content within a document that you want to use more than once.

Presets

In Adobe's software, preset generally means a tool that can be saved as a setting so it will always return to its original state instead of allowing you to save over it. For instance, if you edit the settings for one of your brushes saved as a brush preset, the brush will always return a brush to its original settings when you open a new document. When the software-supported options for a document are saved for quick use in the "Create New Document" screen, such as canvas size and PPI, that is a preset.

Presets are a great shortcut to creating a new document using your frequently used document settings. This can both save time and prevent errors during document configuration. Depending on the software, presets may remember your document size, color mode, PPI, background layer setup, and canvas size. Photoshop and Procreate will automatically generate presets based on your recently used settings, but you can formalize your presets by saving them with names. Because the automatically generated presets are based on recent use, naming and saving your presets ensures that you won't lose your favorite presets after changing file configurations.

Templates

When you create a document with user-generated content that you will use again and again, such as a title block or background, you are creating a template. Templates can house a preset document within them, allowing you to swiftly make a set of documents that share not only content elements, but PPI, color mode, color of background layer, and more. You can also create templates for specific projects, especially if there are repeating elements like backgrounds, scenic elements, or title blocks you'd like to include in every rendering.

> I keep my costume rendering size standardized to 11" × 17" across all of my projects. I do this for a few reasons: most office printers and copiers can work with 11" × 17" paper, the format is large enough for me to communicate in detail, and it is consistent when I organize and present my portfolio. Additionally, all of my self-made digital croquis (I have over 150) are also in this format so I can drag and drop them into new documents when I'm working on a design. I have 11" × 17"/300 PPI presets in all of the digital painting platforms I use so that I can create new documents quickly. Making broad decisions about your work creates a habitable eco-system where everything flows together.

Creating templates has a lot of potential for theater artists. Costume designers can create a template that includes a signature, title

block, and numbering system; scenic designers can create templates with inset frames and scenic title blocks that are ready-made with opaque backgrounds. Even on a show-by-show basis, creating a production template will save time and repetitive labor.

Creating a template can be as low-tech as creating a document base that works, then duplicating that document several times and using "Save As" or naming conventions to make each duplicate copy into its own file. Photoshop and Procreate also allow you to copy/paste layers between documents, so you can always make a sort of retroactive template by dragging and dropping materials from one document to another in order to add things like consistent backgrounds and title blocks. The danger of working this way is that you can easily forget to choose "Save As" instead of "Save," causing you to constantly overwrite your template document. Dragging and dropping layers between Photoshop documents also means you'll need to reset placement of any dragged and dropped items; they do not automatically land where you had them placed in their original document. Copying and pasting layers between Procreate documents is a little easier because the layers automatically drop where they were positioned in the original document, provided the document dimensions are identical.

Photoshop has more advanced template functionality available. When saving a document you intend to use as a template, you can change the file extension (PSD to PSDT) in order to tell Photoshop to use it as a template. When you open a PSDT document, it will open the template content, but it will open as a new, untitled document. Saving a document that makes use of the template will require naming it, preventing you from saving over the template content.

Templates can be for broad use or very specific use. A broad-use template might be a document set up to the paper size, PPI, and a blank title block you commonly use. A specific-use template might already contain title block text and background texturing for a specific production. Thinking ahead about how to streamline your rendering on the front end can save you a lot of time retro-fitting documents at the end of your process.

Menus and Palettes

Most digital painting software programs allow for some level of customization in how the user interface is displayed and organized by adding or removing different menus and palettes from your visible workspace. Everyone will have their own particular preferences for their workflow and there are no set rules for how you should set up your workspace. Experiment with different setups and change your mind frequently, or set up different kinds of workspaces for different tasks. For example, use a different workspace for when you are using digital watercolor

than when you are using photo bashing techniques. If you pay attention to your workflow, you'll notice that you may spend time constantly reaching for the same settings; this is usually a cue that you should add a palette or menu for those settings to your visible workspace.

Your digital painting software of choice is likely to have several elements that are common across many programs:

- **Menu bar:** This is a collection of specific commands and functions organized in a menu system, usually laid out horizontally at the top of the screen. This is one of the older UI elements in software in general, so the functions that are accessible here may tend to be the most basic and essential: new file, open, save, etc. Desktop applications like Photoshop and Clip Studio use a text-based menu bar and mobile applications like Fresco and Procreate use an icon-based menu bar. Menu bars vary, but this is usually where you will find commands to save, edit, cut/paste, and get technical help. The menu bar can look different across platforms. For instance, Photoshop has a very detailed, text-heavy menu bar to support its broad offerings, but Procreate has a minimal menu bar because many of its controls are hidden within other menus or adjusted using multitouch gestures.
- **Palettes:** The word "palette" has a few potential meanings when we talk about digital rendering. It can mean the overall color story for a project; it can mean the finite color swatches chosen for a project; or it can mean the small windows available for customization within digital rendering software. In this context, palettes are small trays of information about your file that may also have menus, buttons, tools, dials, sliders, and other user interface control elements. These are often specific to certain tasks, such as layer management, type tools, and brush settings.
- **Toolbar:** This is a collection of small buttons with icons on them to indicate what kind of tool can be accessed. The functions included here are the tools you use to interact with your painting: brushes, smudge tools, erasers, and selection tools, among many others.

Screen space is precious, regardless of screen size. You might only be working on a 13" notebook computer or a mini tablet, or you might be working on a pair of the latest curved ultrawide gaming monitors or a massive 32" pen display. No matter how much or how little space you have, you will always find yourself wanting more screen space. Menus should be in frequent use in order to get awarded precious on-screen real estate.

If you're using software that allows you to customize your workspace (likely a desktop application), it will take some trial and error to optimize your layout. Below is a list of menus commonly used when making digital renderings.

The Essential Menus and Palettes

If you are working on a desktop application, you'll choose which of these windows you'd like to keep visible as part of your workspace. If you're working on a mobile application like Fresco or Procreate, you'll want to know how to navigate to these menus quickly.

1. **Layer control**: Having easy access to your layer structure speeds navigation, supports good document organization, and ensures you're not wasting time painting on the wrong layer. This menu typically gives you access to creating, duplicating, and deleting layers and to layer mask functions.
2. **Painting navigation**: Photoshop and Clip Studio offer a navigator that allows you to see a distant view of your canvas at all times. You can use the navigator to quickly zoom in, zoom out, and pan at. Some artists like the opportunity to see their work miniaturized at all times, as it allows you to spot contrast and composition issues. Think of it like pinning your rendering to the studio wall and stepping back to reevaluate it from a distance. If you're working with a touchscreen application, you can also pinch to zoom out for a similar effect.
3. **Brushes**: If you like to change brushes frequently while you paint, keeping the brush settings menu close at hand will speed your navigation through enormous lists of brushes or brush presets.
4. **Brush settings**: If you frequently edit your brushes or build new brushes, the brush settings menu is great to have on deck.
5. **Color well**: Some artists like to keep the color well open at all times. You might also want to dedicate temporary space on your canvas to a mixing palette that you can repeatedly sample from while you paint. Another option is to use the color swatches or color libraries feature to keep your project-specific colors always handy. Using the hotkey or multitouch gesture for color swatching will increase your speed and fluidity while painting.

There are dozens of other menu options that may support your workflow, or menus that are more helpful in some instances than others. For example, in Photoshop, the properties menu is indispensable when working with adjustment layers, but isn't as actively useful while painting.

There are other things that will take up screen real estate that aren't specifically generated by your software. For instance, it's necessary to have reference images visible while painting. Reference images can either be temporarily placed on your canvas while in use or opened in a small window outside your software. If you want to keep an eye on your music, you may want a small window visible for your playlist. You will figure out how you like to tile your screen for optimal use of the space you have.

Additional Settings

Shortcuts and Hotkeys

Though these two words are often used interchangeably, there is a difference between shortcut keys and hotkeys. Shortcut keys are single-key commands that are program-specific and meant for swiftly navigating menus without a trackpad or mouse, while hotkeys are key combinations that are always available and relatively consistent from program to program. While this is an official designation, the terms are generally used interchangeably to mean any key or combination of keys that circumvents menu navigation.

Most programs will allow you to assign your own or re-assign the shortcut keys for various functions and tools. Some artists that work in multiple programs like to standardize their shortcut keys across programs based on personal preferences so that they feel equally at home in any interface. Some pen tablets have customizable shortcut buttons on both the tablet and the pen, allowing the user to quickly access their favorite features without engaging the keyboard, trackpad, or mouse.

When working in tablet-based painting software like Adobe Fresco and Procreate, you may be more reliant on multitouch gestures. Some of these will be familiar to anyone who uses a smartphone (like the two-finger zoom gesture), but others may be less intuitive. For instance, Procreate uses a long touch for color swatching, and a two-finger tap to undo. It's always a great idea to watch tutorial videos online to learn your software's most up-to-date gestures. Learning the shortcuts, hotkeys, and multitouch gestures for your software will greatly increase the fluidity and speed of your work.

Interface Colors

Some software allows you to customize the colors of your interface, and many programs now offer a dedicated "dark mode" color scheme that is much easier on the eyes over a long work session.

Saving Layouts

All of these settings listed above can usually be saved, exported, and accessed on other computers or devices. Photoshop has dedicated workspace layouts for certain tasks, and the ability to save custom layouts as well. Whatever your program of choice, consider saving your workspace layout so that when you open your file, you are set up and ready to work. Otherwise, it is a bit like having to clean off your desk every time you want to paint.

Memory Cache

In various painting programs, you will have the option to change the amount of memory dedicated to the memory cache. A memory

cache is simply a section of memory that software on your computer dedicates to storing information that it thinks you will need again fairly quickly. By keeping data that you will be using frequently in an easy-to-access spot, the software is able to work faster and be more responsive.

Some software allows you to set cache levels for desired results. You can adjust both cache tile size, and number of cache tiles. The more cache tiles you have, the faster the program will respond to your input. The size of the cache tile also matters. Smaller cache tiles can be regenerated in less time than large cache tiles. Smaller tiles are better for things like individual brush strokes, while larger tiles are faster at things like filter operations. If you're working with Photoshop or Corel, they provide several presets for the cache to make things simpler. Essentially, you want higher cache levels (more tiles) at smaller tile sizes for paintings.

The simpler your software is, the less control you'll have over advanced settings like memory cache. In fact, iPad software caches in a way that is difficult to purge, leading to slow loss of hard drive space over time. If you've worked on iOS mobile devices, you may have seen the "Other" section of your phone or tablet storage growing, but found few controls for managing the space. The only true solution to leftover cached data on your iPad is to back everything up and perform a factory reset on the device.

Undo Settings

There are few things worse than trying to step backwards and undo a stray brushstroke only to find that you max out at 20 undo commands. It's a great idea to figure out how to increase or maximize the available undo commands in your software. This is usually hidden in Preferences menus and a quick internet search will turn up instructions on where to find it in the latest version of your software. This setting may not be possible on all digital rendering platforms. Also, take note of how your undo count affects your computer's performance; the more undo commands you allow, the more memory your computer will require to run the software.

Being able to hit undo is quite possibly the most attractive feature of digital painting. You can draw a line several times until it's right, change your mind about media, switch colors after painting a few strokes, swiftly correct mistakes: the possibilities opened up by undo are truly endless. It is worth learning either the hotkey or gesture that speeds your access to undo, or programming one of your tablet keys to undo at the press of an onboard button. The more you can do without looking away from your work, the faster and more fluid your process will be.

Libraries

Libraries provide an opportunity to store anything you use often – filters, assets, signatures, watermarks – within your digital painting workspace. Not all digital painting platforms provide this option, but it can be a great support to your workflow if you analyze your own process to determine what you might store in your libraries. Once something has been added to your libraries, you can drag and drop it into any new document without affecting the original document. It's almost like creating a file of object templates for repeat use. Items added to libraries can be sorted into named folders to support well-organized assets that are easy to access.

Theatrical artists might think about storing the following broad-use items in libraries:

* Signature
* Union stamp
* Watermark
* Blank title block
* Croquis (blank faces or bodies for makeup and/or costume sketches)
* Object assets like trees, rocks, walls, and buildings
* Surface textures like stone, wood, etc.
* Scale human figures
* Backgrounds
* Frequently used color palettes

You can also build libraries for large projects that can be shared amongst teams. The team can work from the same color palette, the same branded show logo, fabric swatches, and the same drafting provided by the company.

Eliminating Digital Distractions

There are programs and settings for your device to help you minimize distractions. Try closing every other program window (including all of those many internet browser tabs) that is not directly related to your painting work. Disable email, calendar, and program notifications that may pop up while you paint. If your computer desktop has many random files on it, create a new folder with the day's date and drop all of those disorganized files inside it to clear your digital desktop of work. If you are on a tablet device that is connected to data or Wi-Fi, try turning on a "Do Not Disturb" mode. Set up your music of choice, and let the world fade away while you paint.

Saving Your Work

As you're working and at the end of every digital painting session, it's imperative that you are mindfully saving your work. Being

overly cautious about saving can prevent the heartbreak of accidentally losing a file you've spent hours perfecting. While some digital painting software has auto-saving features, you should not rely on these features unless the software is built without a manual save option. Auto-saves are indiscriminate, and will save over older versions of your files that you may find yourself needing. Auto-save may have other consequences: in Procreate, you cannot use undo commands between sessions, meaning you're locked into the version of the file you open and close.

It is best to make a practice of iterative saving, or saving your file several times in different stages of completion. Even with your memory cache maxed out and your undo count set at its maximum, you may find yourself wishing you could step back to an earlier stage of your work. Iterative saving makes that possible. For software without a manual save command, iterative saving may mean closing and duplicating the document, then proceeding forward.

Another consideration when saving is where to save. Most computers and tablets will default to saving on the device's hard drive. Create redundant files, especially when you're working on a large project. This means saving your files to both a hard drive and to a cloud server like Google Drive, OneDrive, Dropbox, or iCloud. Most of these services offer a small amount of storage for free, then charge a monthly fee depending on how much storage you require. Compare costs, eco-system, and interfaces before choosing, as there is a steep difference in cost between services.

Saving to both the cloud and a hard drive ensures that if something happens to one of your devices or to your cloud account, you'll be covered by making the file redundant in at least one place. Further, if you are working with collaborators in a cloud space, be sure to save copies of your documents outside the shared workspace. Collaborators may open, alter, and save your document without intending to cause permanent damage, so it's good to have a pristine copy in a folder only you can access. Once a project is complete, you can purge the iterative documents and archive the final version of the project.

File Names

When building your digital archives and working documents, it's important to establish a file naming and organization system that works for you. Having some continuity in the way documents are named across all your projects will help you use your computer's search function effectively. Keeping a standardized system ensures that if you misplace a file, you'll be able to use key terms in order to search for it effectively.

A file naming system will be a direct reflection of how you organize your digital spaces. Here are some elements you may

want to consider when determining what to include in your file names:

- **How things will be alphabetized**: Do you want to skim through your files by project title, venue, or date? Think about what to put first in the document name, as this will determine how your operating system sorts the file names. You can also use numbers before letters, especially if you want the files viewed in a specific order.
- **Your name**: Remember that many of your files are going in shared folders to be viewed by collaborators, and it can be helpful if your last name, full name, or at least your initials are on every document name.
- **Document title**: This name will likely be related to the name of your production and the name of the specific documentation it includes.
- **Don't use abbreviations**: Removing random letters or shortening words can harm your ability to find the document using search functions. While "ImpofBngErnst" makes perfect sense to you, remembering how you've abbreviated that show title years later will be almost impossible. If you don't want a long file name, it's better to use a keyword from the title than to abbreviate.
- **Date**: Including at least the year you worked on this project for archival purposes will help you to sort, store, and keep your CV accurate.
- **Venue**: You are very likely to have repeat titles on your résumé as you develop your theatrical career. Using the venue in your naming system will help differentiate one *Midsummer* from the others.
- **Illegal characters**: You cannot use certain characters (periods, slashes) in document titles because they interfere with the computer's ability to identify where the document is saved or identify the file extension. Operating systems and mobile devices vary on how they handle spaces in document names, so it can be best to replace spaces with underscores to prevent any surprises when documents travel from one machine to another.

It's also a good idea to think about how you're storing your files. Are you organizing your archives by years, by venues, or by types of projects? How are you storing your archived working documents in relation to the documents you get after a project concludes, like production photos and press clippings? Spending time on the front end building a framework means that archiving projects will be faster and more organized going forward.

File Organization

Your file organization system is something like the idea of a Memory Palace. Each artist's file organization system will be

unique to them, but there are a few things you can try to keep your organization clean, consistent, and easy to access:

- Remember that files and documents are automatically sorted by the first character and that numbers will come before letters. You can use this to automatically sort files in a way that will help you. For instance, using iterative saving, you can number your files prior to the name so they will always sort to the correct chronological order.
- If there are files you always tend to need on a project, create a "new project" file template and duplicate it, then rename it when beginning on a new project. For instance, I often need a show folder with subfolders for costume paperwork, budgeting and spending information, sketches, renderings, and research. I may also preload that folder with a document containing my bio and headshot. I include templates for my sourcing, piece list, budget

tracking, and dressing plates so I am not building these documents from scratch on every show *or* hunting them down from piecemeal sources.
- It's a good idea to move inactive projects to an archive folder. This folder should also be backed up regularly, but it will keep your system folders or cloud drives from getting too cluttered with projects that have already been completed. (Sidebar tip: keep a document in each archived folder listing your collaborators on each production and their contact information. You never know when you need to recommend a colleague, cite designers, or ask someone the name of the bar you all liked!)
- Remember, redundancy is the safest plan! If you are a devotee of cloud storage, remember to regularly back up to a physical hard drive. If you are a hard drive person, figure out which cloud subscription your collaborators use most frequently and become a subscriber.

CHAPTER 4
Working with Layers

The Concept of Layers

Layers are a way of organizing the picture plane that is universal in digital rendering. When you work in traditional media, you usually only have one picture plane – one piece of paper, one cut of illustration board, one canvas – on which you make your marks in a specific order in order to create an image. This means that any mark made near the beginning of the process is very difficult to change once you're further along. Digital picture planes can have near-infinite surfaces, each on its own layer. Layers appear to sit on the same two-dimensional plane, but they are actually different pieces of an image held separate from one another. Layers offer you the opportunity to keep a discrete workplace for different components of your image.

Figure 4.1 Individual layers contain separate information. Imagine each layer as a pane of glass with part of your image painted on it. When the layers are stacked and viewed from the front, a cohesive image appears. (Author's own)

DOI: 10.4324/9781003212836-4

If you need help with understanding the concept of layers, think of this metaphor. Imagine each layer is a pane of glass. Imagine that one pane of glass shows your rough sketch. Another pane of glass the same size has just the skin tones painted on it, corresponding to the layout of your rough sketch. Another has a vibrant dress. Yet another has some highlights and shadows that are universal to the image and only work when laid over the top of the other layers. If you stack the panes of glass and view them from the front, the individuality of the panes will disappear and the image appears to be solid, as though painted on a page. If you were to shuffle the order, you could achieve different effects. If you decide you don't want to see the rough sketch through the paint of the finished image, you can slide that pane out of the stack and discard it. Layers are an immensely powerful way of maintaining editability in all components of an image.

Setting Up and Using Layers

Learning to be strategic with layers takes practice, but is well worth the effort. Start by thinking of each phase of an image as a new layer, or try thinking "what may change independently of everything else here?" Layers containing background elements and title blocks can be easily copy/pasted into new documents, reducing repetitive labor. If you want to try something but aren't sure it will work, you can duplicate a layer and try something, then delete the trial layer if you're unhappy with the result. You can turn layers on and off without deleting content at all, leaving yourself redundancies in your later process. Using layers maintains the integrity of the overall image while providing maximum flexibility to theatrical designers.

Good layer discipline will save you (and your collaborators!) a lot of heartache in digital painting. Try to never work on the layer that is automatically generated as your "background"; the image (s) will be more flexible to you when isolated from a background. Layer organization is key, especially working on large documents or documents meant for collaboration. You should also make a habit of naming all of your layers as you create them, then adjusting those names if the content of your layers shifts. Sorting layers into named groups can help with layer menu organization, especially for files with many layers. For instance, you can group all of the layers associated with a particular asset and collapse them under one file folder heading.

Organized layers will help your collaborators to use your images effectively. For costume renderings, it can allow the shop to isolate a sketch or line work to use as a technical drawing. In the scenic world, strong layer organization is vital to collaborators because the drawings are being used by associates or assistants to coordinate with the scene shop, the paint department, and the props artisans.

Don't delete what you can hide! By turning off layers instead of deleting them, you preserve the history of your document in case you need to step backwards in order to isolate or recreate some element of your design. You can even hide selectively within the same layer using layer masks.

Once you understand the basic concept of what layers are and how to make them work for your images, there are more advanced layer techniques to explore, including using layer lock and clipping masks, linking layers, and using layer blend modes.

Layer Locks and Clipping Masks

Some of the most useful tools in digital painting are layer locks (alternately called alpha lock in some software platforms) and clipping masks. Layer locks allow you to paint without worrying about coloring outside the lines; layer locks do this by locking all the transparent pixels on a layer. This allows you to fill a form with its base color, activate a layer lock, and paint outside the lines with a soft round brush to add subtle, blended dimension. You could also use an enormous, 500-pixel brush tip to paint texture on an entire surface without worrying about the directionality of your brushstroke. It's incredibly useful and really helps to speed things up.

Figure 4.2 Layer lock is turned off in the left version of the image and turned on in the right version of the image. You can see that when the transparent pixels are locked, no marks appear outside areas that have already been painted. (Author's own)

Clipping masks are similar, but they are on a different layer. Let's say you're working on a painting of a dancer, and you want this dancer to be absolutely covered in tattoos. You might finish the painting of their body, then make a new layer above the body painting. If you activate clipping or a clipping mask on the new layer, you will see your layer icon in the layer navigation pane shift slightly inset, usually displaying a downward-pointing arrow to the layer beneath. This signifies that the layer you're painting on will clip to the areas that have been painted on the layer beneath it. Essentially, it's a layer lock, but on a new layer. This allows you to activate layer blend modes or try new painting ideas without compromising your base painting. You can cover the dancer in tattoos in multiply mode (great for painting tattoos!), and no part of that painting will appear off the dancer's body.

Layer Masks

Layer masks are a great tool for hiding and revealing content within the same layer. One of the greatest benefits of working with digital media is that you can use non-destructive tools in your work instead of erasing content, leaving yourself with options should the design ideas change or revert back to an earlier iteration. With traditional media, if you want to tone everything down with a wash of dirty water, or some diluted Payne's gray, you must be certain that is what you want to do; there is no going back. Most image creation software provides you with tools to allow you to change an image, but also change your mind. One of the most powerful features for non-destructive editing is layer masking. Layer masks allow you to change what is visible on a layer by editing a grayscale image that is tied to your layer. Grayscale layer masks interpret areas that are white as transparent and black as opaque. Shades of gray represent different levels of translucency. If you change your mind, you can always un-mask that part of the layer by activating your layer mask and painting in black, white, or gray to alter the mask. This is preferable because erased pixels are gone forever unless you make heavy use of your undo command.

Layer Blend Modes

Layer blend modes are an indispensable tool for adding depth, shadows, highlights, and glow effects to digital paintings. These tools are offered across platforms, and while they sometimes have different names, they're not to be confused with layer style; layer style allows for beveling, embossing, blend-if, and other layer effects. Layer blend modes act directly on the color environment of a layer in relationship to the layers below it. Layer blend modes use the information from one layer and blend it with information from another layer to create a new visual effect. Some are more useful than others for theatrical rendering purposes, but they all share a core truth that makes them very powerful: layer blend modes allow for non-destructive editing, even without iterative

saving. It's very simple to throw in a blend mode, play with it, and discard it if it doesn't suit your needs. Photoshop also allows you to apply blending modes to brush tools or to layer groups; this section will focus primarily on how these modes impact entire layers, but know that the information here will transfer to more specialized uses.

Usually, these modes are accessed on the layers menu somewhere. In Photoshop and Fresco, they're visible in a drop-down menu above your list of layers. In Procreate, they're on the layer name as initials that can be expanded into a menu. This section will discuss the layer blend modes, focusing on those that are most useful in creating theatrical design renderings.

To best demonstrate the functionality of each color mode, the sample rendering will use a black and white value painting with an abstract color layer on top (Figure 4.3). This will allow you to see the way the layer blend modes act on the relationship between these layers. In a few cases, additional imagery will be provided to demonstrate a layer blend mode's unique properties and potential. Layer blend modes that you may find the most useful for painting purposes are marked with asterisks. Layer blend modes are also grouped by type, indicated by the parenthetical after each mode name.

Some of the functionality of layer blend modes is quite technical, and playing with layers is the best way to learn the layer blend modes that you'll find most useful in your work.

Normal* (Normal)

Normal is the default mode for all new layers. Normal means no layer blend mode has been applied, and the color will appear exactly as you see it in the color picker. This is set as the default mode for all layers until you choose to change it.

Dissolve (Normal)

Dissolve is sort of like a cross-fade effect. It separates the pixels of the blending mode layer with the layer below it, revealing more or less of the background layer depending on the layer opacity. Because dissolve works on a pixel level, the dissolve will appear grainy and noisy.

Darken (Darken)

Darken looks at both colors presented in the pixel stack (between the blending mode layer and the background layer) and chooses the darker one. Results are often very similar between this layer blend mode and "darker color."

Multiply* (Darken)

Multiply is one of the most useful layer blend modes. This mode multiplies the base color by the color in the blend layer, always resulting in a darker color. While you may think that this will muddy your image and make it too dark, multiply is an

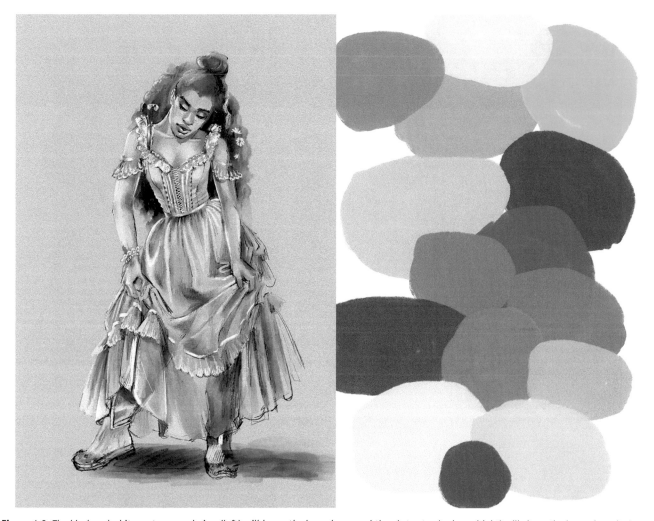

Figure 4.3 The black and white costume rendering (left) will be on the lower layer, and the abstract color layer (right) will sit on the layer above it. Layer blend modes activated on the abstract color layer will cause the color environment of the layers to change appearance. (Author's own)

incredible mode for adding shading and depth to an image. For instance, quick, universal shadows can be applied to a rendering by adding a layer above your base layer(s) and changing the mode to multiply. Select a pale gray-violet and paint in your shadows. You'll notice that because this color is being multiplied with the base color, the resulting visible mix will be a perfectly calibrated shadow color for almost anything contained in your base layer.

Color Burn (Darken)

Color burn produces a darkening effect, but with more saturated midtones and bumped contrast. You can get similar results using Photoshop's burn tool, which can create this effect in concentrated areas using brushstrokes.

Linear Burn (Darken)

Another darkening blend mode, linear burn darkens the color of the base depending on the value of the blend color, resulting in

the darkest and most high-contrast blend of all the blend modes.

Darker Color (Darken)

Darker color looks at the two available colors in each pixel stack and simply keeps the darker of the two. It doesn't blend or multiply them. The results can be a fractured, difficult-to-read image, useful if you're aiming for a glitchy effect.

Lighten (Lighten)

This is the opposite of "darken." The software compares the two values in the pixel stack and keeps the lighter of the two.

Screen (Lighten)

Mostly useful for people doing photo editing, screen prioritizes luminosity when choosing between the base layer and the blend layer. Black values remain unchanged, but Screen will choose the brighter of the two color values.

Figure 4.4 The sample image layers seen in normal or dissolve mode. The lower layer is not visible through the abstract color layer. (Author's own)

Figure 4.6 The sample image layers seen with the upper abstract color layer in multiply mode. (Author's own)

Figure 4.5 The sample image layers seen with the upper abstract color layer in darken mode. (Author's own)

Figure 4.7 The sample image layers seen with the upper abstract color layer in color burn mode. (Author's own)

Figure 4.8 The sample image layers seen with the upper abstract color layer in linear burn mode. (Author's own)

Figure 4.10 The sample image layers seen with the upper abstract color layer in lighten mode. (Author's own)

Figure 4.9 The sample image layers seen with the upper abstract color layer in darker color mode. (Author's own)

Figure 4.11 The sample image layers seen with the upper abstract color layer in screen mode. (Author's own)

Figure 4.12 The sample image layers seen with the upper abstract color layer in color dodge mode. (Author's own)

Figure 4.13 The sample image layers seen with the upper abstract color layer in linear dodge/add mode. (Author's own)

Color Dodge (Lighten)

Color dodge decreases the contrast between the blend mode color and the background color. The result can look very blown out and saturate at 100% opacity/100% fill levels.

Linear Dodge/Add* (Lighten)

Linear dodge is similar to color dodge, but it adds more white to the mix because it changes the background color of each pixel stack based on the blend color. This blending mode is incredibly useful for adding bright, glimmering highlights and glow effects. Check out the glow effect tutorial on page 46 to learn how linear dodge/add can add magic, elemental effects, and otherworldly light to your digital paintings.

Lighter Color (Lighten)

This mode does not create blends between the base color and the blend-layer color. Instead, it looks at the two values and chooses the brighter of the two.

Overlay* (Contrast)

Overlay and color are the two blending modes best for colorizing a grayscale image. As one of the contrast blending modes, overlay will make decisions based on whether the value of a base color is above or below 50% gray. If it is

Figure 4.14 The sample image layers seen with the upper abstract color layer in lighter color mode. (Author's own)

Figure 4.15 The sample image layers seen with the upper abstract color layer in overlay mode. (Author's own)

Figure 4.16 The sample image layers seen with the upper abstract color layer in soft light mode. (Author's own)

below 50% gray (darker), it will use multiply to create a darker blend between the base color and the blend layer color. If it is above 50% gray (lighter), it will use screen to create a lighter blend between the base color and the layer color. This allows for a dynamic contrast range when colorizing images.

Soft Light (Contrast)

Soft light works much like overlay, but preserving more of the gray midtones in the final blend. This can be a good mode for creating a more subtly colored monochrome image, creating a blend that looks a little like a colorized black and white or sepia-toned image.

Hard Light (Contrast)

Hard light works much like overlay, but prioritizing the colors of the blend layer over the colors of the base layer. It can look pretty aggressive, and you'll lose a lot of your value structure at 100% opacity.

Vivid Light (Contrast)

Vivid light pushes the contrast values of your base layer and blend layer away from 50%, resulting in a high-contrast image.

Figure 4.17 The sample image layers seen with the upper abstract color layer in hard light mode. (Author's own)

Figure 4.18 The sample image layers seen with the upper abstract color layer in vivid light mode. (Author's own)

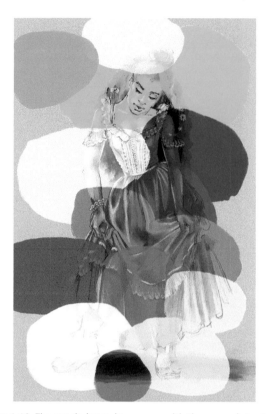

Figure 4.19 The sample image layers seen with the upper abstract color layer in linear light mode. (Author's own)

Linear Light (Contrast)

Linear light will dodge your lighter values (above 50% gray) and burn your darker values (below 50% gray), resulting in a high-contrast image.

Pin Light (Contrast)

This mode will replace colors based on the relationship to the 50% gray mark: blend layer colors lighter than 50% gray will be replaced by darker pixels, and pixels lighter than 50% gray will remain unchanged.

Hard Mix (Contrast)

At 100% opacity, hard mix will reduce all colors in your image to black, white, cyan, magenta, yellow, blue, red, or green. It eliminates all midtones and intermediary hues, resulting in a harsh, posterized effect. This can be desirable if you're trying to emulate early screen printing, over-xeroxed, or posterized effects.

Difference (Inversion)

Difference calculates the difference between the base layer and the blend mode layer, using the difference to generate a new blend. White inverts the color of the base layer, often creating a photo-negative effect.

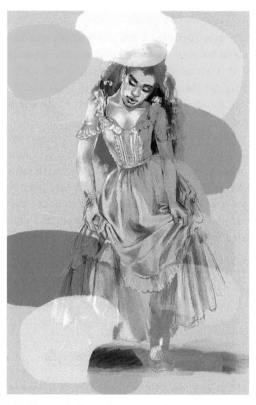

Figure 4.20 The sample image layers seen with the upper abstract color layer in pin light mode. (Author's own)

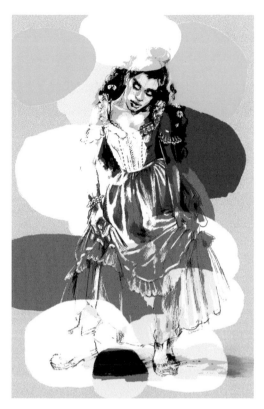

Figure 4.21 The sample image layers seen with the upper abstract color layer in hard mix mode. (Author's own)

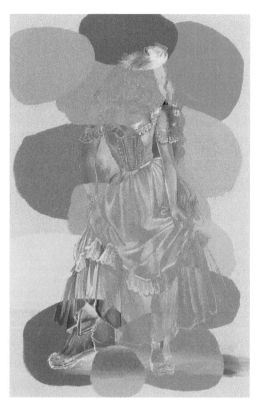

Figure 4.23 The sample image layers seen with the upper abstract color layer in exclusion mode. (Author's own)

Exclusion (Inversion)
Exclusion is very similar to difference in functionality, but 50% gray is preserved.

Subtract (Inversion)
Subtract produces extreme darkening by subtracting the values of the base layer. This is similar in appearance to multiply, but much darker.

Divide (Inversion)
Divide is the opposite effect of subtract. It brightens all the values. White stays the same, and all other values are determined by brightening. This mode can appear very blown out.

Hue (Component)
Hue preserves saturation and luminosity in the base but prioritizes the colors of the blend layer. If a color layer is used over a grayscale image, it will not colorize the image. When used as with the example image, the color layer becomes opaque, as pictured in "normal/dissolve."

Saturation (Component)
Saturation preserves the luminosity and hue of the base layer but prioritizes the saturation of the blend layer.

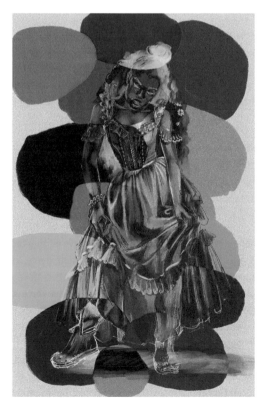

Figure 4.22 The sample image layers seen with the upper abstract color layer in difference mode. (Author's own)

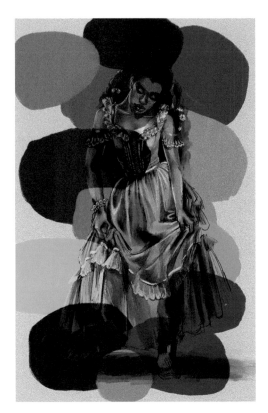

Figure 4.24 The sample image layers seen with the upper abstract color layer in subtract mode. (Author's own)

Figure 4.25 The sample image layers seen with the upper abstract color layer in divide mode. (Author's own)

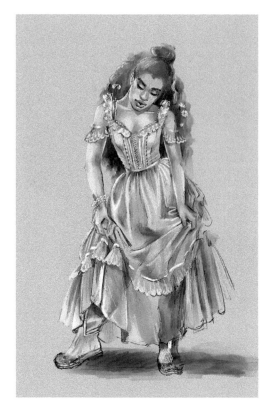

Figure 4.26 The sample image layers seen with the upper abstract color layer in saturation mode. (Author's own)

Color* (Component)

Color preserves the luminosity of the base layer, but applies the color and saturation of the blend layer to the value system of the base layer. This is a great mode for colorizing monochromatic paintings. It has less of a contrast effect than overlay, but it's difficult to preserve true black or true white, as they will colorize.

Luminosity (Component)

Luminosity preserves the saturation and hue of the base layer, prioritizing the luminosity of the blend layer. If your blend layer is more luminous than your base, your base layer will disappear.

Adjustment Layers

Adjustment layers are a powerful non-destructive editing technique. Not all digital painting software offers adjustment layers, as they're more commonly used for photography adjustments. Software intended for photo editing (like Adobe Photoshop) is where you'll find this feature. If you like to create renderings with dramatic lighting, this is a great tool to learn. With adjustment layers, you can create a scenic rendering, then add adjustment layers for different lighting conditions to storyboard the show without changing the base rendering. As a costume designer, you can show a costume in a highly dramatic lighting condition without sacrificing the readability of the original rendering for the costume shop. Adjustment layers can be easily turned on and off without affecting the original image.

Usually found on the layer menu, "add new adjustment layer" creates a masking layer above the layer you've selected. Think of the adjustment layer as a filter layer that will contain corrections, but it will not touch the original image. Adjustment layers allow you to make adjustments to color balance, hue, saturation, brightness, exposure, and other qualities of your image on separate masking layers. This allows for two important things to be true as you edit:

1. All adjustments are infinitely adjustable without loss of image quality. At any time, an adjustment layer can be deleted or hidden in order to revert your photo to its original state.
2. All adjustments can be selectively masked out using the black/white paradigm of layer masking. This means that you can correct for a small part of the image, then mask out the rest of the image.

Adjustment layers are one of the best ways to create dramatic lighting effects in a rendering. Make an adjustment layer, then turn the brightness or highlights (via curves) up until the image is very bright, but before you start to lose information. Edit the mask to hide overall (black ground), then paint into the mask with a white soft round brush to reveal the highlights where you want them. You can even create beams of light using the polygonal selection tool to create shafts of light, then converting them into masks on your adjustment layer. Select the beam of light's area, add a new adjustment layer, and the layer will automatically be created as a mask in that shape. Layering a haze effect into these beams of light (using a transparent photo or painting clouds into the image) makes them even more dramatic.

Layer Composites

Some software includes a special functionality that allows you to create snapshots of different combinations of layers, then view or share them quickly and easily. You can even export your layer comps as JPGs or PDFs. Adobe Photoshop calls this feature layer composites, or layer comps for short.

Layer comps were first used by graphic designers and website designers to be able to organize many different versions of an image that used the same basic components. This allowed designers to work more efficiently and share variations with clients easily. Theatrical artists can use them to create storyboards or iterations of the same look. Layer comps can save several different aspects of a document in one checklist-style window. Aspects of the variations saved by using layer comps include:

1. **Layer position:** where the objects are placed on the screen
2. **Layer visibility:** whether the layer is turned on or off
3. **Layer comp appearance:** the blend mode of the layer, as well as any layer effects
4. **Layer comp selection for smart objects:** You can also set the states of smart objects referenced to inside of your project.

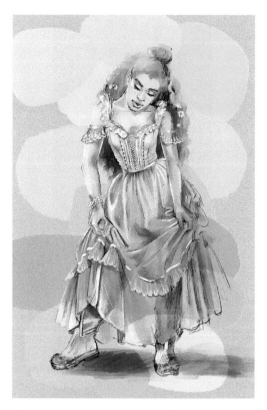

Figure 4.27 The sample image layers seen with the upper abstract color layer in color mode. (Author's own)

Figure 4.28 The sample image layers seen with the upper abstract color layer in luminosity mode. (Author's own)

Saving layer comps on a project allows you to screen multiple different options to your team without awkwardly clicking through layers, rearranging things, or repositioning objects during meetings. With layer comps, you can use a set of saved assets to show multiple different looks for scenery or lighting, or you can show a director multiple colorways for a costume.

Layers and Collaboration

Live performance is a collaborative art form. All the artistry in the world will not save your work if your collaborators can't use your documents to parse what it is you've imagined. Further, a digital space can get just as messy and untenable as an analog studio. Being able to access your work quickly, jumping to files you need without opening and double-checking, is an important time saver. Being diligent about naming and organizing your layers is an important part of this mindset.

Naming, Grouping, and Merging Layers

Within each digital painting file, organization is not only important to maximize your workflow, but to allow your collaborators to navigate your documents. If you have experience painting digitally, you've likely made the mistake of working in haste, not naming new layers, and then wasting time turning layers on and off to find where you painted a specific element. Further, large documents get complex, and scrolling down a long list of named layers can take time. Make a practice of grouping layers into named folders that can be collapsed for efficient navigation. This also makes it possible to move or edit multi-layered parts of your image without merging layers.

Merging allows you to highlight two or more layers and collapse them into one layer. While it's best to maintain separate layers to preserve maximum editability, this can also make for gargantuan file sizes. If you are sending work along to collaborators or printers, you may consider duplicating your archival document and making a new save that condenses your layer structure. Put like items

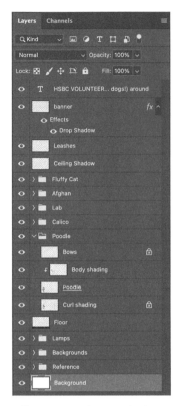

Figure 4.29 Grouped layer structure for a complex document. (Author's own)

together, but keep in mind how your collaborators might need to access the information. It's always best to keep raster and vector items on separate layers to preserve the vector images. Even if you're trying to collapse an image as much as possible, keeping two layers (one with all of your raster content and one with all of your vector content) will maintain the quality of the image for printing.

With good layer hygiene, your collaborators can quickly access information they need from your large painting documents. For instance, the linework layer on a costume rendering can be isolated and printed out as a technical drawing for use in the costume shop. Lighting effects can be turned off or on in a scenic rendering in order to get a better read on the colors the designer chose to use.

Applied Skills Tutorial: Cel-Shaded Paintings

Now that you've explored the powerful mechanics of using layers, try experimenting with small compositions that rely on layers to create specific effects. If any of the painting in this section feels unapproachable, circle back after you read Chapters 5 and 6.

Cel-shading (or cell-shading) refers to a style of painting meant to evoke the hard-line shading seen in cartoons and classic comics. In cel-shaded painting, areas of tinted and lightened

color are used to model dimensionality on the form. Cel-shaded painting can be an evocative tool for theatrical designers.

Layer blend modes offer a great shortcut to creating cel-shaded renderings. Try these steps to achieve a classic comic book feel:

1. Begin with a rough line drawing in any media you'd like. Pencils are traditional here. Because I grew up fascinated

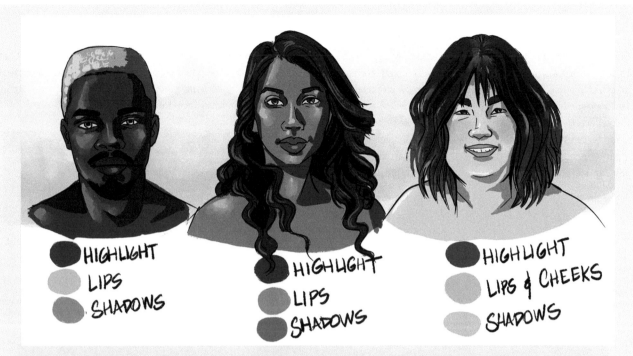

Figure 4.30 The difference between swatched colors (left) and how they appear when painted over the sample image on a layer set to the multiply or add blend modes. Trial and error can help you to pick the perfect universal shadow color for your cel shaded rendering. (Author's own)

by Disney animators, I like to set my digital pencil to a classic no-copy blue for sketching.

2. Once your sketch is complete, add a new layer named "ink." Choose a sharp, clean-edged ink brush and ink over your sketch. Black outlines give a classic comics art feel, but other outline colors can be more evocative and modern. Bump your brush smoothing/stabilization to give your lines a slick finish.

3. Hide your sketch layer. Don't delete it! You never know when you might want to return to this information.

4. Create a new layer behind your ink layer and name it "color." Paint the image behind the outline using flat color. Choose one color for each part of the sketch. Think about 2D cartoons: one skin tone, one shirt color, one grass color, etc. (If you're using Fresco, you can set the ink layer as a reference and quickly fill inked areas using the paint bucket, even if you're not on the same layer as the linework!)

5. Add a new layer above your ink layer and name it "cel shade." Set your layer blend mode to multiply.

6. Grab a light gray-violet from the color picker. Experiment with brushing it over the base drawing to see if you like the depth of shade (Figure 4.30).

7. Using an expressive inking brush (look for brushes that respond to pen pressure for dynamic line weight changes), paint in a layer of shadows. To create greater depth, you can layer these shadows. Use crisp lines to do this and don't blend. One of the hallmarks of cel-shading is the hard-edged shadows.

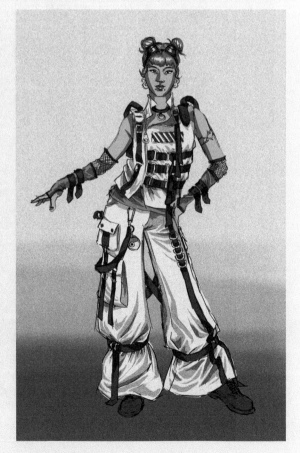

Figure 4.31 Cel-shaded renderings can evoke pop art, classic animation, comic books, and video games. (Author's own)

Applied Skills Tutorial: Let It Glow

Glowing effects can be powerful in painted renderings. It's best to start with a simple composition in order to practice creating an effective glow. The best compositions for glow effects usually feature a glowing item and something against which to bounce the reflected light. Good starter compositions don't include too many textures or too much distance; a great example is to paint a pair of hands cupped around a glowing orb. Start simple, then you can make these effects more dramatic with practice.

1. Begin with a line drawing of your composition drawn on its own layer. Name the layer "line drawing."

2. Add a layer behind the line drawing and name it "background color." Choose a dark, desaturated color that is the complementary color to your glow color. For instance, if you want a golden glowing orb, make your background a dark, desaturated violet.

3. On a new layer (named "value painting"), paint the parts of the image surrounding your glowing object using colors that are darker than your background color. It helps to paint in largely monochromatic tones (Figure 4.32).

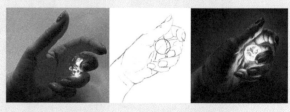

Figure 4.32 A basic reference photo, composition sketch, and quick color application for a glowing object painting. (Author's own)

4. Create a new layer above your previous layers named "glowing object." Paint the glowing object in a bright color. You can also use multiple colors; you're not limited to one.

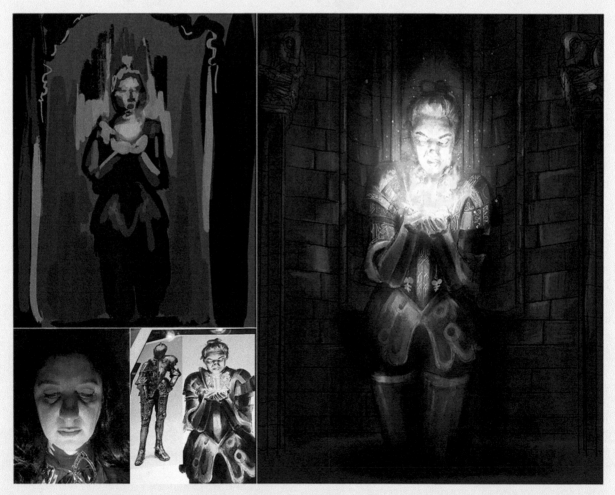

Figure 4.33 Self-made reference photo and composition sketch side by side with the painting, now with the areas of reflected glow added. Reference photos are invaluable for mapping out light across objects. (Author's own)

5. Look critically at the places where the glow would reflect light off the surrounding surfaces. Paint a less saturated tone of the glow color on those surfaces as part of your "value painting" layer. If you're unsure how to map out the reflected light, use or make a reference image for yourself.

6. Hop back up to your "glowing object" layer and duplicate it. Rename the new layer "glow halo 1." Change the layer blending mode to luminosity or add/linear dodge. Try both and see which you like best for your image, toggling back and forth between them as you extend the glowing effect.

7. Apply the filter "Gaussian blur" to your "glow halo 1" layer. Play with the slider to spread the pool of light further from the image.

8. Duplicate "glow halo 1" a few times. Play with Gaussian blur and layer opacity to spread the light halo further out at different opacities.

9. Be amazed at the magic you created and think of the possibilities of this painted effect!

Figure 4.34 Glowing composition by designer Sarah McElcheran. (Sarah McElcheran)

Figure 4.35 Scenic rendering by designer Tyler Herald for *The Curious Incident of the Dog in the Night-Time* using glow and directional lighting effects. (Tyler Herald)

Applied Skills Tutorial: Painting Directional Light

While digital painting will not lay out an effective composition using directional light, it can certainly help you amplify lighting effects in your renderings. To keep things simple for this exercise, start with a simple still life or portrait. Work from life or from a reference photo. Place your subject near a window and focus on one light source hitting that object. Work in desaturated color or grayscale until you're more confident; sometimes, removing variables from an exercise will help you better understand its core principles.

1. Begin by creating your composition. Working largely in desaturate grayscale or monochrome, map out your figure, your ground, and the direction of your light. This will work best on a midtone ground, a color fill layer (name it "ground") that will sit behind your painting. You should have at least two layers at this point, your "composition" layer and your "ground" layer.

2. Render the scene so it's clear which surfaces are being touched by the light. Use a range of values, but steer clear of true white or true black, as these will blow out your contrast range.

Figure 4.36 Directional light painting exercise in monochrome composition. (Author's own)

Figure 4.37 Shaft of light before and after diffusing it with Gaussian blur. (Author's own)

3. Create a new layer on top of the previous layers. Name this layer "light."

4. There are so many ways to paint shafts of light. Try these three methods to start:

 a) Using a large, soft-edged brush, paint the shafts of light. Use responsive pen pressure to create depth and texture in the light, like a sunbeam streaking in through a window.

 b) Use the polygonal lasso tool to draw the shaft or shafts of light. Fill the selection area with white, then adjust the opacity to 30% or lower.

 c) Use the polygonal lasso tool to draw the shaft or shafts of light, then add a curves adjustment layer. Brighten the highlights on the Properties window to brighten the unmasked area of the adjustment layer.

5. Apply a Gaussian blur filter to this layer, adjusting its diffusion level in order to make it look natural. This will make the light appear more diffuse in your space.

6. Once you're happy with the light's overall placement and appearance, set the layer blend mode on the "light" layer to add or luminosity. Try both and see which you like better. If the effect is too harsh, try reducing the layer opacity. If the effect is too weak, try duplicating the layer, alternating the Gaussian blur on successive layers to create a corona around your light shaft. Playing with the layers, layer blend modes, opacities, and blur effects will help you get to the lighting effect you want to portray.

7. Create a new layer on top of previous layers. Name this layer "motes" and set the layer blend mode to add or luminosity.

8. Using a small, hard-edged brush or a spatter brush, add tiny, bright motes floating in the shaft of light. You can also play with duplicating this layer and blurring successive layers so the motes appear to gently glow.

9. There's no shortcut to good painting! Make sure all of the reflected light on your figure matches the color of the light beam. The effect won't work unless all of the elements in your picture plane are working in harmony.

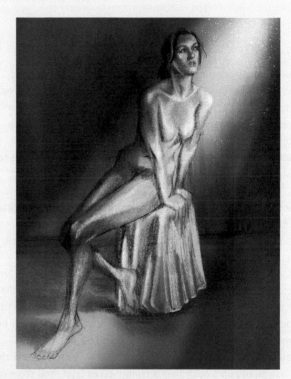

Figure 4.38 Finished directional light painting exercise, complete with glowing dust motes. (Author's own)

CHAPTER 5
Digital Art Supplies

Your studio is set up, your optimized computer stands at the ready, and your document is open. You're staring at a blank digital canvas and it's time to begin creating images. This chapter will explore the mechanics of digital art supplies, including brush setup, brush customization, and emulating various types of traditional media. Chapter 5 is about helping you to achieve the best possible results when painting with pixels.

The best digital paintings have a lot in common with traditional media artwork: beautifully composed spaces with cohesive palettes, dynamic chiaroscuro, visible mark-making, and a few unpredictable moments in which natural media surprise us. Digital painting "looks digital" when it's too perfect: the gradients are too smooth, the color is all over the place and too saturated, there are no hard edges, or there are no soft edges. Sometimes, digital tools will produce these results for us without a lot of effort, but sometimes, we have to take a moment and be sure that the charcoal is a little smudged, the watercolor is bleeding, and the oil has picked up a color from an under-cured layer. You can even work some dry media on top of digitally painted prints, adding texture and depth to your finished work. Embrace and cultivate an eye for irregularity and your digital work will benefit.

Digital Brush Mechanics

At its simplest, a digital brush tells the software how many pixels to change from one color to another. A digital brush can represent a single pixel changing from black to white, or it can be hundreds of pixels sampling from a dynamic range of hues and values. Your choice of brush determines the style of your image as you begin to build it. Do you want the look of messy, water-washed charcoal, or bright mid-century gouache? Creating or choosing the right brush is key to achieving your desired results.

Two basic controls that will shift a brush's output are size and opacity. These controls will change the number of pixels a brush will address, and the strength with which the brush will act. To translate the idea of size into traditional media terms, this is

similar to the choice between a fine detail 00 paintbrush and a wide wash brush. To translate the idea of opacity, think about working with a dry brush versus loading a watercolor brush with clean water before picking up pigment. Manipulating these two simple controls can bring tremendous variety to your paint applications as you get to know your digital painting landscape.

Figure 5.1 Brush opacity and size impact the stroke of a simple hard round brush. (Author's own)

One of the simplest types of brush, and one that comes pre-loaded in almost any digital painting software, is the round brush. Round brushes are usually offered in a hard round, in which the pixels change with a hard-edged line, and a soft round, in which the pixels end in a soft, graduated line. There are many proponents of the round brush that believe you can master these and never use anything else. Exploring the round brushes and round brush tutorials is a great first step in exploring the digital painting landscape.

DOI: 10.4324/9781003212836-5

Applied Skills Tutorial: Limited Variable Still Life

Whether you are brand new to digital painting or experienced but a little stuck in your ways, try this exercise. Start by finding a single still life object. Objects with unpredictable colors work well for this, like apples, fall leaves, seashells, and interesting rocks. Open a new digital painting file with a white background and explore the following steps:

1. Build a quick palette. Grab a hard round brush and visually color-match the five main hues you see in the object. Give yourself a good range of values to work with. Paint a big dot of each color, then return to your palette again and again to sample using your color picker.

2. Start sketching the object, using only hard and soft round brushes.

3. Play with the brush's size and opacity. Don't erase; just paint over any areas you don't like.

4. As the soft round edges overlap and begin to create new blends and values, use your color picker to swatch from your painting.

The end goal is to recreate the object as faithfully as possible using limited variables. This will give you a stronger sense of the malleability of these tools, and hopefully will help to make the digital painting space a little less overwhelming.

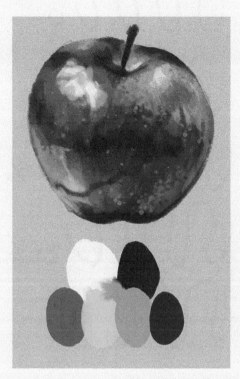

Figure 5.2 An apple using a limited color palette and round brushes. (Author's own)

Adjusting Brush Settings

Once you understand what the simplest presets can do, you may want to start exploring more complex brush creation and brush alterations. In this section, I will discuss the controls that govern brush manipulation, a few methods for building brushes, and a few reasons why you might want to build custom brushes instead of using pre-packed or downloadable brushes. Because the brush customization controls are a little different on every platform, this will not be a menu-specific walkthrough. Familiarize yourself with the process of seeking out technical walkthroughs on forums and video sharing sites, as they will always have the most up-to-the-minute information. This section aims to discuss artistic approaches and brush vocabulary.

Toolbar Brush Settings

The toolbar brush settings allow you to make quick adjustments to your brush as you work. These settings are usually visible in the digital painting workspace once your brush is selected, though their appearance can be opaque on some software platforms. These settings will look very different depending on the software you're using and sometimes based on the brush you select. Here are a few settings you're likely to encounter, and how they'll change your brush output.

- **Size:** Every brush toolbar menu will have some version of a size control, which changes the number of pixels in a brush tip.
- **Opacity:** This slider from 0–100% will determine how opaque the marks you make with your brush will be. Low percentage will create a very translucent mark, while 100% opacity marks will be completely opaque. Sometimes, a brush will automatically adjust this setting to help a brush look its best.
- **Flow:** Flow controls the speed at which the paint is released from the brush, much like the trigger on an airbrush.
- **Smoothing/stabilization:** Smoothing addresses the amount of correction a brush provides to your hand. If you want smooth, swooping lines that look almost vector-generated, try increasing the smoothing in a brush. If you want something to look very handmade, reduce the smoothing.
- **Load:** Load tells the software how much media to load on your brush for each stroke. This allows your brush to "run out" of paint as you lay down strokes on the page, creating realistic natural media effects.

Figure 5.3 Marks executed with the smoothing controls turned up incrementally for each stroke. (Author's own)

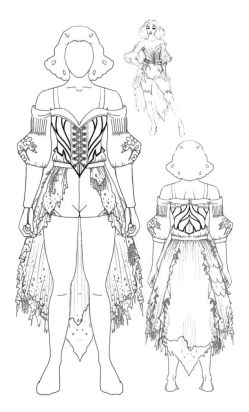

Figure 5.4 Technical drawings executed using the symmetry tool. (Author's own)

- **Symmetry:** Symmetry controls are sometimes on the toolbar and sometimes hidden in other menus, but most digital painting software offers them. Symmetry allows you to split the canvas down one or more axis. You draw in one half, quadrant, or section, and your drawing is mirrored in the other section(s). This tool can be used to create binary symmetrical drawings, like perfect butterflies, or complex mandalas with intersecting designs.
- **Mode:** The brush mode menu allows you to use a brush in a layer blend mode. This is a powerful way to move swiftly between the layer blend modes without navigating through a maze of new layers constantly. Some brushes will automatically choose their layer blend mode based on the effect the brush was built to emulate.

Brush Settings Menu

Every worthwhile digital painting platform has a brush settings menu. Unlike the basic controls offered on the main display, like brush size and opacity, these advanced controls allow you to manipulate the behavior of the brush in great detail. Let's start with some basic vocabulary you'll encounter in these menus, and what effect each control will have on your brush.

- **Brush tip shape or taper:** This control governs whether or by how much your brush tip drags out to a thinner shape as you complete a pen stroke. In traditional media, this is the equivalent of using the belly of a round watercolor brush, then transitioning to using the pointed tip. With no taper control, it would be more like using a blunt oil pastel crayon in that the shape will never get finer than the threshold set by the brush's pixel dimensions. This control allows you to control your line weight and how your lines will begin and end.
- **Spacing:** This control will determine whether the shape of a brush is used as a repeating stamp or dragged into a continuous line. Increasing spacing allows you to see the individual marks made by the brush tip (very useful in painting foliage, wallpapers, and fabric prints). Decreasing spacing allows you to turn any shape into a mark-making device or line.
- **Jitter:** Jitter describes your ability to impart forces of chaos into your brush. Jitter tells the brush how far it can act from its original parameters. There are many different jitter sliders, depending on your software: size, shape, angle, roundness, hue, and more. Zero jitter means the brush will stay the same size, shape, and distance from the center of the mark you're making. Increasing the jitter means your brush can behave unpredictably along that line. For instance, if you have a brush that is a single dot set to a wider spacing, you can paint a row of perfectly equal size dots on zero jitter. Increasing the size jitter will vary the size of the dot. Increasing the angle jitter will tilt the dot at random angles, treating it like a 2D object on a rotating plane in 3D space. Jitter controls often sit within a Shape Dynamics menu.

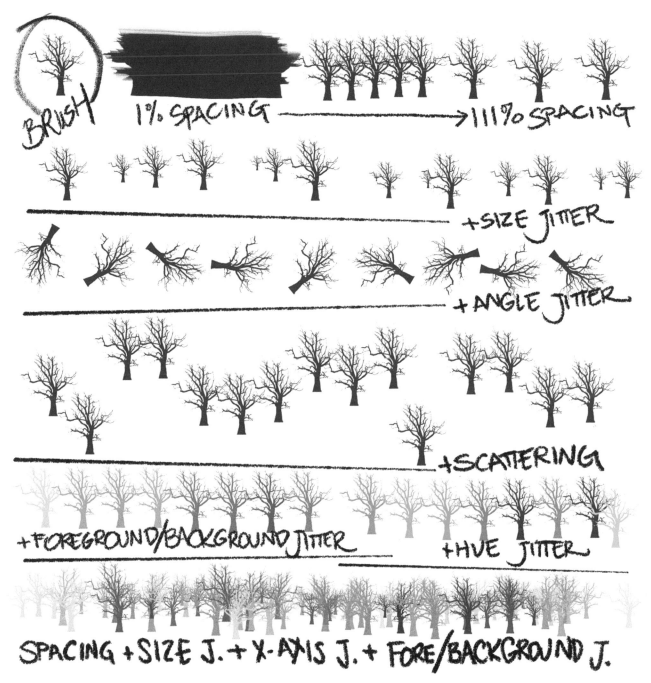

Figure 5.5 The impact of brush spacing, jitter, scatter, and color dynamics. These effects can be further manipulated by combining them to create compound effects. (Author's own)

- **Scatter:** Scatter is a distance jitter. It tells the software how far from the central mark you can deposit paint. Returning to the metaphor of the line of spaced dots, increasing the scatter will create a mist of dots around the central mark-making line. This stacks with other forms of jitter, allowing you to create a little cloud of variably sized, rotated, and angled marks. This control is phenomenal for creating scatter print fabric brushes, splatter painted effects, and glitter effects in your paintings.

- **Texture:** Texture is one of the more complex brush customization features. Texture gives the brush tip you're painting with a source from which to apply texture to the brush output. This is what creates watercolor paint brushes that look as though they're painted across dimpled hot press paper, or number two pencil marks that look like they were shaded on the flat side of a sharpened pencil lead. Textures allow brushes to be less predictable. Many good-quality

brushes come with textures pre-loaded, but you can also create your own custom textures, which can be very helpful if you want to paint repeating patterns on fabrics or walls.

- **Control source:** Many brush customization options have a drop-down menu called control. This menu allows you to choose a condition under which certain properties of a brush change. For instance, perhaps you want a little scattering on a spray paint brush, reminiscent of nozzle spatter. You can tell the brush to activate these properties based on pen pressure, pen tilt, direction, or a number of other controls (depending on your software). Using a control source can bring unpredictability and life to your digital paintings.
- **Tilt/brush pose:** Some brushes are prepared (or can be told) to respond based on the way you hold them. Tilting the brush, laying it nearly flush with your tablet, or shifting its position as you paint can yield surprising and natural results. A great example of this is the Apple Pencil, which has highly responsive tilt controls. Working in Fresco or Procreate, artists can use the sharp tip of a pencil, then shade with the side of the lead.
- **Color dynamics:** Color dynamics offer another form of jitter, but related to hue choice. When color dynamics are activated, the software will choose random hues that are either close to or very distant from the artist's color well choice(s), depending on how high the thresholds are. In some software, you can isolate color jitter by individually adjusting hue, value, saturation, brightness, and foreground/background (addressing both colors in the color wells) jitter. An example of how this could be useful would be painting swaths of fall leaves. With a leaf brush set to scatter, angle jitter, size jitter, and making use of color dynamics in a fall palette, an artist can paint a range of leaf sizes, colors, angles, and placements with a single pass of the brush.

While there are other controls available depending on the software you're using, these are the primary vocabulary terms you'll encounter that will have a large impact on your brushstrokes. The best way to learn them is to just open a blank canvas and play. Try the sliders individually to see the effect each will have on your brush, then try using them alongside one another in order to understand how the controls will impact each other.

Building Brushes

While some artists are devotees of building brushes, many others prefer to outsource this job to the many experts offering brush packs. Try all of your available brushes before you build your own so that you have a sense of what your software can do. It can be a great (albeit time-consuming) exercise to build

yourself a brush swatch chart so you have a handy reference for all of your brushes.

The diamond standard in brush creation is the Original Design Gangsta, Kyle Webster. Webster's Photoshop brushes arrived on the third-party marketplace scene in 2014 and were immediately adopted by industry giants like Disney, Pixar, and Cartoon Network. KyleBrush was acquired by Adobe and as of the time of this printing, Webster's brushes are available to all Creative Cloud subscribers. Kyle Webster's brushes emulate traditional media in ways that are beautifully messy, surprising, and unpredictable. If you are using Adobe products, download all of the KyleBrush brushes and enjoy a deep dive into hundreds of traditional media options ranging from the classics (pencil, ink, watercolor, gouache, oil) to unique special effects brushes (inky brayers, halftone screens, copier brushes, and concept art brush packs).

Even with a tremendous number of brushes at your fingertips, you still may want to learn how to build a custom brush. It is a great way to quickly customize fabrics, wallpapers, textured surfaces, and other surface treatments.

There is a difference between a brush and a brush preset. While this distinction uses Adobe terminology, the distinction between these two types of interaction occurs throughout platforms using different names. A *brush* is an editable, adjustable way for you to create pixel change on a digital canvas. A *brush preset* is a way to lock your adjusted brush settings, allowing live changes to the brush, but the brush will return to the preset values when you start a new document. Saving brushes as brush presets allows for greater flexibility and memory.

Basic Mechanics of Brush Construction

Most brushes begin the same way: as a small black shape on a white background, saved as a small document (usually around 150 × 150 pixels). The shape can be as simple as a dot or as irregular as a texture sampled from a black and white image. When this small monochrome image is saved as a brush, it will become available in the brush menu immediately. Using the brush settings adjustments described in the previous section, you can now customize this brush tip to create a host of effects.

Scatter Brush

In my work as a costume designer, I find that creating scatter brushes is one of the ways that I most often make use of custom brush construction. Scatter brushes are a great way to paint scatter prints, or any print with organic organization of information; think about foliage, splatter painting, and organic textural effects like mold growth. If you want to paint a more repetitive or geometric print, hop down to the section on repeating pattern brushes.

To create a scatter brush, I like to start with a shape that is a very basic version of the image I need. In the photo (Figure 5.6), I'm using a 1960s deadstock fabric with a scatter floral print as an example. To create a brush for this print, I would start by painting a basic daisy shape and saving it as a brush preset. Once I have it live in my brush menu, I open brush settings to begin manipulating the brush. I use scattering, size jitter, and hue jitter to manipulate the brush, playing with the sliders until I see something appearing that looks more or less like the print on my fabric. Once the brush is built, I can paint all of the floral print on a dress in just a few strokes.

As always with painting patterned fabric on costumes, keep stage distance and scale in mind. Make sure the scale of your brush is appropriate to how the fabric will appear on the body. A great way to check scale is to use relative measurement. For instance, look at the length of the vertical repeat in your patterned fabric and find a part of your body that is relatively the same length. Maybe it's the length of your hand from the base of the palm to the tip of your middle finger. Use this length as a reference on the page: the length of your pattern repeat will be the same length as your figure's hand. It can also help to affix a swatch to the wall, then walk across the room and view it at a bit of a distance to see which details soften and which details stand out.

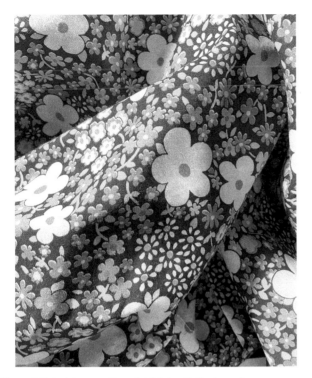

Figure 5.6 A vintage scatter print fabric. (Author's own)

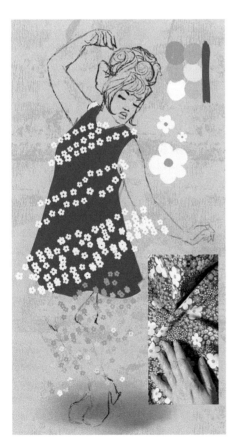

Figure 5.7 Build the scatter brush by adjusting your brush control settings until the brush stroke is accurately recreating the print. (Author's own)

Figure 5.8 The scatter print in relation to a hand, then scaled to the hand of the digitally painted croquis. (Author's own)

Figure 5.9 A suit uses a fabric's grain in very specific ways. The suit on the left is painted with the striped pattern filled in the same direction. The suit on the right is painted by correctly aligning the striped pattern according to the grainline of the garments. While designers can certainly play with expectations and grainlines, it's always good to know which rules you're breaking so you can break them intentionally. (Author's own)

While custom brushes can convincingly match the print, pattern, and textures of the world you're painting, they will only ever appear on a two-dimensional surface. In order to make the print appear to wrap around curved surfaces, like furniture or clothing pieces, you should overpaint the area needed, then use warping tools to distort the print into a curve that moves around the body or into folds on the garment. This prevents the flattening effect of a print that doesn't appear to change as it moves over three-dimensional surfaces. You can read more about the use of warping tools in Chapter 8.

Painting with a pattern also won't automatically work on the correct grain of the fabric. You may need to make a new layer, paint a broad swath of your print, and rotate it into the correct alignment according to the grain of the garment. Digital tools make this so easy: decide which direction is your selvedge and rotate new sections of "fabric" as needed. If you're unsure of the grain orientation, try looking at pattern diagrams or using reference images. Certain garments, like suits and circle skirts, have specific grain orientations, and failing to align your fabric

may frustrate your draper and create false expectations of what the garment will look like when finished.

Grayscale/Mixed Opacity Brush

Interesting brushes can be made by pulling out interesting textures from photographs, desaturating them, and saving them as brush presets. Start by finding a high-quality photo of a texture you find interesting. Think about something that works in micro, like crumbling asphalt, your pet's hair, or a particularly interesting succulent at the hardware store. Import the picture into your digital painting software. Use a freehand selection tool/lasso to select an area you find interesting. If possible, copy/paste this area with feathering turned on. Feathering will make the selection soft around the edges for as many pixels as you request; five to eight is usually enough. If you do not have a feathering option, you can get the same result by selecting the area you like, then choosing a soft round eraser and erasing around the edges of your selection. Correctly done, it should look like the image is in soft focus around the edges and clear in the center. Copy the image and paste it into a new document.

Figure 5.10 A rock formation photograph provides an interesting, high-contrast sample for a grayscale brush. (Author's own)

In the new document, desaturate the image so it only appears in grayscale. You can also play with some of the menu settings like brightness, exposure, and contrast to make sure the image is as dynamic as possible. You can even copy, paste, and layer the image over itself in different directions to get a more dense mark. Once you like what you see, save it as a brush preset and go to a new, blank document to try it out.

Figure 5.11 The sampled rock formation has been desaturated and layered on itself until it becomes unrecognizable. (Author's own)

The grayscale brush will require fine-tuning using the brush settings menu. Play with spacing, taper, scatter, and jitter until you get something you like. Using this method, you can make great "happy accident" brushes that will give you messy, unpredictable natural media effects.

Figure 5.12 The rock formation brush can be adjusted to create a variety of effects. Some samples of strokes made with variations on this brush. (Author's own)

Repeating Patterns and Brushes

Repeating patterns and repeating pattern brushes can be a great way to wash large surfaces with complex printed patterns. Consider a Victorian parlor with streaming damask curtains or a gaggle of chorus dancers in multicolored plaid costumes; yes, the impact will be gorgeous, but you don't have the time to paint every twirl and grid. In digital painting, you can spend a few minutes creating a repeating pattern, telling your software to remember that it can be used this way, and then it will be available as a paintable or drop-fill texture.

Let's start with creating a repeating pattern. If you've never created a repeating pattern before, showing an example of how it works in analog format is an easy way to demonstrate the concept, and you're welcome to play along at home. You'll need a square of paper, any mark-making tool (pens, pencils, stamps, paint, etc.), paper scissors, and some clear tape. If you have it, a scrap of gridded wrapping paper will work really well for this demonstration.

1. Grab your square of paper. It's important that it's a perfect square and not an eyeballed/estimated square. You'll need to be able to divide it into four equal parts in order to create the repeat. Draw or stamp some images on the page, but don't let the images touch the paper's edges.
2. Measure or fold the paper to mark the y-axis, then cut it in half along the marked line.
3. Without reversing the halves, switch them with one another. The images should remain in the same orientation, but the

Figure 5.13 Create a repeating pattern image by starting with four quadrants and images that do not touch the paper edges. Cutting the grid and reversing the positions of the tiles will create a repeating pattern. You can see how "cut" pieces of the image would connect from left to right and top to bottom. (Author's own)

former center line/y-axis of the image now sits on the outside edges of the page, and the former outside edges now touch at the y-axis. Tape your paper back together.

4. Repeat the measuring and cutting process for the x-axis center of the page. Fold or mark the paper's horizontal center, then cut in half along the marked line.

5. Without reversing the halves, switch them with one another. The images should remain in the same orientation, but the former center line/x-axis of the image now sits on the outside edges of the page and the former outside edges now touch at the y-axis. Tape your paper back together.

6. You should now see two things:

 a) If you look at the edges of the paper, you will be able to see where any image divided by your cuts will now repeat either left to right or top to bottom. If divided images do not repeat, take a few steps back and try again, revisiting the directions.

 b) There is a sort of visual hole in the center of the image.

7. Keep drawing, stamping, or marking! Add new marks to the "hole" in the center of the image. If necessary, continue cutting, switching, and re-taping until the page looks pretty full. Make sure none of the imagery you're adding touches the outer edges of the square.

If you were to take this image to a copier and make several copies of it, you would be able to cut them out and line them up end to end to create a repeating, infinite pattern. Working digitally, you'll follow the same conceptual process, but you will use selection tools in place of cutting and rearranging strips of paper. The image doesn't have to be square, but the quadrants all have to be the same size.

When setting up to create a digitally painted repeating pattern, you can approach the idea of cutting the paper horizontally and vertically a couple of ways. Before trying either of these, check your selection tool controls to be sure your software's version of snapping is turned on. Snapping allows anchor points or guidelines to have a magnetic grab so that when you're moving a selection, your document will grab it when it's close to the correct placement. Snapping makes sure you don't have to land a selection tool drop on the exact one-pixel-width-perfect spot to get your pattern to line up correctly.

Guidelines

1. Set guidelines if your software allows. In Photoshop, you can create guides by making your rulers visible, then dragging horizontally or vertically from your rulers onto the canvas. Set a vertical center guideline and a horizontal center guideline; snapping will help you land these in the exact right space. If you don't want the guidelines active while you draw (the snapping can do some weird things to brushstrokes), you can toggle them on and off. Be precise when placing guides: incorrect placement by even one pixel width will show as breaks and overlaps in the final pattern.

2. With guidelines active, use a rectangular selection tool to grab the left vertical side of the canvas and move it to the right, then grab the original right and move it to the left. Rinse and repeat for the horizontal axis.

 a) If you want to try this approach and your software doesn't have true guidelines, you can create a new layer (name it "guidelines") and draw in the x- and y-axis grid. Use this visual reference when moving sections of the canvas from left to right, but be warned: if you don't get your selection pixel-perfect, there will be breaks in the pattern repeat.

Canvas Shift

1. Start by flattening or grouping all of the layers in your image before you start cutting it. Copy and paste the flattened layer, hiding the grouped layers as you move forward. Feel free to hang on to the grouped layers for archival purposes if you think you'll want them.

2. Select the entire image, then shift it half-off the canvas to the right. Make sure snapping is active to tell you when you've reached the halfway point.

3. Paste the original flattened layer, select all, and then shift it half-off the canvas to the left. The new y-axis center should be perfectly flush against itself.

4. Repeat for the x-axis center line, shifting your pasted canvas up, then down.

The functionality of your selection tools will be slightly different depending on which software you're using. Please check for specific tutorials as needed to select and move your pattern correctly.

Once your pattern is set up to repeat, add a new layer. Fill in the "holes" in the pattern to create a fuller repeat and to help prevent the pattern from banding. The pattern can be split along the x- and y-axis again and again to fill in holes as you develop the pattern. Keep an archive of your drawings on separate layers just in case you want to take steps backward. You can add pattern elements that touch the edges of your pattern, but only if you are done splitting and rearranging quadrants.

You can save your drawing as a pattern to test it and see how it's going to look. All of the major software platforms have ways to save an image as a pattern, so check your tutorials to find out the latest information about how to navigate those menus. To check the pattern repeat, open a larger document than your pattern document and fill the canvas with your saved pattern. This will allow you to

Figure 5.14 Increasing image density will change the appearance of your finished repeating pattern. (Author's own)

Figure 5.15 Repeating patterns have been used to paint the curtains, the character's clothes, and the textured light on the stage floor. (Author's own)

test the accuracy of the repeat and the look of the pattern. If you're not happy with it, make your adjustments and save it again.

Once a pattern is saved, it can either be used as a fill (with the paint bucket tool or its equivalent) or you can pair it with a brush tip so you can paint in an area using the pattern you've created. If you're planning on using a print or pattern repeatedly in a design, or over a large area, creating patterns can both save you time and prevent the distortion of your pattern's proportions.

Adobe Fresco Brushes
Adobe Fresco has special brush types that, as of the time of this publication, aren't yet available in any other software. Because Fresco was developed especially for digital painting with a stylus, Fresco includes live brushes and vector brushes, and both these special brush types make Fresco worth exploring.

Fresco's live brushes are the most exciting facsimile of the unpredictability and wet edge manipulation offered by traditional media. Most digital paint brushes can offer you a "live edge" so long as you don't lift your stylus; you can continue to blend and play with opacity, color pooling, and the

blend, but that ability is removed once the stylus is lifted. In Fresco, the paint stays wet, allowing you to paint into both watercolors and oil paints until you're ready to "dry" the layer. The brush tips available as live brushes are limited, but the effects are spectacular.

The watercolor effects available to the digital painter are phenomenal: you can drag wet edges out until the color disappears, you can dot color into washes and allow it to bloom, you can choose to load a brush with water and just blend, and you can create true wet-on-wet washes. Fresco's live watercolor brushes are controlled using three sliders: opacity, brush size, and wetness. You can control each element independently, allowing for a control of watercolor painting akin to moving from dry brush application to large, soaking-wet washes. Using the lasso selection tool is a great way to create a quick, temporary mask for wet watercolor work, allowing you to make the most of a messy paint application with all the advantages of a digital environment.

With oil paints, you can build an area for an impasto effect, you can allow your brush to get progressively more "dirty" with all of the colors you've touched, or you can softly blend areas of color to create Botticelli-level color transitions that lack the

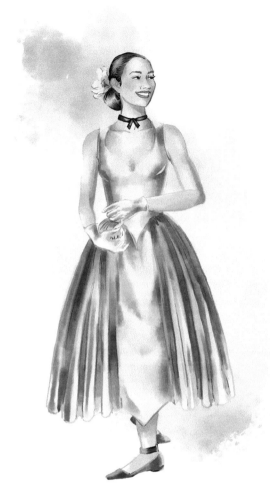

Figure 5.16 Adobe Fresco's live watercolor brushes can create stunning natural media effects. (Author's own)

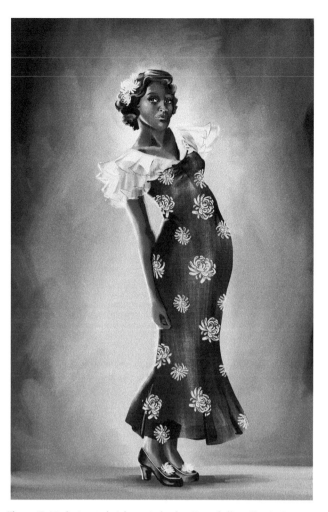

Figure 5.17 Costume sketch created using Fresco's live oil painting brushes. (Author's own)

slickness of a perfect digital gradient. Oil paints have traditionally been a bit off-limits for theatrical use due to their long curing times, but digital oils bring them back into the theatrical artist's toolkit.

The other brush type unique to Fresco are the vector brushes. Vector brushes allow you to make freehand vector drawings, a capability that will be useful to anyone looking to make logos or drawings that will scale to very large media (digital drop printing, projected media) without loss of quality. For more information about the differences between raster- and vector-based lines, please visit Chapter 3.

Traditional Media With Digital Tools

The irregularities, happy accidents, and unpredictable nature of traditional media are part of what makes them so beautiful.

Luckily, these qualities are available to you when rendering digitally. Part of achieving these effects successfully is a matter of understanding how to use digital media, but part of it is how to allow for a little grit and mess in your work. Digital media will allow us to fuss endlessly without degrading paper or muddying color. Learning how to manipulate the media and learning when to stop editing the work is part of the digital painting journey.

A great way to explore your brush landscape is to make a large canvas, grid it into small squares, and sample all, or at least many, of the brushes in your inventory. See which of them respond well to your hand, then drag them into a new brush category called "Favorites." This category can be fluid and change with time, but when you have hundreds of brushes in your inventory, it's an enormous time saver to have your favorites within easy reach. Another brush organization project suggestion: third-party brush packs often include many different media options. For faster brush selection, eliminate the source folder for brush packs

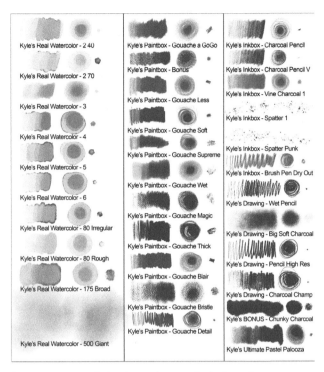

Figure 5.18 A sample brush swatch page. (Author's own)

and re-organize your brushes by media type rather than the brand or season under which they were issued.

As you begin making marks and sampling brushes, you should both play with your brush sensitivity and with your tablet's screen sensitivity. Third-party pen tablets have their own control panel, and setting a sensitivity threshold that works for your hand is key to getting results you're happy with. If you have a very heavy hand, you may need to tell the tablet to be a little less sensitive. If you struggle to make your light-handed marks appear on the screen, try asking it to be more sensitive.

Digital Paper

If you plan to print your digital paintings, it's best to think about paper during document setup, not once your painting is finished! Printing on different papers will give slightly different effects. For instance, laser printing on inexpensive printer paper will yield matte or eggshell results, but laser printing on card or coverstock will appear more highly saturated and more reflective. Printing on toned paper can provide an antiqued look, but you will lose anything that was meant to be white, as printers use the paper as white when printing. Printing with a laser printer will mean bright color, crisp edges, and toner that sits on the surface of the paper. Printing with an inkjet printer may mean slightly less saturated color than laser printing and water-based color that will be absorbed into the paper. Chapter 3 discusses the mechanics of

printing choices, but here, we will discuss the artistic choices you'll need to make for printing your paintings.

It is always helpful to work on a toned background to help you better see the value structure of your painting. Make a plan for your toned paper based on your answers to these questions:

- Are you using a toned background that matches the toned paper you intend to use for printing? If so, you should delete the toned layer prior to printing. You will also want to make a plan for adding white back into the painting, if needed. High-quality white colored pencils (like Prismacolors or Derwent) work well for this, as do opaque white gel pens. This can also add a wonderful hand-touched quality to your digital painting work.
- Are you planning on printing the toning as part of your painting? This is easy to do, and you won't lose your white values. Remember that you will not be able to print with an edge bleed, so you may want to plan time for hand-trimming these renderings so they appear professionally printed.

You may also want the tooth or visible grain of a traditional media paper as part of your finished rendering. You can achieve this in a few ways.

- Make your own high-quality photos or scans of the traditional media paper you like to use. Scanners will sometimes bleach out the interesting textures of these papers, but most mobile phones are capable of taking very high-quality photos that can be used for backgrounds in your digital renderings. Take the photo of the paper, adjust the photo to highlight the grain and to correct any skewed perspective. Drag and drop this photo into its own layer in your digital painting software, then work over it. To make sure the tooth is visible in the way your painting interacts with the paper, try using a layer blend mode like overlay at a low opacity. You can also purchase high-quality paper scans from many online sources for stock photography.
- Print the renderings on the paper of your choice. You do not have to use office supply papers in printers. Most copiers can handle paper up to 90 lb. weight art paper if you hand-feed to the printer using the bypass tray. Ink jet printing with hot press watercolor papers works well because the color absorbs into the surface of the paper and looks very much like natural media. Digitally painted colored pencil renderings look great on lightly toned Canson paper. You may also consider a hybrid digital approach in which you print your sketches or based-toned renderings on high-quality paper and then complete them with traditional media. Remember that printer inks will not pool like traditional watercolors in the tooth of the paper; if you want this effect, you have to build it in as part of your

Figure 5.19 Designer Kimberly Powers builds show packages using a blend of analog and traditional media. A traditional drawing is scanned and converted to a digital rendering for Syracuse Stage's *The Little Mermaid*. (Kimberly Powers)

digital painting. You also cannot print in white, so plan for this if you are printing on toned paper.

Set your digital painting workspace up to look as much as possible like you intend your printed renderings to look. Make sure to pay attention to printable colors as you select from the color picker and soft-proof your work using CMYK preview modes (see Chapter 3 for detailed information about soft proofing).

> Remember that inkjet printers and laser printers produce different results that may impact the choices you're making about toned or base papers. Inkjet ink is absorbed into the page and it is translucent, meaning colored art paper will be visible through any printed color. Laser printers (most copiers and commercial print shop printers) use toner, a product that sits on the surface of the paper and often appears opaque with a satin finish. Always leave plenty of time between test printing and deadlines so you have time to troubleshoot any printing issues.

When determining which media are the best fit for your project, look to your research for ideas. Does your take on this text or period feature razor-sharp black and white printmaking, lush impressionist paintings, or intimate hand-drawn illustrations? You might borrow from the artistic styles you've already seen in your research. You may also think about the tone or mood of the piece: does it call for bright, crisp graphics or murky, splattered paint? Mirroring the mood of the work in your rendering can support your storytelling as you communicate with the creative team and the performers.

Digital Dry Media

Digital dry media is a great place to start in your digital painting journey. Digital sketching is perhaps the most one-to-one relationship between analog image creation and digital image creation. If you are accustomed to executing sketches with pencils and erasers, doing so digitally will not feel tremendously different, especially if you're interacting directly with your screen.

What really makes a digital dry media sketch look like a traditional media sketch is the way you handle erasing. If you use a hard round eraser at 100% opacity, the sketch may look too clean and perfect, or interrupted in a visibly digital way. In digital painting, any brush can also be used as an eraser. Try using a rough-textured digital eraser at a low opacity for the best results; this will leave ghosted lines on your paper.

Smudging brushes are important to digital dry media. Smudging brushes, when used correctly, are the digital equivalent to a

chamois, a tortillon, or (if you haven't been trained out of the habit by art teachers) your fingertip. The best smudging brushes for dry media are always textured, as it brings a little unpredictability and natural grit to the work. It's also fun to use a rough-edged smudging brush instead of an eraser, as this leaves history and media mess on the page.

Pencils

Pencil brushes require very little explanation. They're often named exactly as drawing pencils are, according to relative hardness. 6B digital pencils are softer and will generally make a wider, darker line with a lot of grit. 6 H pencils are harder and will often create a thin, light line, even if you're bearing down pretty hard. 2B pencils sit right in the middle and are a great choice if you love a Ticonderoga yellow pencil for drawing.

To get the most out of digital pencils, make sure you're using them with tilt sensitivity. This will allow you to make sharper marks with the tip of the stylus, but you can lay it more flush with the screen to get a softer fill mark for shading.

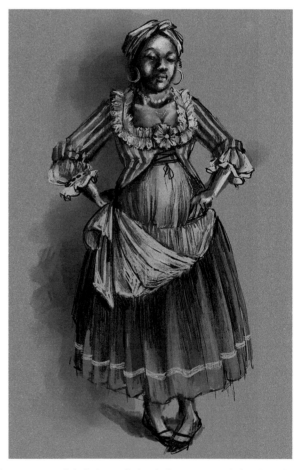

Figure 5.20 A digital 6B pencil sketch for a costume design featuring search lines, smudges, and stray marks. (Author's own)

Charcoal

If you love the look of charcoal but hate the mess, the dry rasp of it moving across paper, or its ephemeral nature, rejoice. Digital charcoal is a fabulous replacement with none of the above downsides. Digital charcoal brushes emulate both vine charcoals, charcoal pencils, compressed charcoal sticks, and even wet charcoal washes. Kyle Webster has produced wet charcoal brushes for Adobe that produce stunning natural media effects.

Much as with pencils, charcoal will look most like its traditional media counterpart depending on how you move it across the page. Rough-edged smudge brushes and erasers will serve well for charcoal editing. You may also try using a watercolor brush as an eraser to see if you like the wet charcoal wash effects that can be created this way. To create a very academic-style drawing, use your charcoal of choice on a midtone background for shadows, then add your highlights with white charcoal pencil. Try revisiting the techniques of life drawing class by holding the stylus with an overhand grip instead of a pencil-style grip.

Don't over-blend the charcoal, and make sure some of the rough marks are still visible on the page in order to keep to the traditional media effect of this brush style. Charcoal is often used in art school to break students of their dependence on the tight control of a pencil or access to an eraser. Charcoal encourages sweeping marks, light search lines, and gentle brushing in order to redraw an area. To master digital charcoal, practice working with the largest, swiftest hand motions your tablet will allow. Keep your hand pressure light at first, then begin to bear down as you become confident of the lines and composition. Use smudging instead of erasing whenever possible and remember that your supply of digital paper is bottomless.

Chalk and Pastels

Much like digital charcoal, digital chalk and pastels lack the mess and impracticalities of their traditional media counterparts, especially for theatrical design use. Digital chalk and pastels handle similarly to digital charcoal, but you can use a full range of colors for convincing traditional media effects.

Much as in traditional media, chalk and pastel media look best on toned or colored paper. For the best results, scan your favorite tinted papers so you can use them again and again.

Colored Pencils

Digitally replicated colored pencils are very true to their traditional media counterparts, but there are ways to speed up the process that aren't available in traditional media. Traditional

Applied Skills Tutorial: Timed Gesture Drawings

For some artists, learning to loosen the hand and arm for digital drawing the same way they would for traditional drawing is a challenge. In order to get used to loose sketching in a digital space, try incorporating timed gesture drawings as a warm-up or daily practice.

1. Open two side-by-side windows or create a split screen.

2. On one side (the side of your non-dominant hand), open a browser window to a website that provides random life drawing photos in a timed environment. Set the timer to 60 seconds or less. If you have the ability to limit the number of poses, try starting with ten.

3. On the side of your dominant hand, open your digital rendering software. Create a new document and make the same number of layers as you have poses.

4. Dim your canvas background from bright white to cream, tan, or gray. Choose a charcoal brush, making sure that it's set to respond dynamically to pen pressure. Your brush color can be set to black.

5. Start the timer on the life drawing photos. If you've never done gesture drawing before, the concept is simple: try to capture the entire pose in the time allotted. Focus on tension, proportion, and weight, not on details that create a likeness. Don't think of your marks as outlines; try instead to work structurally with the interior of the form, or think about capturing value instead of line. Resize figures quickly if they start to reach the limits of your page size, but do try to get everything from the top of the head to the bottoms of the feet in each sketch. If you are new to this practice, it will feel frustrating or impossible at first. Keep at it, and don't cheat by pausing the timer!

6. When the pose changes, hide the layer you were working on and move up to the next. Think about it like flipping a page in a sketchbook.

7. When you have more time to explore, you may think about returning to one of your gesture drawings and developing it into a longer-form academic drawing over 10–30 minutes. Bring back your reference photo and continue to develop the drawing. Consider using a white or off-white charcoal brush to emulate the toned paper value drawings taught in art school. This is a great way to break yourself of thinking of the figure in terms of value instead of line, and to learn how light interacts with different surfaces.

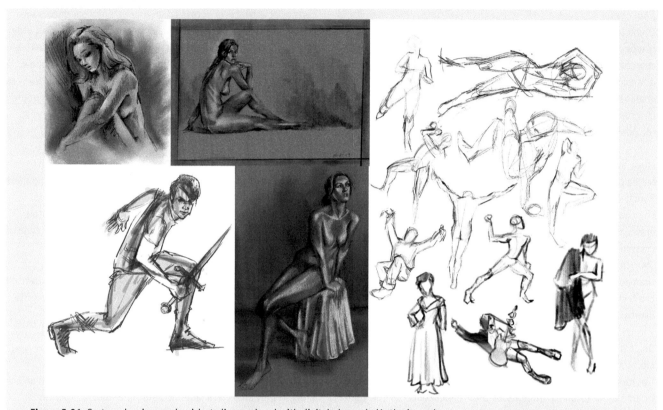

Figure 5.21 Gesture drawings and quick studies produced with digital charcoal. (Author's own)

colored pencils look their best when color is built up slowly in layers. Digital colored pencils look great this way, too, but there are ways to skip time-consuming steps in the process. Start by using rough dry media to lay down thin base layers in undulating colors to create the appearance of a slow buildup. Finish only the top layer or two using slender colored pencil marks.

You can also do large area fills of slow media like colored pencils, something you can't do traditionally. Say you're painting a large sky drop in colored pencil on digitally toned paper. Make sure the sky is on its own layer, separate from the toned base. Once you have a good sized section painted, you can use selection tools to grab a section, copy/paste, and overlap slightly with the existing painting in order to hide any edges. Set your selection to use one to three pixels of feathering if possible. If your digital painting software has clone brushes, you can also use clone brushes to exactly copy specific areas of your work, using a designated target area as the source for your brush tip. With the clone brush selected, hover your stylus over the area you'd like to use as a source. Hold down the option/alt key and tap your stylus to set the cloning origin point. Now, as you paint, you'll be cloning directly from your own work. Alternately, use a flat or mottled color fill for the large area, then break it up with lightly sketched colored pencil marks. Adding colored pencil marks as your topmost layer will make it seem like all the colors beneath are also generated by colored pencil.

To work quickly in digital colored pencil, take the time to set up a detailed color palette on your canvas. This way, you can use the color picker to swiftly grab new colors while working. The palette should be on its own named layer, and you should swatch all the colors you plan on using in your rendering. You can save this layer in your libraries or as its own document. Think of it as your entire box of colored pencils, conveniently downsized!

Digital Pen and Ink

Classic comic book art uses slick inking over light pencil drawings to finalize and define the image. This is also a really satisfying way to draw digitally. It's a great way to center bright linework. You can also convert your love of markers, which has probably been kneecapped more than once by the lack of exactly-the-color-you-need at least once in your artistic practice, to a love of digital markers.

Ink

Digital linework has a lot of advantages over traditional media linework. Adjusting the smoothing control will give you control over how much your hand shows up in the line. 0% smoothing results in a line that is exactly what you draw with your stylus. The higher the percentage of smoothing, the more the line conforms to a slick, swooping line. If you have a particularly cautious or wobbly hand, digital pens can help hide that in your work. Also, digital linework is

Figure 5.22 Costume rendering produced with digital chalk pastels. The background is textured to look like art paper. (Author's own)

Figure 5.23 Costume rendering produced with digital graphite by designer and illustrator Keyon Monté. (Keyon Monté)

malleable. You can switch from a tightly controlled line like a technical pen to a scratchy, dry calligraphy nib to a sumi-e brush with just a click. Linework can be painted in black for maximum visibility during rendering, then quickly changed to a different color or colors. You can even manually add spattering around swift brushstrokes to increase your traditional media verisimilitude.

> Did you know most digital painting software allows you to rotate your canvas while painting? If you are used to tilting your paper as you draw, this will make digital drawing feel a lot more natural. Rotating your canvas can also help when you need to change directionality for drawing or for filling large areas. Rotating the canvas in no way affects your final image and can be continuously changed as you work.

Markers

With digital markers, you'll never again face the horror of missing the color you need the most. That being said, the digital color

Figure 5.24 Line art over a reduced-opacity pencil drawing creates a classic comic book feel. (Author's own)

Figure 5.25 Costume rendering produced with digital markers in Adobe Photoshop. (Author's own)

landscape can be overwhelming, and it's helpful to limit your colors to promote color harmony in your work. Building a swatch palette of marker colors will both tighten your palette and speed up your work, as you'll be able to grab colors with your color picker instead of goofing off with the color well. If you're unsure of where to start in building a palette, try borrowing one from a commercial marker company! Grab a picture of an expensive art marker set from the internet and bring it into your digital painting workspace. Use the color picker to swatch the colors from each marker's color-indicating tip, and make yourself a palette on its own named layer. Procreate can even generate a palette for you based on a photograph.

Digital markers act like traditional markers in a lot of ways. As you fill an area, you will see the striations produced by traditional media markers, especially if you're using Kyle Webster's Art Markers pack for Adobe. Depending on the marker you chose or the adjustments you make to the brush, this effect can be more or less pronounced. Reducing flow, or the amount of pigment deposited by the brush, will highlight this effect. Marker brushes come in a range, from markers meant to emulate brand new art markers to markers meant to emulate the scrubbing effect of a nearly dry marker. Using some imperfect markers in your rendering can create a more convincing natural media effect. Also, resist the urge to use blending tools or gradual erasers when using markers. Think of the rules of traditional markers: blending can be minimally achieved using alcohol, and there is no erasing. Erasing should be a complete wipe when erasers are used.

To prevent yourself from "coloring outside the lines" when using digital markers, there are a few things you can do. Using freehand selection tools will always provide a quick, temporary mask, preventing you from painting outside the "marching ants" boundary of the selection. You can also use the marching ants selection mask to create a layer mask if you'd like to return to this boundary area again and again (more on layer masks in Chapter 8). If you want a solution that will still allow you to use selection tools while working, try using your freehand selection tool to make an outline of the area you intend to paint. On a new layer, fill this area to match your background layer, or simply use white paint. Layer lock/alpha lock the layer to lock transparent pixels, and you can now paint without stray lines leaving the boundary of your paintable area. And of course, you can choose to leave your stray or jagged edges in place to help sell the traditional media effect of the brushes.

Digital Wet Media

Digital wet media are a greater adjustment for traditional media artists than digital dry media. Because the liquid components (water, acrylic medium, oils) are not visible to the digital painter, it takes a little practice to get the hang of emulating their effects.

The upsides are, of course, worth the journey: digital wet media are erasable, editable, and you can change their colors at any point in the process. There is also no curing time and no dangerous fumes, allowing theatrical designers to work in oils if they like.

Mixer Brushes

In Adobe software and Corel Painter, digital wet media brushes make use of a special class of brushes called mixer brushes. Mixer brushes are unique because instead of picking up a single color, they can sample from an area of the canvas, then paint with all the colors sampled. This powerful tool allows for moments of unpredictability, imperfection, and dynamism that are difficult to capture with a single-color brush. As of the publication of this text, mixer brushes are unique to the Adobe suite of products and to the Corel Painter Mixer Pad. In Corel, any brush can sample from the mixer pad. In Adobe, brush icons marked with a small droplet have the mixer brush capability.

Once base colors are laid down on your canvas, you can use a mixer brush to act similarly to a wet brush loaded with paint. When you use the color picker, it selects from the area of the canvas under your stylus (in Adobe, make sure the "Load Solid colors only" option is unchecked in the mixer brush drop-down menu) and allows you to paint with the colors that appear in the pickup well, a small color well located on your toolbar. You can even make small paintings for intentional use as mixer brush tips. Painting a small, shaded shape can create interesting three-dimensional effects when the shape is sampled by a mixer brush.

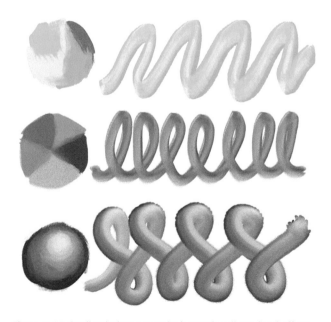

Figure 5.26 Small paintings can make interesting dimensional effects when sampled by the mixer brush. (Author's own)

Watercolor

In traditional media, watercolor is commonly taught for use in theatrical design. While beautiful and versatile, these transparent paints can be intimidating to new artists. They encourage "leave well enough alone" thinking, as the fear of destroying hours of work with one incorrectly applied layer is very real. Luckily, digital watercolor comes with an "undo" command, a feature not offered by any traditional media.

Success with digital watercolor is, with some exceptions, tied to the stylus touching and releasing from your drawing surface. While the stylus is engaged, the color will flow and blend, creating recognizable

Applied Skills Tutorial: Traditional Watercolor Exercises

Create a new digital canvas and grid out nine squares. Try the following exercises in digital watercolor, aiming to recreate natural media effects, and make sure you try them with a few different digital watercolor brushes so you can learn which brushes you like. You can't adjust the water on your brush (unless you're using Fresco), but you can find a brush that's meant to perform more like a wet wash brush or more like a dry brush.

- **Flat wash:** Try to fill the entire square of this grid with a flat wash by starting at the top left corner and gradually working your brush down the blank area in a switchback pattern. There should be as little as possible in terms of variegation in the flat wash.

- **Graduated wash:** Choose a brush where the amount of color deposited on the page is related to pen pressure or adjust a brush to respond in this way. Start with heavy pressure and gradually release the pressure as you make switchback strokes to fill the space. You can create a more flooded look for this sample by using a watercolor blender to soften any streaking that occurs.

- **Dry brush:** Find a watercolor brush that creates a dry brush effect. This may require tinkering with the flow, the spacing, and the load of the brush. If you can't find a satisfactory watercolor brush for this, check the inking brushes in your software for a good dry brush effect.

- **Wet on wet:** Start with a flat wash of color. Using a darker or more saturated color on a high-flow watercolor brush, drop the paint into the flat wash. Use a watercolor blender to create the blurring and blooming around the darker dots.

- **Two-color wash:** Choose a brush where the amount of color deposited on the page is related to pen pressure, much as you did for the graduated wash. Create a shallow graduated wash in the top half of your paintable area, fading out to the paper white just below the halfway point. Load your brush with a different color, preferably one that will create a secondary color when blended with your first color; complementary colors get muddy here. Paint a graduated wash up from the bottom of the square. Use a watercolor blender to gently break up any streaks or edges left behind.

- **Wet on dry:** Return to your dry brush and make a few strokes on the canvas. Choose a wet-edges watercolor brush and paint over it. This effect can be very useful for underpainting and adding distressing to a design.

- **Spatter, salt, and alcohol:** For all of these sections, paint a flat wash in your square.

 - **Spatter:** Choose a spattering brush and a darker and more saturated version of the background color. Test your spatter brush, adjusting as needed for density and size of spattered dots. If you want to build your own spatter brush, paint an assortment of black dots on a white canvas. Save as a brush preset, then edit the brush to increase spacing, add shape and size dynamics, and add scattering effects. Ideally, the brush should make a collection of different marks every time you mark with it.

 - **Salt:** To mimic the effects of adding salt crystals to wet watercolor, you can either choose a salt brush or choose your spatter brush. If you're adding salt with a spatter brush, you can either change the brush color to match your paper color and slightly lower the opacity or change the brush blending mode to lighten. To mimic salt accurately, the flat wash shouldn't be totally removed. It should be unevenly lightened in a scattered pattern.

 - **Alcohol:** Alcohol has a wider bloom than salt when added to wet watercolor paint. To mimic this effect, you might use an alcohol brush or you might use your spatter brush with some additional edits. Rather than editing to provide a fine mist of irregular dots with crisp edges, the alcohol brush should have a close cluster of irregular blotches with feathered edges. Set the color to the paper color (or white) with lowered opacity or set the brush blend mode to a lighten mode.

Much like watercolor paint, digital watercolor brushes use the paper white in place of white pigment when creating color. For true adherence to natural media, think strategically about building layers so you do not use any white paint in your watercolor renderings. Remembering to start from your lightest values and slowly working into more saturated and darker colors will yield more natural results. You can also use natural media tricks and re-introduce light values over your watercolor with digital colored pencils, gouache, and gel pens.

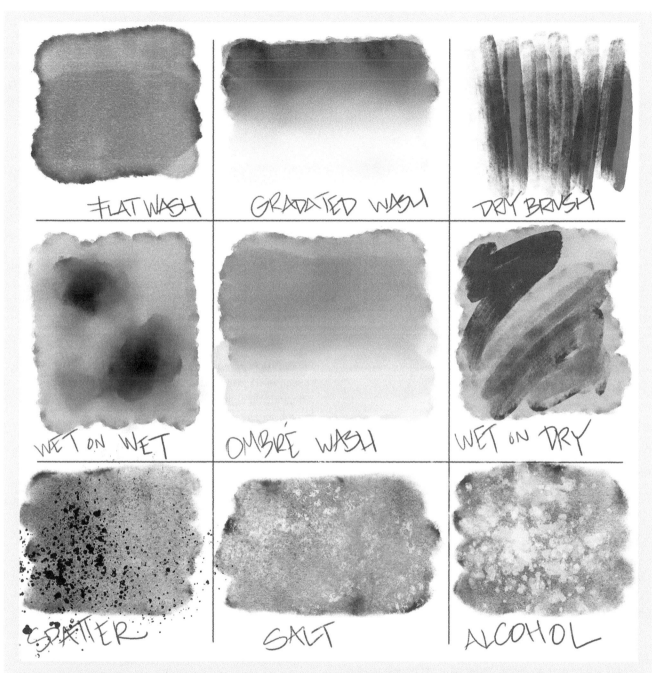

Figure 5.27 Traditional watercolor exercises are a great way to get acclimated to digital watercolors. (Author's own)

watercolor effects as you apply pressure to the stylus. Unlike traditional media watercolor, you do not get live wet edges to work with; edges must be blended out with watercolor blending brushes in order to appear active. (The exceptions to this rule are the watercolor live brushes available for Adobe Fresco, which have live wet blending totally parallel to natural media.) When you separate your stylus from the drawing surface, you now have an area of painted watercolor that will act like fully dried watercolor would in traditional media: you can

paint over it and it will not bleed, but it will remain visible through the transparent layers of watercolor as you continue to paint.

Reacclimating to painting watercolor by strategically thinking of your stylus touching and releasing from the surface of your drawing tablet can be a challenge, so it's best to start with repeating traditional exercises commonly taught when you are first learning watercolor.

Figure 5.28 Vintage-inspired costume rendering by designer and illustrator Aidan Griffiths for *Dreamgirls*. (Aidan Griffiths)

Gouache

Gouache is a divisive and often misunderstood rendering media. Essentially, gouache is made similarly to watercolor paint, but with an opaque gypsum base rather than a transparent gum arabic base. Used correctly, gouache delivers rich, punchy colors, a mix of dry brush and wet-on-wet media effects, and a cool mid-century vibe. Using traditional gouache requires strategy, as layering the colors too much will make them appear chalky or muddy.

Digital gouache brushes are a blast. They make dense strokes, deliver creamy color, and have dynamic taper responses to the stylus. They leave beautiful rough edges, or they blend down to create a richly painted look. They pair really well with the use of masks or the use of selection tools to isolate areas. To get a great sense of why isolation/stenciling and gouache are best friends, take a quick detour to YouTube and look for videos of traditional background painting for animation posted by Renwaldo5. Hopefully, these videos stay posted in perpetuity, because they're excellent examples of blended media techniques and how traditional media artists structure image creation.

Oil and Acrylic Paint

Though in traditional media oil and acrylic paint work pretty differently, in digital brushwork they are similar enough to group. In both oil and acrylic painting, different mediums are blended with paint to change the translucency, viscosity, and drying time of the paint. Thickened, opaque paint applied to the canvas in three-dimensional strokes is called impasto; transparent paint applied in thin layers to produce shimmering, Old-Masters style color is called glazing. These processes are all time-consuming,

Applied Skills Tutorial: Alpine Composition in Gouache

Here are some fun techniques to try using digital gouache in order to understand how you might make use of these brushes, inspired by the Alpine surroundings of the Von Trapp family home.

1. On a blank canvas, grab a large gouache brush and paint the canvas two colors, divided roughly horizontally. The upper color will be your sky and the lower color will be your ground.

2. On the sky side, switch to a large sponge brush and mop up a little of the color to break up the sky. Remember that the sky usually appears less saturated near the horizon.

3. Choose three colors. The colors should be three versions of the same color, moving from warmer, darker, and more saturated to cooler, lighter, and less saturated. Create a quick palette in your image on its own named layer.

4. You'll next be drawing three layers of mountains on three separate layers. Pull reference images as needed for shape, but you'll be simplifying them.

5. On a new layer, use a freehand selection tool to draw the farthest layer of mountains; these will also sit the highest in relation to the horizon line. Use the paint bucket tool/fill tool to fill this area with your most desaturate mountain color, then layer lock/alpha lock this layer. Grab your gouache brush and visit the color well to choose a few near-colors. Make sure your brush is set to a large size and practice making bold, wide swipes with it. You're adding texture to your mountain layer.

6. Repeat this process for two additional layers of mountains that sit above the farthest mountains, each on their own layer.

7. Add a new wash of land in the foreground, almost like a foothill. Choose a brighter and warmer color than the closest mountains. Add stylized flowers and brush to complete the scene. The hills are alive with the sound of … brushstrokes!

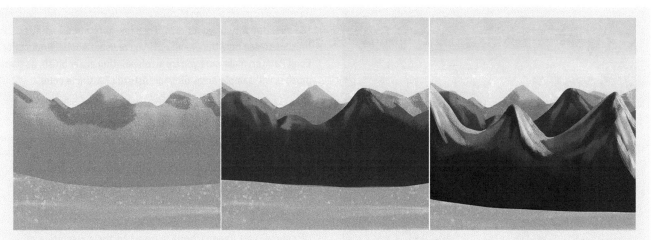

Figure 5.29 Alpine painting exercise – adding layers with different environmental elements layered over one another creates a sense of depth in the composition. (Author's own)

Figure 5.30 Alpine painting exercise finished. (Author's own)

8. On your locked layers, try other methods of texturing the gouache: spattering, sponging, lowering brush load to create more streaky end strokes. This is a great way to play with the brushes and get accustomed to their behavior.

Gouache brushes are also great for more traditionally detailed paintings. Try laying in your darkest values, then your lightest values, then painting in your midtones with a broad gouache brush. The edges should pick up and blend automatically as you paint.

including weeks of drying or curing the paint. Digital oil and acrylic paint are much faster and, as an added bonus, lack the dangerous materials components of traditional oil painting.

What separates digital oil paint from other digital wet media is the behavior of the brushes. Digital oil brushes lay down creamy paint like gouache, but they have a memory. They can sample from multiple layers of a work, much like a traditional media brush painting wet paint over wet paint and picking up unintended colors on the brush. Digital oil brushes put down a creamy line similar to gouache, but they also sample live from other colors they touch. When laying new colors over digital oils in some software, you won't

be laying a clean layer over the lower layers; instead, the colors you've already laid down will drag through the new paint unpredictably. This can create some really exciting effects.

To get the hang of digital oil painting brushes, draw a circle on a blank canvas. Using a reference picture if necessary, you'll be painting a value structure on this circle in order to transform it into a sphere. Choose a palette of three to five colors and paint the different value areas, but don't let the areas of paint touch. Paint the edges as close as you can without allowing them to touch. When all the value areas are mapped out, use your color picker to continue picking in-between tones as you drag the value areas into one

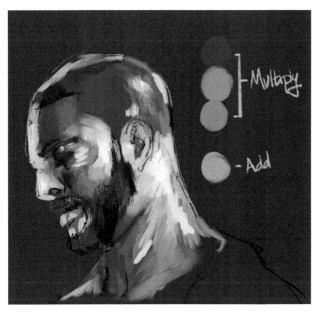

Figure 5.31 Quick portrait sketch produced with digital oil paint and layer blend modes. (Author's own)

another. Try painting long strokes versus short strokes. Try changing the directionality of your brush. Try a few different oil painting brushes to see how they handle. If you're using Adobe products or Corel Painter, make sure you try an oil painting mixer brush, as these brushes will sample areas of color instead of a single color.

Other Media

Once you've covered the traditional media classics, do explore the other categories of digital paintbrushes and see how they might enhance your work. Halftone brushes are a great tool for creating a screen printed or comic/manga style in your renderings.

Mixed Media

Of course, you needn't limit yourself to the parameters of natural media when you're using digital tools. You can cross-pollinate using different media to create a cohesive and unique visual style for your renderings. You can also incorporate photographic elements or scanned surfaces to create a collaged appearance. The possible combinations are endless.

Figure 5.32 Using a limited palette puts the focus on value, texture, and form, as seen in this costume rendering from Austin Blake Conlee for *Urinetown* at Northern Stage. (Austin Blake Conlee)

Rosemonde

Figure 5.33 Costume designer and illustrator Aidan Griffiths uses mixed media, including photo bashing, to create beautiful costume renderings. (Aidan Griffiths)

Figure 5.34 Costume designer and illustrator Keyon Monté uses a blended approach, creating a sketch in a digital environment and finishing it with traditional watercolor paint. (Keyon Monté)

If you're new to digital rendering, it may be helpful to you to begin with trying the different media individually. Get a sense of each one's individual handling before you begin to combine them, as over-mixing media can lead to the generic "digital" look this book aims to avoid.

Career Highlight Interview: Jean Gillmore, Former Visual Development Artist with Walt Disney Animation

Jean Gillmore, now retired, contributed in costume and character development for 18 feature films including *Frozen* and *Zootopia*. Here, Jean shares some insight about the role of drawing in the development of her life as an artist and about adapting to digital drawing technology.

Jen Gillette: Can you give me a brief overview of what you do in your day-to-day life as an artist? This can be about both your work life and your home or personal art practice, if there's a difference.

Jean Gillmore: I will speak about what my work life USED to be like, as I am retired from animation for the present. Digital painting, as you refer to it, was something I did less frequently than digital *drawing*. I worked in pre-production, where the means of presenting one's visual ideas were less dependent on what tools you used than the content of the images presented. In some jobs (not only Disney Feature Pre-production) I created characters, which *included* their costumes and were not a separate job category. In other jobs I created digital turnarounds of characters in line only, presenting all different angles to facilitate digital modelers building characters in 3D. When not in the work setting, I am trying to flood my brain with historical and contemporary visual material to inform future drawing creations.

Jen Gillette: In terms of your life as an artist, what did you think you wanted as your career? How did you find your way into what it is you're doing now?

Jean Gillmore: As a young person, I enjoyed drawing very much, but did not think it could be an actual career. I flirted with being a veterinarian (loving animals and drawing them) but did not have the science acumen I thought I would need. I admired cartoons, but when I learned about the Disney Studios, I became a huge fan and started trying to draw like that. It was a convoluted path into animation, and Disney was not my first stop. I had a short job at Filmation Studios (still a going concern at the time), where I realized I could easily do the layout drawings that were required, but it was later at Hanna-Barbera that I took a night class in animation in-betweening. Mind you, there were NO computers or digitally aided drawing systems at the time, and cartoon "cels" were hand-painted, as were backgrounds for animated scenes.

Jen Gillette: Can you talk about digital tools and how they found their place in your practice? Can you talk a little about what you love about digital painting versus what you love about traditional art mediums?

Jean Gillmore: By the early 2000s, computer drawing and the attendant hardware/software was the norm, and various entities I was working with preferred submitted images in digital form for ease of editing and sharing with artistic teams on projects. What I have come to LOVE about digital

painting, etc. is the *ease of changing* drawing aspects – color, design, texture, effects – without losing the original image. And digital tools are *so less messy* than traditional art materials! I always disliked that about being an artist, getting my hands dirty. Go figure!

Jen Gillette: How did you learn digital painting?

Jean Gillmore: Digital tools came late into my career, with a very protracted learning curve as the new technologies supplanted traditional hand-done drawing. I needed to learn digital tools to survive in my chosen profession. I now drew on a Cintiq tablet (STILL hand-drawn in a way, but with an electronic stylus instead of a pencil or pen) on Blue Sky's *Rio* [released 2011] animated feature, then was thrown into the digital painting aspect on the first *Frozen* [released 2010]. Many of my colleagues were younger and already digitally-adept, having come through college courses where knowing the various software was required. At this point, I assure you, they know much more than I.

Jen Gillette: What's been one of your favorite projects or parts of a project to work on, and what role did painting play in it?

Jean Gillmore: *Frozen* was definitely the most challenging, as the Art Director wanted a charming and realistic costume representation of actual Nordic "rosemaling," an elaborate floral and curli-cue painting style for a classic fairy tale vibe. In costuming circumstances, that meant dimensional sewing details including embroidery, pleats, pin-tucks, piping, textured buttons, applique, metal clasps, stitching, fur, and leather. Many of these particulars had never been done in CG [computer generated animation] in such detail, and many of the different digital departments were involved: modeling, look development, fabric simulation, rigging, etc. As I personally didn't have these skills, I moved from department to department in more of an advisory capacity to inform the actual CG artists making these things happen. It was not an official position, just a sort of liaison for the first time out creating these looks. I would provide the general design, color palette or structure diagram they needed to complete their work. There was no formal position as Costume Designer at the time; it was part of Character Design. Because of the sheer bulk of the demands on *Frozen*, I think an official position has been more recently created. Now, there is pattern-making software available; digital costume building is not very different from actual costume making.

Jen Gillette: What artists are you inspired by? Where do you go for inspiration when you're feeling creatively tapped?

Jean Gillmore: I grew up on Dr. Seuss, Ronald Searle, and Disney art. I love Gustav Klimt, John Singer Sargent, Tim Burton, Hieronymus Bosch, and Thomas Hart Benton, among others. When I am stumped for creativity, I like to hit a lot of museums for sheer volume of material. I have a big collection of design books in hard copy that I will peruse for hours, when I have a window. Sometimes an art film or a dance performance will jog something. Classical concerts at the Hollywood Bowl can be image-making for the brain (forget the video screens; just listen). Even my dreams while sleeping can be inspirational.

Jen Gillette: What advice do you have for rising artists interested in your field?

Jean Gillmore: For up-and-coming animation/gaming artists, learn all aspects of pertinent art: digital media of all sorts, drawing (not copying!), color theory, lighting, illustration, historical and international design, architecture, and costuming. ALL of it will be relevant. Sculpture might be useful, too, if one wants to better understand 3D modeling in the computer. It's important to not only know your own part in the pipeline, but how your design decisions impact all the other production steps that follow you: help others do their jobs, also.

CHAPTER 6

Building a Design Rendering

Building a Painting

There are endless ways to go about setting up a digital painting. This chapter aims to fill your digital toolbox with ideas, techniques, and examples from colleagues working in theatrical design. Learning how other designers execute digital paintings continues to teach us a0nd expand our ideas of this tool's capacity.

Classical Painting in a Digital World

Knowing a little bit about the structure of classical paintings can help you to make stronger choices in setting up your digital paintings. The structural theory of classical painting is a tremendous, broad study. What follows is an introduction to some key terms and concepts that are meant to inform, inspire, and promote further research.

Composition

Composition in classical painting applies directly to design for proscenium theater because the audience experiences the world of the show as a picture plane. Composition is, at its simplest, the harmonious arrangement of design elements within a picture plane. Functionally, it's better described as finding perfection in imperfection. Symmetrical compositions require imperfections in the symmetry in order to generate interest and direct the viewer's eye around the picture plane. Asymmetrical compositions must be offset and balanced so they do not become too weighted to one area of the picture plane. This is where the different design areas can benefit from sharing painted renderings: a brilliant yellow dress can create the perfect compositional offset to a moody, deep gray-violet set, or a diagonal shaft of light can balance the angle of a raked stage floor.

There are compositional systems that can help you to understand how different artists approach composition. Renaissance painters used a mathematical Golden Spiral, also referred to as the Divine Proportion, to organize the picture plane toward compositional perfection. Baroque painters, often more concerned with high

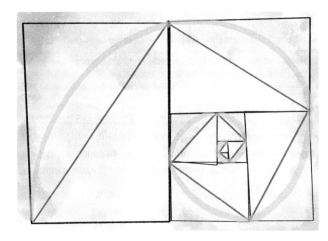

Figure 6.1 The Golden Spiral, a compositional concept developed in medieval Europe and widely used in Renaissance and Baroque painting. (Author's own)

drama, used X-shaped compositions to create tension and excitement in their works. A 17th-century Chinese compositional concept called the Dragon Vein draws the picture plane elements together along rising and falling rhythmic movement (Fong, pp. 282–292). Photographers talk about the Rule of Thirds, in which the picture plane is divided up into three even sections vertically and horizontally and major compositional elements are set outside the center box of the grid. If you feel that your compositions lack power, try studying painters and film directors you admire. Grab screenshots of their work online, bring them into your digital painting space, and add compositional line overlays. Studying the work of other artists always helps us past our own worn-in habits.

When examining your own work, try looking at your composition and either squinting or letting your vision soften. You can also be very digital about this and use a blur filter to soften the image for you. This will allow you to see the overall layout of the work without getting lost in the details. Think about how the composition leads your eye around the picture plane. Do you end up returning to just one spot again and again? Add something elsewhere to draw the eye from that spot. Do you not know where to look because all of the

DOI: 10.4324/9781003212836-6

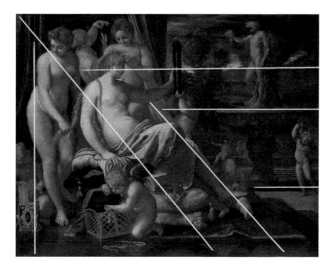

Figure 6.2 *Venus Adorned by the Graces*, Annibale Carracci, 1590. An example of a classical painting with an exploration of its composition in a line overlay. (Samuel H. Kress, National Gallery of Art, Washington, DC)

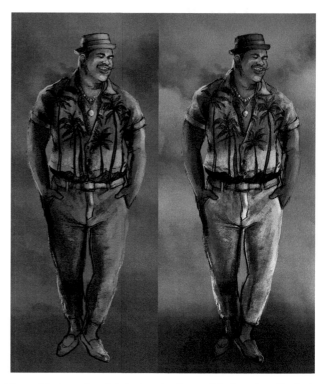

Figure 6.3 An underpainted value structure and its impact on the final rendering. (Author's own)

elements are too chaotic? Add a unifying element to draw everything together. You might also try rotating or flipping your canvas (left to right and/or top to bottom) to spot compositional defects. Our eyes naturally weight things and flipping a canvas helps us see past the biases in our vision.

Underpainting

Underpainting describes the use of layers of transparent or translucent color in order to create a value scheme for a work prior to the use of color. Like many truths of analog art, underpainting was born of necessity. When paint came from natural materials, rarity determined pigment cost. Brilliant, richly saturated colors came from rarer materials like Afghan lapis lazuli stones for ultramarine blue, New World cochineal insects for dazzling red, equatorial indigo plants for deep blue-violets, and a variety of highly toxic material combinations to create greens and blues. Earth tones came from the earth, and some of the color names we use today refer to the specific geographic areas from which those colors originated: umber from Umbria, sienna from Siena. Lead for white paint and charcoal for black paint were cheap and plentiful. It was more cost effective to create a value painting using all desaturated tones, then layer expensive colors into the final stages of the painting.

Underpainting can create stunning effects in digital painting, and it remains a practical approach to painting even though our colors are unlimited. Building a value painting without the added complexity of color can help to keep variables at a minimum while you're still figuring out what you need. Concept artists sometimes work backwards from a black silhouette painted on a medium-gray ground. Digital painting's layer blend modes (Chapter 4) allow for the transparent addition of color to a finished value painting. Further, underpainting in a specific

color tone (gray-violet, burnt umber) can create more unified color harmony throughout the finished work.

Color

There is a lot of advice throughout this book about developing a strong sense of color. One of the most powerful decisions an artist can make to improve the overall clarity and cohesion of their color palettes is to eliminate true black and true white from their toolkit. True black and true white have blowout effects: you can't get any lighter or brighter than white, and you can't get any darker than black, so it creates a sense of the finite within the picture plane. Choosing a lightest tone and darkest tone for your work that are not true black and white will always make the work more sophisticated and interesting. This is doubly true for outlines, which can be a crutch for some artists. Using value to delineate edges creates a more dimensional image, but if you must use outlines, consider painting the outlines using a clipping layer in order to make them more harmonious with the overall composition. The exception, of course, comes when you're trying to capture the energy of vintage comic book or pop art that makes use of black outlining.

Using color can be tricky. Color is a moving target, constantly changing based on the colors it's surrounded by, the lighting conditions, even by the relative sensitivity of the viewer. We tend to grab the color we know to be true rather than the color as it

actually appears in the given context. When people take to the internet to debate the color of a poorly photographed dress, it's typically because they don't know how to understand local color.

Local color describes the appearance of color in flat white light. We recognize these colors to be true even as lighting conditions act on those colors, changing them visually. Think of this example: sunlight has different color temperatures in the winter and summer, so a photograph taken of the same street corner at the same time of day in two different seasons may appear to have wildly different colors. We see the same scene, but we don't think we are looking at two different buildings, or that the building was painted between seasons. We understand how to adjust for the shift in color temperature. Knowing how to deploy this type of shift rather than choosing the "flat white light" version of every color is an incredible tool for the painter.

Figure 6.4 The same scene photographed under different color temperatures, and the resulting differences in the palette of each scene. (Author's own)

To practice understanding local color, start snapping pictures of interesting lighting conditions. Pull the pictures into your digital painting workspace and use the color picker to swatch out a palette. Unlike our eyes, the color picker is completely objective. You may be surprised to learn that what you know and what you see are two different phenomena.

For those who feel uncertain about color, it can be a helpful learning experience to pull palettes from other works of art in order to understand how experienced artists use palettes. Download a picture of a master painting; it can be classical or modern, but choose something representational so it uses a range of colors to describe its subjects. Using your color picker, sample every color you see and swatch it to the side of the painting. Once you've swatched all of the colors in the work, try adjusting the swatches so they appear proportionate to their use in the painting. Evaluating the proportion of neutrals to saturated colors or the overall appearance of the palette can help teach your eye how to select a harmonious, well-proportioned color palette.

Figure 6.5 *Still Life with Flowers, Grapes, and Small Game Birds*, Frans Snyders, 1615. On the right side of the page, the swatch palette for this work is shown in proportion to the use of color in the work. (Gift of Mr. and Mrs. John E. Pflieger, National Gallery of Art, Washington, DC)

Light and Shade
Painters all over the world use value to delineate form from ground. Western art uses chiaroscuro, or the modeling of forms using different values to create dimensional effect. Non-Western art may use chiaroscuro and/or calligraphic line work to describe form, value, and distance from the picture plane. The manipulation of light functions very differently depending on the medium and ground in use.

Because watercolor paint is transparent, watercolor painting traditions use the paper as the white value in a composition. Every mark made in a watercolor composition removes light values, so the artist must plan from lightest to darkest and build toward their darkest values. Further, white is added to colors by adding water, thinning the pigment and revealing more of the paper. Oil paint is translucent and opaque. Oil painters traditionally paint on a midtoned ground, pushing into darker values before painting in lighter areas using opaque paint. Mirroring an analog media approach to building value can help bring verisimilitude to your digital painting.

Figure 6.6 A hybrid rendering from designer and illustrator Keyon Monté in which the drawing was made digitally, printed out, and traditionally painted. Note the use of the white of the paper to create areas of highlight on the figure. (Keyon Monté)

Value can help us to understand directional light in a two-dimensional rendering, creating dramatic effects. Scenic designers and lighting designers can demonstrate powerful shafts of light cutting through darkness, pools of saturated light, the drama of lighting performers from behind, or the spooky quality of footlights. Costume designers can show a team what the costumes will look like under these lighting conditions by rendering using directional light. Deploying directional light in theatrical renderings creates powerful opportunities for collaborative storytelling.

Building a Consistent Color Palette

Building your eye for cohesive color can be daunting for new artists, but also daunting for experienced artists who are new to a digital workspace. Building a painter's palette creates a grouping of colors that are harmonious and balance well together in a finished image.

Creating a Painter's Palette

1. Create a new layer in your document and name it "Palette" so you can find it easily while working. Leave the layer mode on "normal"; this will be really important to being able to color-pick colors when painting with layer blending modes.
2. Before you start painting, add daubs of paint to the palette layer in your intended primary colors. Experiment with some different approaches: try all warm primaries, then all cool primaries. Try choosing your saturation from the same point in the color picker.
3. Keep the palette to a limited area, as you'll want to be able to paint around it without having to constantly turn the layer on and off or move the palette around the canvas.
4. Use a blending tool or smudge brush to bring the colors together, blending for your secondary colors. You may need to boost your green, as screen-blended greens often become mute or muddy. Use the color-picker (hotkey OPT) to sample secondaries and blend them together in order to generate a range of harmonic neutrals.
5. If you want colors that are darker and lighter than the colors your palette contains, try blending the colors on your palette with true white and true black. You can also combine all three of your primaries to blend for a custom black. This will create more interesting, textural lights and darks and a more dynamic contrast range. As with analog paint, true white and true black can deaden an image. Mixing your own blacks and whites will always yield aesthetically superior results.

If you feel at a loss as to where to even begin with choosing your initial palette colors, try borrowing a swatch palette from a painting, as described in the section above.

Using Reference Imagery

If there is any game-changing hint I can offer to new painters, it's to make constant use of reference imagery. When drawing, there is a scale of difficulty: drawing from your imagination is the most difficult, drawing from an abstracted object (like a 3D model) or fusing multiple images together is slightly less difficult, and drawing from direct reference is easiest of all. Reference imagery is any image that helps enhance your visual understanding of the composition you're trying to create. Not sure how the rock formations look in Utah? Pull reference images. Not sure how a skirt looks when a dancer is twirling? Pull reference images. Not sure now the light temperature in Tuscany affects the colors of a

Figure 6.7 A digital watercolor rendering, shown in three stages, shows how the painter works from light to dark, preserving the white of the paper as the lighter values in the composition. (Author's own)

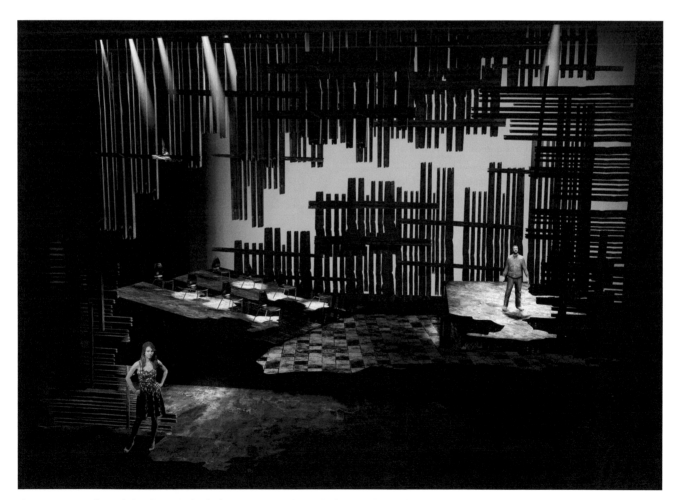

Figure 6.8 A scenic rendering for *Violet* by designer Tao Wang shows the impact of dramatic lighting and high contrast. (Tao Wang)

Figure 6.9 Building a palette by digitally blending primary colors together will yield a more harmonious color palette. Examples of a cool primary palette, a warm primary palette, and a blended warm and cool primary palette. (Author's own)

landscape in late August? Pull reference images. Not sure exactly how all the knobs look on an antique camera? Pull reference images. It cannot be overstated how much more detailed and powerful your painting will be if you make a habit of finding and making use of good reference images. "Guesstimating" the appearance of something creates a vague, uncertain image.

When working on a large-scale painting, it is helpful to pull reference images directly into your canvas. Set them to the side of your drawing or painting so you can clearly see them as you work. When you have finished using them, add them to a group of all your reference images. Save them, as you may be called upon to rework parts of the image and the last thing you should waste time on is re-sourcing the same image you found during a research rabbit hole.

Finding Good Reference Imagery

Finding good reference imagery is a lot like finding good design research images. You have to look beyond the first-round picks generated by your image search algorithm, beyond the echo chamber of Pinterest, beyond the internet's propensity to show you corny stock photos. Seek out databases of photojournalism, local photo archive sites, antique and vintage family photos, and museum archives. For a novel experience, visit a library and snap photos of printed research images. As with design research, provenance matters. Knowing that you are actually quoting the

correct time period, culture, and geography is crucial, and skimming surface-level image searches will not give you that certainty. This will also improve the specificity and uniqueness of your work.

Another important factor for reference imagery is image size and quality. Small, pixelated images will obscure details. Great reference imagery sources like museum websites sometimes offer multiple views of an object and useful information about the materials used to make the item. The better the quality of the image, the better the functionality as a reference image.

Creating Your Own Reference Images

Sometimes, you won't be able to find a reference image that shows you the object or person in the pose, lighting, or condition you're looking for. Perhaps you want a lantern that is lit in low light or you want to see what a suit jacket looks like when badly wrinkled. Making a hasty tableau and snapping your own reference images is a great practice to solve for the specificity of your ideas. Grab whatever is near at hand, sprinkle a little ingenuity on it, and make a useful reference image. You can also plan trips to locations to take useful reference photos on location, of certain lighting conditions, or in specific garments.

Figure 6.10 Capturing your own reference photos makes for more richly detailed and informed work. (Author's own)

Creating an Image Morgue

As you find your images for a given project, or when you see images that you think will be broadly useful in your design practice, build an image morgue. An image morgue is a large bank of named, well-organized image files that you can pull from at any time. Maybe you always take photos on your phone of homes with interesting architectural details, or unusual plants. Save these to a dedicated location, roughly sorted by image type. Not only is it handy, it can also be a great place to go for ideas when you've hit a creative block.

Do not assume that a good online source will be around forever. The life drawing website I visited daily for use of reference images shut down suddenly with no warning, and there is no other site quite like it. If you see something you like and know you'll use often, download it and save it to your own archive. If something you use disappears suddenly, try your luck with an internet archiving site like Wayback Machine to see if any version of it has been saved for posterity.

Storing and organizing your image morgue is entirely based on personal preferences. You can use an online service to store and organize your photos, or you can make large documents using slideshow software, or you can just save thoughtfully renamed image files to your hard drive or cloud storage. Choose a method you're most likely to keep organized and return to often.

Perspective in Digital Painting

Perspective drawing has incredible support tools in digital painting software. Depending on the software you choose, you have a range of options to assist accurate perspective drawing, from creating quick perspective grids to actual mechanical aids to force perspective lines as you draw.

Each form of perspective aid offered by digital painting assumes you know how to place a horizon line and your vanishing points. If you aren't sure how to do this, try this simple exercise.

1. Import a photo into your digital painting workspace. The photo should include something that is in one or two point perspective, such as a room interior or an exterior view of architecture. Even a three-quarter view of boxes (grab storage containers from your kitchen cabinets) will work well for this. It can be helpful to take your own reference photo from an angle you want to use. Let's say you want to create a dense cityscape, but you only have a few small boxes of vegan mac and cheese. Use the boxes in the rough layout and angle you imagine for your city, knowing the perspective grid will be the same even if the structures vary.

2. Reduce the layer opacity of your photo to 50%. Also, reduce the size of your image in order to create a wide white border around the photo. (You can also do this by increasing your canvas size.)

3. Create a new layer over your photo. Name this layer "Vanishing Points."

4. On the "Vanishing Points" layer, trace any angled line you see on your structure. Extend these lines far out from the form until you find the places where the angled lines intersect. In one point perspective, your intersections will be in the center of the image. In two point perspective, your intersections will be in the margins around the image. You may also be looking at multiple overlapping perspective systems, i.e., a stack of boxes inside a room; try to isolate just one for now.

5. Draw a horizontal line that moves through your vanishing point(s). This is your horizon line.

6. You can use these reference points to set up a perspective grid for your drawing.

Figure 6.11 Overlaying a photograph with a perspective grid is a great way to reverse engineer perspective for a rendering. (Author's own)

Mechanical Perspective Aids

Mechanical perspective aids are tools that allow you to set up a horizon line and your vanishing points, then the mechanical perspective aid will assist you in locking your lines to the

perspective system. It will not allow you to draw a line that doesn't work on the grid. This is an incredible tool for image setup, but eventually you will want the freedom of movement that comes with organic lines.

At the time of writing, Procreate and Clip Studio are the main software platforms that provide mechanically aided perspective drawing. It is an incredibly powerful tool for setting up successful perspective sketches. Think of the applications: you can start with a photo of the stage you're designing for, completely bare and in work light. You can map your vanishing points and build yourself an accurate template of your space in perfect perspective, then play with the sightlines of your scenery in quick sketches. Generating intricate technical drawings of pillars, molding, and niches can happen in just a few minutes. Isometric drawings can be dashed off without breaking a sweat.

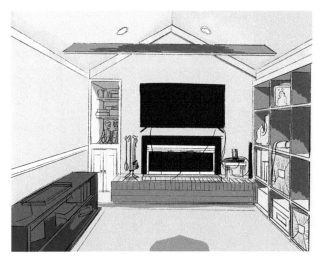

Figure 6.12 A sketch created using the assisted drawing tool and a one point perspective grid in Procreate. (Author's own)

Manual Perspective Grid

If your software platform doesn't provide mechanical perspective aids, you can create your own accurate perspective grid quickly, then use it to gauge the accuracy of your perspective lines as you draw. It won't lock your lines, but it can be a constant visual reminder.

Start by drawing your horizon line and marking the vanishing point(s). Change the shape tool to "polygon," set the number of sides to 100, and set the star ratio to 1%. This will give you a starburst pattern when you click and drag on the canvas. Set the starburst center at your vanishing point(s) to create a perspective grid that will guide your drawing. If you're drawing in two point perspective, it helps to make each of the grids its own color so you can easily navigate the sea of interlocking lines as you draw.

If your software cannot generate perfect starbursts, try downloading .PNG (transparent background) images from the internet and using them instead. You can easily resize them, and because these grids will not be a part of your final image, the image quality of your starbursts isn't terribly important.

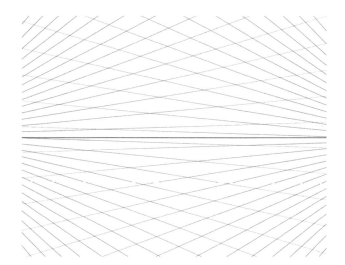

Figure 6.13 A manually generated perspective grid serves as a visual guide for accurate perspective drawing. (Author's own)

The Human Figure in Digital Painting

The human figure, in all of its gorgeous variety, is central to effectively communicating a costume design. This section will discuss approaches to building the human figure in a digital painting space.

Layers and Costume Renderings

If you are brand new to digital painting, it's important to understand that the central difference between traditional media renderings and digitally painted costume renderings is the use of layers to organize information, preserve editability, and make non-destructive edits to the design. In traditional costume rendering, the rough sketch is refined into a finished sketch, then transferred to watercolor paper via photocopier, a lightbox, or transfer paper. In digital painting, these pages all live within the same document. Think of a digital costume rendering as existing on stacked pieces of vellum paper with adjustable transparency.

Like many analog costume renderings, digital rendering relies on successive traced layers. Good tracing is an art that requires thought and practice. If you trace the outlines of objects, it is likely your traced drawing will look stilted and odd, hemmed in by its own awkwardness. If you instead begin a tracing like you begin a good

drawing, by paying attention to the internal structures and large shapes that constitute your drawing, your traced image will have a life of its own. When tracing, use large, quick strokes with your pen tool; this will require practice and a lot of use of the hallowed "undo" command. In the words of costume designer Erik Teague (interviewed in Chapter 7), "The use of undo is not a moral failing." Using slow, tight lines or hairy, hesitant little strokes will result in a timid, inelegant drawing. Digital rendering allows you to try for a beautiful line again and again without degrading the paper, so make use of that advantage! Poor tracing can drain the life from a drawing as it moves from thumbnail or rough sketch to painted rendering, so it's worth putting practice into this part of the process.

As you develop the rendering, it's advisable to keep every part of the costume on its own layer to preserve editability and flexibility. This way, you can change out elements of the costume without redrawing or repainting the entire rendering. You can even sit in a meeting and show live changes to color and proportion, facilitating conversations with collaborators that would not have been possible without this technology.

Developing a Sketch from a Thumbnail

Many costume designers use thumbnail sketching to create quick, iterative ideas capturing silhouette variations for a character. These emotive, gestural sketches sometimes capture the exact mood and energy we want to see in our finished design. Sometimes, we are pressed for time on a production and are not able to make the shift between approved thumbnails and full-sized sketches. Digital rendering allows us to use thumbnail sketches as the basis for larger, more finished sketches without starting from a blank page.

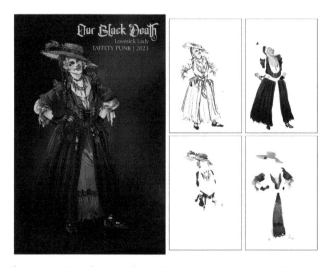

Figure 6.14 How pieces can be maintained on separate layers. The image on the left shows the costume rendering and the tiled images show the layers that make up this image when isolated. (Author's own)

If your thumbnail sketch is on paper, begin by taking a photo of the page. While this photo does not have to be pristine quality, it helps if there is a relatively even tone to the page and clear focus. Avoid a phone-shaped shadow on your page by casting your light source from an opposite direction; for instance, lay your drawing near an open window, positioning your phone on the opposite side of the drawing. You can also tape the drawing to a wall or hang it on your refrigerator to get an unshadowed vertical view. Import the photo into a correctly set up (printable size, 300 PPI) document for your final rendering, where it will populate on its own layer.

If your thumbnail sketch is also digital, import it as a layer into your final rendering document. Name this layer (i.e., "Thumbnail sketch"), reduce the "Thumbnail sketch" layer's opacity, and create a new named layer above it called "Rough sketch 1." Reducing the layer opacity on a source layer creates the feeling of using vellum or tracing paper; it allows you to see the line you're drawing more clearly without interference from the source image. Think of this as a digital lightbox, if that's helpful.

Using a pencil tool and working on the "Rough sketch 1" layer, loosely and lightly trace your thumbnail. Focus on capturing the large shapes and energy of the thumbnail rather than capturing all of your marks. This is an impression of the finished idea, not the final product. Once you have successfully transferred the idea to the "Rough sketch 1" layer, hide the layer containing the photo of your thumbnail sketch.

Before moving on to a more detailed version of this drawing, it can be helpful to use digital tools for proportion corrections. Look over the drawing carefully. Are the arms the same length as one another? Is the head the correct size for the height of your figure? Are the legs balanced on solid ground? You likely know what your proportion blind spots are, and if you have a hard time seeing them on your own, create a new layer (title: "Proportion check") and use lines to check for errors. Try the following:

1. Create a vertical line from the top of the character's head to the lowest point at which their feet meet the ground. Divide the line into seven or eight equal-ish sections; six and a half to seven is a more everyday proportion and eight represents a more elongated proportion (showgirls, athletes, models). The head should take up one of these sections. If it is larger than one of these sections, it's probably too large. If it's smaller than one of these sections, it's likely too small. Alternatively, select the head. Copy/paste the head and create a vertical stack that is seven or eight heads tall. Use this "head stack" to check your overall proportions. If the body is too short, your head is too large. If the body is longer than the head stack, your body is too long.

2. Use a selection tool to grab your body-height vertical line so you can move it around the page. You have a lot of choices

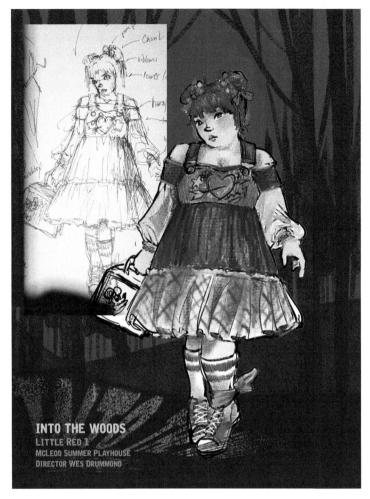

Figure 6.15 An inset thumbnail photographed and imported into Procreate to create the color sketch of the costume. (Author's own)

here: you can use a rectangular marquee or a freehand lasso tool to select the line. Move the line so the base of it sits at the inside of the weight-bearing ankle. Follow the line up. It should intersect with the point where the character's ear meets their jawline on the *opposite* side of the body. Exceptions to this rule exist, such as the character standing with their weight balanced equally on both feet or a dancing figure in motion. If your character is standing casually and the line doesn't follow the described path, you may want to use the selection tools to re-pose the sketch. When re-posing a sketch, I like to select the entire limb first, then move to more distal sections of the limb, joint by joint. For instance, if the leg isn't where I want it, I might use a lasso and select the entire leg to begin repositioning it from the hip. Once the hip-to-knee position is correct, I will grab the leg from just below the knee down to the whole foot and reposition again. Once that section of the leg is placed, I grab the foot from the ankle down.

3. On your "Proportion check" layer, draw a line that represents the length of one of your character's forearms. Move this line

around the drawing to check that the forearms match each other in length. You can also use this line to check foot proportion, as the length of the forearm (inner elbow to wrist) is typically the same as the length of the foot. You can make and delete additional lines to check that all pairs on the body match. Take care with foreshortened body parts: if the limb is moving directly toward or away from the viewer, the limb will be artificially shortened in order to create the illusion of three-dimensional space on the page.

4. Temporarily reposition limbs in order to check lengths. For instance, reposition an arm so it is hanging at the character's side. The elbow should be on the same latitude as the waist. The tips of the fingers should sit at the low hip line.

5. Sometimes proportions aren't easily corrected using simple resizing tools. In this case, try using warp or puppet warp functionalities for more subtle control over corrections.

Once you are satisfied with your proportions, smooth all of your corrections. Sometimes, repositioning, resizing, and warping will leave remnant marks or broken lines behind. Correct these, then

move on to completing your sketch. You have now used a hasty thumbnail sketch and speedy digital corrections to save the time of a lengthy redrawing.

Developing a Sketch from a Life Drawing Photo

If you do not thumbnail as a part of your design practice and prefer to make iterative sketches directly on a correctly proportioned figure, digital rendering makes for a speedy jump from life drawing to costume sketching. Using digital sketching, you can create a library of croquis, or undressed body sketches, that can be copied and used again and again.

Good life drawing comes from a deep understanding of the human body. Poor life drawing will lead to ill-proportioned costume renderings that are difficult for a shop and a director to interpret. Many would-be costume designers struggle with a lack of training in life drawing, and it's not surprising, as life drawing is a discipline all its own that takes years to master. Luckily, the proliferation of life drawing photos online makes it easy for costume designers to

choose reference images that will allow them to draw accurately posed and proportioned human beings on the page.

There are two ways to approach using life drawing reference images to build costume croquis: you can either use them as visual references, working side by side with a reference image, or you can trace the life drawing model. Each has its advantages and disadvantages. A drawing made side by side with a reference image tends to have a little more personality, but it often takes longer and has a wider margin for proportion errors.

Start by looking for high-quality images of figures in the nude or figures dressed in minimal, form-fitting layers. A good photograph is one that includes the entire figure and has minimal post-production editing. Import one of these images into a document formatted to your preferred rendering size. It won't work to open the photo as its own document and create your croquis on top of it; this will result in a low-quality image that is the wrong size for printing. Instead, set up a new document and import the photo on its own layer, resizing as necessary to fill the space. A good croquis leaves around 1–1.5" of space above the head and below the feet (this will also prevent clipping when printing). Name the photo layer ("Reference photo – body") and proceed to either of the methods below.

Making a Side-by-Side Life Drawing Sketch

To create a sketch using side-by-side reference imagery, shift the reference image to one side of your canvas, extending your canvas size if necessary. Create a new layer (name: "Reference lines") and create the following reference lines to help your drawing.

1. Project lines horizontally from the photograph for any proportion that would be helpful to you: project the top of the head, the base of the chin, the shoulder line, the waist, the low lip, the knees, and the bottoms of the feet. This will aid you in building a sketch with accurate proportions.
2. Next, draw over the photo on the "Reference lines" layer to capture the gestural pose of the photo. I like to draw the spine, the shoulder balance, the hip balance, the head, and the limbs in a stick-figure configuration. This helps me to understand the geometry governing the pose.
3. Create a new layer (name: "Body sketch") and begin drawing your body. Start with the large forms of the body before moving to details like facial features or hands. When the sketch is complete, you can hide both the photo reference and the reference line layer.

Whenever possible, hide a layer instead of deleting it. You never know when you may need to step backward and rebuild your content, and it helps to have all of the intermediary steps in place when you do this.

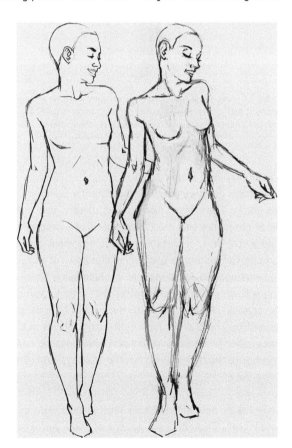

Figure 6.16 The croquis on the left was generated as a side-by-side drawing. Note the slightly distorted proportions but more expressive posture. The figure on the right was traced from the same life drawing figure, leading to more accurate proportions but also less expressive distortion. (Author's own)

Using Life Drawing Imagery to Trace Croquis

Traced croquis have to be approached from the inside out, using structural lines and large shapes. Tracing the outline of a human form results in wooden, blobby forms that betray a lack of understanding of the figure. Good tracing practice can lead to excellent and quickly generated croquis that are free of proportion issues. Some designers struggle with drawing, and as a result, they struggle to communicate their ideas with collaborators. Learning the human body via tracing is a great place to start, and results in renderings that are more accurate tools for communication.

Start by navigating to the layer you named "Reference photo – body" and reduce the layer opacity by 20–40%. Drop a new layer over it (name: "Body sketch – structure"). Work from the interior structure of the body outward in order to capture the energy of the pose and the honesty of the body's mass.

Follow these steps to capture the energy of the posture when creating a traced croquis.

1. Start by drawing light horizontal lines showing the angle of the shoulders and the angle of the hips. These lines are often sitting in slight opposition to one another.
2. Continue down from the shoulders and up from the hips, creating trapezoids that capture the torso and the hip area for your figure.
3. Draw quick stick-figure lines that capture the center of the neck, the center of the arms, and the center of the legs. Note that the center of the legs might shift above and below the knee.
4. Draw a bubble around each major joint. Each bubble should graze the edge of the figure. Start at the top and work your way down the figure, capturing the shoulder joints, elbow joints, wrist joints, knee joints, and ankles.
5. Begin connecting the bubbles, using the edges of the figure to guide you. Connect the torso to the hips.
6. Capture the head, hands, and feet in broad strokes. For the face, use the side of your digital pencil or a soft graphite brush to shade in the hollows of the eyes, the shadows around the nose, and the values of the lips. It's also helpful to capture the figure's hairline; drawing the hair isn't as worthwhile because it will almost always change for the design. Use geometric lines to capture the basic shapes of the hands and feet.
7. Erase any guidelines that aren't useful to you, but know the bubbles can be very helpful in describing range of motion when you want to re-pose a figure.

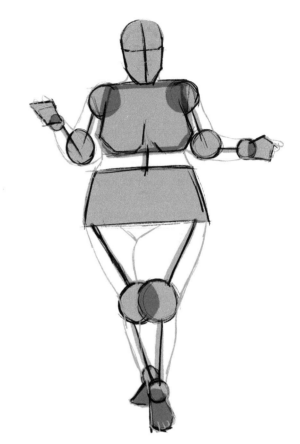

Figure 6.17 Traced croquis are more anatomically accurate and lifelike if they are built with the mass of the body rather than its outline. Begin with your interior shapes, joints, and body structure, then connect joint to joint to create a fully realized figure. (Author's own)

Building a Croquis Library

In my costume design practice, I'm constantly building my croquis library. Sometimes, new projects demand very specific people or poses: regional or cultural specificity, proportions dictated by the text, or certain styles of movement can really support the storytelling in costume renderings. For instance, I may be working with Fosse-inspired choreography, I may be working with a specific type of corset that distorts posture, I may be working with younger performers, I may have dancers en pointe, or I may be drawing for a fight-heavy show with a lot of weaponry. Specific bodies sometimes require engaged muscle groups or postures that are less neutral than typical costume rendering poses.

Whenever I draw new bodies, I save them in their skins or unclothed forms. Depending on the type of figure you're drawing and its future utility in your work, you can be vague around sensitive areas of the body, communicating only important shapes

and landmark points. I usually do not draw hair on my croquis, but I do sketch in a hairline so it's easy to begin building a hairstyle. When it comes time to sketch a new design, having 100+ sketches of bodies allows me to jump straight to sketching clothing by copy/pasting the croquis sketches into new documents. The more different types of shows I work on, the more opportunities I have to stock my library with new poses.

Re-Posing the Figure: Selection Tools and Warping

Figures aren't always posed in the way you want them posed, especially when you're leaning on found life drawing imagery or your own croquis library. Perhaps the hands are on the hips, but you need them held out to the sides to show the drape of a cocoon coat, or perhaps your sketch doesn't match the proportions of the performer who was cast for the role. Selection tools and warping allow you to make changes on a two-dimensional plane. Think of it like one of those old school jointed paper puppets or Da Vinci's *The Vitruvian Man*: you can pivot the limbs, head, and torso, but you cannot twist or rotate the body forward or backward in space.

Warping tools allow you to make more advanced changes to the figure, including resizing the body's proportions without redrawing the entire figure. Let's say you provided a sketch of a curvy woman for the romantic lead, but the director casts a very slender person in the role. In order to shift the proportions of the costume and provide an accurate tool for communicating with the shop, your assistants, the performer, and the director,

you can make quick adjustments to the sketch to better reflect the casting decision.

Warping tools are usually housed within selection tools. There are two types of warping tools available: basic warp and puppet warp. Basic warp is usually an option once an area is selected, usually by using the freehand selection/lasso tool. It provides a linear grid over the selected area. Using your stylus to tug on the grid can change the shape of your painting. Even a basic warp grid allows for finer control than using selection tools to resize the image.

Puppet warp is a more advanced option, and not all digital painting software provides it. Puppet warp allows you to select an area, then activate the puppet warp functionality. Puppet warp generates a latticed cage of intersecting points over your painting. You can activate different points in the grid by clicking on them, then you can drag those points to re-pose or re-shape a figure. Puppet warp allows for extremely fine control of re-shaping, even allowing for some rotation effects. This tool will take a little practice, and sometimes you will unintentionally "break" the image by not making the right point selections. No worries: you can undo it. Keep playing with it until you harness the power of this incredible editing tool.

With all warping tools, go slowly. Make small changes in each direction, gently coaxing the shape inward or outward. Moving slowly through this process is still faster than re-painting a rendering from the ground up! Making drastic changes will result in odd-looking distortions to the figure and to the aspect ratio of the finished work.

Applied Skills Tutorial: Re-Posing a Figure

When re-posing a figure, I always like to work from the inside out. To use anatomical terms, start with the most proximal joint and move to the most distal joint. If you start with the distal joints, you may be choosing an angle that won't look right by the time you work your way back to the shoulder. This is a simple cut-and-rotate approach that works well for simple changes.

1. Make a duplicate layer of your body sketch. Hide one of the duplicated layers in order to preserve it for reference, just in case the re-posing gets a little wonky.

2. To re-pose an arm, use a freehand selection/lasso tool to select the entire arm, including the ball-and-socket shoulder joint. Pivot the arm to its new location and don't worry too much about breaks in the line, as these can be fixed later. You will also need to think about the ways that flesh will pull or fold depending on tension. For instance, if you are moving the arms from hanging at the body's side to

being raised up overhead, this will likely add a fold to the shoulders and some taut tension to the underarm and ribcage. When in doubt, use reference images!

3. Deselect and use the lasso to grab the arm from the elbow joint down to the hand. Rotate to re-pose.

4. Repeat for the wrist and hand. Once the arm is placed correctly from shoulder to elbow, de-select. Next, you'll select the entire lower arm, carefully tracing the bubble of the elbow joint. Pivot the elbow to its new location and de-select.

5. Once the arm is placed correctly from shoulder to wrist, you can re-pose the hand. Select the hand, including the bubble of the wrist joint. Manipulate the hand until you have the pose you want. You can continue posing individual fingers, if you'd like.

6. Redraw any resulting disjointed or broken lines.

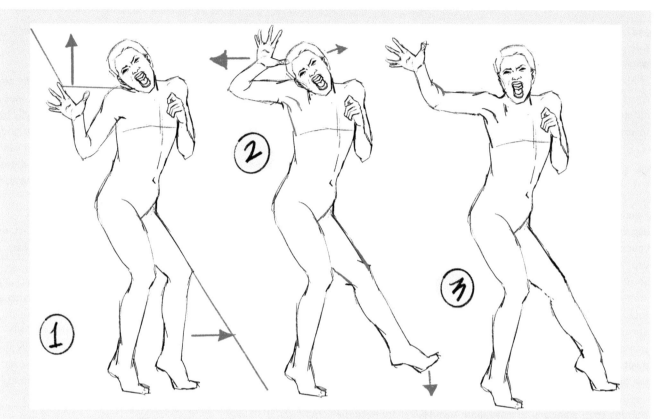

Figure 6.18 Working from the proximal joints to the distal joints ensures that the pose will make anatomical sense when complete. (Author's own)

Landmark Lines

Whether you're drawing side by side or tracing, it's important to set yourself up for costume rendering success. Using landmark lines on the body will help you to place costumes accurately on the form, add hairstyles, and add expressive faces to your characters. While this is a helpful practice in both digital and analog media, creating these landmark lines can be especially helpful to those who are new to navigating the abstraction of digital workspaces. I suggest lightly marking the following, working from the top of the figure down:

1. Capture the hairline, not the hair. You'll almost never use the exact same hair twice, so it's better to capture the shape of the head and the placement of the hairline. If you want a reference for the amount of volume in the hair, create a light shadow showing the silhouette of the hair, including how it falls around the face.
2. Capture the model's vertical center of face and horizontal eye line as a crosshairs. It can also be helpful to lightly shade the contours of the face, though leaving facial features vague will create maximum flexibility in using the sketch for a range of different performers in the future.
3. Capture the center front line of the body. This line travels down the center of the body, not necessarily the center of the drawing, from the clavicle through the belly button to the groin

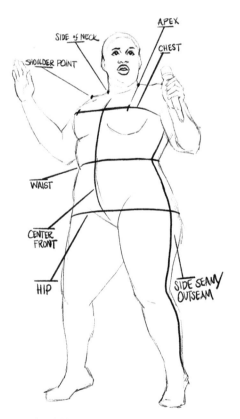

Figure 6.19 Landmark lines make it easy to accurately place costume items on the human figure. (Author's own)

4. Make horizontal lines showing the placement of the chest (traveling horizontally through the widest part of the chest, usually through the nipples), the waist (traveling horizontally through the narrowest part of the torso, usually through the belly button), and the low hips (traveling horizontally through the widest part of the hips and seat, usually intersecting with the bottom of the groin). Remember that these lines are almost never perfect horizontals. They will usually curve around the form and twist with the spine.

If this feels like several steps, remember that you'll be able to use this figure again and again, so it's useful to get it right. If you're ready to move on to sketching a costume on your figure, remember to save in a format that preserves your layers, uses your naming convention, and maintains the integrity of the base figure without a costume. When you're ready to add a costume, duplicate the document and give it a new name. You can also save your croquis as templates so you cannot accidentally overwrite your original files.

Sketching Clothing Using Proportional Measurements

Rarely do costume designers sit down and draw completely from their imaginations. More often, you'll be referencing period research or contemporary clothing options to develop your design. Digital rendering allows you to mark up your research images in order to transfer proportions accurately to a modern body.

Usually, life drawing figures are barefoot. To reposition the feet for high-heeled shoes, select the front part of the foot, from the toes to the base of the heel. Move the front of the foot directly down so it appears to be landing on the same plane, but lower. The ball of the foot should be parallel to the heel. Erase the middle of the foot (the arch) and draw new, curved lines connecting the ball of the foot to the heel.

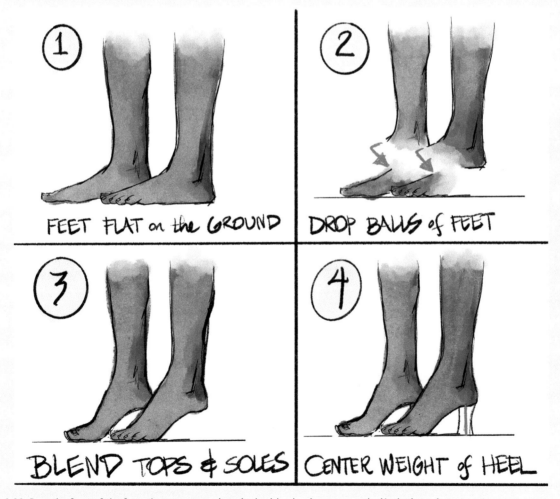

Figure 6.20 Drop the front of the foot, then re-connect it to its heel by drawing a new arch. (Author's own)

Digital rendering allows you to sketch with your research images arranged around your drawing area. By pulling research images into your rendering document, you can turn the research layers on and off for quick reference. It's helpful to put each piece of research on its own layer, name the layer accordingly, and add all the research layers into a nested group (or folder, depending on your software) so they can be turned on and off collectively or separately. If you're using period research, you can also use the same markup technique you used on your croquis to create landmark lines and anchor points on the period imagery. This will be especially helpful if you're using fashion plates, pattern drawings, or paintings as your reference materials, as all of these forms of primary source imagery use physical proportions different from those of most modern performers. Adding anchor points to the research will help you evaluate the placement of different style lines, seams, and hemlines.

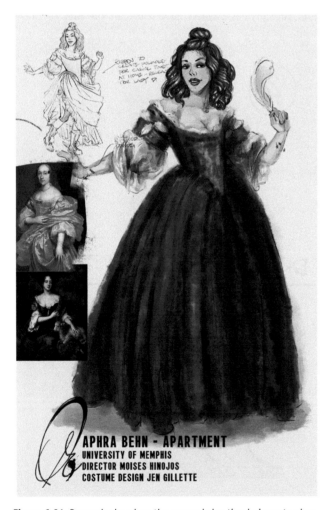

Figure 6.21 Research placed on the canvas helps the designer to place landmark lines and anchor points on both the research and on the croquis. Anchor points help in accurately translating proportion and style lines from research to the body of the performer. (Author's own)

Begin by thinking about how the structural base of the garment interacts with the body. Where is the armscye seam in relation to the wearer's armscye? Where is the waist in relation to the wearer's natural waist? Draw anchor points, or small dots, that allow you to mark how the garment sits on the body. Connect the dots to begin adding the foundational seams to your garment. Think about where to start in terms of the most basic geometry. For instance, if you are translating an effusive 1830s romantic silhouette to a modern body, try the following steps:

1. Start with the bodice. Mark the width of the neckline, the places on the arm where the fullness of the sleeve begins and ends, and the slightly elevated waistline.
2. Drop an anchor point at the center front of the body, which may not be in the exact center of the figure if they are turned to a three-quarter angle, where the center front of the neckline sits. Connect the neckline width to the center front dot.
3. Draw the waist seam, adding a slight curve to describe the roundness of the form.
4. Add any style lines to the bodice, using reference points from the body: a gathered or pleated neckline, a lapped bodice at center front, general scale markings for any ruffles or bows, etc.
5. Before working with volume (this will be covered in the next section), move down to the skirt. Mark the length of the skirt as it relates to the legs.

Judging volume accurately is another key to nailing a period silhouette. Digital rendering allows you to take proportional measurements easily, and proportional measurements quantify volume in clothing. Proportional measurements are easily taken using these steps, continuing with our 1830s dress:

1. Create a new layer in your document (name: "Proportional measurements").
2. Choose a simple brush, like a pencil or an inking brush.
3. Choose a dark color or a color that will stand out on your sketch. Choose a part of the body that is visible in the research image and in your sketch. In this example, we will use the proportional measurement of the waist as a reference point to understand the width of a hem. Working over your research image, draw a horizontal line that represents the width of the waist. Copy and paste that line, moving it around the canvas to use it as an increment to measure the width of the hem at its fullest point. How many waists wide is your hem?
4. Translate this information to your sketch. Draw a horizontal line to represent the width of your performer's waist. Copy and paste that line the same number of times it took to reach the width of the hem in your research image. For instance, your proportion may be 1 waist x 2.5 = hem. You can then use this horizontal line as a guide for creating a skirt that will appear proportionally accurate on a modern body. This is part of how to make a

modern costume look like a fashion plate. Fashion plates tend to have impossibly small waists, but if the proportion is relatively consistent between the width of the actor's waist and the width of the hem, the period look will be achieved.

5. Repeat this process for the sleeve on the garment. You can use a different unit of measurement between different areas of the garment, but do not change units between the fashion plate and the rendering.

Using this method will also help you to make educated proportion adjustments for the specific bodies you're dressing. For instance, a performer with a large bust may require lowering of a waistline in order to prevent them looking short-waisted, or you may realize that a performer with narrow shoulders needs padding to achieve the broad-shouldered 1940s look you want for them. This method can be used to gauge any scale: width and height of hats, the scale of a pannier, the size of an embroidered monogram, even fantasy elements like animal ears and tails. Creating

proportionately beautiful sketches can also support a more diverse vision of the period, showing that any body or ability can look fabulous in the silhouette.

It's important to remember that most photos of life drawing figures are nude. When dressing your figure, be sure to adjust the posture, the bust, and the gravity of the anatomy to sit in period-appropriate undergarments. Drawing a figure wearing a modern bra or dance belt may only require a slight adjustment, but drawing a figure in a corset or girdle may require redrawing parts of the body to align the posture to the undergarments. It's important to use photographic research of structured undergarments on bodies here, not fashion plate images or images of garments on mannequins. Structured undergarments rearrange the posture and the fullness of the body, so it's important to see the effects on flesh.

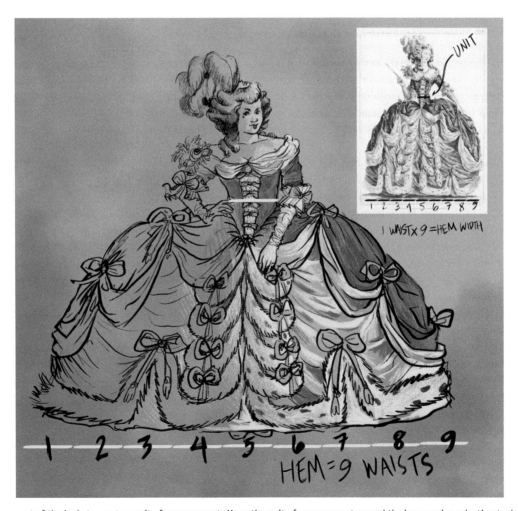

Figure 6.22 Use a part of the body to create a unit of measurement. Move the unit of measurement around the image using selection tools to measure and translate proportion accurately. (Author's own)

Coloring Costume Renderings

Once you're happy with your sketches, it's time to paint or color! This section will cover the workflow for painting digital costume renderings in order to support flexibility, non-destructive editing, and strong time management.

Organizing Your Digital Costume Rendering Layers

Keeping a consistent and well-organized layer structure is key to moving quickly through a set of digitally painted renderings. The following recommended layer structure moves from the top layer down to the background. This may seem like a counter-intuitive listing order if you're new to digital workspaces, but this is the order you'll see reflected in your digital rendering software. You may not use all of these layers for every production, but it's helpful to think about an order of operations. For ease of use, you may consider saving the following setup as a template document (more on using templates in Chapter 3) for each production, then adding your sketches rather than adding all of these elements to each sketch document.

- **Notes**: Some designers like to notate design choices in the rendering for clarity, including discussing the effect, the fabric, the seaming, or any other finishing detail that will help the shop to achieve the desired outcome. It's helpful to have the notes on their own layer so it's easy to turn them on or off.
- **Highlight and shadow/special effects (layer blend modes)**: If you choose to use layer blend modes to add highlight and shadow to your costume renderings, it's best to have them floating at the top of the layer structure so your actions here lay over all the layers beneath. For instance, using a multiply layer here to add shadows creates a shadowed appearance on your base clothing colors *and* your trim, prints, and patterns. If you want to isolate these effects to specific layers, it's best to highlight both layers and lock them together. This means they will turn on and off as one, and if you move layers around, they will stay attached to one another without needing to be merged.
- **Line art**: This is an optional part of the process, but some designers love the clean look of line art as part of a costume rendering. Proceed with caution, as line art can create an impression of contrast or a graphic quality where one will not exist in the finished look.
- **Highlight and shadow (painted)**: Adding painted contours and highlights will add so much dimension to your renderings, even if you plan on using layer blend modes later. It will also help you navigate the challenge of distorting prints and patterns over the contours of the body and the contours of the clothing.

- **Print and pattern**: These layers add print, pattern, applique, buttons, and all contrasting costume elements. Prints and patterns should all be painted or manipulated to move over the contours of the body and the contours of the clothing. Keeping them on layers separate from the base garment allows for flexibility in altering design elements.
- **Base colors**: It's helpful to throw down flat base colors to begin understanding the rhythm of the color story before you pour too much energy into minutiae. Showing these color sketches to a director and creative team will also create a more complete sense of the design than working strictly in colorless sketches. It is beneficial to separate your base color layers into clothing base colors, hair base color, and skin base color.
- **Sketch**: This is the completed costume sketch. This may appear as one or more layers; if it uses more than one, you should group the layers together for quick access.
- **Title block**: This layer or layer group contains the text you'll edit to help the viewer navigate your renderings. If you're using more than one font (for instance, one font for the title and another for the characters, look, etc.), it's best to keep each font and/or font size on its own layer. This makes editing easier and more consistent. Costume rendering title blocks may include:
 - Show title
 - Character name
 - Information about where in the show this costume appears, if needed
 - Show venue
 - Date
 - Director
 - A numbering system to clarify shop communication.
- **[Show title] background**: If you're using a background for your renderings, this layer should sit just above the background layer. For ease of grouping and transfer, this is best as a single layer.
- **Document background**: This layer is automatically generated when you open a new document and should remain blank.

There will be additional layers in use, including those containing your reference imagery and palettes. These layers should sit wherever it's convenient for you, as they will likely be hidden in the final version of your rendering.

Painting Skin and Hair

Painting skin and hair accurately is critically important to creating an inclusive design with an accurate depiction of your intended color story. Luckily, there are a few tricks to making sure that you're choosing accurate skin colors and painting hair that looks like hair.

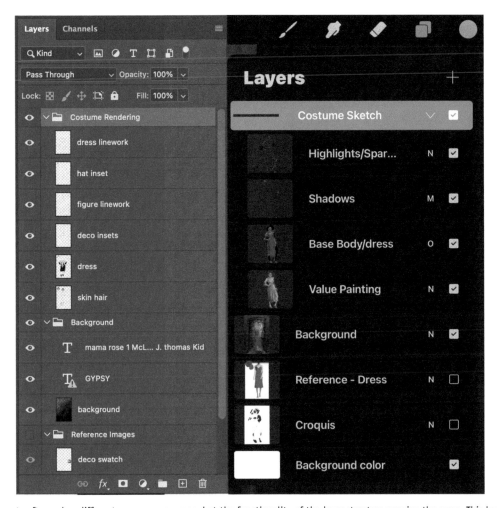

Figure 6.23 Different software has different menu appearances, but the functionality of the layer structure remains the same. This layer structure shows the structure of a costume rendering in Photoshop (left) vs Procreate (right). (Author's own)

Choosing Skin Colors

The overwhelming options provided by the color picker can lead to skin color choices that feel off: a little flat, a little lifeless, a little too saturated. A great way to choose a skin color that accurately represents your performer is to grab a photo of foundation makeup from a website and use the color picker to swatch. Look for makeup brands with inclusive color ranges, including a broad array of undertones. Because photos of humans are often heavily edited, grabbing a skin tone directly from a photo of skin can lead you astray. However, grabbing a photo of makeup meant to blend into a skin tone will usually lead to a strong skin color choice.

Adding dimension to skin can also be tricky. Different skin tones cast different toned shadows and reflect light differently. For instance, very light, peach-undertone skin often has gray-violet or blue toned shadows, but will reflect light in a way that makes the skin look lighter. Darker, golden-undertone skin reflects brighter (not lighter) and with a little more golden sheen, and shadows are more umber than blue. Aging skin is usually a little less saturated and cooler-toned, as is skin around where a beard grows in.

Simply choosing a lighter value on the color picker will rarely result in the best highlight options. When in doubt, return to makeup websites. Look at the colors on a contour palette according to skin tone to help you choose great colors for sculpting your humans. Make sure you're looking at reference photos, especially when you're rendering someone who doesn't look like you. While it would be wonderful to spend hours adding layers of sheer, shimmering color to every rendering until the skin simply glows, the truth is that every minute you spend on the process reduces your hourly wage. The faster you can arrive at something beautiful, representational, and communicative, the better.

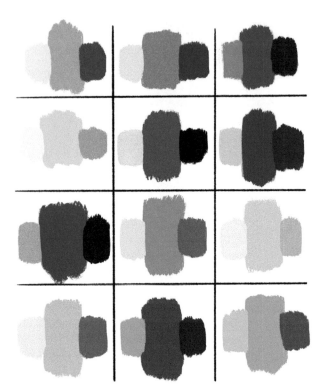

Figure 6.24 Different skin tones have different highlight and shadow colors. Looking at reference images is a great way to determine how to choose accurate colors for your performer's skin. Choosing well will help the performer look alive on the page; choosing poorly will make your performer look ashen, ill, or simply incorrect. (Author's own)

Painting Hair

Exploring different hair textures, colors, and styles is such an important part of building the character on the page and such a great way to help performers feel seen in the work. Using plenty of reference images, think about the following when planning a painting of hair. Learn the curl scale (1–4 C) as a way of referring to hair texture. This provides really strong search terms for research, great vocabulary for referring to curly hair (coils versus curls versus waves) and a great way to communicate hair needs with performers, wig designers, and salon professionals.

When painting hair, work from soft to hard. Start with your silhouette, add highlight and shadow, then end by adding some individual strand details. Working from soft to hard will always yield better results when rendering hair than starting with individual strands. I like to work with messy textured brushes like charcoals, rough-edged gouache, and pastels for rendering hair, as they have a lot of irregularity in their

edges that will create a more dynamic final look. Here is a step-by-step process of painting hair using the soft-to-hard method.

1. What is the overall silhouette of the hair, and what is the shape of the hairline? Is the silhouette sharp or soft? Paint in the silhouette first in a hair midtone, smudging it so it's a slightly blurry cloud around the head. Make sure the hairline sits accurately for your performer's gender identity, age, and ethnicity. Getting the shape of the hairline wrong can create a real sense of "something's wrong but I'm not sure what" later in the process. Remember, reference images for everything!

2. Make yourself a quick color palette. Even if the hair you're painting appears to be true black, digital true black leaves you nowhere to go. Observe (or take liberties with) the hair's undertone and choose some near-black browns, deep grays, purples, red-oranges, or blues. This will look more dimensional and life-like.

3. Begin painting in the areas of shadow to begin sculpting hair. For period styles, this will start to define waves and curls. For modern hair, this will begin to show the shape, dimension, and texture of the hair. Usually there's a shadow around the ears (if they're visible), around the back of the neck, or under any areas of volume. If you are painting braids, locs, or long beachy waves, there will be vertical bands of shadows that grow more dense near the neck.

4. How reflective is the hair? Does it have a strong sheen, does it diffuse light, or is it absorbing light? Use this information to start blocking in areas of highlight. Hair that absorbs light will have softer areas of faint highlight. Hair that is slicked or highly reflective will have high-contrast highlights with sharper edges.

5. Once the dimension of the hair is painted, paint in selective strands to add dimension. Remember, you aren't painting every strand of hair, every braid, or every tendril of curl. Less detail will appear more visually accurate. This is also your chance to really develop the character: are they wearing a polished style that's starting to come loose with stray hairs? Do they have meticulously laid baby hairs? Are they wearing a short style that has grown out due to lack of maintenance? Can we see a different color appearing at the roots? These choices all say something about who a character is. Be sure to follow the trajectory of the hair style when drawing individual strands.

6. The final step is to pop in a few more darkest-dark shadows and a few more lightest-light highlights.

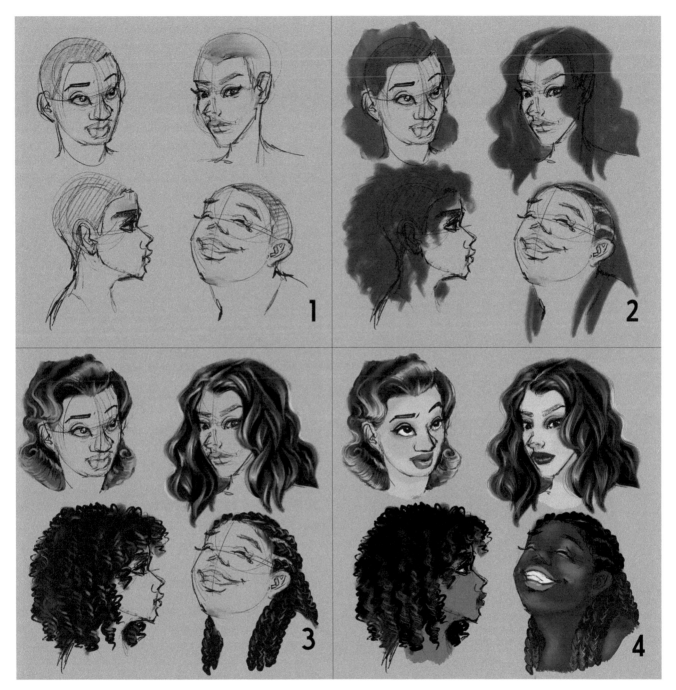

Figure 6.25 A grid demonstrates painting four different hair textures in various stages, moving from soft to hard. (Author's own)

The lines used to draw hair should always be swift and confident. Make sure you're choosing a brush that responds to pen pressure or adjusting your brush so that it responds to pen pressure, giving you beautiful, tapered lines as you draw. With the power of the "undo" command at your disposal, there's no reason why you should allow fear of making the wrong mark to slow you down or inhibit your hand. Practice making quick, smooth lines until you start to see results you like.

Wig and makeup designers can also make great use of digital painting! Wig and makeup designer Loryn Pretorius used Adobe Fresco not only to communicate the hair and makeup design for *The Cunning Little Vixen* at Manhattan School of Music, but to plan for the show's many one-minute quick changes. By painting directly over fitting photos she took of the performers, Loryn was able to design for the performers instead of designing on generic croquis.

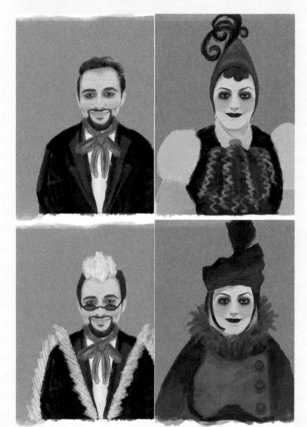

Figure 6.26 On the left, the same singer plays both the Parson and the Badger. On the right, the same singer plays both the Cock and the Jay. Both performers were involved in elaborate one-minute quick changes, and the renderings helped both the singers and the makeup team to understand how to achieve the change in seconds. (Loryn Pretorius)

Tattoos

Tattoos are increasingly becoming a part of the body's landscape for a range of different performers. Whether you are including an actor's personal tattoos or adding tattoos to help create a character, it is easy to use digital tools to create realistic tattoos that respond to the performer's skin tone.

Create a layer above the skin tone layer and name it "tattoos." Set the layer as a clipping mask to the skin tone layer, then change the layer blend mode to multiply. Setting the layer as a clipping mask will only allow your tattoos to appear where there is skin, and setting the layer blend mode to multiply will add the skin tone to whatever ink color you choose. Remember, multiply is a darkening blend mode, so you may have to choose a lighter color than you think in order to achieve an accurate tattoo color. Real tattoos generally only darken skin tones, and using multiply will help keep to this convention. Once you have your color(s) picked out, use an airbrush to add blended tattoo color, then a clean inking brush to add line art to your tattoos. Make sure that your tattoos are responding to the undulating shapes of the flesh, musculature, and shapes of the body.

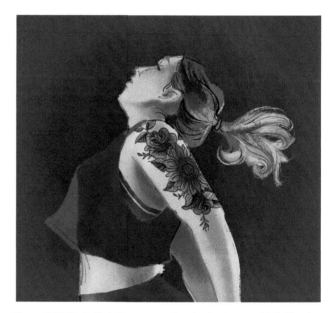

Figure 6.27 Realistic tattoos are easily added using a multiply blend layer. (Author's own)

Creating Surfaces

Much like costume designers create libraries of reusable croquis, all designers can make libraries of reusable objects, textures, and surfaces. A great woodgrain painting can be reused, planked, tinted, and tiled infinitely. Once tiled, the perspective can be edited or warped to apply it to any surface in a rendering. Creating a deep library of assets is front-loaded work, but the longer an artist spends making these investments, the more payoff there will be as the library fills.

Not all surface painting techniques can be stored for repeat use, and soft surfaces are an example of a surface that must be painted in response to its surroundings. Fabric cascades, responds to gravity, pools, drapes, and crumples. Understanding fabric's inherent properties, as well as the ways in which digital tools can help to describe those properties, can help in rendering all types of fabric in your design work.

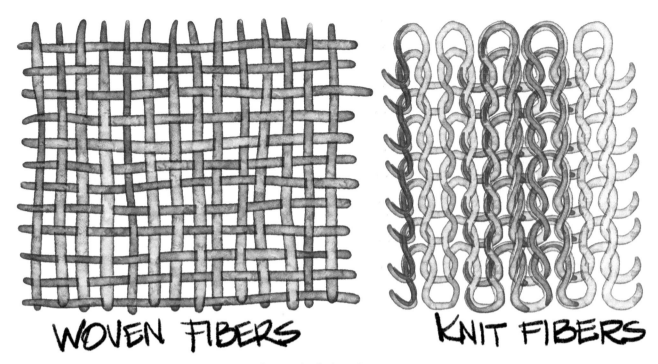

Figure 6.28 Woven fabric (left) and knit fabric (right) in close-up. (Author's own)

Soft Surfaces: Fabric Drapery, Translucency, and Surface

Painting soft surfaces can be intimidating. The intricacy of what fabric does can be difficult to capture, but with strategy and study, it can be mastered. Knowing a little about how fabric works helps to understand why it does what it does.

There are two large "families" of fabric: woven and knit. Woven fabrics are made on looms. The threads are interlocked on an x-/y-axis, and generally, these fabrics do not have any stretch unless they are made with stretch fibers. Woven fabrics may be represented in your life by your bed linens, your (non-stretch) jeans, your curtains, and formalwear fabrics. Beyond the basic mechanics of creating a woven fabric, there are many different weave patterns that are used to create different surfaces, patterns, and textures in the fabric. For example, creating longer "floating" threads on the surface of a woven fabric provides satin. Using two different colors of thread in a specific weaving pattern provides houndstooth.

Knit fabrics are created by looping threads together to form a spongy material that provides variable degrees of two- or four-way stretch. You probably wear some knit fabrics every day, as stretchwear is used to create socks, underwear, t-shirts, leggings, and a host of other flexible-fit garments.

Whether fabric is knit or woven, its properties change depending on the direction in which it is used. When fabric is used on the straight of grain, or along its factory-made selvedge edge, it is very stable and will hang straight, even if other forces are acting upon it. When fabric is turned at a 45-degree angle, this is referred to as the fabric's bias. When fabric is used on the bias, it has a softer, more fluid drape and is more responsive to flowing over surfaces.

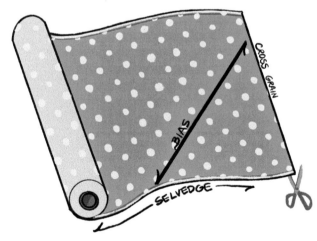

Figure 6.29 The selvedge, or straight of grain, and the direction of the bias. Fabric is cut or draped on different grains to use different qualities of woven fabric. (Author's own)

The other ingredient to understanding fabric well enough to paint it is fiber. There are three basic categories of fiber used in producing textiles: cellulosic fibers, protein fibers, and synthetic fibers. Cellulosic fibers come from plants like cotton, flax (linen),

and hemp. Protein fibers are fibers we harvest from animals, like silk (from the Bombyx mori moth) and wool (from sheep, llamas, alpacas, and goats). Synthetic fibers are petrochemical-based plastics fibers that are extruded to form threads. Rayon is a hybrid fabric, as it is a synthetic extrusion process using cellulosic fiber. Fiber determines a lot about the behavior of a fabric: its response to dye, heat, water, age, fire, damage, draping (often called the fabric's "hand"), and handling.

Most fabric names are a combination of the weave type + the fiber type in use: silk charmeuse, linen jersey knit, cotton velveteen. Words like "chiffon" do not imply any specific fiber; instead, you pair chiffon with the fiber to arrive at a better understanding of the fabric (silk chiffon, polyester chiffon). When you're designing with fabric, whether it's for a costume or for a soft goods piece,

understanding the properties of that combination will help you to paint your fabric quickly and accurately. There are fabric companies like Dharma Trading Co. and Rose Brand that will send you physical swatches so you can get your hands on the specific fabrics you may want to use. This is a great way to cultivate your understanding of each fabric's hand.

In determining how fabric will look in a painted rendering, it's helpful to have two things: a swatch of the fabric you intend to use and a larger piece of similar fabric to mock up the idea with. Let's say you want a large curtain to swag to the side, then cascade downward with beautiful waterfall folds. Making a quick mock-up of the look with fabric and pins can save you a lot of time in your rendering. Mock it up, snap a picture of it, import it into your digital painting software, and trace it as a basis for your sketch.

Applied Skills Tutorial: Fabric Studies

While it would be impossible to cover painting instructions for all fabric surfaces, here are a few fabric study ideas to try in digital painting. Thinking about how the digital space can generate the surface effects of various fabrics can add depth, dimension, and realism to your finished renderings.

1. Generate a sketch of gently swirled or gathered fabric. Drawing fabric flat rarely reveals its most interesting properties. If you'd like, snap a photo of fabric in the desired configuration and import it to your digital workspace. Trace the fabric on a separate layer from the photo, then hide the photo.

2. Pull reference photos or fabric swatches for the following fabrics: velvet, satin, chiffon, faux fur, burlap, and sequin or glitter fabric. It is highly recommended you choose fabrics that you can hold in hand rather than research photos online. Manipulating the fabric to see its response to light is key for this activity. Visit your wardrobe or the thrift store if you're short on fabric options.

3. Begin by setting a midtone gray as your base layer.

4. Select and copy/paste your sketch several times, spreading the copies out in a grid. Merge the copied sketch layers and name it "line drawings."

5. Beneath each sketch, label it according to your pulled fabrics.

6. On each sketch, try to emulate a different fabric surface. Examples follow below.

 a) **Velvet:** Velvet's distinct feature is its pile, or the small cut threads that form its furry surface. Because of the pile, velvet absorbs light when viewed head-on and reflects light along its edges, as the pile turns away from

the eye. Light also scatters across its surface, creating a bit of a mottled pattern depending on the fiber, length, and style of the pile. To paint velvet accurately, start by painting in the midtone base color of the fabric. Using a creamy, slightly soft-edged brush (oil or gouache work well for this), paint the rich shadows, gently blurring them as needed. Choose a lighter, slightly more saturated version of the midtone for the velvet highlight. Paint the highlight using a slightly wobbly line to give the effect of light scattering across the nap of the fabric.

 b) **Satin:** Satin fabrics are prized for their reflective sheen. Painting satin is not unlike painting metal: to capture it accurately, you need a mix of softly blended tones and hard-edged highlights. Satin also usually has a rim highlight, meaning the core shadow doesn't touch the edge of the form because light is bouncing off the edge as the form curves away from the viewer. To paint satin digitally, begin by filling with the base midtone of your satin. To add shadows, create a new layer above the base layer. Use your freehand/lasso selection tool to select different areas of the satin at a time, which will allow you to paint near the edges of a section without muddying a nearby section. In my illustration, each area of the fabric is separated by a fold, so those are the areas I independently selected for painting. Painting your shadows on a separate layer allows you to blend the shadows to perfect smoothness without graying or muddying your base color. You may also try painting your shadows on a layer with the layer blending mode "multiply" turned on, as this will create a less grayed-out color. Paint your shadows with a large soft round brush with reduced brush opacity. Highlights can be painted on

the base layer over your base midtone. Try painting your highlights using a thick, pressure-responsive brush with hard edges, like an inking brush. To capture satin's unique properties, blend this highlight out along one side using a smudge brush but leave one edge of the highlight crisp.

c) **Chiffon:** Digital painting is great for painting transparent and translucent fabrics. Painting them with opacity tools makes it simple to capture translucency effects, especially with help from layer blend modes. Start by filling your color layer with the base color for the chiffon, then reduce the layer opacity until the color looks accurate for how your chiffon appears when in a single layer over a neutral base. Add a new layer and set the layer blend mode to overlay. Reduce your brush opacity and flow, testing your percentage levels until the layering looks correct for your chiffon. Instead of just painting the surface of the fabric, think about the fabric you would see folded beneath. Make sure the fabric is painted in layers according to the way your drawing is set up. Use the freehand selection

tool/lasso to grab sections of fabric and paint them. The overlay mode will intensify the color as you build your layers of fabric on the page, much like layers of chiffon become more saturated and opaque as the fabric is layered with itself. As a final touch, use an airbrush or soft round brush to add soft shadows as needed.

d) **Faux fur:** There are many brushes and brush packs out there in the world that will help you to achieve fur quickly, but the following will help you paint fur without downloading anything. Furry textures are best when you begin with the darkest tone, the color your see in shadow between the strands of the fur. Start by creating the silhouette for your rendering in the darkest tone, making sure the edges match the directionality and length of your faux fur. Try making this outline using a freehand selection tool/lasso, including jagged directional spikes for the fur. Switch to a dry, streaky brush, adjusting the brush settings to make sure the brush will taper with pen pressure. Start at the edge of the fabric you want to represent the back edge of the fur's directionality.

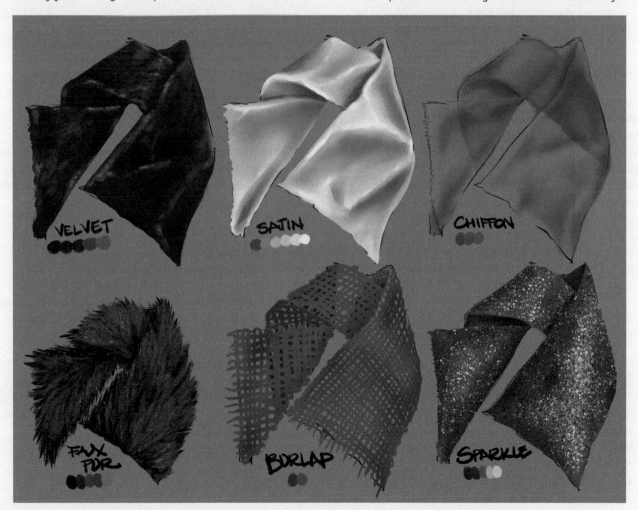

Figure 6.30 Fabric studies showing the different brushes, shadowing strategies, and reflected light on different types of fabric. (Author's own)

For example, if a piece of fabric is cut in a horizontal rectangle with the "pettable" direction of the fur moving from right to left, you would start painting on the left edge of the rectangle. Make short, quick strokes, thinking of them as growing from the base fabric. Fur isn't usually perfectly flat, which can make paintings of fur look wrong. Make small, quick arc shapes up from the base. Continue building the fur using slight color variations and overlapping brushstrokes. At the end, add some extra dimension in by painting shadows on a new layer with the multiply layer blend mode active. If you're painting a very glossy fur, adding scattered pinpricks of a bright tan using an inking brush can make it look like it's shimmering in the light.

e) **Burlap:** Burlap is here as an example of a loosely woven fabric. While burlap won't show this kind of detail at a distance, it's a great exercise in creating a realistic texture up close. Choose a base color for the burlap and a rough-edged inking or drawing brush. Following the edges of your fabric, draw the weave of the fabric, making sure that your lines have some pressure variation and some wobble. Activate your layer lock/alpha lock, choose a darker shadow color, and use a soft round brush to paint in shadows where the burlap curls in on itself or away from the light source. Finally, make a new layer below your burlap painting layer, choose your darker color, and paint in the fabric as it moves from one section of your swatch to another. This will give the impression of looking through the weave and seeing the fabric as it folds over on itself.

f) **Sequins/glitter fabric:** Fill the swatch area with a midtone base that matches the base color of your fabric. Paint in highlights and shadows with a soft round brush, sculpting the base so it looks three-dimensional. Create a new layer and activate a clipping mask to make sure you're only able to paint on your base. Choose a brush that paints spatters, adjusting it if necessary to make sure the spatters are relatively evenly spaced and a good size to represent your sparkling element. Choose colors that are lighter and darker than your base and make quick, sweeping strokes over the base fabric. You want a good mix of lighter and darker flashes over the whole fabric, but you want to concentrate the lighter spatters on the highlight and the darker spatters in the shadows. To make your brightest sparkles extra sparkly, use a selection tool to grab a section of them and copy/paste to a new layer. Change the layer blend mode to linear dodge/add. Copy/paste the layer, and add the Gaussian blur filter to it. This should create a glowing halo around your brightest sparkles.

Fabric Physics

Fabric behaves according to certain rules, so its behavior can be predicted once an artist is familiar with these rules. Unless controlled, fabric will respond to gravity and hang at a 90-degree angle to the floor. It doesn't float around the body in three-dimensional space or hang in the air unassisted. Fabric will also bunch where it is compressed and lay flat (or stretched) where it is pulled taut. Fabric will not move horizontally to fill spaces as it falls through space. When falling fabric intersects with a floor or other horizontal surface, it will pool according to its hand. Some fabric, like a heavy upholstery-weight cut velvet, will make bulky, bulbous folds. Some fabric, like a silk charmeuse, will cascade into tiny, delicate folds.

Think about the way fabric is interacting with your space in order to predict its behavior. Think of a pair of medium weight wool, wide-legged pants. If your performer is rendered at a three-quarter angle taking a step forward, the leg striding forward will be pushing the fabric forward in space, causing it to lay across the front of the leg with all the excess fabric to the back of the body. The leg at the back of the step will likely have the fabric pulled forward, meaning the fabric will lay flat over the back of the thigh and calf, hanging its excess to the front of the leg.

If you're swagging a large piece of fabric as part of a scenic design, the density and arrangement of the swag will change the fall of the fabric. Playing with where the density is gathered, the circumference of your swag's curves, and the weight of the fabric will give you vastly different effects.

Applied Skills Tutorial: Drawing Fullness

To draw cascading fullness in fabric, it's best to work from the bottom up. This is true whether you're rendering a full skirt, an Austrian curtain, or a frilly jabot. Begin by marking the origin point of the fabric: does it start at the proscenium frame, the performer's waist, or the neckline? Mark a simple geometric form that shows the large shape you're trying to achieve. For example, if you're drawing a deeply gathered skirt, you'd draw a bell shape with a slightly rounded bottom. At the bottom of the form, draw lines indicating what kind of fullness you're looking for (see Figure 6.31):

- Neat, even zig-zags show the fullness created by flat pleating (knife pleats, box pleats, etc.).

- Neat, even s-shapes show the fullness created by cartridge pleating.

- A vertical soft zig-zag shows the fullness created by jabots or a fabric cascade.

- Overlapping, hooked amoeba shapes show the fullness created by gathering.

- Neat, even scallops show the bottom edge of an Austrian curtain.

Once your hem or bottom edge is in place, send a vertical line up from each edge of your hem treatment. Include any underlapping, ending the vertical line where it meets the horizontal hem line. Add highlights and shadows to bring out the depth in your folds. When your bottom edge/hem is wider than its origin point, as it would be for a jabot or a skirt, the vertical lines should radiate toward the smaller width, following the outer edges of your basic geometric shape.

There are no digital shortcuts to understanding how fabric behaves. Use plenty of good reference images and play with fabric in your hands until you understand how to communicate what it is you want.

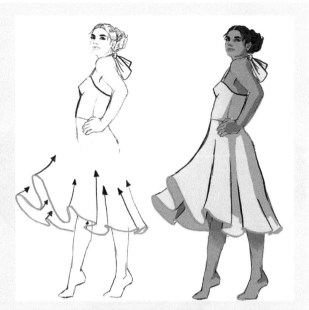

Figure 6.31 Working from the hem or bottom edge of the fabric up is a great way to create realistic fullness in fabric. (Author's own)

Distressed Fabric

There are many times in theatrical design when showing fabric in a state of heavy distress, age, or even decay can support the storytelling on stage. To paint distressed fabric, it's best to start by drawing and painting the fabric in its pristine state. For instance, if you're painting the sail on a pirate ship, paint the entire sail, including adding highlights and shadows. Once the general shape of the sail is roughed in with color, choose a really rough-edged eraser and set it to 100% opacity. Use the eraser to eat away at the edges of the fabric, creating chewed up, irregular edges. The eraser can also be used to create irregular holes in the fabric.

Next, set the layer with the fabric painting to alpha lock/layer lock to prevent activating any of the transparent pixels on this layer. Choose an airbrush and set it to a low flow setting, but with a very large brush tip. Gently brush layers of a color at your worn edges to discolor the fabric, or use the airbrush to discolor fabric around the sweaty areas of the body. Be logical about applying discoloration: where would the fabric drag through a muddy street, or encounter other dirty surfaces the most? A farmer might show a lot of dirt around their buttonholes from handling the buttons with dirty hands, a tavern keeper might have beer stains on her apron from leaning across a dirty bar, or a castaway might have heavily discolored pants hems from being stuck in the same garment for months while awaiting rescue. Color matters, too: what color is the earth where your story is being told? Sweat tends to leave yellowish stains, where dirt stains can range through yellows, browns, grays, and blacks. Brackish greens create a sense of moldiness. You may also load up your airbrush with a lighter color than your fabric to create sun bleaching effects for characters who spend a lot of time outdoors.

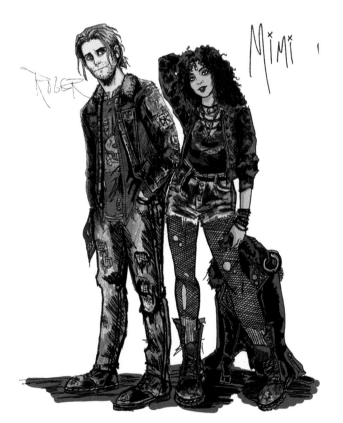

Figure 6.32 Costume renderings showing heavily distressed fabrics help communicate the characters' lifestyles and social statuses. *Rent* at Signature Theatre. Costume Designer Erik Teague. (Erik Teague)

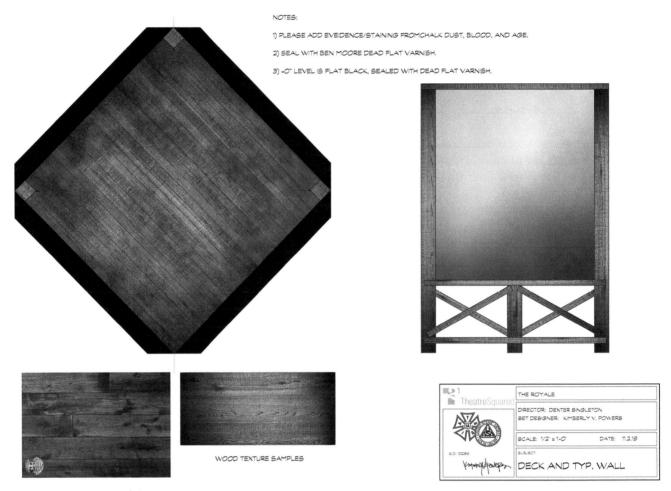

NOTES:

1) PLEASE ADD EVEIDENCE/STAINING FROMCHALK DUST, BLOOD, AND AGE.

2) SEAL WITH BEN MOORE DEAD FLAT VARNISH.

3) +0" LEVEL IS FLAT BLACK, SEALED WITH DEAD FLAT VARNISH.

WOOD TEXTURE SAMPLES

THE ROYALE

DIRECTOR: DEXTER SINGLETON
SET DESIGNER: KIMBERLY V. POWERS

SCALE: 1/2" = 1'-0" DATE: 11.2.19

SUBJECT:
DECK AND TYP. WALL

Figure 6.33 Paint elevations can be distressed to show damage over time, lack of care, and accumulated filth. Designer Kimberly Powers notes the ageing and materials that should be visible on the floor for TheatreSquared's production of *The Royale*. (Kimberly Powers)

Finally, add some specific stains. These can be realistic or fantastical, depending on what you and your team have determined as a means of storytelling. Watercolor brushes make excellent water and mildew stains on garments. Watercolor brushes with hard-pooling edges and white paint make excellent salt stains for sailors, pirates, seafarers, and folks who live in deep winter climates. Alcohol, spatter, and salt brushes create an effect like spattered dirt, bleach, or blood. It can also be beneficial to paint loose threads and evidence of shredding as a final step in the distressing process. Showing precision in your distressing will save you time in communicating with paint shops, props artisans, and crafts artisans.

Hard Surfaces: Wood, Stone, and Masonry

Hard surfaces make great asset libraries. Boulders can be rotated, resized, recolored, cracked, or covered in moss to make them useful across many different projects. Skeletal trees can be created as brush tips and used again and again, with various colors of leaves on their boughs. Thinking critically about the future of hard surfaces as you engage with these paintings can help you to create a deep library of pieces you can reuse in the future.

Wood

Let's talk about two different main types of wood: raw wood (trees) and processed wood (boards). The main differences will be painting the bark on a curved surface versus painting woodgrain on a flat surface.

If trees are something you will paint a lot in your work, you may want to consider purchasing or building your own concept art brushes. Concept art brushes will help shortcut the painting of many environmental elements, like clouds, trees, greenery, and skylines. You can also invest a little time and build your own brush library over time. Some of these brushes are used like stamps, depositing one perfect skeletal tree on the canvas. Others use shape dynamics to generate randomized clusters of items as you draw.

Rocks and Boulders

Rocks are a lot of fun to emulate in painting. As always, start with great reference images, as the color, texture, and sediment of rock is highly regional. Whether you're painting the stacked-blob pillars of the American West or the undercut igneous rocks of Fiji, specificity will help sell the appearance of your rocks.

Applied Skills Tutorial: Creating a Tree Stamp

If you'd like to try creating your own concept art brushes for trees, let's start by creating a simple stamping brush.

1. Open a new document, making sure it's at least a couple of inches tall at 300 PPI.

2. Draw your skeletal tree, either by looking at reference images or by tracing a photo of a tree you like.

3. Save the drawing as a brush preset; the mechanics of this will vary by software platform.

4. Once you are in your rendering document, open your brush presets and navigate to your new tree brush. It will likely default as a streak created by the tree shape. Open the brush editor. Increase the spacing slider in order to generate one tree at a time. This will allow you to create one stamped tree with each tap of your stylus. This tree can be made smaller, flipped horizontally, warped to change its shape, and dressed in a variety of seasonal leaves. The tree can also be chopped up and used as a fallen log, its branches can be woven into a spindly wreath, or it can be used like a gobo to create patterns of light across the floor. It's a great multitasker, and the more items like this you make, the more you can mine them for their uses.

Figure 6.34 A simple skeletal tree stamping brush paired with foliage brushes can be used to create a variety of different finished trees. (Author's own)

Applied Skills Tutorial: Creating Lumber

You can create large paintings of woodgrain, then tear the paintings down into boards to create beautiful planking. Start with a large canvas and generate a painting of woodgrain. You can do this manually, you can paint over a few stock photos, or you can use a mottled canvas combined with a distort wave filter to create the distinctive wave pattern found in cut lumber. Once the painting is finished, save it in your assets folder. In Photoshop, you can save it as a template by changing the file type to.PSDT. You can also simply duplicate the file every time you want to use it to preserve the original file for future use.

Once in the woodgrain document, use a rectangular selection tool/marquee to grab a slat of wood. Copy and paste it to a new layer, then return to the woodgrain layer and grab another slat. When you have a few slats on separate pasted layers, arrange them so when the layers are merged, they will not be in their cut order. Moving them around helps create the appearance of irregular grain because you will not see the pattern continue from one plank to another. Line the planks up in the arrangement you need, then merge the layers. On the merged layer, you can use bevel and

emboss tools to make the individual planks appear three-dimensional. While the bevel and emboss tool can look phony on large or organically shaped items, it provides believable dimension

Figure 6.35 A woodgrain painting made by creating a mottled field of browns and running it through a distort wave filter in order to create the woodgrain. (Author's own)

for wood lumber. From here, your possibilities are endless. Distortion and perspective tools can angle the wood planking in any way you'd like. You can think about it like real wood: it can be stained (adding a multiply layer with a rich color), sun-bleached (increase the contrast and desaturate it), or covered in climbing moss (a textured brush used to paint clusters of different greens).

Rendering tree bark is probably too granular for a lot of theatrical rendering, but when necessary, there are great digital tools to help add bark (at any scale) to your trees. Achieving realistic bark is best done using photo bashing, a technique discussed at length in Chapter 8.

Figure 6.36 Planks extracted from the woodgrain painting shown in fig 6.35, then skewed to make them appear to be seen in perspective. (Author's own)

Painting rocks is not unlike painting hair in that you work from soft to hard, filling in detail gradually. Choose a midtone from the rock coloration and block out your silhouettes. Large, blocky brushes with some translucency work well for this because they deposit buildable color. Shift to blocking in the large areas of highlight and shadow, but don't get too caught up in the fine details until the rock really begins to take shape. Keeping it general in the early stages allows you to make bigger corrections without distorting your details. For instance, if you notice your rock is leaning to one side, you can use warping tools to right it.

Painting in all of the texture on a rock, especially when you're designing a set that's full of various boulders, can be too time-consuming for theatrical work. Instead, try applying rough texture using a giant, highly textured brush. Create a new layer, activate clipping layer, and set the brush mode to overlay, which will automatically toggle between screen and multiply depending on whether you're choosing a color that is lighter or darker than your midtone. To vary the effects, try making your brush larger than the surface of the rock, or blocking facets of the rock using the freehand selection/lasso tool. Add some texture and interest to the surface of your rock, being sure to keep viewing scale in mind. The rock doesn't need to be photographic in order to read as a well-painted, textured rock.

Once the structure of the rock is accurate and your texture is in place, switch to a smaller, rough-edged detail brush like a dry inking

brush to begin painting in cracks, fine highlights, and surface texture. This is also a great time to add moss and overgrowth, though if you can keep these items on separate layers, it will make the painting of the rock more flexible for future uses.

Smaller rocks, or rocks that will be seen at a great distance, can be roughly suggested with a few strokes of digital oil paint.

Masonry

Where rocks and boulders are irregular, organic shapes, masonry is very structured and geometric: brick, granite, and marble represent rocks shaped into architecture by human hands. Good paintings of masonry start with strong perspective drawings, then use lighting, surface interest, and specificity to bring the geometric forms to life.

Begin with a rough value sketch of your scene. This sketch doesn't have to be proportionately accurate or in perfect perspective, as its main purpose is to guide your plan for perspective drawing. Keep the rough value sketch either beside your work, or create your perspective grid on a separate layer directly above it.

Using assisted perspective drawing or a manually created perspective drawing grid, begin by laying out the perspective drawing for your masonry pieces. Even if your eventual plan is to have a crumbling brick wall or ancient stone temple, begin with the clean, intact form. Once your line drawing is in place, use a

Figure 6.37 These rocks can be saved as individual assets, then reused infinitely in different paintings. They can also be copied, resized, warped, and re-colored to help fill in large areas, saving the artist from painting hundreds of individual rocks. (Author's own)

polygonal lasso/geometric selection tool to select the different faces of your masonry and assign light values in grayscale. Remember that you're working from general to specific and not to get tied up in details too early. Start by creating a value map.

Figure 6.38 Using one of the rocks in fig 6.37, this image shows how that rock can be resized, warped, recolored, and stamped to create highly variable results. (Author's own)

Once your value map is in place, think about the seams or mortar lines in the masonry. On a new layer, use a thin drawing tool to begin mapping your mortar lines. If you're using assisted perspective drawing, this will be easy. Make a series of dots down the edge of your structure, then carry those lines around the visible sides of the form. If you do not have access to assisted perspective, copy and paste your dot map to all the corners of the form, scaling it appropriately to the different heights of the walls according to perspective. If you do not intend to see any mortar lines in the finished rendering, keep these lines pretty thin so they'll just work as a map to help you place your values.

Drawing Straight Lines

Most digital painting software has a built-in assist for drawing perfectly straight lines. In Procreate, hold the pencil in place for a moment after you've drawn a line or a shape, and it will snap to a corrected, smoothed version of itself. Don't like it? Release your pencil from the screen and tap the screen with two fingers to undo. In Photoshop, hold down the shift key before drawing a line to execute a perfectly straight line. If you're using another platform, check your software's support forums to find out how to do it.

Figure 6.39 The brick wall in pristine condition with accurate perspective lines. (Author's own)

Once the wall is mapped and your values are laid out, it's time to begin adding some personality to it. Using the polygonal lasso/ geometric selection tool, select one face at a time. Use a square brush that is hard along the top and bottom edges but soft to the left

and right to paint in broad textures, irregularities, and slight tonal shifts. For instance, if you're painting brick, try filling the entire surface with a base tone for your bricks, then individually painting random bricks with color variations to make the wall seem more natural and interesting. Look at your reference images to determine irregularities, cracks, staining, crumbling spots, and mortar irregularities as you develop your painting. Sometimes, you may not see mortar at all in a stacked natural stone wall. Other times, you may see mortar oozing out like buttercream frosting between bricks. Add broad swaths of texture with coarse dry media paintbrushes.

A key to bringing dimension to masonry is to paint highlights and shadows on each block. Try doing this using a small, relatively hard-edged brush like a dry inker or a streaky brush. Think about the directionality of the light and add painted highlights along the top edges of the blocks. The blocks will either cast shadows over the mortar lines or the mortar lines will appear bulbous or 3D, depending on the look you're going for. You may also go over the outside edges of the masonry, using your eraser tool to add divots between the blocks or areas where the masonry has crumbled away. Keep everything on separate layers with alpha lock/layer lock activated to enable you to paint these details quickly and precisely.

To add interest to the surfaces of your walls, you may want to add posters or graffiti. A great way to do this quickly is to create a new

Figure 6.40 The brick wall is finished by adding dimensional mortar, broken bricks, cracks, and dimension. (Author's own)

layer with a bounding rectangle that is the height of your tallest corner and the width of your wall. Hide the masonry wall painting layers and paint your wall additions within the bounding box. Using the polygonal lasso tool, select the wall addition items just inside the bounding box and copy/paste to a new layer, deleting or hiding the bounding box layer. Use transform tools like perspective or distort on your selection to match the perspective of your wall so the wall additions look like they are correctly aligned with the wall surface. Using overlay or multiply mode (sometimes with the opacity of the blend mode, not the layer, reduced) helps graffiti and posters to respond to the values of the wall beneath it.

Plant Surfaces

Greenery is best approached through working with silhouette, large areas of highlight and shadow, and selective detail. Depending on the style of your design, you may want to create a highly stylized, highly realistic, or hybrid approach to representing greenery on stage.

Stylized greenery will appear more two-dimensional and cutout, giving a cartoony or classic stage scenery appearance. If you are accomplished at drawing greenery, you can probably generate drawings that represent exactly what you want. If you are unsure or cannot picture exactly how you want the greenery to look, choose reference photos to stylize. Stylizing something specific will always lead to more interesting results; stylizing based on generalizations will lead to generic greenery, and generic choices do not support storytelling as well as specific choices. Pulling reference photos will also help to keep plant ecosystems believable; your dim jungle full of dangling vines and garish orchids shouldn't be peppered with elm trees.

To draw a stylized tree, try drawing with the freehand selection/lasso tool. Working over or beside your reference image, start with the trunk and branches of the tree. Don't get too lost in the fine details; work in broad strokes, knowing that fine upper branches can be painted in more easily later. Don't try to create the entire selection drawing in one pass, as this will force you to start over rather than use the undo command if you make a mistake. Work in chunks by adding to the selection: base trunk, then major branches, then root clusters, etc. You can add new areas to your selection using the "add to selection" command, or you can edit out of your selection using "subtract from selection" commands. Once you're reasonably happy with the structure of your tree, fill the selection with the base color for your trunk. Do not add additional detail until your leaves are in place.

On a new, named layer, create a stylized outline for the leaves. This can be amorphous and rounded, like a midcentury animation background tree, or it can have a silhouette with specific leaf edges protruding. Remember, work from general to specific, and make sure you're not drawing the whole crown of leaves in one pass. Remove some areas from the leaves so there are areas where

light and branches will be seen through the leaves. Fill the selection with a base color for your leaves.

Once you have both a trunk and leaves, it's time to play with texture. Flat color is death on stage, which I am sure you already know. Digital brushes offer so many fun ways to add texture and life to your paint elevations. Layer lock/alpha lock your tree layers and play with the following ideas:

- It's a theater classic to use spattering to add visual interest to surfaces on stage. Grab some spatter brushes and see how they work on your tree. You can go into brush settings and increase your hue jitter to get some more unpredictable color into your spatters.
- For a classic animation look, use rough-edged gouache brushes to create some gradient paintings.
- Use concept art brushes to add a general sense of foliage to the leaves.
- Use rake brushes to add stylized grain to the trunk of a tree.
- For an illustrative, storybook look, try painting the tree with large watercolor brushes.

Figure 6.41 These trees represent the different looks that can be achieved with different styles of painting the same silhouette. (Author's own)

Also consider that all of these techniques make for quick, iterative exploration of the relationships between your forms and your surfaces. You can copy/paste a form and throw several different textures, blend modes, colors, or lighting conditions on them in order to explore what you want. Directors and technical directors love options, and this is a great way to arrive at options quickly.

When approaching greenery from a place of realism, it can be helpful to have a sense of what sort of realism you are after. If you

Figure 6.42 Progressive values added in soft layers help to build realistic greenery. (Author's own)

want photo-realistic greenery, you may be best off turning to photo bashing techniques from Chapter 8. If you want realism that looks more like a realistic oil painting, pull reference images to help guide your style and brushwork.

Painting more realistic greenery should be approached much like drawing hair. Pull reference photos for the time of day and geographic location you're rendering. Start from the back of the composition, remembering that objects furthest from us in space will shift to bluer colors and appear with less contrast. As you move the greenery closer to your eye, the colors will grow warmer. Try painting the greenery form with the darkest value, then activate alpha lock/ layer lock in order to be sure you don't overfill your negative space

while adding value. Work from the darkest value to the lightest value, building to your lightest values. Much as with drawing hair, realistic greenery painting doesn't show you each individual leaf: it highlights specific leaves in a scattered pattern, usually following the areas in the brightest highlight. The outer edge of the greenery silhouette should be broken up by leaf shapes, but make sure the leaves aren't all facing the viewer. If you download or build a stamp brush, try adjusting the rotation jitter to make sure the leaves get tilted in space for a more dimensional look.

Career Highlight Interview: Story Artist Oakley Billions

Digital painting supports storytelling in many adjacent industries, including film and television. Story Artist Oakley Billions shares some insight about their work, their process, and how digital painting supports creativity.

Jen Gillette: Can you start us out by giving a brief overview of what a Story Artist does?

Oakley Billions: Story artists do a lot! They're writers, artists, and cinematographers – they're given outlines and scripts and asked to translate the words into drawings on a page. We create how a scene looks, how the characters act, and what the camera does in a scene – all through drawings. We take scripts and create storyboards for those sequences.

Figure 6.43 Oakley Billions works as a story artist, creating storyboard art that describes how a filmed sequence will unfold. (Oakley Billions)

Figure 6.44 Story artists help determine much about the visual appearance of a finished film, including how characters act, move, and react to story beats. (Oakley Billions)

JG: It sounds as though drawing is really central to working as a story artist. Can you talk about what that looks like on a day to day in terms of volume and quality? How many iterative sketches are you working through? Are you always working in color? When are you dashing things off versus creating something really detailed?

OB: When a story artist is assigned a sequence, it is usually several pages of script. Translating all of the text into boards can take hundreds of drawings! So, on a day to day, a story artist is tasked with a sequence, and must draw up to hundreds of drawings a day to meet a deadline (usually around one to two weeks) where they then pitch their drawings to the director. Because of the high quantity of drawings needed, story artists are encouraged to work fast, and sometimes rough, but to always have clarity and meaning in their shots. We don't use much color in our boards outside of greyscale to show light. I think most story artists know when to

work rough and quick in some parts of the scene, so that they can spend more time on the other parts they really enjoy. It's a balance of time.

JG: Working fast but with clarity; this phrase makes me think about where the creativity lives in the process for you. I like to say that I think with my hands and my ideas take form in drawings, not in my head. Can you talk a little about how creativity and drawing interact for you?

OB: Oh, for me the creativity comes from interpreting the scene – when you're given pages as a story artist, there are so many different ways to interpret one – in the moment, you are the director of that scene; you're able to decide how your actors will deliver the lines, how it will be shot, how it will be lit – and no two board artists will ever board a scene the same. It all comes down to you adding your spin on that scene, and interpreting it in your own way. You get to create everything, as long as you can draw it!

JG: "As long as you can draw it" feels like an important condition there. Do you do any "conditioning" to keep your drawing strong, or does your story artist work take care of that for you?

OB: Well like anything, it's a skill you have to hone and a tool you have to sharpen! Looking at reference always helps. Watching films and dissecting how they are shot helps. I think reference can help build up a story artist's arsenal. The more you study and learn from other filmmakers, the more you'll be influenced to try new things! I think it's just keeping your mind strong, so that you can convey the scene in the best way possible.

JG: Speaking of watching other filmmakers, what other artists inspire you most? To whom do you go or what do you do when you're feeling creatively tapped?

OB: Oh man there are so many! I constantly look to directors like Peter Ramsey, Brad Bird, Dean DeBlois, and I'm constantly in awe of my peers and the artists of this generation as well!

 For me, having a hobby outside of drawing was incredibly important. Being able to clock out and do something completely different, like watch films, play video games, read a book, go to the gym, doing stuff that fulfills you outside of drawing, is a great way to have recharge time. If I'm having a really bad block, I'll go back and watch my favorite movies, stuff that really made me fall in love with story boarding

JG: That is very good advice. Last question: Can you spec out your digital art setup? What hardware and software do you love working with?

Figure 6.45 Artist Oakley Billions at work in their studio. (Oakley Billions)

OB: Ya sure! I work with an Apple laptop and 24-inch Cintiq. I think any computer and tablet combination can work though! For storyboarding, I personally love Photoshop or Storyboard Pro, and I also enjoy the iPad Procreate app. I get a lot of use out of the Adobe Suite, and the Google Drive.

Reference

Fong, Wen C. "How to Understand Chinese Painting." *Proceedings of the American Philosophical Society*, vol. 115, no. 4, 1971: pp. 282–92. *JSTOR*, www.jstor.org/stable/986090. Accessed June 22, 2022.

CHAPTER 7

Digital Painting in Production

When work shifts from design to production, the flexibility of digital painting supports detailed designer-shop communication, nimble design adjustments, and inter-area synchronicity. Digital painting allows designers to move quickly between ideation and realization, using hasty sketches and rough models as the basis for more finished renderings. As changes are requested in the design due to adjustments needed by the director, the shops, or the performers, the designer is able to swiftly shift the renderings to reflect these changes. Digital painting supports not only clear communication, but also efficient editing.

This chapter will discuss how digital painting interacts with production work. While it is most obvious to think of digital painting as a one-to-one replacement for traditional media rendering, digital painting can also be used within production constructs to support custom printing, accuracy in rendering for casting, and presenting various scenic looks. This chapter includes workflows for scenic and costume designers using digital painting, including different ways digital painting may be utilized to save time or improve communication. Additionally, there are case studies for costume, scenic, and projection design outlining how design professionals utilize these tools in their careers.

Editing Research

All designers conduct extensive visual research when building the world of the show. Designers amass research differently based on their experience, training, and personal tastes. Some designers collect piles of single.JPG images to files or to Pinterest boards, sorting them into like piles until the favorites emerge. Some designers favor slideshows like PowerPoint or Google Slides to organize their research by look or character or into detailed tear sheets. Others make collages, blending traditionally sourced images with digital images, textures, scanned fabrics, or emotional images. While research can be treated perfunctorily as a part of the process, it can also be viewed as part of the design.

The way it is arranged and presented can support the world building and storytelling of the creative team.

Digital painting software is a great place to create research collages. Images can be resized, cropped, or swiftly edited to more accurately reflect the designer's aims. Images can even be drawn over to show the scale of applique, trims, or additions to the silhouette. The design team can add handwritten notes to research boards. Digital image editing combined with painting makes it so a designer never has to settle for a less-than-perfect research image. The one exception to this rule is when the designer finds a tiny or low-quality image; unfortunately, these images cannot be fixed in a way that guarantees a good outcome.

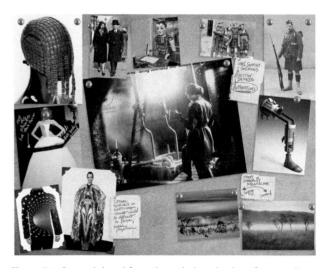

Figure 7.1 Research board for a theoretical production of a surrealist *Macbeth* showing the research images as though they are pinned on a corkboard, surrounded by crumpled, handwritten notes. (Author's own)

Applications of Digital Painting in Scenic Design

This section considers the ways in which swapping traditional media techniques for digital painting techniques can alter workflow for

DOI: 10.4324/9781003212836-7

scenic designers. Previous chapters have discussed building assets while creating a digital rendering; this section will discuss the ways in which assets can be manipulated to create highly specific design communication while still retaining flexibility in the collaboration.

Rendering versus Modeling

When embarking on visual communication for a scenic design, where should you start? Is it better to start with a painted rendering, or better to begin with a physical model of the space? Each of these tools helps describe the scenic world of the show, but each has different strengths and weaknesses. A model, especially an early-stages white model, will be more honest about the physical space available to the director on stage, and it allows for conversations about the mechanics of the scenic design in terms of layout and flow. A rendering will be more evocative and emotional, showing a view of how the set will feel as part of the realized production. Both are useful and are best developed in tandem with one another.

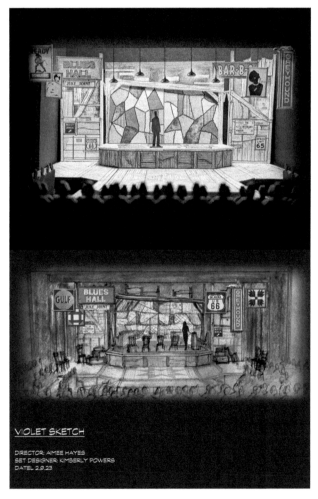

Figure 7.2 Pairing a realized scenic model with a scenic rendering by designer Kimberly Powers. Note the differences in atmosphere and mood, but also in the treatment of proportions in space. (Kimberly Powers)

Discover what works best for your mind. Do you need to structure your ideas for the design using form and shape first, before adding color and texture? Do you need to see the emotional space of the piece before working backwards to the mechanics of it? Often, removing variables at the beginning of the process can help clarify thinking about theatrical design.

Developing a Sketch from a White Model

White models, also called bash models and rough models, are a great iterative, physical tool for developing a scenic design. Working in a scale model box of the space, scenic designers can use inexpensive materials to sketch in 3D, adding physical elements to the space to work through the mechanics, flow, and artistry of the design without committing to time-intensive modeling or drafting processes. The white model can also come from a digital 3D environment like Vectorworks or SketchUp. The white model can also serve as a proportionate base for a scenic sketch or rendering.

Once a white model has been developed, it can be photographed and imported to a digital workspace. Add a new layer over the white model layer, then drop the opacity of the white model layer to about 50%. If you are working in software that has assisted perspective drawing, you can turn this feature on and generate a sketch that only uses correct perspective lines for your space. If you don't have this feature available, create a light sketch over your rough model, refining the shapes and proportions as you go. Once the sketch of the scenery and the space is complete, turn off the photo layer.

It can help to make the sketch into a rough value study to give a better sense of the dimensionality, depth, and mood of the space. The fastest way to do this is to drop a new layer behind your sketch layer named "midtone." Fill the entire layer with a 50% gray or another neutral midtone better suited to the world you're creating (sepia, conte red, a gray-violet, etc.) Create another new layer above the "midtone" layer, calling it "shadows." Here, use a dark value that is not true black to paint in the shadows of your work. Map out the directionality of light, the visible masking, and any important textures. Finally, create another new layer over your "shadows" layer, naming it "highlights." Use a lighter version of your midtone color that is not true white to paint in some shafts of light and highlight areas. Using just three colors can be highly effective, especially when you adjust the opacity of your brush as needed to build your values with variable subtlety and drama. You may want to fade or hide your sketch layer, as the value sketch will be diminished by outlines.

If you, your director, or your collaborators are having a hard time seeing the world without any color, you can lay in iterative

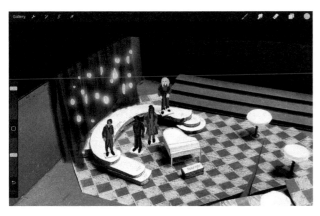

Figure 7.3 Photographing a scenic white model and sketching over it in digital painting software is a great way to begin adding detail, atmosphere, and story elements as the design concept evolves. (Clare Kelly)

color ideas over the value sketch using layer blend modes. Create a new layer over your topmost layer and name it "color trial 1." Set the layer blend mode to overlay, then add color. Your values will automatically be applied to the colors you add, making it very quick to see whether or not your color ideas will work.

Once the major elements are in place, this sketch can be refined and developed into a full scenic rendering. The more you keep assets and elements on separate named layers, the more chance you'll have to refine and edit without re-painting. If the elements of your composition are on their own layers, they can be manipulated using the warp tools without impacting other elements of the design. This will also make it a breeze to create storyboards, a process discussed later in this section.

There are no boundaries between digital painting and photo bashing other than the designer's aesthetics. If you want a more photorealistic look, you can import textures, wallpaper, architectural details, and period furniture for use in your rendering. Even if you want to paint everything in the rendering to unify the image, you can import these items as reference images directly to your canvas, allowing you to easily draw or trace them for use in the final rendering.

When sharing digital renderings with a team, digital delivery is great for general looks, but for final approvals and shop use, the designer should send printed hard copies. You cannot control the printer or monitor calibration for your collaborators, and a hard copy printed by the designer is an easy way to ensure the entire team is approving the same vision. It's also possible (even helpful) to list Pantone colors for the team's reference, but this relies upon everyone in the team having access to an up-to-date Pantone book. Check with your team before assuming that everyone is up to date with their Pantone materials.

Visualizing Light in Scenic Renderings

One of the ways that scenic renderings can make a large impact is through the incorporation of lighting ideas. While it is best to do this in partnership with the lighting designer, there are productions for which the lighting designer is not working in tandem with the development of the scenic design. In this case, the scenic designer might use lighting ideas to showcase the composition of the space and the atmosphere of the piece.

To create simple shafts of light in a digital rendering, create a new layer above the other layers in your rendering and name it "light shaft 1." Numbering these layers or giving them descriptive names will help as you develop multiple looks for your scenery and need to navigate multiple layers containing lighting effects. Use the polygonal selection tool to draw your shaft of light, then fill the selection with a solid, light color. (If the solid-filled shaft is too aggressive, you can also use transparent gradients to build light shafts.) Deselect and add a light Gaussian blur to the shaft, probably between 10 and 30 pixels, depending on how sharp you want the edges to appear on your light shaft. Change the layer blend mode to linear dodge/add (the name of this blend mode will change depending on your software) and adjust the opacity of the blend mode until you like how it looks.

If you want a more dramatic effect, you can duplicate the light shaft layer, adjust opacity to fine-tune, then merge down to unite the duplicated layers. If you want to add further drama, try dimming the area around the shaft. Choose a shadow color; this look will appear especially dramatic if you choose complementary colors, like a golden shaft of light piercing through dim, purple-gray shadows. On a new layer, use a large brush to paint in the negative space around the light shaft. Apply a Gaussian blur to cross-blend this effect against your light shaft, adjusting the depth of the blur as needed. Change the layer blend mode to multiply, then adjust the opacity of the blend mode and/or the layer until you get what you want.

You can also add light haze effects to help texturize the light. On a new layer above your light shafts, either paint some loose, amorphous cloud shapes on a dark background or, if you're using Photoshop, use the filter render clouds. Set the layer blend mode to multiply and adjust the opacity to your liking. It can help to use skew or distort filters in order to taper the clouds toward the light source so their density changes further from the source of the light.

You can use light on scenic renderings in more subtle ways. Imagine you're designing a box set, but we see the action of the play take place at different times of day through windows. If it's sunrise or sunset, the light will get more intensely warm. Try using a lasso tool to roughly select your windows. On a new

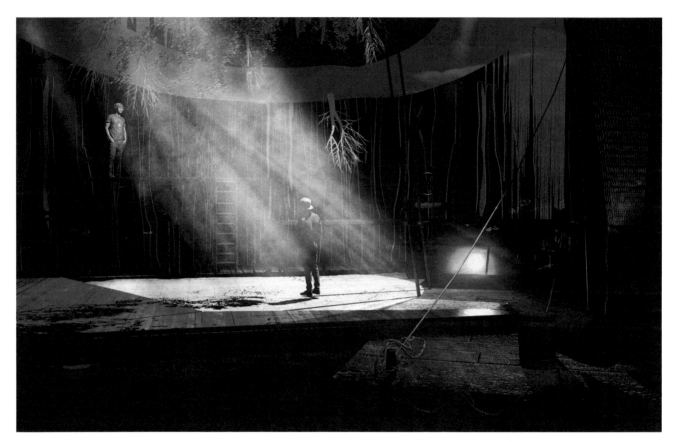

Figure 7.4 Using shafts of light and atmospherics in scenic renderings adds excitement to the scene. Scenic and media designer Tao Wang creates a scenic rendering that uses beams of light through haze in his design for *Peter and the Starcatcher*. (Tao Wang)

layer, fill the selection with a gradient that looks like the sunrise: think rich golden yellows, warm pinks, and peachy oranges. Gaussian blur to soften the edges, then change the layer blend mode to linear dodge/add to make it look like the morning light is glowing through the windows. Duplicate the layer and increase the spread of the Gaussian blur. Repeat the process of duplicating and spreading the light until the room is lit with a golden glow. To boost this effect with some all-over front light, create a new layer and fill it with your gradient.

Change the layer blend mode to overlay and adjust the opacity until you like what you see.

These techniques can be applied to any practicals or held light sources. For instance, a floor lamp's light can be rendered using a few quick shapes created with the polygonal lasso tool. A paper lantern can be rendered to emit a soft glow. Even neon effects are easy to duplicate using layer blend modes, Gaussian blur, and duplicated layers over a dark background.

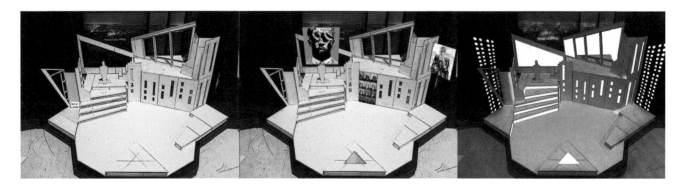

Figure 7.5 A scenic sketch without any lighting effects (left) and the same sketch with media content (center) and with light effects (right) added. Scenic designer Ethan Sinnott, *Cinderella: The Remix*. (Ethan Sinnott)

Renderings and Storyboards in Scenic Design

It's important for the entire team to understand how the scenery changes over the course of the production via storyboards. Creating or enhancing your storyboard using digital rendering can help convey the excitement and the atmosphere the team might expect to see in the finished production. Treating scenic elements as assets saved to their own layers, adding lighting effects, and text manipulation in digital rendering makes it easy to create storyboards, all while minimizing the generation of new content. If you prefer to photograph a model for storyboards, consider adding lighting effects to the model in order to show the progression of the story. These storyboards can also use digital costume renderings and imported content from projection or media designers.

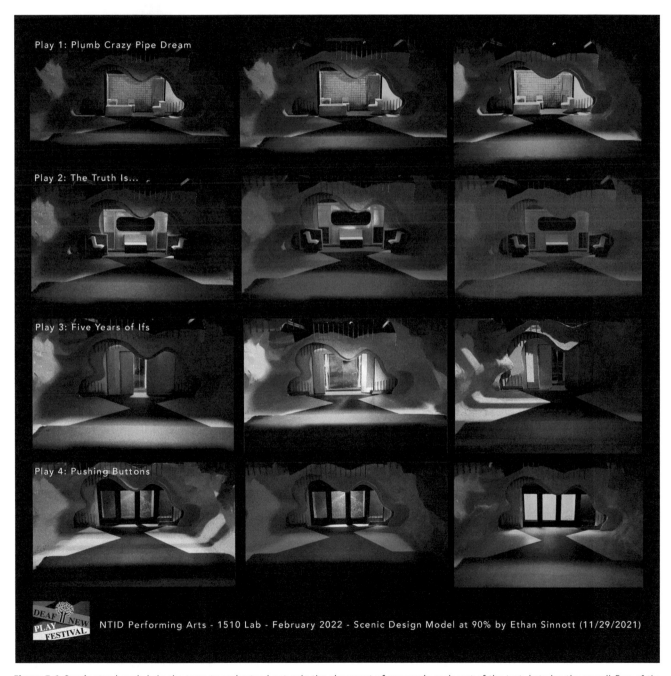

Figure 7.6 Scenic storyboards help the team to understand not only the placement of scenery in each part of the text, but also the overall flow of the production. Scenic designer Ethan Sinnott. (Ethan Sinnott)

You will need to generate new drawings when a piece rotates in space as part of the storyboard change. While there is no way to rotate a two-dimensional painting in space to create a three-dimensional object, it is possible to use the view you have to quickly map out proportions for a different view. Colors can be swatched using the color picker. Using the materials you've already generated as a reference point, you can swiftly generate new content as needed.

Scenic storyboards should be notated as other scenic renderings, but with added information about the exact moment of the show being depicted. You can supply an act number and scene number, but if you want to be very specific, you can give an exact line of dialogue and a script page number for reference.

Scenic Design Paint Elevations

There are many ways in which digital rendering can improve the workflow for scenic paint elevation. Scenic drafting can be exported from CAD or Vectorworks into digital painting software, creating a "coloring book" of scale scenic frames. Scenic palettes can be saved to Libraries and used in multiple documents, creating perfect consistency from elevation to elevation. While libraries will help to keep things consistent, it's useful to have enough monitor real estate to work on large sections of the design all at once. Opening one scene, piece of scenery, or item from the design at a time can create frustrating inconsistencies in brush stroke, palette, and composition once the realized scenery is assembled on stage.

While digital rendering puts an entire art supply store at your fingertips, there are important considerations to keep in mind if you are handing your renderings over to a scenic charge. Certain effects, like computer-perfect ombre, transparent gradient transitions, photo realism in collaged items, unprintable colors, and the use of mixed media can be difficult to translate to traditional paint. Scenic designers should be ready to talk to charge artists about the desired effect, produce traditionally painted samples, and approve sample work from the scenic painter in order to support clear communication. It's also a good idea for the scenic designer to print a copy of the digital elevations for the change artists in order to prevent communication errors based on color calibration or backlit screens.

Due to ever-contracting budget lines, many scenic backgrounds are now digitally printed instead of hand-painted. Digitally printed or projected backgrounds are almost exclusively used in film and television sets over hand-painted drops, unless a very specific look is needed. When deciding which finish is right for the project, consider the timeline, the available skilled labor, and the aesthetics of the finished piece. In any case, always request samples prior to committing resources to a large job.

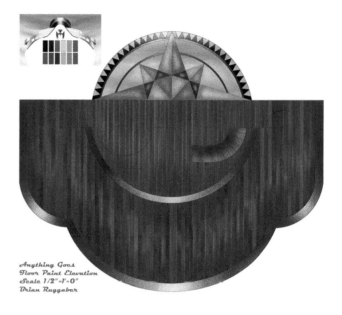

Figure 7.7 Digitally painted scenic paint elevations by Brian Ruggaber for *Anything Goes* at Cincinnati Conservatory of Music. (Brian Ruggaber)

Applications of Digital Painting in Costume Design

This section will explore some of the ways that digital painting can shift a costume designer's workflow. In many ways, painting costume renderings digitally isn't that different from using traditional media, especially if you're working on a tablet or pen display. Digital painting offers advantages such as speed, accuracy, and flexibility for the costume designer. In this section, we will work through a rendering process using a few different approaches in order to demonstrate the range of possibilities in digital painting.

Technical Drawings and Insets

Costume designers often need to provide supplemental information in order to help the shop realize the costume in three dimensions. Sometimes, shops request technical drawings, or passively posed line drawings that highlight the construction of the garment. Sometimes, an inset is added to the rendering to show the costume from another angle. Digital techniques make these requests easier to meet than ever.

Technical Drawings

Sometimes it's helpful for costume shop technicians to see technical drawings, especially if your rendering style is more impressionistic. There are a few methods for doing this. For the first, you can use layers, extracting key information from your sketch or rendering in order to create clean, easy-to-read technical drawings for the shop.

1. Start by duplicating your rendering file, renaming the new file to indicate that it is a technical drawing.
2. On a new layer (name this layer "technical croquis"), trace a version of your drawing using a smooth technical pen brush with very little pressure sensitivity. The goal for a technical drawing is to show the costume on as neutral a body as possible, so minimize detail but keep your lines sharp and clean. While the proportion of the hair may be helpful to see in technical drawings, expressive faces are not. If hair is worn long on stage, you may want to consider not including it in the technical drawing so it doesn't obscure the back of the garment.
3. Hide the layer with your original rendering.
4. Adjust the drawing of the garment so it hangs as though not in motion on the body. For instance, if you drew a circle skirt in mid-twirl, hang it as though the performer is standing in front of a fitting room mirror, even if the body's pose indicates motion.
5. Add drawings of seam lines, buttonholes, buttons, and other technical details. Do not worry about drawing print or pattern in this rendering.
6. Copy and paste the line drawing, then flip it horizontally. Name this layer "technical drawing back." Use your eraser to eliminate anything indicating the front of the body, redrawing it as the back of the body. For instance, if you drew a halter with a sweetheart neckline on the front of the body, the back would show the bow behind the neck, the shape of the garment across the back, and possibly the zipper at center back. Continue the hairline across the back of the neck, then erase the face and upper neck.

If you don't believe your renderings will provide enough information to create successful technical drawings, you can create an entirely new image for your technical drawing. To do this, you'll start by creating a technical croquis. You can build a small collection of technical croquis using the method detailed below and these can be used to generate technical drawings every time they are requested by a shop.

1. Begin by taking a selfie in a full-length mirror. Your body shape and gender expression don't matter here: you're taking a photo to use as a proportion guide. Make sure you stand in a very neutral pose, looking straight ahead with your weight equally balanced on both feet. If you use any assistive devices for standing, balance your weight evenly across your feet and/or any assistive devices,

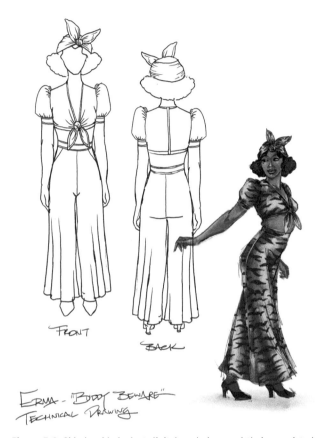

Figure 7.8 Side-by-side look at digital renderings and their associated technical drawings for *Anything Goes*. (Author's own)

trying to minimize visible tension in your shoulders. If you don't stand but need a pose of a standing performer, grab a friend (online or in person) to use as a model. Hold the camera at waist height to be sure the photo isn't foreshortened.

2. Set up a document as you would for any croquis (300 PPI+, the paper size of your choice). Import the photo to a new rendering and resize it to full height for the page. Don't worry about resizing the photo to make it larger, as it won't be visible in the final rendering.
3. Using a rectangular selection marquee, bisect the body vertically. Copy and paste your selection, then flip it horizontally. Place it so the body is now exactly mirrored from left to right.
4. Drop the opacity on your photo layer to about 40% so you can see black lines drawn over it.
5. On a new layer over the photo layer (name this layer "technical croquis front"), choose a smooth pen tool without a lot of pressure sensitivity. Activate the symmetry tool, using the vertical axis. Place the axis down the center of your body.
6. Using generalized lines, trace your form. Unlike a character

rendering, this should be passive and generic. Avoid adding too much detail, but make the body proportionate.

7. If necessary, use warp tools to resize or reshape the body to match the performer's body.

8. Once the body is traced, hide your photo layer. Move the body to the right side of the page. Copy and paste the "technical croquis front" layer and name the new layer "technical croquis back."

9. On the back croquis, change the front of the head to the back of the head. Remove the bust or chest details and replace with indications for a spine and shoulder blades. Change the groin area to a seat. Change the inner elbows to outer elbows and fronts of knees to backs of knees. Draw indications of the heels below the ankles.

10. On a new layer (name this layer "costume front"), draw the costume on the front of the body. Use the symmetry tool when appropriate to generate the most accurately technical drawing. Be sure that the proportion, fit, and style lines match your rendering as closely as possible. Remember that on a technical drawing, the costume should be hanging on a still body, not activated by movement. Do not worry about drawing print or pattern on this rendering.

11. Erase any front-of-body lines that sit under the clothing.

12. Copy and paste the clothing, then move it to the rear view body. This keeps the proportion the same. Name this layer "costume back."

13. Erase and redraw anything that appears different in the back of the garment. Some of the garment, like hem and sleeve lengths, will stay the same.

14. Erase any back-of-body lines that sit under the clothing.

15. Go over the drawing carefully for details. Be sure jackets are buttoning over the body in the correct direction, there are the right number of buttons, and that seams are drawn where you want them.

If you would like a side view, which is helpful for certain time periods, use projection lines to match proportions between your front/back views and your new side view. On a new layer, send horizontal lines out from the body to show the performer's top of head, chin, shoulders, chest, waist, hips, knees, and feet. Draw a new figure in profile that conforms to these proportions, then add the technical drawing on a new layer. Be sure to use reference images for the human body in profile, or take a quick selfie to use as a reference. Delete the projection line layer before finalizing the technical drawing rendering.

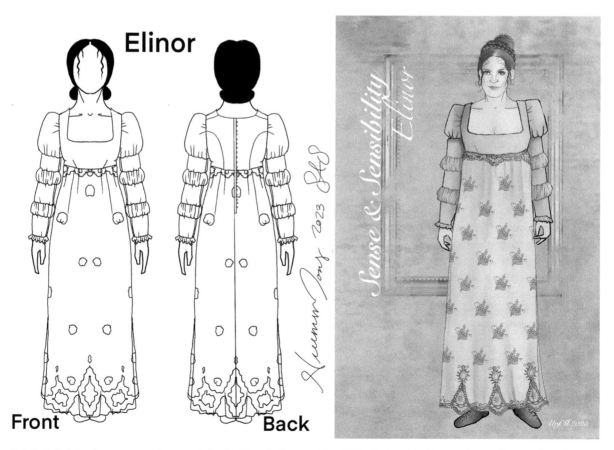

Figure 7.9 Technical drawings versus costume rendering for Elinor in *Sense and Sensibility*. Designed by Newman Jones. (Newman Jones)

Insets

Insets can be helpful for showing a costume in different stages or from another view. To skip a few redrawing steps when generating insets, try copying all of the layers that make up your costume rendering (without the background or any supporting text), merging them to a single layer, and then resizing down to fit in the margins as an inset. From here, either edit the image from front view to back view (flip horizontally, turn the face into the back of the hairstyle, change clothing to the back of the body view) or simply add elements to create a helpful inset.

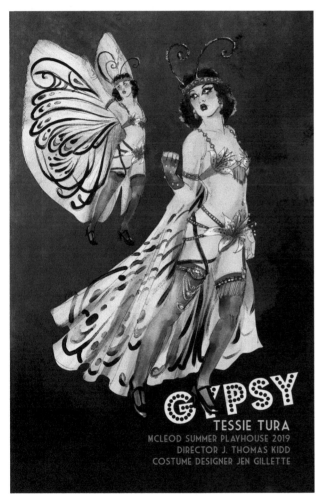

Figure 7.10 A digitally painted rendering for *Gypsy* uses an inset to show Tessie Tura with her wings fully extended. This helps both the creative team to understand the scale of the wingspan and the craft shop in adding the painted designs to the wings. (Author's own)

Adjusting Skin Tone, Proportion, Body Type, and Ability to Reflect Casting

It is imperative that costume designers assume the responsibility of helping the director to imagine a more diverse world for their production by rendering using a range of skin colors, hair textures, body types, and abilities when rendering a show prior to casting. Once the casting information is available, it's likely there will be changes from the original sketches. The costume designer can help be sure everyone in the cast feels seen and welcomed into the production by shifting the renderings to better reflect the people cast in the roles. Digital rendering makes these adjustments quicker; the costume designer no longer has to re-render the entire show in order to achieve this.

Skin Tone

Adjusting skin tone is perhaps the quickest adjustment a designer can make, though the designer should be careful to adjust facial features and hair textures to suit the finished rendering.

1. Select the layers or the areas with skin tone. If you have merged skin tone with hair or any other layer, use the freehand or automatic selection tool to select just the skin.
2. Find your layer adjustments menu. This menu will allow you to access hue, saturation, lightness sliders to change skin. (You can make finer adjustments and use masking by using adjustment layers, explained in detail in Chapter 8.) Move the sliders until you achieve a good skin tone for the performer.

You can also use layer blend modes to correct for new skin tones.

1. Select the layers or the areas with skin tone. If you have merged skin tone with hair or any other layer, use the freehand selection tool to select just the skin.
2. To make the skin darker than your original painting, make a clipping mask on a layer above the original skin layer. Set the layer blend mode to multiply and experiment until you achieve a good skin tone. A single pass with a large round brush in multiply mode should shift all of your skin colors. Remember that you can change brush or blend mode opacity. You may need to erase your layer blend overlay from lighter areas of the rendering like eyes, teeth, or skin highlights.
3. To make the skin lighter than your original painting, make a clipping mask on a layer above the original skin layer. Set the layer blend mode to linear dodge/add and experiment until you achieve a good skin tone. You may need to erase your layer blend overlay from darker areas like lashes, brows, and shadows.

Hair

Evaluate the hairstyling in the show to determine whether or not hair can be recolored or whether it needs to be repainted. Period hairstyles can likely be quickly recolored using the techniques described above. However, if you do not intend to wig your performer, you should repaint your hair if the original rendering does not reflect the hair texture of your performer. For more on painting different textures of hair, revisit Chapter 6.

Proportion

Always begin with a realistically proportioned human body when generating theatrical croquis. If you search the term "croquis," you will see a lot of fashion, anime, or manga croquis. These forms present highly exaggerated proportions: fashion croquis are usually 8+ heads tall with impossibly long legs, while chibi manga croquis may have outsized heads on tiny bodies. Neither is helpful to the theatrical costume designer, and neither will reflect the proportions of your costumes on performers.

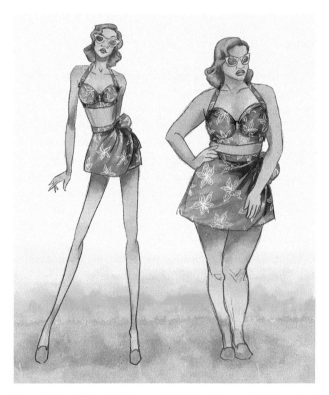

Figure 7.11 Looking at fashion croquis (left) next to a realistic human body (right) really shows the stark differences in these forms. (Author's own)

It's also important to draw costumes on a range of body types when visualizing a show. When a show is cast, you may find that the performers are all the opposite sizes of what you've rendered, but it's always helpful to show a performer (and the shop) renderings that reflect the proportions of the body accurately. When you need to make minor adjustments to the body, using warp tools can achieve this easily without redrawing anything. When warping a finished rendering, work in small increments and bounce from left to right, top to bottom. Inch the figure in or out as needed, working from the center of the figure out toward the silhouette and limbs. It can be helpful to highlight different sections of the body and warp them individually to minimize distortion. For instance, you may want to use a selection tool to grab the torso and hips, then arms,

then legs, then face. Warping sometimes causes breaks in the image, so you may need to patch the renderings once you've reset the size. Drastic size changes may require redrawing the rendering.

If you are resizing a garment for a body with different proportions to the one you originally drew, you may also evaluate the style lines to be sure they will work with the new body. For example, if the width of the hemline is proportioned to the waist, make sure to scale the hemline width to the new waist in order to keep the look consistent with your original proposal. In a drop waist silhouette, the dropped waistline may raise to keep the proportion of the skirt longer than the proportion of the bodice. If a performer has particularly broad shoulders, the width of a fedora might shift to keep the rhythm of period proportion intact. Princess seam lines may move or change shape, waistlines may move up or down, or the width of a lapel may be adjusted to flatter the current wearer. The word "flattering" is often coded to mean "makes you look thin," but it should be used to mean making sure the proportions of the body and the garment are harmonious with one another.

If you learn that there is a person with special needs in your cast, make sure you reach out to talk to the performer as soon as possible so meeting their needs becomes part of the design. All assistive devices, adaptive closures, prostheses, or necessary medical hardware should be accounted for in the rendering and the costume. This may require additional research into adaptive clothing. This can be as small as making sure the costume provides safety and coverage around an insulin pump. Including different abilities in the renderings prior to casting can help the director to visualize these performers as a part of their world.

Visualizing Light in Costume Renderings

Much as scenic designers may use lighting ideas to balance compositions and convey mood while storyboarding a project, costume designers may choose to embrace early lighting ideas by communicating them in the renderings. Adding directional light to renderings can be powerful, dramatic, and give the team a good sense of how the costumes will look under specific conditions.

There are no shortcuts to knowing how to add light to a two-dimensional rendering, but you can either reason it out or use reference images to help understand the lighting. When imagining directional light, think about it hitting every surface that faces it. Surfaces that protrude will catch the light and surfaces that recede will sit in shadow. Objects that protrude forward into the light will also cast a shadow against any surface behind them. For a good, simple reference photo, stand a dressed doll up against a

plain wall and turn off all the lights in the room. Use a flashlight to light the doll from various angles, noting the change in shadows. Take reference pictures of the various angles and add them to your reference image morgue.

If you're looking for an exercise to help build your literacy in painting directional light, try this.

1. Make or pull a costume sketch from your archives. Do not add any value to it; it should be a relatively clean line drawing. (Some search-marks or sketch markings are fine.)
2. Duplicate twice so you have three identical renderings available to you on the page. Label one "side light," one "top light," and one "foot lights."
3. Tone your paper or background layer to a light-medium or medium gray.
4. Make a new layer behind the sketch layer and name it "midtone."
5. Navigate back to the sketch layer. Select the figures. You can do this in a few ways depending on the ease for your software. You can use a magic wand tool to grab the negative space around your figures, then invert the selection so only the figures are selected. You can also use a freehand selection tool to trace around the outline of one figure, then do the following step one figure at a time.
6. Navigate back to the midtone layer. Choose a medium-dark gray or violet-gray and fill your selection, either by using the fill command or by using a large brush to fill the area.
7. Deselect your figure(s) and choose a light yellow or near-white gray. Select a soft round or soft gouache brush.
8. Make a new layer above the midtone layer and name it "highlights." Working on this layer, think of your brush as the light. Depending on the direction, where would it hit the folds of the garment, the contours of the face, or the sides of the body?
9. Use the blend tool strategically to soften the edges of your light moving over the body and the clothing. Keeping the highlights on a layer separate from the midtone layer will keep the color from muddying while you blend.
10. If you'd like to add more drama, make a new layer under the highlights layer but above the midtone layer. Name this layer "shadows." Choose a deeper, darker tone in the same hue range as your midtone. Push this color into the shadows, in the areas the light can't touch. This will help mold your form in three dimensions.

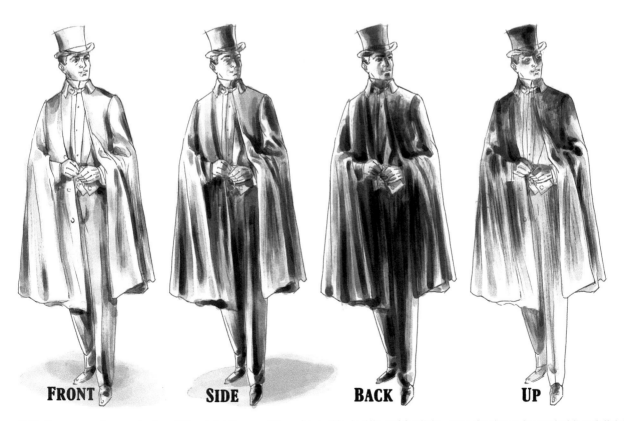

FRONT　　**SIDE**　　**BACK**　　**UP**

Figure 7.12 The same costume under four different lighting conditions: front, side, backlit, and footlights. Note the change in mood with each lighting condition. (Author's own)

Strong directional light in costume renderings can make beaded elements take on extra sparkle, add a mood of foreboding, show off textures, or communicate the tension in the text. It can also show your costume designs more accurately under the likely lighting conditions, especially if the lighting designer has already shown research images communicating the direction and temperature of the light. Think about a rendering of a ballerina en pointe, her musculature highlighted by dramatic side lighting from both sides; the Kit Kat dancers posed in front of eerie footlights with pooling darkness behind them; Curly kissed by the "bright golden haze on the meadow" as he beams into the morning; Moses and Kitch standing in a harsh, downward pool from an overhead streetlight. The possibilities are endless.

Using Digital Rendering to Notate Photos

Digital rendering allows for clarifying communication via fitting photos in a few ways. Designers working at a distance and conducting fittings through shop staff or assistants can notate fitting photos directly. Designers working with garments that will be heavily altered can use digital rendering to show the shop, the performer, and the director how the garment will look when reimagined. Professors and instructors can also use digital notation to help their students visualize corrections to their costume sketches.

Direct notation of fitting photos allows the designer to adjust proportion, style lines, and trim placement very exactly. When fitting at a distance, whether synchronous or asynchronous, it can be frustrating to try and describe exact placement via video call. Fitting photos can be imported into digital rendering software and covered in sketches and notes in order to capture the designer's exact intention on the performer's body.

Sometimes, garments will be completely re-imagined as part of the design process. These fitting photos can be difficult to share with directors, choreographers, drapers, and dressers, as they often look nothing like the finished garment will look. These photos can be imported into digital painting software for quick sketch alterations that will help communicate the final look.

For instance, a performer was being fitted for a costume that would undergo major transformations. The vintage shirt was to have its sleeves shortened, have added decorative elements, and its blouson fixed to a waistband. The skirt was fitted when it was still the bottom half of a dress. The bodice of the dress was to be removed and the built-in crinoline detached. A waistband would be added to the skirt. Rather than hoping the team can imagine

all of those changes accurately, the fitting photo was redrawn (Figure 7.13) with the changes sketched over the performer's body. The color picker is used to grab colors from the actual garments and the sketches are completed in quick, broad strokes, helping communicate the ideas without the designer spending a great deal of time on these sketches.

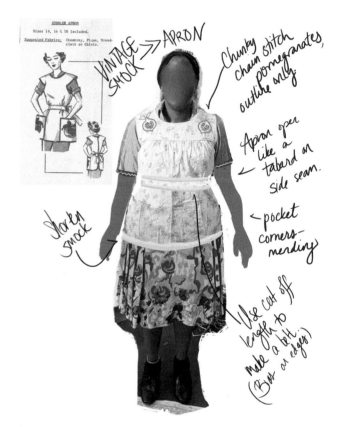

Figure 7.13 Fitting photo with designer notes drawn and written over the top. (Author's own)

Teachers, professors, and instructors offering mentorship in costume design can use digital notation to help their students visualize corrections to proportion, pose, and clothing on their costume sketches. Rather than requiring students to print renderings (or drawing directly on their original traditional media renderings), instructors can use JPGs imported to a digital painting platform to add notes to student work. Seeing is always easier than hearing a description of what's wrong. This is also a lightweight way to check in on student progress for remote or asynchronous learners, during times of remote learning, or for design professors who spend time away from campus for their creative scholarship.

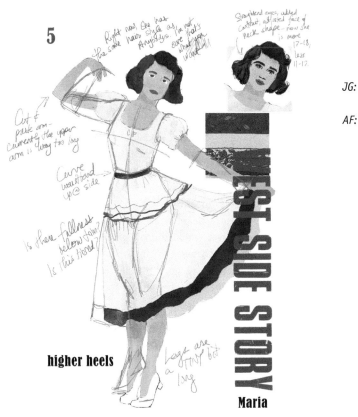

Figure 7.14 BFA student Aubrey Dearen's rendering work with mentor corrections. Using a combination of visual corrections and text can help students see what can be improved, then apply these lessons to future drawings. (Aubrey Dearen's costume design, Jen Gillette's notations)

Career Highlight Interview: Digital Patterning and Costume Technology with Ali Filipovich

Ali Filipovich is a costume designer and technician living and working in Memphis, Tennessee. She is a freelance designer and technician, and she works as the Costume Shop Supervisor for Ballet Memphis. Ali's interests are varied, encompassing design for costume and fashion, sustainability in costumes and fashion, integrating LED technology in costumes, dance costuming, and digital pattern making.

Jen Gillette: Let's begin with an introduction to you and your work. You engage in so many different forms; what's central to your practice as a costume and fashion artist?

Ali Filipovich: As an artist, communication is what matters most to me. When I think about creating and I'm making a rendering, I try to be as clear and concise as possible. I want the overall image to match the tone of the show or project. I want it to convey the style and the narrative that we are trying to create. This can come from a lot of places: from the character's pose, expression, or the background.

JG: Can you describe your training? What media did you start with in your education?

AF: I started out with traditional media in my undergrad training. I had never really drawn much before taking a theater rendering course at the University of Wisconsin-La Crosse, but they taught me how to use colored pencils, pastels, charcoal, markers, and watercolor. I continued using traditional media for the next six to seven years. When I was in graduate school at the University of Memphis, I was trying to keep up with the renderings I needed to produce for classwork and for production designs. On a whim, I went to the Apple store and bought my first iPad. I downloaded Adobe Fresco and realized the glory of the undo button. Since that moment, I have never looked back. The time it saves is reason enough to switch to digital rendering. There is zero setup, no more finding space to paint, no more getting out brushes and water glasses and a palette, no more accidental spills that ruin hours of work, no more cleanup when you're done! You only need the iPad which means you can bring it almost anywhere. You also have the power of copy and paste, and the power of simplified tracing. I would honestly never go back to traditional media. I am very glad to have learned with it first, as it gave me some building blocks and understanding of what the digital media is trying to recreate, but I am too in love with the portability, zero setup, and the undo button to ever go back.

JG: How does digital painting help you with your process?

AF: It can help me to work through ideals more quickly. I can change the color of a dress in seconds, then line up my different options to easily decide which color is the most correct in the context of the rest of the show. I can doodle different silhouettes on the same figure, hiding the layers I don't like until I come up with my best idea. It just helps me draw. On paper, I would be so hesitant of making the wrong choice because it would take so much time to redo. Digital rendering takes away that fear. I can just *go*, draw it as many times as I need, then hit undo or hide layers when I find what I want.

JG: What are your digital rendering tools? What hardware and software do you use?

AF: I use a 12.9" iPad Pro, an Apple Pencil, and Adobe Fresco. I use my iPad for rendering even though I have a Microsoft computer that can convert to a tablet. I like Fresco the most. I use Kyle's brushes, especially the oil painting brushes. Rather than creating new brushes, I prefer to edit the brush settings to make them paint in different ways. That's how I like to lay down prints in my renderings. I use digital or scanned swatches and sample them with mixer brushes, then paint. I print my renderings at 11 ×17 on laser printers, and I don't tend to work on the printed renderings with any additional media, unless I want to add some sparkle. Sometimes I don't even print my renderings. I was designing *Junie B. Jones* for Playhouse on the Square recently, and I didn't even need to print my renderings for them. I delivered them digitally.

JG: Let's transition to talking about your work as a technician. Can you walk us through what digital pattern making is?

AF: Digital pattern making is essentially flat patterning in a digital space. There are some programs that offer draping, but that technology is newer. I primarily use Adobe Illustrator for digital pattern making, which utilizes a lot of drawing lines and doing math, especially geometry. Instead of holding a ruler, the tools are on the screen creating the shapes and making the scaled measurements of the space. I love that I can import historical shapes. When I was draping for *Romeo & Juliet & Zombies*, I was importing scale drawings of historical patterns, then adapting those shapes to fit our performer's body. Sometimes, I go the other way: I draft a sloper first, then draw the shapes for the costume on top.

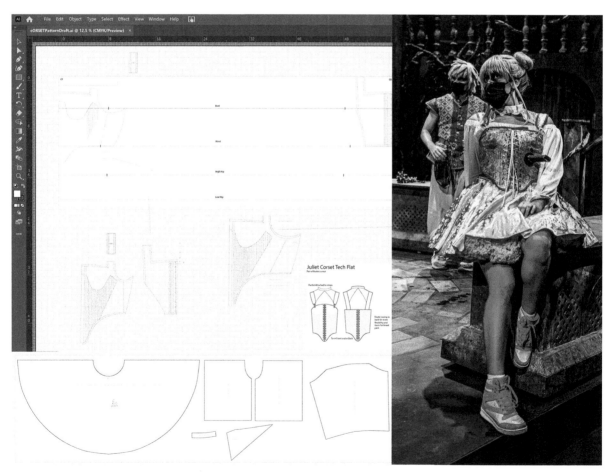

Figure 7.15 Ali Filipovich's digital pattern draft for Juliet's costume in *R&J&Z* (University of Memphis, 2021) and the finished costume as it appeared on stage. The costume was patterned using Gerber AccuMark and Adobe Illustrator. Costume designed by Hattie Fann, actor Aly Milan as Juliet. Production photography by Bill Simmers. (Ali Filipovich, Bill Simmers)

It works either way, and you're not wasting paper while you're figuring out all of your slopers. It also results in having a sloper size that you can use again and again without having to preserve paper patterns that will crease and degrade with repeated use. Of course, there are changes that you'll have to make to the pattern after it's printed, but these are minor tweaks, similar to the changes made between a mockup and a final pattern. It's important to keep editing and to take breaks. True up the pattern in a different time period than your patterning time. It's a lot like editing a paper – you're reading and re-reading what you're writing, but you have to stop and walk away for the problems to become visible. You won't see them when you're too close to it. Walk away, come back with fresh eyes.

JG: How do you handle complex or unusually shaped pattern pieces, like color blocking?

AF: I draft the general silhouette first, then break up the pieces by hand on a printed pattern. I print out the large pattern pieces, then work on blocking out the smaller pieces using a numbering system.

JG: What about pieces that create a complex or unusual shape, not just assembly? I'm thinking about the sculptural stretchwear you created for the University of Memphis Wearable Art Show.

AF: I started by creating slopers for my base pieces (a leotard and a mesh catsuit) in Illustrator. The more unusual spiraling pieces had to be patterned by hand on a dress form. It was a hybrid approach. It made the whole process easier. I could generate the patterns for the base pieces digitally and spend more time on the complex draped pieces.

JG: What are the advantages in terms of space management?

AF: I can pattern giant pieces without needing space. Not being in school, I've run into my own space

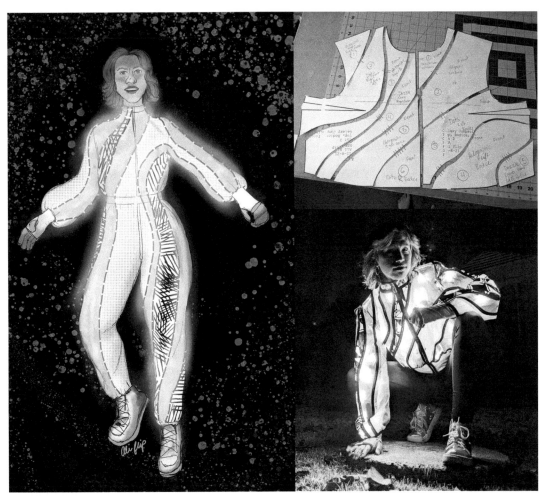

Figure 7.16 Ali Filipovich's Galaxy Jacket project, from rendering to pattern pieces to finished garment with installed LED lights. (Ali Filipovich)

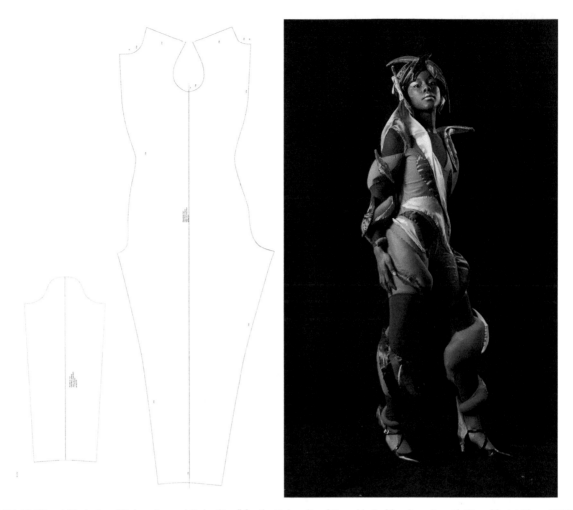

Figure 7.17 Ali Filipovich's design, "Stalagmites and Stalactites," for the University of Memphis Fashion Department's Wearable Art Show, 2022. Modeled by Zyunia Palmer. (Ali Filipovich)

management issues. I can sit at my computer with a cup of coffee, my measurement sheet, and my research to guide me, and that's all I need. It's sort of amazing to think that you can do this at an airport; you don't have to be in a studio. I think it makes it more accessible in some ways. You need access to these programs, but not to space. A challenge I'm facing is that I don't have access to a plotter since leaving graduate school, and commercial print shops charge by the square foot for plotter printing. I'm printing everything on small sheets, then taping it together. This creates more waste because that paper can't be recycled unless the tape is removed.

JG: You've worked in other commercial fashion and costume construction environments. Have they shown you any additional applications of digital pattern making technology?

AF: Yes! I worked at a sportswear company that sent digital patterns directly to printers and CNC [Computerized Numerical Control] machines. The pattern pieces' cut lines would be printed on the entire bolt of fabric, then cut by CNC machine. Can you imagine the beauty of having access to a CNC machine that cuts fabric? Draft your pattern, set it to cut, and go! It creates a lot of fabric waste, of course, because sportswear is concerned with speed. I think fashion is much further into the digital age than theater. They've been using these digital tools for longer than we have: Gerber, Clo, Illustrator, and the other smaller softwares. They've developed processes for automating cutting and printing of fabric.

JG: You've mentioned waste a few times. How does digital patterning stack up against analog patterning in terms of sustainability?

AF: They both have their own sources of waste, but digital patterning creates less physical waste. Continuing to try and find new ways of doing things more sustainably is so important. Switching to digital patterning doesn't save *that* much paper, but if everyone does it, it will add up. It also creates far less waste when grading patterns and lets you pattern layout for your yardage. Instead of hand-tracing a pattern onto new paper in order to grade it, you can make runs of patterns sized for everybody, and it's much quicker. For pattern layout, you can create a scale box in Illustrator that's the same size as your yardage and move your pattern pieces around to figure out how you want to nest your pieces. This can be difficult to do at full scale, even if you have cutting tables available to you. It's a great way to minimize fabric waste.

JG: Is there anything you miss from analog?

AF: No, but I'm glad I learned to paint that way. The first class I took was a traditional media class in undergrad. We learned a little bit of everything: various media, gridding your paper, drawing in perspective. I feel like that helped my hand get a sense of what it was doing, how to apply pressure. With paint, I like to throw everything at the paper: throw it on there, erase it, paint over it again. In paint, you can't undo, and I love being able to try new techniques or applications on multiples. It's so great. You can do it in analog, but it requires resources and time. Digital is more economical, but learning to draw by hand was important for me to have confidence in my drawings. I resisted tracing for so long. I thought someone was going to take a magnifying glass and say, "you traced that arm! How dare you! Burn it!" I was made to feel as though my design was trash if I didn't draw it all from scratch. Fashion students use croquis all the time, so why aren't all theater students taught to do it? You can go so much faster if you can pop a person into the rendering and check your proportions or get that arm right on the first try. The arm is not the most important thing about the look. The most important thing about the look has nothing to do with the rendering: it's the finished costume on stage, telling the story.

Digital Painting in Production Processes

Sometimes, the work we do across areas is remarkably similar. This section discusses shifts to the production workflow via digital rendering that are applicable across multiple design disciplines.

Creating Custom Fabric

Sometimes, a production requires custom fabric printing. Custom printing is more accessible than ever, is available at a variety of price points depending on the needed quality and speed of printing, and is available on a huge range of natural and synthetic textiles. Custom printing can be used to execute a designer's exacting vision, recreate vintage or antique textiles, or repeat print elements in costumes and scenery. Digital rendering is a great tool for creating custom fabrics that will be printed for use in a production.

To set up a digital document for fabric printing, it helps to start with a vendor. Knowing your fabric dimensions and color requirements is key to successful document setup, and will prevent re-painting images later in the process. For instance, you may want your fabric printed at 60" width, but you learn that the printer you're using only prints 44" wide fabric. Some printers require CMYK document formatting or specific file types. Many vendors offer swatch books showing how their print work looks on various textiles, and it's a great idea to order these books in advance of building your art, as it may influence your fabric choice.

Next, determine the type of print you intend to execute. Is it an all-over repeating print? Is it a border print? Is it a large-scale repeat? Determining the size of your repeat in relation to the width of the fabric will help you determine the size document you'll need. For instance, if you know you want a 16" x 16" repeat, that will be the size of your document. If you are making a border print with a 15" repeat on 44" width fabric, your document must be 44" x 15". No matter the inch size of your document, you will need to use at least 300 PPI, or whatever your print company recommends. Consider the scale of the print and the muscle of your computer. Large-scale prints at 300 PPI can be taxing for your device, and you may experience lag while painting.

Chapter 5 has instructions on how to build a repeating print. It's highly advisable that you check your work before submitting your artwork to the printer, making sure the pattern will repeat seamlessly. Many printers will offer digital or physical proofs as paid options, and it is worth the extra money to be sure your colors and pattern will print as expected. It's likely far less expensive to proof the print than it would be to re-order the fabric after correcting the art, and you may not have time in your process to wait for a second round of custom printing.

If you love creating custom prints, you can build a passive side hustle in uploading your prints to custom printing websites. Many of these sites allow customers to choose from other independently designed prints, printing them to order on fabric, wallpaper, or framed art prints. This means you do not have to invest in stock or do any shipping. You get paid when other people order your design. Keep copyright in mind, as you can't sell custom prints that refer to copyright designs or prints that use copyright imagery in their designs.

Using Digital Swatches

Unless you are a designer working near a major urban center with access to fabric stores or interior design superstores, you are likely doing some of your shopping online. Online swatches can be used to create color palettes and brushes in digital renderings, helping the designer to use the fabric, wallpaper, or textile exactly as it will appear on the stage.

Applied Skills Tutorial: Creating and Cutting Digital Yardage

While a swatch can be used to build out a repeating pattern (the process for creating repeating patterns is described in Chapter 5), you can also use a swatch to make a more hasty, less repeatable version of repeating pattern by using it to create a length of fabric, then applying that "fabric" directly to the rendering.

1. Find a high-quality swatch of printed or patterned fabric. Swatches that include a visible measurement are very helpful, because you can use the measurements to determine the relative scale of the print as it relates to the performer's body.

2. Import the swatch to your digital painting, making sure it's on its own layer.

3. Crop any information you don't need from the image so all you see is the printed fabric. (Take note of the measurements, if needed.)

4. Copy and paste the swatch, then move the copied swatch over the first swatch until you find the repeat. The line separating the swatches should be invisible. Deselect the copied swatch and merge the two swatch layers. Touch up the overlap if necessary using the clone stamp, heal brush, or simply some light smudging.

5. Copy and paste the layer with both swatches on it.

6. With the newly copied block of swatched textile/wallpaper, repeat the process, creating a quad swatch with no visible lines/an invisible repeat.

7. Repeat until you have a large enough length of textile/wallpaper for the application. Ideally, the piece you've created is larger than the surface to which you're applying it in every direction, which will allow you to warp and shape it.

8. Lay the textile/wallpaper under the sketch layer. If it's a textile, be sure the grainlines are correctly placed, which may require copying, cutting, and pasting from your yardage.

9. If you are using the digital yardage on a garment, be sure you are using warp tools to create curves in the fabric, sculpting the yardage around the body. On a layer over the fabric layers, set the layer mode to multiply and add shadows that help sculpt the fabric around the body.

10. If using on an architectural surface, use skew and perspective tools to make sure the pattern shifts as it moves away from the viewer and follows the perspective lines of the set.

This method will create a rendering that looks more like a photomontage than a painting, but it can be a great way to communicate with your team where exacting grainline placement is important to the garment or surface, or when you need to generate your sketches very quickly. You can also use this method to create a grid or map for complex prints if you'd like to hand paint, but also want to make sure the print doesn't distort unexpectedly.

Figure 7.18 A digital swatch manipulated into a length of fabric. (Author's own)

If you have the time and inclination to paint your renderings, online swatches are still very helpful in determining your rendering palette. You can import digital swatches or good quality photos of your physical swatches to your digital workspace and use the color picker to grab the colors directly from the swatch, eliminating the need for time-consuming color matching with traditional media.

Theatrical Documentation

Correct documentation and meticulous title blocking makes documents easily accessed and understood by all the collaborators, from the shops to the artistic director. Digital rendering software usually contains text tools that allow designers, associates, and assistants to swiftly generate title blocks, templates, and notes for their images. This section will break down template content for theatrical documentation, including specific documentation or notation required based on design area.

Common Items to Include in Theatrical Documentation

- Name of the producing organization: In most cases, this is the theater's name. Sometimes adding a note about the production venue is useful as well.
- Production title
- The designer's name
- The director's name
- Revision date: Revision numbers can be hard to follow, so it's advisable to use revision dates instead. If there are multiple

revisions in the same day, time stamp your revisions or add ascending alphabetics to each name.
- Union stamp, if appropriate: If you are a union designer, you will add your union stamp and signature to finished documents.

There are also some discipline-specific items you should include, listed below.

Notation to include in Your Scenic Rendering

When painting a rendering of a set, you will want to include the following items:

- **Title block**: The title block contains, at a minimum, all of the common items listed above. For scenic designers, this may also include:
 - **Scale, i.e., ½″ = 1′–0″**: If this is a perspective scenic rendering, no scale is listed, but if the rendering is a front elevation style rendering, then listing the scale is appropriate.

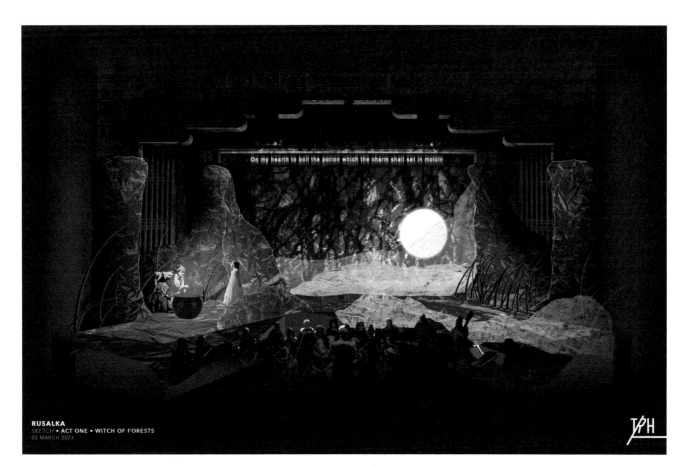

RUSALKA
SKETCH • ACT ONE • WITCH OF FORESTS
03 MARCH 2023

Figure 7.19 Digital scenic rendering with title block. Scenic Designer Tyler Herald's design for *Rusalka*. (Tyler Herald)

- **Notes:** You will want to set aside space on every rendering to list notes that pertain to the rendering.
- **Act number, scene number, and the location being shown:** List this as specifically as possible.
- **Line of dialogue:** Renderings that depict specific storytelling moments are more powerful than those that merely display a neutral space.

- **Scale figure:** Including a human figure in the rendering of the set is necessary for your collaborators to accurately interpret the scale of the rendered space. Traditionally, this has been a standing figure about six feet in height. It is preferable that the figure be a character from the play or opera in the rendering rather than something generic.

Human Figures in Scenic Renderings

It is important to include a human figure in any rendering of a scenic design, as a production uses scenery to create a world to support the story of the characters. It is always preferable that the figure in the rendering be one of the character renderings created by the costume designer, but sometimes those renderings have not been finalized by the time the set is to be rendered.

The proportions of the silhouette of a human figure are inherently related to the proportions of the world around them. For example, chairs in French Rococo interiors were designed with armrests that sat further back to accommodate the panniers worn under women's dresses. In the 1860s, the western fashion of wearing bell-shaped cage crinolines made

wide doorways a necessity. The way that characters dress has effects on their environment and vice versa. The scenic designer may choose to render a common period silhouette, but without showing any further interior detail. This is a step in the right direction, but even choosing a silhouette is a costume design choice.

In general, when the costume design renderings are not available for the scenic designer to use or reference in the rendering, then the scenic designer should consult with the costume designer about choosing an appropriate period silhouette. The scenic designer should never use a photo of a costume from another production as the figure in the scenic rendering.

Little Shop Of Horrors
University of Memphis
Department of Theatre and Dance
SL Walls
1/2"=1'-0"

Figure 7.20 Using a human figure is key to communicating proportion in scenic renderings, as seen in these paint elevations by Brian Ruggaber for *Little Shop of Horrors*. (Brian Ruggaber)

Notation to Include in Your Paint Elevation or Properties Rendering

When you are creating a paint elevation or stage properties rendering, you will want some of the same information as a scenic rendering, including the title block and scale information. You should also include a scale figure.

- **Scale information**: If the rendering is in scale, list that scale in the title block, i.e., ½" = 1'–0".
- For painted drops, a reference line marking the center can be helpful.
- **Notes**: Here, the notes can vary greatly in scope and detail. You will probably want to annotate and call out specific materials or surface finishes, such as matte, glossy, eggshell, etc.

Notation to Include in Your Projection/ Integrated Media Design Storyboards

If you are a digital media designer, you may also want to consider including these additional items in your storyboards:

- **Callout boxes for the media**: When showing media projected onto a surface where the surface texture might interfere with interpreting the image, it can be helpful to create a separate callout box showing the media separate from the surface.
- **Media license information**: In rare situations where it is important to know the license holder of the media while viewing the storyboard, it is helpful to include this information.

STREET SCENE
CCM
FRONT FACADE
SCALE 1/2"=1'-0"

Figure 7.21 Digitally rendered paint elevation by designer Brian Ruggaber. (Brian Ruggaber)

Figure 7.22 Digitally rendered stage properties by designer Kimberly Powers for *Beat Bugs*. (Kimberly Powers)

Figure 7.23 A photo of the model can be overlaid with digital images of media content to communicate projections ideas, as seen here for *Faustus* by designer Ethan Sinnott. (Ethan Sinnott)

Notation to Include in Your Costume Rendering

A set of well-executed digital costume renderings has much in common with a set of hand-painted costume renderings. There are formal cues and standards to help guide the viewers through the design. Digital costume renderings should include:

- **Realistically proportioned figures that take up most of the page**: Ideally, about ½"–1" of space should be left above the head and below the feet of the sketch, depending on the size of the paper. This space also allows for a title block and other notations without crowding the design. Avoid using fashion croquis, as the elongated proportions rarely match human forms. Figure 7.24 shows a digitally drawn figure on

Figure 7.24 Digital croquis for costume design with ¼" bleed margins, a natural proportioned figure, and appropriate headspace/footspace on the page. (Author's own)

the page prior to the arrival of the costume and the supporting documentation.

- **Costume title blocks that include the following**: Be sure to set the title block at least ¼" from the page edge to prevent clipping when printing.
 - Show title. (For the show's title, it can be helpful to use the same font for the show title that the company is using in the marketing materials. This creates visual unity and will tie your renderings to the production if they're used in any media releases. For all other information on the rendering, a readable, classic font is preferred over anything gimmicky.)
 - Character name
 - An indication of when this costume is worn (act/scene or song title)
 - Company name or producing organization
 - Optional information:
 - Director's name
 - Designer's signature
 - Performer's name
 - Show's date, or other relevant information about the production
- **Numbering**: Numbering costume renderings can be a helpful way to communicate with the costume shop. Renderings can be organized by character or chronologically according to the costume plot, then numbered. Act and scene numbers may change depending on cuts or additions to the text, so a numbering system can be very helpful in maintaining consistent communication.
- **Background**: Atmospheric or representative backgrounds are not strictly necessary and should be applied thoughtfully. A good costume rendering background shouldn't distract or detract from the rendering of the character, and it should always reference the choices being made by the scenic designer. The costume designer should never display the costumes against a background that doesn't refer to the scenic design of the production, as this will create an unsupported expectation for the appearances of both the costumes and the scenery. Simple gestures, like splashes of paint that provide colors from the scenic design or contact shadows that land the character on an unseen ground, are usually enough to push the character off the white of the page. If you want to include background color or elements, request information from the scenic designer so your choices accurately reflect the world of the show.

Once you have established a method and style of adding this information to your renderings, you can set up template files for elements that will repeat many times within a set of renderings. This helps increase rendering speed and create uniformity across the design.

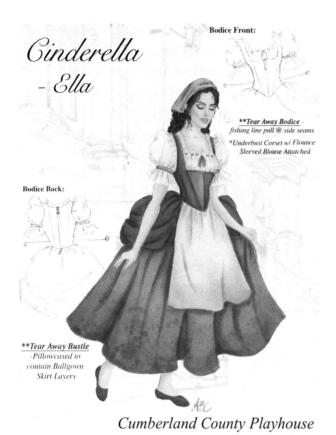

Cumberland County Playhouse

Figure 7.25 Digitally painted costume rendering that includes title blocks, notes, and backgrounds. Designer Austin Blake Conlee for Cumberland County Playhouse's award-winning production of *Cinderella*. (Austin Blake Conlee)

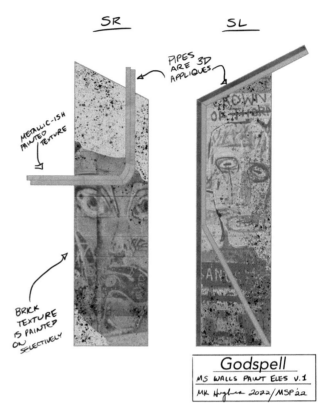

Figure 7.26 Digitally painted paint elevations with notes from designer M.K. Hughes for *Godspell* at McLeod Summer Playhouse. (M.K. Hughes)

Text in Digital Rendering Software

Various digital painting platforms have variable ability to handle adding text to your renderings. Because text is a necessary part of all theatrical rendering as a way of communicating with a team of collaborators, it is not recommended that you use software that does not allow for the addition of text to your images. Some software, like Adobe Photoshop and Clip Studio, have extensive tools for adding and manipulating text while still maintaining vector-based graphics for text layers. Other software, like Adobe Fresco and Procreate, have more rudimentary text tools, but they will allow you to get the job done. These software platforms are always growing and adding new features with updates, so make sure to keep your applications updated to access these features as they develop.

In order for text to print looking its best, it has to stay in vector format rather than be rasterized. This will, in some ways, limit your ability to manipulate the text in your image, but over-manipulation of text can interfere with clear communication, so maybe this is for the best. To maintain

vector lines for printing, you must save in a format that preserves vectors, like.PDF. For more information on saving for vectors, see Chapter 3.

Watermarking Images

Digital sharing makes it convenient to share high-quality images across great distances, but it also exposes your intellectual property to theft. Adding watermarks to your work prior to sharing or posting online is one way to deter those that would make you an unwitting collaborator.

Visible watermarks are a clear deterrent, making it difficult to adapt your image without serious editing. You have probably seen watermarks on images when browsing source or research images online. Watermarks usually appear as a translucent logo, brand name, or distortion over part of an image. Creating a visible watermark is easy. Import your logo into your digital painting software and place it so it is not easily cropped from an image but doesn't detract from the central focus. Reduce the transparency so the image behind it isn't completely blocked. Some designers also add bevel and emboss effects to the watermark in order to make it more difficult to edit out. If you're working in Photoshop, you can store watermark layers as assets in a library so they can be swiftly

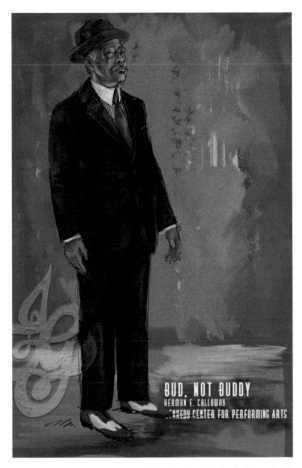

Figure 7.27 An example of a digital rendering that includes a visible designer's watermark. The watermark marks it difficult for others to claim authorship over images found online. (Author's own)

dragged to new images, or you can build them into your design templates.

Newer technology is emerging to support the protection of image-based intellectual property. For a subscription, you can use algorithmic watermarks. These watermarks aren't visible, but are detectable at the pixel level, even when an image is cropped or compressed. If you are seriously concerned with the idea that your images may be reappropriated, consider investing in an advanced watermarking service to protect your images online.

Screen to Page

There comes a time in every production's timeline when a designer will want to extract their renderings from the digital workspace and present them in printed form. Printed renderings aid both the shop and the rehearsal room in making sure all decisions are being made with the designer's intent close at hand. Accuracy in printing is key to making sure the renderings have the same quality on the printed page they do on a backlit monitor.

Quality printing begins with document setup. Chapter 3 goes into detail about file setup and file types, but it's worth reiterating: if you have not set up your digital painting file correctly, you will never achieve a print quality that you will be happy with. This quick-reference list can be used to check that your document is set up accurately for printing:

- Choose a high PPI during document setup (at least 300 PPI).
- Create your document using the dimensions of your intended printable page size, taking into account whether you're printing on a plotter/large format printer or a commercial/office printer.
- Save as the correct file type to maintain editability, preserve vectors, and maximize quality in your prints.
- Keep printable colors in mind by watching for printable color alerts and by soft-proofing to CMYK color.
- Do not put critical information within a one-quarter inch of the page edge to prevent clipping during printing.

There are few digital painting tragedies more severe than realizing you've spent hours building a painting at poor resolution, or at the wrong document dimensions. While you can resize a document to increase its size and PPI, you cannot increase the information stored in a document during this process, leading to a pixelated final product. Accidentally leaving your document at a low PPI during new document creation is a mistake that can only be fixed by repainting your image.

The final stage of pre-printing setup is to save a copy of your document as a.PDF, flattening as many layers as you can while preserving vectors on their own layers. Vector layers are those with text, pen tool lines, vector brush marks, and/or any other vector-driven image content. These layers should be left unmerged. Any painting layers should be merged to reduce the size of the document before printing. Merging painted layers will reduce document size by reducing the complexity of the saved file, not by compromising or compressing the image information. Do this with a copy of the original painting in order to preserve your original layer structure for editing.

Color Accuracy

Color calibration can be a frustration for digital painters. Monitors aren't calibrated to one another, leading to color variations between viewers. While this is not entirely preventable, there are steps the digital painter can take to reduce the amount of tolerance in perceived and printed color.

There are options for improving color calibration. Most computers have a native color calibration function, allowing the user to fine-tune color displays and balance their whites. These native tools rely on the user's eye to measure correctness, which

allows a great deal of subjectivity in the calibration process. While the native calibration tools on your computer may be helpful for making minor changes to your color display, true calibration relies on objective color information. Digital painters who want the most objective calibration, work in very exacting color, and often create printed content may wish to invest in a colorimeter. Colorimeters are intended for calibrating displays to objective color data.

Commercially available colorimeters are small devices that clip to your monitor or display and measure your color output. These devices are checking the following elements:

- **Tone** is a catch-all word referring to your monitor's brightness, contrast, and gamma. Gamma is a complex relationship between displayed colors, lightness, and darkness. A good example to think about is watching a scene from a movie that takes place in a dark room. Adjusting the gamma will allow you to see the details in the darkness, even in low-light settings. Poor gamma calibration will leave the scene completely dark, even though the color information is present that would allow for viewing.
- **Gamut** refers to the range of colors your monitor can display. Calibration data can correct a computer that is mishandling its gamut and presenting you with fewer colors than your monitor is capable of displaying.
- **Color accuracy/dE levels** will create a numerical value showing the difference between a color standard and what your monitor can display. This allows you to quantify the color accuracy in your display and correct accordingly.
- **White point** refers to the color temperature of what your monitor displays as "white." Cooler white points will shift blue and cool all other display colors. Warmer white points will shift into amber tones and subsequently warm all other display colors. A neutral white point is key to color accuracy.

Every year, trusted computer and consumer goods websites release lists of the best color calibration tools. Do your research to determine whether or not investing in one of these tools is necessary for the work you do. Further, if you want your printer calibrated to your monitor, you may consider investing in a spectrophotometer, as it can measure color data from a printed page. These devices are much more expensive than calibrators intended to correct monitors.

Paper Choice

Choosing the paper for your printed renderings isn't just an aesthetic choice. Different paper finishes will either allow printer ink to absorb into the paper fibers, creating a more convincing traditional media finish, or they will allow the color to sit on top of the paper to create a bold, graphic finish. This choice will also be impacted by the type of printer you choose, but we'll discuss that in more detail below.

When selecting paper for printing, you'll want to think about the following qualities:

- **Lb:** Good quality paper is sold with a lb, or pound, rating. This number refers to how much 500 sheets of this particular paper will weigh. Papers with a high lb number are heavier weight papers, while papers with a lower lb number are more lightweight papers. It is important to keep weight in mind because plotters and large-format printers will allow for heavy weight papers, but commercial printers may not. Plotters and large format printers allow a single sheet of paper at a time, and the paper path through the printer is very simple. There are fewer opportunities for paper jam, so you'll be able to choose a lovely 140 lb cold press watercolor paper without issue. If you plan on using an office-style printer or copier for your renderings, you will need to consider a lb rating under 100. Remember that to get the broadest range of paper choices, you should consider buying full-size printmaking or watercolor sheets from an art supply store and cutting them to size. Full sized sheets are usually at least 22" x 30".
- **Tooth:** Tooth refers to the surface quality of paper. Cold press watercolor paper has a rough tooth with lots of irregularities, pockets, and bumps that many artists prize in the texture of their finished work. Paper with less tooth has a smoother finish, allowing for more slick, even surfaces. Hot press watercolor paper is usually quite smooth. Neither is better or worse than the other, and tooth selection is based on the preference of the artist. Some printers may struggle with very toothy paper, so remember to print a sample first and be ready to move on to a more medium-textured paper if you don't like the effect.
- **Color:** Choosing a tinted paper can add mood or dimension to your digital renderings. Choosing a cream or ivory paper warms the colors, while choosing bright white paper or palest blue paper has a cooling effect. It's important to remember that what appears white on a monitor is assuming white paper, and the printer will not print in white ink. (For more on this, revisit the section on additive and subtractive color in Chapter 3.) If you print on a midtone paper, you may want to go back into your rendering with wet or dry media to add white highlights back in.
- **Dry and wet media finishing:** A theatrical artist may choose to add additional dimension to digital renderings by including some finishing touches in wet or dry media over the printed work. This may include shading with an ebony pencil, adding gel-pen highlights, or using light gouache or colored pencils to push light colors back into a rendering printed on midtone paper. A costume designer may choose to use specialty products, like tiny gems or iridescent paint, to highlight those aspects of a costume. If you intend to add any traditional

media to your rendering, consider this in choosing your printer paper. Wet media need a heavier weight paper and can't be supported by office supply products without causing the paper to buckle. Laser toner creates a liquid-resistant surface, making it difficult to use any wet media on the printed image. Inkjet prints are water-soluble, and using wet media may reactivate the printer ink on the page.

My personal preference for printing costume renderings is to print on 90 lb hot press watercolor cut to 11" x 17". I typically make these prints on commercial laser printers (office-style color copiers). This type of copier allows me to set the paper weight to a heavier bond or coverstock, and I usually experiment a little to figure out which setting works best when printing on an unfamiliar copier. I use the manual feed/bypass tray, usually located on the right side of the printer, and feed the paper through one sheet at a time to prevent jams.

Printer Types

Knowing how your specific printer deposits color on the page will help you make the best possible choice in printer type whether you're choosing a printer for purchase or choosing how to have your prints created. As mentioned above, choosing your printer's color media will also dictate how you can interact with the print once it's made.

Inkjet printers are common household printers. They use small cartridges of expensive ink, often sold in a CMYK array, and print by depositing microscopic dots of ink on the page. Inkjet printers are accessible, often inexpensive to buy, and a great option for theater artists who don't print in volume. Because inkjets work by depositing liquid color on the page, they are a strong choice for artists who want to render in digital watercolor. Artists should consider that inkjet ink can be reactivated by water, an important consideration for the life of the print and for wet media finishing. Small inkjet printers often have a simple paper path, allowing for more flexibility in paper weights and textures.

Laser printers are more expensive, and are often found in copy shops, offices, and professional print shops. Laser printers print by depositing toner on the page and heating it to fix it to the page. Laser printing is bright, bold, and graphic, often appearing to sit on the surface of the page. Laser printers and their toner refill cartridges can be expensive, but usually a toner cartridge lasts a lot longer than an inkjet cartridge. Many laser printers have more complex paper paths, meaning the artist should choose a lower lb paper to prevent paper jams. It's also worth considering that toner creates a water-resistant environment on the page; it doesn't absorb into the paper it is printed on, and it will not allow the addition of

wet media after printing. You can use drier wet media, like gouache and acrylic, over laser prints without issue. Watercolor will not work over laser prints; it simply beads off the surface of the toner.

Large format printers like plotters are typically inkjet printers unless you're investing in an extremely high-end machine meant for large-scale production. Plotters offer a tremendous amount of flexibility regarding print size and paper weight, but the machines are large and expensive. A plotter is a great resource for a shop, a company, or a university department, but may be out of reach for a freelance designer.

Whether or not to own a printer is a choice every digitally driven theater artist must make. The pros to owning a printer are being able to control color calibration between your monitor and the printer, accessibility, ease of color correction during trial printing, and making the choice to print on questionable materials without having to justify your choices to co-workers or copy shop employees. The cons to owning your own printer are costs and space. Not only does the owner need to purchase the printer, but replacing ink or toner is expensive, as is repairing or replacing the printer when it inevitably breaks. Printers for theatrical rendering take up a considerable amount of space, and artists may not be able to dedicate the space needed for a plotter in a New York studio apartment. If you choose not to own a printer, building a positive rapport with a local print shop will be the difference between reliable print quality and constant frustration.

Shared Drives and Collaboration

Most productions use a cloud-based service in order to share documents during the production process, beginning with the designers and director, but eventually including the shops and sometimes the performers. This is a convenient repository for all information relevant to the various stakeholders on a production. The larger the production, the more people will be engaging with the shared content on the drive. This section covers drive organization and etiquette, as well as giving a brief overview of some of the major providers of cloud-based collaboration.

Drive Organization

It is likely a production manager will sketch the outline for organization in any production-related drive, and you will have a folder dedicated to your area. As you are invited to the drive, be sure you have permission to add nested folders and upload content. These are not discoveries to be made as a deadline is closing. Preferences for folder setup will vary by area and by artist, but it's important to remember that this folder will be used by collaborators outside your area, and using clear names for folders, without abbreviations or jargon, is important.

Within your area folder, think about breaking down the files you will upload into larger categories. This will help both you and your collaborators navigate the drive folders; if absolutely everything is loose in the top-tier folder, it can be difficult to sort through for the needed document or the correct iteration of a document. For example, the costume drive might have top-tier folders for costume paperwork, costume research, and costume sketches. Subfolders within these top-tier folders can be used to organize further, depending on the complexity of the show.

Outdated documents should be immediately moved to an archive subfolder or removed from the drive entirely in order to prevent someone from accessing outdated information. (It can be helpful to save all the iterations of a file on your personal drive, as you will often be asked to reference an earlier version of your images.) For instance, imagine the wallpaper color has shifted and all of the paint elevations were corrected to reflect the new color. If both versions are saved in the production drive with no indication (other than file date) that one is more correct than the other, it's possible a props artisan would color-match upholstery to the outdated elevation.

When choosing a file naming convention, remember the default sorting mechanism in the shared production drive. Usually, file organization is sorted alphabetically from A to Z. In this format, numbers will come before letters when files are sorted. This can be helpful in making sure the files sort in the order you'd like them to be seen. For instance, you can number costume renderings prior to naming the character, as relying on the character name as your first alphanumeric value will result in a director skimming through the show out of order.

Drive Etiquette

Good drive etiquette relies on common sense or on learning through failure. In order to prevent major missteps on a shared drive, keep the following drive etiquette tips in mind.

- You will likely have editor-level permissions in all areas of the production drive, so it's important to treat the files in the other design areas with care. Never edit a file that you did not upload without the designer's permission. Never delete a file that you did not upload unless you have been asked to do this by the designer. Never edit the name of a file without the designer's permission.
- Some cloud services like Google Drive and Microsoft OneDrive allow users to edit documents within the drive. If you need to tool around with someone else's file, copy it before doing this. For instance, stage managers sometimes make use of costume plots or scene breakdowns. Copy these documents, rename them, and move them to your own area's folder prior to editing.
- If you need your drive storage space back following a

production, ask the person who set the drive up to remove you from the drive. Some services allow you the option to delete a folder or series of folders. Doing this will sometimes delete the folder for you and for all of your collaborators.
- Remember that what you add to folders will weigh on everyone's allowed gigabytes or terabytes. Consider archiving unneeded information, like your huge.PSD files, in a personal drive to prevent weighing too heavily on anyone's cloud storage.
- Update your drive content as often as the design changes. Leaving outdated paintings in the drive will lead to collaborators making ill-informed decisions about their work, and by the time you find out about it, it may be too late to change things.
- Check for needed information in the drive prior to emailing another collaborator with a request for that information. The purpose of the shared drive is to promote unassisted communication, and it's everyone's responsibility to keep themselves informed of what their collaborators have provided.
- Use universal file formats whenever possible, or provide easily viewed options for proprietary documents. Some software, like Vectorworks, AutoCAD, and Photoshop are not available for preview for collaborators who do not have the software installed. Further, even if you do have this software installed on your computer, you may need to see these files on a mobile device. Providing JPGs, PDFs, or other universal formats for all information can save you frustration and email requests.

Cloud Services

Cloud services provide varied storage, editing, and sharing solutions for production. Below are some of the common cloud services, including their pros and cons. It is worth noting that while some of these services have a free subscription tier, most of the free services offered have very low storage limits and won't be practical for a working designer. You will likely want to select one cloud service as your "home base" where you save archived production materials, back up your hard drives, and save templates needed for future work. This will require paying a subscription fee for more storage space.

The cloud services most commonly in use for production are Dropbox and Google Drive. Other services, like Microsoft OneDrive, Notion, Box, and VirtualCallboard, are present in the market but often have more niche audiences or aren't as universally accessible by collaborators. Dropbox and Google Drive each have their strengths and weaknesses, but learning to navigate these services is unavoidable for theater artists.

Dropbox is commonly used by larger theater companies. It has a suite of mobile apps for every device, automated backups, and

universal name recognition in the theater industry. Dropbox also has live editing tools through integration with the Microsoft Office Suite and Google Suite. Live editing is helpful in keeping show paperwork up to date without constant re-uploading. Dropbox's major drawback is its monthly subscription price, which is high compared to its competitors. Dropbox also has a lower amount of free storage for unpaid subscriptions. Dropbox has some notable security features, like password-protected files and sharing expiration dates.

Google Drive is a clean, intuitive platform with a wide variety of native applications built into its cloud storage platform. Documents can be created in Google Drive, but they can also be seamlessly exported in a range of file formats. Like Dropbox, Google Drive has mobile apps available for all devices, but a drawback to Google Drive is that several apps are required in order to edit content. Google Drive has a very approachable price point, but concerns have been raised about Google's privacy. Files cannot be password protected; once a file is shared to a collaborator, the only way to control access is to change access settings for that specific document.

Do your own research to determine which cloud storage solution is best for your home base, but you will almost certainly be asked to interact with the two platforms above as you work in this industry.

Career Highlight Interview: Costume Design for Opera with Erik Teague

Designer Erik Teague has designed costumes for Washington National Opera, The Glimmerglass Festival, Atlanta Opera, New Orleans Opera, The Kennedy Center, and various theater and opera companies around the United States. Though Erik works in opera, musical theater, theater, and other realms of live performance, opera remains his favorite form. A recent convert to digital painting, Erik discusses the role of drawing in storytelling, design, and his life.

Jen Gillette: Let's start with a little getting-to-know-you, a little table-setting. What drew you to theatrical art forms in the first place?

Erik Teague: I guess because I've been a magpie for as long as I've been alive, so seeing live theater performance that was so engrossing and encompassing as a film, but it was something you could literally reach out and touch, and feel the same breath in the same room, that has always been and continues to be electric for me. That's what keeps me coming back all the time.

J: Can you talk a little bit about how drawing and painting sit in your process as a designer? When do you start drawing? How does it enhance your communication with the team?

E: I tend to draw as the second step. My first step is casting a wide net with collages so we can at least see if we're bare min on the same page. If we're in the same universe, awesome. Then I can get into the specificity of drawing. I tend to be very specific in the things that I draw, as most designers are, and that's not the first step in the process but it's close on the heels of the first step. I like to get a little check out of the way and then dive into the world.

If my drawing can get someone excited about the work, then it doesn't matter how long it took, it's worth it. You have such a finite amount of time with your team and your performer. You have to get everyone on your side from the get-go, otherwise it makes for a very rocky process. If you can show someone a piece of art that's well thought out and has their face in it, and really feels like a whole character on a page, that facilitates so many conversations that a faceless fashion plate won't. I've seen it happen in rooms! I used to draw a very sketchy, impressionistic face – this is way back when I was still figuring stuff out – really focus on the clothes, and no one cared about the clothes. They didn't have that face to hang their hat on. When I started drawing actual people, the reception got a lot better.

J: When we're lucky enough to have a costume shop working with us to make something happen, how do technicians respond to and use the paintings?

E: Technicians *super* respect a drawing that takes their art into account. If you can provide something that has suggestions of seams or physics that actually work, the shop loves it. And naturally, the black and white technical drawing is always a requirement of the shop, but when they can look at your sketch and immediately say, "Oh, I know that. I know how to do that," that's cool. It's helpful as a designer so that you've given them a platform to really riff off and ply their trade. They're artists, too, and they have to be able to have creative freedom within their parameters.

J: I know that you are a more recent convert to digital painting. Do you want to talk about what drew you to painting digitally?

E: Sure: fear. I didn't want to be leftover as a fossil. As much as I love traditional, analog painting and drawing, I realize that the pace of our industry is never going backward and it will never accommodate the time I truly needed to do traditionally painted renderings. It also offers much more flexibility than my traditional drawings did. You can edit so quickly! It still

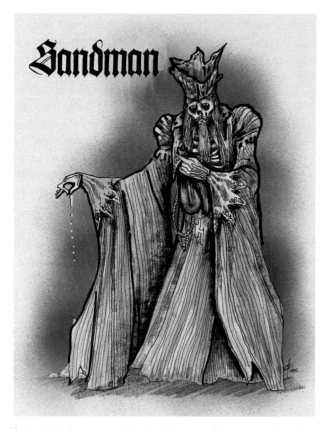

Figure 7.28 Costume rendering by Erik Teague for *Hansel and Gretel*, New Orleans Opera, 2021. (Erik Teague)

can look beautifully painted, just the pace is sped up so much and you can serve the need better that way.

J: Do you have an example of a time in production you were able to offer one of those nimble edits and keep things moving quickly?

E: Absolutely. I had a director ask me if a certain color was better than another color. It wasn't, but I had to explain why and having a visual example that I could immediately say, "Nope, it's not going to live with all of these other sketches in the same way." It was this color versus that color, and I could toggle back and forth between the two. That expediency helped win the case.

J: Do you think your practice as an artist has shifted since converting to digital rendering or do you think it's a one-for-one exchange for your traditional media practice?

E: It's definitely different in ways I can't fully articulate, but the benefits outweigh the weirdnesses. I can do a lot digitally that would take so long in an analog setting. Just ... [dreamily] layers! As you know, I'm a multimedia artist. I will throw a ton of things on that page and when I'm doing it analog, it's a very organic process. You build up the layers to what you want, but there has to be a specificity and a boldness to that because there's no going back. I had to get over the undo button as a moral failing. It's not! It's just a

part of the process. My analog experience brain had that "don't mess it up, you only get one shot!" still in there. Which isn't true, it's just a piece of paper. You could throw it away and get another one.

J: You can, but of course every minute you spend on a design reduces your hourly wage, so you also have to take that into account. So you mentioned weirdnesses, that the benefits outweigh the weirdnesses. Can you talk about what some of those weirdnesses are for you?

E: Yeah! The tactile difference between drawing your pencil over watercolor paper and drawing your stylus over a clean glass screen is so different. It's a massive weirdness. The control you have to exhibit over your hand is different. I had to get a paper texture screen cover so there would be some kind of tooth for me to work against because I like the scratch. That was one of the first big discoveries. I also needed a stupider stylus than most people. Your beautiful Apple Pencil that is so responsive was too responsive for me. I needed something dumber.

J: So you had to blunt the instrument in order to get the results you wanted?

E: Yeah! It's weird, right?

J: What do you use?

E: I use these cheap, $12 Amazon things that I'm also not mad about if I lose them.

J: Sounds a lot better than losing an Apple Pencil.

E: That would fill me with a lot of agita.

J: Speaking of hardware, what model of iPad are you working on?

E: iPad Pro, 12.9".

J: What software do you use to render?

E: Procreate.

J: How do you feel about Procreate? What do you like about it? What do you think its shortcomings are?

E: Okay, shortcomings: its text editing is not great. When you're titling your sketches, you want it to look clean and you want it to look nice. The text integration is not really intuitive. However, the brushes that it just straight up comes with are all great. I'm still learning what each one of them does, but they replicate the analog media very well. It does take a little remedial learning to figure out what Procreate thinks a watercolor wash behaves like. Getting a grasp on that has been an interesting process. And trying to keep an irregular, organic impression while working on something that's clearly doing math to make sure that it looks the way it's supposed to look, that has been an interesting process.

J: Do you have pet peeves of things you think look "too digital" that you try to avoid?

E: Yes. When I can definitely see the brush, where it begins and ends. If you use it multiple times and you haven't hidden those elements, that makes me crazy because it looks like stamps to me. Or when it's too shiny! When I look at a rendering and every texture has some sort of luminous glow

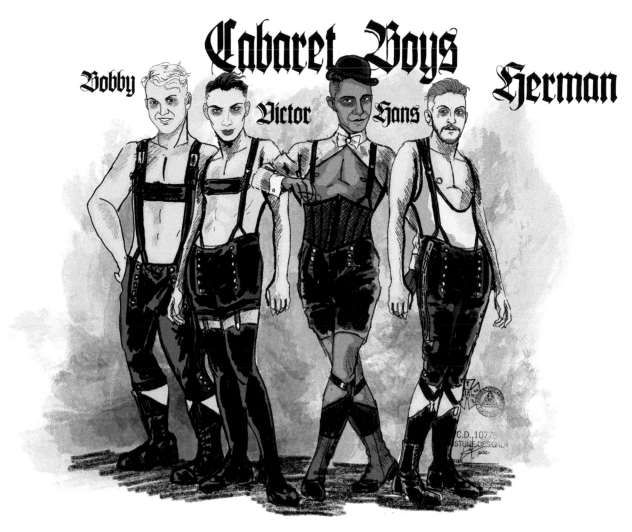

Figure 7.29 Costume renderings by Erik Teague for *Cabaret*, Atlanta Opera, 2022. (Erik Teague)

because you've just used the round paintbrush to drop in color behind everything and haven't textured it enough? That makes me crazy, too. I need it dirty. This will shock no one.

J: I'm thinking of your process specifically, which I've been lucky enough to witness: being able to dunk a broken paintbrush in a muddy vat of ancient paint. How do you like to replicate that kind of intentional mess in digital? Can you talk through some of the brushes and techniques you use?

E: Totally. I give a lot of credit to one of my digital drawing friends Aaron Sherko because we did a big project together, and he very sweetly made me a brush pack based off previous things he'd seen me do in my art. It was really helpful. One of them was literally paint splatters. Being able to customize brushes is a good way to get things a little closer to your organic roots as a painter. Also, I made a couple of palettes that are just like gunge water, the various swamp gross that you find in the bottom of my paint water.

J: On a slightly different note, of course we know that the pandemic shut down our industry and a lot of artists needed to or took the opportunity to pivot to other sources of income or expression. Can you talk a little bit about your journey and how painting was a part of some pandemic pivots you engaged in?

E: In a normal season, the idea of settling down with a new piece of technology and learning from the ground up would terrify me and I would just start seeing all of the dollar signs of lost money. Honestly, the pace of our production schedules for anybody who is making it as an artist was, pre-pandemic, in such an unhealthy space that any kind of remedial learning was going to set them back a lot. It was terrifying to me, so I put it off until the world shut down and all of those excuses just evaporated. I realize, like we said before, the industry is not going backwards. If anything, things are just getting faster and faster. If I'm going to keep

up, I'd better keep up. I took the time and, because I know myself, and I know if it was just homework to execute it, I wouldn't do it. There had to be some stakes. There was a show I got hired to design, one of the very few that was popping up. It was 2021 by this point. I said, "Okay, I'm gonna draw this digitally for the first time. This whole show: digital. No napkin sketches, no nothing. All digital."

J: What show was this?

E: This was *The Threepenny Opera* at Atlanta Opera. You can see the sketches and how those still have kind of the same quality as my analog sketches. When you look at my sketches today, in 2022, they have a different flavor for each show. I freed myself up a little more. All of that to say, I needed the pressure of a project looming over me – at least one project – to keep me accountable. Now I have the time, I'm going to practice every day, and I'm going to go back to my fundamentals. How did I learn to draw in the first place? I went back to a lot tracing, a lot of gridding out things, using my eyes in a different way, but the same way. That's why it's so difficult to articulate bridging this gulf, because you're using a lot of the same tricks. If I didn't have a strong fundamental background of drawing traditionally, I think the gulf would have been a lot bigger.

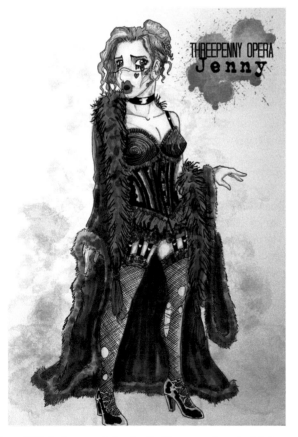

Figure 7.30 Costume rendering for *The Threepenny Opera* by Erik Teague. Atlanta Opera, 2021. (Credit: Erik Teague)

J: A lot of the work you do is in opera. Would you talk a little bit about why you, as an artist, are drawn to the form?

E: I love opera, and anybody who knows me knows this. I love it because it requires extreme technical precision from every aspect. Musically, precision is key. The training is key. The ability is key. And design wise, things have to have such a great specificity and breadth. I love being able to work in an art form that expects so much of its performers, its designers, its technicians. When you're in the same room as a singer with a full orchestra and you can feel their sound vibrating in your chest, it's that same electricity that brings me back to live theater every time. We're experiencing an emotional, physical thing together. I'm not a jaded audience person in that way. Every time I go hear a singer who really lays it all out on stage, it's extremely moving. That's why the art form needs to survive. It's a very human experience. It seems unattainable for a lot of people for a lot of reasons that I find silly. The great operas are about things we can all relate to: love, death, fear, compassion. They're about the human experience. We've just gotta get off the high horse, culturally.

J: As a designer thinking about this art form that tells stories of the human experience, what is your role there in realizing the humans at the center of it all, while also meeting this expectation of "every artist at the top of their game" and the general level of grandeur that an opera audience may expect?

E: You've gotta make them relatable. Your audience walking in might not speak the same language, they might not know anything about this piece other than the synopsis that's in front of them. My job as a designer is to tell the story in a visually relatable way. Whatever lens we're seeing the show through – it could be sumptuous, it could be stark – whatever it is, it needs to be relatable. I try to find the human in the story as much as possible.

J: How does rendering help you along the path to those discoveries, in finding those human, relatable moments between the characters?

E: When I'm drawing, I'm thinking about why a person would choose to wear what they're wearing in this world. Why does Carmen wear what she wears? She is the embodiment of sexual freedom and power. She can wear whatever she wants. Even if she wears a burlap sack, Carmen is going to exude the most sensual power on that stage. So I'm making sure that there's something to connect to in whatever style we've decided, as a group, to use on the piece. Drawing is a huge part of getting into the mindset of the character, for me.

J: Do you have any examples from your *La Bohème* at The Glimmerglass Festival of those realizations or discoveries you made during the drawing process?

E: I love that show because people don't often let me do straight period shows. *La Bohème* was a great opportunity to show yes, I can do this, it's not all monsters and weird stuff and animals! I promise you I can do a faithful 19th-century

look. One of those "ah ha" moments was drawing Mimi's arc. She starts as a fresh young thing who is brand new to the scene in Paris. She's a seamstress, she wants to ply her trade, and earn an honest living. She falls in love with a penniless poet, like you do, and they have an on again/off again, tempestuous relationship. It's one of the aspects of love that I think everybody can connect to. She ends up destitute. She comes down with tuberculosis and is eventually claimed by death. She goes on this arc from beautiful, fresh, and young into death. I was thinking a lot about flowers blooming and decaying in fast, time-lapse time. Because of her nature as an artist, her given circumstances, she would probably show up to the city wearing her best clothes, and it would be something she made. I leaned into her as a seamstress and an embroiderer by having her embroider roses on all of her stuff. That was her symbol. That became her prevailing idea, that she's coming to the city to bloom, but she ends up wilting. You see the embroidery in her costume change from roses to death lilies as she gets closer to death, but it still looks like something she has done herself, by hand.

J: Those ideas emerged for you as you were working through the sketches and the drawing process?

E: Yeah, just as I was drawing and thinking about things and listening to the music. Listening to how her point of view changes as she sings through the whole piece.

J: That idea, of listening to the music as you draw, allowing yourself to really immerse into the lives of the characters, is such good advice, which leads me to my final question for you. What advice do you have for young artists and designers who are excited to engage with this form?

E: If you want to get into opera, start studying now. Getting into rooms with tons of people who have lots of experience with these characters and this genre, you have to be able to hold your own. I came from a music background that made me study these things when I was in high school and college. I fell in love with them because the stories are great and the music is incredible. I came out of that with a self-imbued

authority to talk about the pieces. That's not to say that I know everything about opera; I absolutely do not, and that's part of the joy of life, is not knowing something. But being able to come to the table and have a richness of knowledge from the get-go will only help you to tell the stories better. If you like the art form, just dig in. There's an opera-a-day calendar that you could do just to dip your toe into the pieces, getting to know the repertoire that you might be asked to design. Other things that are a little more brass tacks: if you want to get into the industry and really start making a name, find people whose work you admire and try to work with them. I know that seems like a reductive, silly, thing, but the worst that can happen is an unanswered email.

J: What about drawing? What advice do you have for people who are coming into the industry without an art background? Do you have advice specifically relating to that?

E: Catch up! Get into a figure drawing class because, no pressure, but a lot of things ride on the communication tools that you have. That includes whatever comes out of your mouth and whatever you can show on your sketchpad or your tablet. If drawing is not your strong suit coming out of the gate, fine. Figure out collage and other ways you can still get your ideas across in a beautiful way. But there's no substitute for good drawing, so get into those figure drawing classes. If they're not available, get reference pictures and start teaching your eyes and your hands to live together.

Further Resources

www.azosensors.com/article.aspx?ArticleID=324
www.cnet.com/tech/computing/how-to-calibrate-your-monitor/
www.digitalartsonline.co.uk/features/creative-hardware/how-to-calibrate-your-monitor/
www.pcworld.com/article/394912/how-to-calibrate-your-monitor.html

CHAPTER 8
Photo Bashing

What Is Photo Bashing?

Photo bashing is a term that describes all the ways that we create images in software by editing and adapting source photographs. While this book is primarily focused on digital painting, it is valuable to look at these techniques, as they can be blended with paintings to create spectacular effects.

The idea of using remixing photographs to create something new is the digital version of collage or photomontage. Originally an analog process, cutting found images apart and using the pieces to create a new image is a technique with a long history. Now, environmental concept artists and others use photographs combined with digital photo editing tools and digital painting to create fantastical landscapes. Many of these tools and processes can be really valuable to theatrical artists.

Many of the specialty software tools discussed in this chapter are specific to software intended for photo editing, like Adobe Photoshop. Advanced selection tools, dodge/burn tools, and adjustment layers are some examples of tools that, as of the time of this printing, are not universally included in digital rendering software. Rather than exclude these tools for the sake of universality, they're discussed here in the hope that you'll seek them out or that they'll become available across more software platforms as the technology continues to evolve.

Figure 8.1 Photographs from diverse sources are fused to create one fantastical image in Tao Wang's design for *The Princess Plays*. (Tao Wang)

DOI: 10.4324/9781003212836-8

Photo Bashing Tools

There are several tools that most software programs have that accomplish things quickly and easily in ways that are not possible in painting-inspired processes:

- **Fill tool/paint bucket tool:** This tool, common to many programs, allows you to fill an area with a color (or pattern) quickly, with a boundary set by the difference between the area being filled, and areas of differing color or contrast.
- **Gradient tool:** This tool allows you to quickly and easily draw a smooth transition between two or more colors in a large area according to different styles of gradient, such as linear gradients, radial gradients, and more. Creating such a perfectly smooth transition in an image has long been a technique that is difficult to master in painting.
- **Vector shapes:** Likewise, the ability to create perfect shapes that can be easily edited at any point, such as circles, rectangles, and others, is something that is not easy to do in traditional media techniques. Michelangelo, in one (probably apocryphal) account, once demonstrated his artistic ability by drawing a perfect circle without any specialized tools. While drawing a perfect circle in digital painting or photo-editing software isn't as impressive, it's still a valuable tool.
- **Selection tools:** The wide variety of flexible, highly configurable tools for selecting parts of images to cut, copy, and paste is integral to photo bashing. These tools may vary based on your software, but likely include a magic wand tool that selects like pixels in an image, a freehand selection or lasso tool, a freehand geometrical selection or polygonal lasso tool, and a geometric shape selection tool. Warping tools, often housed with selection tools, are crucial to photo bashing. There are more details on selection tools later in this chapter.
- **Type tools:** Some software allows you to create vector-format, readily alterable text. Not all type tools provide vector-based text, so if that's important to your design, make sure you know your text format.
- **Image repair tools, such as clone stamp, image heal, etc.:** Various tools allow you to smoothly and discreetly repair and replace unwanted parts of images, replacing them with information from elsewhere in the image.
- **Photography correction tools:** These tools may vary depending on your software, but typical offerings include burn and dodge brushes, hue correction, curves adjustments, exposure correction, color balance tools, and more. These tools allow you to make sweeping changes to an entire layer, or to focus changes on small areas with the help of the selection tools.
- **Filters and special effects:** While filters do not have a lot of applications in painting, there are many useful filters for photo bashing. The best filters are those used invisibly in an image, like blurring and noise tools; novelty filters that make your photo "look like an oil painting" should be avoided.

- **Layer effects:** This more specialized feature set found in Adobe Photoshop allows for the easy addition of consistent drop shadows, highlights, color overlays, bevel and embossing tools, and more. These features originated with the need to create attractive and uniform buttons for websites in Photoshop, but they can be useful in image creation.
- **Layer masks:** Layer masks are covered in more depth in Chapter 4. They are tremendous iterative editing tools and they are very useful in photo bashing.

These tools are the building blocks that will allow you to take elements from source photographs using varied lighting conditions and unify them into cohesive images.

Images for Use in Photo Bashing

What types of images work best for photo bashing? The answer is more technical than aesthetic: the largest, highest-quality images you can find are the only images you'll want to use in this practice. Remember that image resolution can always be reduced but not increased, so you'll need to start with an image that is at least the same size and PPI as your canvas. Usually, when you import a photograph into your digital painting software, it first appears at its 100% size in relation to your canvas. If your source photo appears and it is a tiny rectangle floating on your wide canvas, don't bother resizing it to make it larger. Making it larger will make it appear pixelated, and running any sort of changes to this image using photo editing tools will highlight the low quality of the image. Even if the image looks passable after resizing, any

Figure 8.2 Two images imported into Photoshop where they appear at 100% of their size in the canvas. The image on the left is large and high resolution, making it an appropriate source for photobashing. The image on the right is very small and low resolution, so resizing it to appear larger will highlight the poor image quality. (Author's own)

further editing during the photo bashing process will highlight the lower quality of the image, showing the pixelation as you run the image through filters, color edits, and warp tools.

As you begin the practice of photo bashing, start collecting an archive of images you like. Even if you grab something from the internet for single use, you may want access to the same textures in that photo later, on another project. Don't count on the internet to keep things where you've left them, or to deliver the same search results twice. Save everything you think may be useful, making sure not to compromise its quality by reducing the file size when you save. Save the images in an uncompressed format, if your hard drive or cloud storage space allows. Name your photos using a consistent naming convention, and keep them organized. You'll thank yourself when you're racing toward a deadline and don't have time to page through 600 unnamed photos. It can also be helpful to group photos by genre, i.e., "rocks," "meadows," "tropical greenery," "cityscapes," etc.

There are many places you can look for high-quality photos. If you have a subscription to a stock photo archive, that is a great place to start. Stock photos are typically high quality and provide access to diverse locations. Cityscapes, nature scenes, and architectural photos can all be helpful sources you'll find in stock photography. You will encounter a lot of stock photographs any time you use generic search terms during online image searches, but keep in mind that free stock photos are often either small or heavily watermarked to protect the artist who provides them. You can also try your luck at Creative Commons sites, but be aware that image attribution may still be a requirement for using these images.

Be cautious about using images from online sources without paying any subscription or use fees, as these images may be copyrighted by their artist or provider, and you may not have the

right to use them in your own work. You can use the work of other artists when you're experimenting or learning, but when you are being paid or when you intend to copyright your own work, you need to remain mindful of fair use laws.

If you do not want to subscribe to a stock photo site, try collecting your own source photos. You may not have white sand beaches with crystalline water or towering skyscrapers close at hand, but you might be surprised what you can do with local texture and color. Any time you see something texturally interesting, or a mundane scene with fabulous lighting, or something plain that could be dressed up in a number of ways, take a few photos and save them to your own archive. Constantly be on the hunt for source images while traveling, as many places have local architecture, flora, and fauna that can bring new flavor to your work. Many people have a decent camera in their pocket at all times, attached to their phone.

Photography Language

When taking your own photographs for digital use, it can be handy to have a little bit of photography vocabulary at your disposal. While you do not need to be an expert photographer to gather useful stock images for yourself, knowing how cameras process images can help you make better decisions about what to capture and how to process it. Here are brief explanations of useful photography terms that will set you up for success, whether you're shooting on your phone or using a DSLR, or digital single lens reflex camera, for the first time. This language will also help you to understand the photographic correction tools available in some digital painting software.

- **F-stop:** F-stop (fractional stop) represents the focal depth of the image, or the depth of field. F-stops with lower numbers have shallow depth of field, and will appear with the subject in focus and the background falling out of focus. If you have a portrait

Figure 8.3 Photograph demonstrating the effect of shifting your depth of field. A shallow depth of field, putting the focus on the subject (left). A high depth of field, bringing more of the image into focus (right). (Author's own)

Figure 8.4 The effect of shutter speed on image capture. The pinwheel on the left is photographed using a very fast exposure to capture movement, making it appear still. The pinwheel in the center uses a moderate shutter speed and appears slightly blurred. The pinwheel on the right uses a very slow shutter speed and appears heavily blurred. (Nevit Dilmen, 2004)

mode on your phone, it is simulating a low f-stop setting on a manual camera. If you increase your f-stop, more of the image will appear in focus. When taking your own stock photos, keeping more of the image in focus may not be as aesthetically pleasing, but it will make for a more versatile image.

- **Exposure:** Exposure measures the amount of time the film is exposed to the light through a camera's lens. Long exposure times in bright light bleach the film, overexposing it and failing to create a visible image. Long exposure times in low light can capture movement of a light across a picture flame in a blur, creating effects like a name spelled out with the tip of a sparkler, ghosts flitting through a scene, or waves melting into soft haze. Short exposure times are traditionally used to capture fast movement, such as in sports or nature photography. Adjusting the exposure of your digital images will not change the conditions in which you captured the photo but can adjust the appearance or amount of light in the image. If you are interested in taking true long exposure photographs, make sure you use a tripod to minimize movement of camera during the exposure; don't try to hold the camera still, as this will result in a blurry image.

- **ISO/film speed:** This is the measure of the film's sensitivity to light. Generally, the more sensitive a film is to light, the faster it can capture an image. Sensitive film is great for fast-moving subjects but can also appear grainy. Slower or less sensitive film is useful for portraiture, landscapes, or any subject that's willing to sit still. This can be useful for the digital artist because you can mimic the appearance of an analog photograph by adjusting the grain according to the subject.

- **White and black in photography:** In a digital photograph, the scale of values is bookended on either side by true black and true white. Much like in digital painting, true black and true white can be troublesome. Here, it's less an aesthetic problem and more an erasure of information. White in a digital photo usually represents a value beyond the sensitivity of the recording device, or completely lost information. Depending on the quality and sensitivity of the camera, black areas of the image may still contain information that can be revealed in post-production editing, but white areas are usually "blown out," or uneditable. Keep this in mind when shooting, especially with a DSLR. It is usually better to take a too-dark image than a too-bright one.

Photography's implicit bias is a well-documented issue. Camera sensitivity was designed for light skin tones as the default subject for capture and film development, so it's important to remember the implicit bias of your device when capturing images so you can make smart adjustments. As built, cameras have trouble with high contrast. Cameras also do not record dark-range (below 50% gray) tones with the subtlety or detail with which they can render light-range (above 50% gray) tones. It wasn't until the mid-1990s that Kodak provided quality control measures for skin tones other than fair white. It is important to remember this issue is inherent to film and not a problem to be solved by your subject. Bracketing your exposure, or taking photos that are both too bright and too dark, can help you create a composite image that shows every tone in your photo at its best.

In general, take your photos at the highest quality possible and store them in a lossless format. If you find yourself using photo bashing a lot in your work, it may be worth investing in a DSLR camera to help with stockpiling incredible source photos. If you are shooting with a DSLR camera, shooting in the RAW format will allow you to make drastic adjustments to the image without degrading it at all, but RAW images take up a lot of storage space. RAW images also require specialized software (like Lightroom) to process and convert them to more universal formats.

Photos taken in neutral lighting conditions will be the most useful to you, so wait for overcast days whenever possible. Diffuse natural light can be turned into anything, including harsh directional light; it does not work well in reverse. Remember that even the most mundane, everyday sights for you – a rotting wooden fence, a cracked curb, a flowering shrub, or a water-stained concrete wall – can become immensely useful in your photo bashing toolbox.

Selection Tools and Masking

Good photo bashing is like a good wig: you have to have pretty edges or everyone will be able to clock it. Selection tools are key to photo bashing, as they allow you to separate images from their source photos. Selection tools allow you to draw around a selected area of an image in order to extract part of the image for warping, color edits, resizing, or incorporation into an entirely new image.

Choosing which selection tool or mask you might use to extract the image you want from your source photo will make all the difference in the world. The key is to get sharply clean or uniformly soft edges, depending on the intended effect; avoiding halos or pixelated, rough edges is difficult, but key. Let's run down each selection tool, masking style, and some selection vocabulary in order to help you decide how to select from your source photos. Keep in mind that selection tools are usually only active on a single layer at a time, so if they're not working correctly, check to be sure you're on the right layer.

Selection Tools

Specific selection tools will be available depending on which software you're using. Below are the most common, broadly used selection tools present in most digital rendering software.

- **Geometric marquee:** These selection tools create a predetermined shape that can be resized as it is drawn. You can create a square, rectangle, circle, or single-line marquee with these tools. Marquee tools are great for quickly selecting large areas when you aren't picky about the edges. For instance, if you can see through a window in a photo bashed image, imagine that the window is cut out from the building layer. On the layer behind the building, you can add the interior shot. This tool can also be manipulated to create a manual perspective grid (see Chapter 6).

Figure 8.5 Public domain artworks and photos of model-quality pets can be used to create fantastical photo bashed compositions, as seen here in the work of designer Logan Benson. (Logan Benson)

Figure 8.6 A rectangular marquee can be used to select, move, delete, or selectively edit content within its geometric boundary. (Author's own)

Figure 8.7 Freehand selection allows the user to draw the selection box around a specific part of the image. (Author's own)

- **Freehand selection/lasso:** Freehand selection tools make it easy to grab organic shapes by drawing around their outside edges. This tool works best with simple or medium complexity shapes: it might be easy to select a shoe, but difficult to select a tree.
- **Polygonal selection:** This is a great tool for grabbing large shapes with hard, geometric edges, like buildings. Clicking or tapping your stylus will drop an anchor point, and the tool will generate a selection line between any two points. You can continuously add points until you close the selection at your starting point.
- **Magnetic selection:** The magnetic selection tool snaps to the nearest unified edge it can detect. While the tool isn't perfect, it is pretty smart about following the line you create. As you draw, clicking drops anchor points, which helps define the selection area and helps the tool understand sudden changes of direction. This tool

Figure 8.8 The polygonal selection tool is helpful for selecting areas that exist bounded by straight lines. (Author's own)

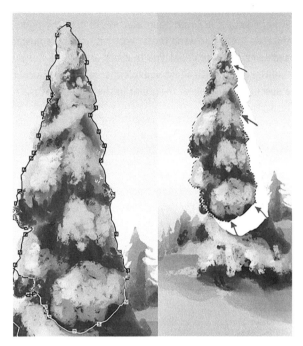

Figure 8.9 The magnetic selection tool guesses, based on contrast and color, where the edge of your image is. You can also drop anchor points to help the selection follow your stylus more accurately. (Author's own)

is useful for selecting medium-complexity shapes that have clear contrast from their surrounding visual material.

- **Magic wand/automatic selection:** The magic wand tool (it has different names depending on your software platform) asks you to click once, and then it will select an entire area based on color and value. For instance, if your figure is standing against a blue sky, clicking once on the sky will likely

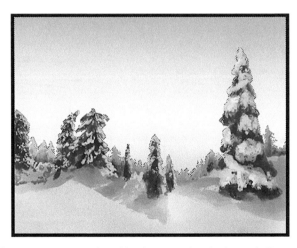

Figure 8.10 An area selected by the automatic selection tool. The automatic selection tool estimates a contiguous area based on color, value, and contrast *or* selects all the like colors in the image, depending on which software you're using. (Author's own)

151

select the entirety of the sky on your canvas, allowing you to either delete it or invert your selection to grab the figure instead. The magic wand tool's sensitivity can be adjusted, and some software allows you to check or uncheck "contiguous," which allows you to either select all of a color in a specific area or all of that color in the entire canvas, respectively.

Masks

- **Layer masks:** Layer masks typically function on the idea that black and white color, when added to a layer mask, will hide or reveal the image that is on a given layer. For instance, imagine a photograph of a performer standing on an empty stage. On a layer mask, you could either fill with white and paint over the performer in black to reveal the stage and remove the performer or fill the stage with black and paint over the performer in white to remove the background and show the performer on a blank canvas.

Layer masks also respond to grayscale paint, showing the masked image in translucency relative to the darkness or lightness of the gray. Layer masks are a great way to edit images non-destructively, especially when a photo bashed composition is still taking shape. If you make a selection using any of the selection tools listed above and then create a layer mask, the layer mask will automatically generate in the shape of the selection you've made. Layer masks are a simple concept with boundless complex applications.

- **Creating selections by using layer adjustments/blend if (Photoshop):** This is an advanced option for making complex selections, like pulling a tree from its background or removing the sky from a cityscape. Start by looking at your image with the channels menu open. Click on each color channel (red, green, blue) individually and look for the image where the item you want to select contrasts from its background the most. This will let you know which channel to use in creating the selection mask. Open the layer style window and look for

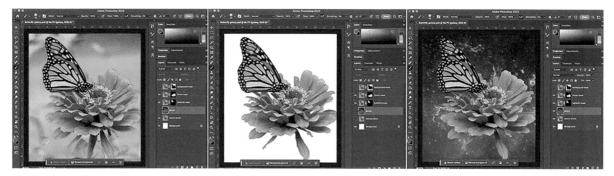

Figure 8.11 Layer masks use black and white color values to either hide or reveal parts of an image. Note the layer masks visible in black and white on the layer menu. The source image appears altered, but remains intact on its own layer. (Butterfly Photo by Derek Ramsey (2006), Galaxy Photo by NASA (2009).)

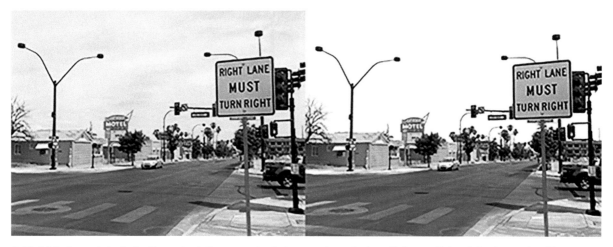

Figure 8.12 Original snapshot of a Las Vegas street. To remove the sky is a complex task given all the specificity of the signs and architecture, but using the blend if functionality on Photoshop makes crisp, clean edits for sky removal. (Author's own)

the blend If drop down menu. It defaults to gray, but you can change it to the color channel where you saw the right amount of contrast. Begin moving the slider from left to right on "This layer" in order to remove brightness from the channel you've selected, and you should begin to see this area disappear from your image. Close the layer style window and either use the magic wand/automatic selection tool to select the empty space, then select inverse or right click on your layer and choose "convert to smart object" to pop the selection to its own new layer. You can always rasterize the smart object later if you don't want to use the image this way.

- **Clipping masks/layer lock/alpha lock:** This tool has different names in different software platforms, but the functionality is the same: these masks will all make it so that any mark you make on a layer will only be made on activated, non-transparent pixels. Any transparent or unactivated pixels will be left blank. This is very useful when you're trying to add highlights, shadows, or color changes to a figure without affecting the entire canvas. These masks essentially prevent you from coloring outside the lines. Clipping masks do this on a separate layer, locking to the layer below the clipping mask layer. Layer lock or alpha lock locks the active layer. There is more information on clipping masks and layer lock in Chapter 4.

Active Selection Vocabulary

Once you've made your selection, there are some terms that will help you to understand how to navigate the selected area and what editing options become available to you.

- **Marching ants:** This term is commonly used for the animation used to highlight the selection area. You may hear or see it if you look at online tutorials. In some software, marching ants can be toggled on and off in order to keep them from obscuring the image during editing.
- **Inverse:** Inverting the selection allows you to move between the area you selected and the opposite/negative space of that area. Sometimes, it's easier to select something small, then invert your selection in order to select everything else in the composition. Inverting will also work on your masking layers, flipping the mask from hiding to revealing and vice versa.
- **Add/subtract:** Depending on your software, there are different ways to add to or subtract from your selection. On desktop software, you'll use hotkey commands. In other software, there may be a button or gesture to add or subtract from your selection. This is very helpful for selecting more than one area at a time in a composition, or for correcting selection errors.
- **Feathering:** Feathering is often shown as a control option for selection and masking tools. Feathering creates a soft blend between the selection area and the negative space, and you can usually control the feathering effect by determining how many pixels you will feather. A shallow feathering range of two to three pixels will barely soften an edge and help a complex shape melt into a new composition. A deeper feathering range can help meld two images into one, such as adding different layers of sky to one another, though you can also use grayscale gradient layer masking to achieve this.

Filters and Adjustments

Filters are tools that apply conditions broadly to an image, selection, or layer. Filters can be extremely useful tools, or they can be traps disguised as shortcuts. This section will cover some of the most useful filters and their uses as well as describing how to avoid rookie digital painting errors by using filters incorrectly.

Beware any filter that names itself after an artistic effect: brush strokes, mosaic, watercolor, oil painting, etc. These filters apply a one-size-fits-all effect over your image, and it will never look authentically like the thing it names itself for. For instance, you cannot paint a rendering in flat color and slap a watercolor filter over it to turn it into a watercolor painting. These filters make work appear amateurish and clumsy. The exception is a cutouts or posterize filter: this can be useful to reduce the number of colors in your image, turning it into a stylized screen-printed image, especially when paired with some overpainting using halftone brushes. Otherwise, leave the artistic filters to the side.

Image adjustment tools are necessary for unifying sourced photos in a photo bashed image. You can make adjustments to the image like changing its exposure, contrast, saturation, white balance, and color balance. If you aren't using Photoshop, look for photo correction tools in your software, as there will be at least basic corrections available to you. These can be especially useful when photo bashing, as they will allow you to change the exposure and color of existing photos. For instance, imagine you have an image of a forest in the summer, but you need for the leaves to be changing for the fall. You can use correction filters to reduce the amount of green in the image and selectively replace it with yellows and oranges. This can be done to the whole image, or parts of the image can be captured with selection tools or masks for targeted changes. You can also use adjustment tools to be sure the white balance, or the relative neutrality of the whites in your photograph, are unified as you marry photos together.

Perspective filters are incredibly useful for photo bashing. They will allow you to define a perspective plane within an image, like an interior wall. Objects pasted into that plane, like a painting, will automatically be reformatted to conform to the defined perspective of that plane. While this filter cannot extrude objects or rotate them

Figure 8.13 The verdant tropical greenery (left) is masked and adjusted to make the plants appear gray and dying. With some additional adjustments to the overall color temperature of the scene and a quick layer of fog, the source image takes on a whole new mood. (Author's own)

in three-dimensional space, it has many applications for flat objects added to 3D space: you can easily blend sourced images to add a street art mural to a building surface, cover a teen's bedroom in fandom posters, or add a texturizing image to a plain surface. Remember to adjust perspective-filtered items so they reflect the lighting conditions of your space.

Blur filters have many uses, both within photo bashing and in digital painting, and Gaussian blur is perhaps the most useful of all. Gaussian blur is generated mathematically and the effect is an adjustable softening and blending of your image. For instance, open a new canvas and paint three horizontal bands of color filling the whole canvas. Apply a Gaussian blur and slide the percentage higher and lower to see its effect in action. Gaussian blur is a great way to create an ombre, add a hazed lighting effect, and soften the halo around glowing objects. Other blur filters are more specific and may be useful under very specific conditions.

Adding noise to an image can, somewhat counter-intuitively, improve your print quality. Imagine your image features a sweeping sunset, with colors gracefully blending into one another as they sink toward the horizon. If you've ever tried printing an image like this, especially at a larger scale, you may have seen every imperfection the printer is capable of generating: slightly different visible colors as the ink runs out, banding, and streaking from the print heads. Sidestep these problems by adding just a hint of noise to your images prior to printing. Speckling the image slightly will break up any banding or printing errors and help your image to look more flawless on the page.

Used in moderation, **liquify** is a handy filter for nudging photographed shapes or patterns into the correct planes, helping them to appear three dimensional. Liquify can be effectively used to push a pattern in and out of the ruffles along a hem, or to

Figure 8.14 Simple bands of color can be blended perfectly by applying a Gaussian blur filter. (Author's own)

gently punch a pattern down into the tufting on a sofa. Used with a heavy hand, liquify can make streaky psychedelic patterns that make great woodgraining.

Different software platforms will have additional filters of varying complexity and usefulness. Open up a photograph and play with them to see how they might be useful in your particular practice.

Macros, Actions, and Batch Processing

Maybe you have around 200 photos you'd like to use as source material for a photo bashed composition, but you know they will all need to be edited in some way: maybe they need an adjustment of hue, an adjustment of color temperature, or you need all of them converted to a new file type. Rather than run all of these corrections one at a time, some digital painting software will allow you to record actions, then apply them to a large batch of documents. You may also want to think about single key shortcuts for actions you perform often, like undo.

Some software, like Photoshop, has these tools built in. Other software may require third-party applications or peripherals to support macros, like the Aoiktye programmable keypad for iPad. Some hardware, like Wacom devices, have on board macro

commands, like the button on the stylus or the buttons to the left or right of your drawing area. Wacom is also bundling tablets with Loupedeck pads, which can be programmed for macros or custom shortcuts. Generally, these buttons can be assigned to various repetitive tasks, like undo, copy, paste, or tool rotation. Employing these tools can really speed up workflow.

Actions

Check to see whether or not the software you're using allows for recording actions. At the time of this printing, Photoshop has this feature, but many of the iPad drawing applications do not. Actions allow you to record a process, like adjusting the saturation of a photograph or applying a filter you've created, so it can be quickly performed on multiple source images. You can even program "stops" in the action for parts of your process that need to be custom to the image you're working on, like applying corrective brushwork. Think of actions like a playlist: you can set multiple processes in motion, but they will happen sequentially, pausing whenever you need them to pause. An example of how this might be useful is for an artist who made a rendering set, then realized they needed to add title blocks and backgrounds to each one. The artist can record pasting the background into the back layer of the rendering, pasting a title block into the top layer, and then use that action on all of the renderings in the set. Menu and command locations are constantly in flux, so look for the most recent tutorials on how to record actions.

Whenever batching images, be sure to work from copies of your original images in order to protect them in case something doesn't go according to plan.

Batching and Image Processing

Once you have an action recorded, you can apply it using Photoshop's automate command to multiple documents. If you want to make changes to a batch of files without using a recorded action, you can do that using image processor. Image processor allows you to select groups of files and perform automated actions like changing all of the files in a group from.PSD to.JPG image types. You choose the file from which Photoshop will extract the images, then you select another file for the output. You can make a decision about how Photoshop should name the processed images, as allowing Photoshop to assign file names automatically will really speed up processing time.

Photo Bashing Techniques

Every successful photo bashed image starts with a cohesive plan. Simply tossing images onto a canvas can yield results that are

messy or look obviously collaged in an undesirable way. It also requires intention to add visual depth to a digital collage. Here are some techniques for creating a plan for your image, then working to be sure all of the images added to it become part of a cohesive whole. This list of techniques can be taken in order or used as needed to successfully build photo bashed images, but always start with the first item listed below.

- Start with a value sketch. Open a new canvas in the correct size and PPI for your final image. On a new named layer, fill the canvas with a midtone gray. Use a large, organic brush to build out your highlights and shadows until you have a rough layout for your scene. Making sure the value structure works in grayscale prior to adding color photos will help you make insightful editing choices as the image progresses. Remember to use selection and warping tools as you build your value sketch if you need to adjust things.

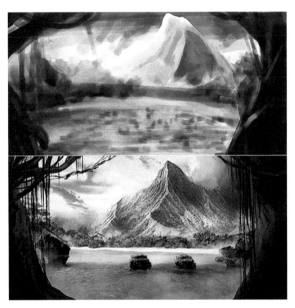

Figure 8.15 A value sketch will help to guide the construction of a photo bashed image, helping the artist to track scale and contrast as new content populates the image. (Author's own)

- Add photos one at a time, starting from the background and working toward the foreground of the composition. Map the photos to the value sketch. You can edit your source photos using dodge and burn brushes to gently bump areas of lightness and darkness. If you don't have dodge and burn brushes, try adding new layers with layer blend modes (multiply, add) to achieve the same effect. You can also edit the entire photo at once using brightness, contrast, exposure, hue, and saturation sliders.
- Check your composition in grayscale by periodically soft-proofing as you work because it's a good way to get a sense of your value structure. If it doesn't work in black and white, it

won't work in color. For instance, if your composition looks too flat, you might switch it to grayscale and see that it's all the same tone of gray. Contrast helps us to read a scene and understand two-dimensional form. Looking for your value errors in grayscale is sometimes much easier than spotting them in color.

- Make a practice of flipping your entire canvas horizontally as you work. The composition should work equally well when flipped horizontally. If it doesn't, try adjusting it before flipping it back to its original orientation. Compositional imbalances are often a result of the way our vision weights things differently depending on where they sit on a page, and flipping the orientation helps us to see things that our eyes have trained us not to see.
- Keeping a navigation pane open or periodically zooming out to check your value composition are both great techniques for making sure your composition is working. Sometimes, seeing the composition in a more compact frame will help you to spot problems.
- Photos do not have to be used literally. For instance, you do not need a photo of a cathedral in order to add a cathedral to your composition. Maybe you're going to use a photo of a stone fence, then build it into an entire structure. Maybe you took a photo of a really interesting crack in a sidewalk; that photo can become a structural fault in the aging cathedral. You have a photo of an interesting door that you saw on a courthouse, and that becomes your main entrance. The door photo can also be edited to create arrow-slit windows. Think of your photo archive as a parts warehouse, not a list of specific items.
- Remember the effects of atmospheric perspective. Parts of the composition that are furthest from the viewer will have fewer details and less of a dynamic value range. Often, things seen at distance are more cool colored, with items in the foreground appearing warmer colored. Focus tends to soften slightly at a distance, and the sky changes color near the horizon at all times of day. Keeping these rules in mind can help create natural depth in your composition.

Figure 8.16 A photographed composition with atmospheric perspective. Note the color swatches, showing the same landscape features changing in color and saturation as they move further away from the viewer. (Author's own)

- Be sure decisions about light sources are true throughout the composition. It can be difficult to change high-contrast lighting conditions in a source image, so try to favor neutrally lit source images or source images that match the light source of your composition. Photos taken on an overcast day are the most useful. Reason through the effects of your light on every part of your composition. If you add a palm tree to a beach, in which direction would its cast shadow fall? Does the shadow need to undulate over the texture of the sand? Dodge and burn tools can be helpful to suggest directional light in a neutrally lit photo.
- Be sure decisions about light temperature are true throughout the composition. Different seasons, times of day, weather conditions, lighting sources, and geographic areas have different color temperatures. Summer sunlight is warmer (more gold/amber) than winter sunlight, which appears closer to a cool or bluish white. Now that your shadows are all in the right place, make sure they're all saying the same thing in terms of temperature. Is the shadow a blue late-afternoon shadow or a golden morning shadow? Shifting the color balance can help to correct color temperature in your source images to make them all cohesive.

Looking for a quick way to make a shadow of a complex object, like a tree? Use selection tools to outline the object, then create a new layer. Fill the selection with a light gray-violet color, then set the layer to multiply so it creates a transparent shadow. Rotate the shadow so it is emanating from its source, but laying on the ground. Then, use skew, distort, and warp tools to reshape the shadow along the ground, conforming to the perspective and textures in your image. Depending on the closeness of the light source, you may want to add a tiny amount of Gaussian blur to soften the edges of the shadow.

- If you aren't sure how the areas of your composition will work in terms of visual perspective, add a perspective grid to help you map things correctly. Selection and warping tools can tweak perspective in source images, but it is very easy for the human eye to spot perspective errors. If you're unsure, check your work against a grid. To review the use of perspective grids, revisit Chapter 6.
- Remember to alter scale appropriately for the work. If you're creating a surreal landscape, there may be fewer rules about relational scale between objects. If you're aiming for realism, use research images of like locations to help govern your decisions. The human figures probably shouldn't be as tall as the castle turrets or the image won't read realistically.

Figure 8.17 A digital fabric swatch has been pasted into a drawing of a full skirt. On the left, the fabric has been left flat. On the right, the fabric image has been warped to help it align with the shapes in the drawing. (Author's own)

- To create more dynamic compositional lines, use the warp tool! Warping high-quality images leaves minimal digital residue. If you have a flat sky with horizontal clouds, it may be too realistic for your "I Want" song moment. Try warping the sky so the clouds radiate from where the main character will be standing to add more excitement to your photo bashed compositions. This is also really helpful for photo basing clothing. If you download an image of a border print fabric and lay it over a full, tea-length skirt, it will flatten the image. Warping it to add roundness to the shape of the fabric will help it appear more dimensional in your rendering.

- Look to your edges. Remember that when we look at the world, we see a mix of hard and soft edges, and your digital composition should work the same way. Mountains silhouetted against the sky have hard edges; clouds silhouetted against the sky have soft edges. When using selection tools to gather soft-edged shapes for your composition, try setting the edges to feather for a few pixels in order to soften harsh lines. If you don't have this option, make your selection, then run a soft round eraser around the edge of your selection from outside the marching ants line. Try to avoid using the magic wand tool for selecting complex forms like trees; the jagged pixel edges are always a giveaway, and they take a lot of work to paint out. It's better to grab the more general form, then support the edges with some clean painting in order to provide crisp silhouettes between areas.

- This is a tip that comes from the world of concept art: try adding layers of barely visible mist to separate compositional elements, especially as they recede into space. Choose (or build) a realistic cloud brush. Choose a near-white color that works with your compositional colors, and reduce the brush opacity to a low percentage. Select a compositional element that represents a change in depth or distance in your image, then invert the selection. Paint light

Figure 8.18 Adding soft mist between compositional elements can create a sense of distance or mystery. (Author's own)

mist "behind" it to create mystery and distance between the element and the areas of your composition that you want to sit further behind it.

- Duplicate repeating elements instead of re-painting or re-selecting them. With digital painting software, you can duplicate the same element over and over again within your image with ease. The simple way to do this is to use a selection tool, then a copy/paste command. You can also duplicate an entire layer. If you want more advanced control, you can also use features such as smart objects in Photoshop, which have a number of advantages. Smart objects are essentially Photoshop documents that are embedded (or linked to) inside of other Photoshop documents. This means you can have a smart object that repeats throughout the same file, or across several files. If you edit the smart object and save the image, it will be updated in every instance in that file. Imagine that you have an image of a tree with apples on it. Now, imagine that each apple is actually a smart object; that is, each apple is a linked copy of the same Photoshop document that is repeated throughout the tree. Imagine you want to change the fruit on the tree. You would open the smart object apple file and change the image inside to an orange. Save it, and close. Immediately, every instance of the apple smart object in the tree file is now an orange. It can be helpful to use smart objects for repeating details like rivets on metal or repeating architectural details on paint elevations. This allows for tremendous flexibility.
- Paint liberally! Paint to fill holes, to ease transitions, crisp up your silhouettes, and to add missing elements. Photo bashing and painting do not have to be mutually exclusive.

Figure 8.19 Designer Maki Niikura's rendering for The Devil tarot card is a hybrid between digital painting and photo bashing, showing how the two approaches can live harmoniously in the same image. (Maki Niikura)

Applied Skills Tutorial: Creating a Desert Drop

Concept and film artists create matte paintings as backdrops for the action, often adding animated elements in post-production to help bring them to life. Here, we'll use similar techniques to build a photo-based desert scenic drop suitable for digital printing or projections. For my source material, I'll be using a collection of photos I took near the Colorado River in Arizona as well as some supplemental images taken in parks around Memphis, Tennessee.

1. Start by collecting information. What proportion should your file be? Make sure the dimensions you use match the stage proportions. You may not be able to use the exact stage dimensions (unless your computer is massively powered!) but keeping the same image ratio will help. Also consider the quality of your source images and make sure you're not working to a scale that can't be matched by your photos. Make sure the document you open is at least 300 PPI. For the purposes of this case study, I will be using all photos I took on my iPhone 11, and my document will be 12" x 5" at 300 PPI.

2. Assemble a collection of likely images. Pull them from subscription stock photo databases or your own collection. Remember to check the usage rights on any images you are using that don't belong to you, including those sourced "for free" online. It is also always helpful to have reference images. Reference images are not images you will directly use in your photo bashed composition, they are images that give you an idea of your final outcome.

3. Create a new layer in your document and name it "value sketch." Create a rough value sketch of the composition you want to see. Remember, if the composition doesn't work in grayscale, color will not save it! Remember to flip your work from left to right as you work to check compositional balance. The value sketch doesn't have to be tremendously detailed, but it will help you map your images successfully and keep an eye on your value scheme. Use reference images to help remind you of the image's needs, including atmospheric perspective and relative scale.

4. Create a new layer over your value painting. When building a photo bashed matte painting, I like to work from the furthest-back object in the composition, but not the sky. Adding the sky now will make it difficult to see your value sketch, and it's better to do once you have a better sense of the objects in your composition. Thinking of the composition as a series of panes (or layers, I suppose), add the most distant mountains first. Work to make sure that edges that will be seen in the final composition are beautiful, but don't fuss over edges that will be covered by successive layers. For instance, the crests of the mountains will be seen and should be pristine. The bases of the mountains will likely get covered in scrubby brush and can be left rough, at least for now. Use warping, resizing, and rotation to make the shapes fit your composition, but make sure the surfaces of those shapes don't get too distorted in the process.

5. Once the mountain layers are in place, it's time to make them look like they're extending deeply into space by enhancing the atmospheric perspective of the layers. Let's take this in three panes.

 a) Furthest distance: These mountains should have the least contrast and detail. Use image adjustment sliders to reduce the contrast, bringing the mountains to a middle/50% gray value. This should also soften any surface detail on the mountains. If too many details are still visible, try selecting the mountains (so there is no change to their outline) and running a very low percentage Gaussian blur filter on the layer. Use the color balance sliders (or better yet, a curves adjustment layer, if that option is available to you) to shift the color of this layer cooler. Remember, things further from us seem blue because we're viewing them through our atmosphere.

 b) Middle distance: These mountains should have a medium amount of contrast and detail. The color may still shift cooler, but not as blue as the furthest mountains. You may still take the detail and contrast down using image adjustments.

Figure 8.20 A sampling of photos taken during a trip into the Arizona desert will be the source imagery for this photo bashed composition. (Author's own)

Figure 8.21 This value sketch will guide the construction of the final image and provide a reference point for placing and scaling source imagery. (Author's own)

c) Nearest distance: These mountains should start to reveal more about the landscape, including some boulders, some scrub near their bases, and more contrast than the other two layers. You may still want to slightly soften the contrast to help keep the attention on the foreground of your composition.

d) Unify your light source: Look over your mountains and make sure the lighting is consistent. Overcast-day photos are the best for this reason, as you'll be able to edit the lighting to suit your needs. If you want to make the lighting more dramatic than it appears, try the following ways of painting into the mountain layers:

i. Paint highlights into the scene. This is the most straightforward way to work and will be available to you no matter what software you're using. Sample the edge colors on your rock formations and choose a color that's a little brighter and a little warmer than the source color. If you work on a new layer using one of the lighten layer blend modes, your painting will still be responsive to the values of the photograph.

ii. Try using dodge and burn brushes. Named for their equivalent processes in film development, dodge means to selectively block an area of the print from receiving exposure and burn means to cook a section of the print just a little longer to increase the exposure in a specific area. Dodge will lighten exposure in targeted areas, while burn will darken. It's a great shortcut to changing the values in your photos using a brush instead of addressing the whole layer.

iii. Use adjustment layers and masks to create specific lighting effects. Create a curves adjustment layer, then lift the diagonal line toward the upper righthand corner of the curves grid. This will increase the highlights in your photo. Set the layer mask to hide (make it all black), then use a brush loaded with white paint on the masking to "reveal" the highlighted adjustment layer.

6. Add a ground. The ground can be tricky, especially if you don't have great source images for it. I found that all of my photos focused on the beautiful rock formations and not on the wide swaths of desert, so I had to build my own ground. When you're working from a small area in a source photo, simply enlarging it won't work. The scale will become imbalance and you'll likely start to see the image quality degrade. Here is one way to create ground from inhospitable photos:

a) I cut out a section of a photo that looked like desert ground. It wasn't large, so I copy/pasted and tiled it until it was larger than the ground area on my canvas. It helps to flip or rotate the tile as you're pasting to make the ground less uniform. Once the pasting was complete, I merged the pasted images to one layer named "desert ground."

b) Using a heal brush (clone brushes would work here, too), I went through to blend out any hard lines or repeating elements in this layer. The human eye is extremely good at spotting patterns and repeats, so this will likely take a few passes. Remember, if you're working zoomed in, keep the navigator panel open in the corner of your screen, or zoom far out periodically. The flaws are easier to spot at a

Figure 8.22 Even a small source area for a photo can be manipulated to make a larger textured area. Here, a small amount of rocky ground is expanded using copy, paste, flipping, and rotation (top). Then, the area is layered over itself (middle) to close gaps. Finally, healing and cloning are used to patch repeating patterns and to make a large area of similar texture (bottom). (Author's own)

distance than they are close up. (Note that you shouldn't use a smudge or blending brush here. Softening the pixels will lose you the photographic quality of the source image and may make the ground stand outside the rest of your composition.)

c) Once the healing is complete, you will still see the rhythms of your pasted image visible on the ground. To break this up, copy the layer, paste it, and flip it

horizontally. Reduce the layer opacity until it's translucent. Repeat, rotating and/or flipping the layer in different directions until the ground looks perfectly imperfect. Merge the ground layers.

d) It's likely your ground looks two-dimensional, or like it's facing the viewer instead of moving off into the distance. As a final touch, try selecting the ground and distorting it or running it through a perspective filter. This will shift the texture on the ground so it appears to move away across a flat plane. You may find that this distortion makes your ground layer too small. If this is the case, go back to the two-dimensional version, tile, and repeat the layering process until you have enough ground to vanish into the horizon.

e) Using a clipping mask, paint into your ground layer so that it gets a little darker/dimmer as it moves away from the viewer. I like to do this on a layer set to the layer blend mode multiply. This adds another layer of dimensionality and distance to the composition.

7. Add your foreground elements, including brush and boulders. This is a great time to layer more texture into the composition and to use photo bashed elements to hide any "seams" in the layering. Be sure you're continuing to align the lighting conditions and values of the new photos in the composition. Remember, the objects in the composition that are closest to the viewer will appear largest. It can be helpful to use scale figures at different depths of your composition for reference.

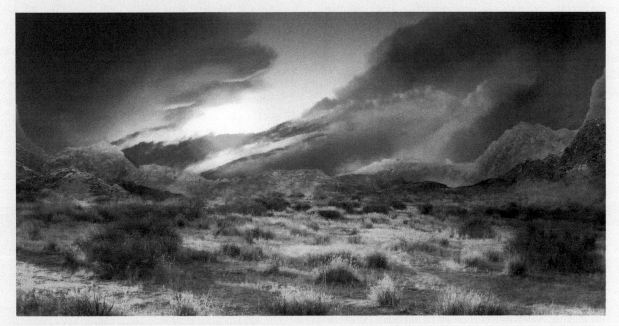

Figure 8.23 The finished desert drop composition, constructed from various photographs. (Author's own)

8. Make sure that your foreground elements are all casting shadows in a direction consistent with your light source. Also, think about the length and color temperature of the shadows as they relate to your time of day and time of year. Multiply layers are great for shadows because you can paint the shadow and maintain translucency.

9. Check your atmospheric perspective. Objects furthest from the viewer should be lower contrast and a blue-toned. Objects closest to the foreground have more visible detail, dynamic contrast, and warmer colors. Making adjustments can help to add a sense of sweeping space to your composition.

10. Once your background, ground, and foreground are in place, it's time to add your sky! Open a new layer behind your other landscape layers, but in front of your value painting. Drop a sky photo in, but you don't have to leave it as is. Here are some ways to pump up the drama on your sky:

a) Use the warp tool and/or the liquify filter to nudge your clouds into a more dynamic, heightened arrangement.

b) Use adjustment layers or color adjustment sliders to bump up the saturation or color story of your sky. You can use the gradient tool combined with a layer blend mode to shift the color of your sky without repainting it. If you want your sky darker, you can use the multiply layer blend mode; if you want your sky lighter, try color dodge or add.

c) Think about a sun, a moon, or stars in the sky. Celestial bodies can be added using the glow effect process described in Chapter 4 to create halos of light.

11. For last looks, save the document and close it. Walk away from the project for at least eight to ten hours, then reopen the document. You may see things that need to be adjusted that you missed during your last work session. Sometimes, all you need to put the finishing touches on a project are fresh eyes.

Do you want to make adjustments to several layers at once without merging them? Try putting the layers into a layer group. Layer groups can be adjusted and moved without merging or collapsing your layer structure. You can also lock layers together so you can't move one without also getting its locked partner(s).

Applied Skills Tutorial: Creating a Photomontage Costume Rendering

Some costumers prefer to create photomontage or collage renderings. These techniques can be especially useful when working with modern clothing, but it's a very lengthy practice. Finding clothes that can be positioned to match a photographed body is tricky and can result in either compromises made to the design based on available photos or slightly wonky renderings. Below are steps to follow in order to take photographs of clothes, accessories, hair, and shoes and turn them into a costume rendering.

1. Begin with a high-quality photo of your performer (or someone who looks enough like your performer), pictured from head to toe. If this isn't available, you may want to find a photo of a body similar to that of your performer. Preferably you should seek out an image of a body wearing minimal clothing, and graft the face onto it. Do this by using the lasso tool to select the performer's face, being sure to include the hairline and the top of the neck. Resize the body until the two are correctly proportioned to one another; it can help to make one layer less opaque so you can see how they lay over one another. Adjust until the proportion and placement looks right. If the face is not lined up accurately with the position of the head, you can use warp (or puppet warp, if it's available to you) to nudge the face into position. If it isn't a repositioning issue that's solved by a nudge, you may have to choose a different body, as it's

not possible to rotate photographs in 2D space. If the seams between the two images are visible, don't worry too much about it. You can lightly smudge them if you'd like, but don't worry too much about blending or color correction yet.

2. Begin adding clothing to the body. Import your clothing photos to the document. It's preferable that the photos you're using were taken on a body, not on a hanger, so the dimensionality matches the form. It matters less that the clothes are the right size for your performer, as it's easy to warp the clothing larger or smaller to fit. Once each clothing item is placed, run down the following list and check for believability errors:

a) If the clothing has been resized, does the aspect ratio look correct or does the clothing look squashed/stretched?

b) Make sure the clothing fits the body. For instance, you might nudge a curve into a skirt waistband in order to help it sit on the body more believably. You may have to bend the arm on a garment completely to fit the pose of the wearer.

c) Make sure that nothing is visible that wouldn't be seen. For instance, if you're adding sandals to the feet, make sure to delete the inside of the shoes that would be filled by the feet when worn.

d) Make sure that the clothes move around the body. Adding a lip where you can see the shirt sleeve looping around the arm helps sell the rendering as dimensional.

3. Use the warp, resize, and selection tools to fit the clothes to the body, working as you would in a fitting. Start with broad corrections (resizing) at the top of the body, then move down the body, correcting as you go.

Figure 8.24 The clothing pieces as they appear when dropped into the image (left). The clothes have been "fitted" to the body using selection and warp tools (right). (Author's own)

4. Repeat this process until the character is fully dressed in all clothing pieces, shoes, and, if using, a hairstyle. Do not waste time with color or lighting corrections yet, but know that major shifts in lighting directionality or exposure will be difficult to correct.

5. Once the character is fully dressed, pop all of the named layers into a layer group and name it "original pieces." Duplicate the layer group, naming the new layer group "merged pieces." Merge the "merged pieces" layers into a single layer and desaturate it to remove all color.

6. Now that the image is in grayscale, it will be easy to make corrections to blend layered selection areas, fix minor exposure issues, and unify the directional lighting.

 a) To fix areas that need better blending, use a combination of smudge and brush tools to correct any areas where the overlaid images don't quite work together. For large or textured areas, you may want to try a clone or heal brush.

 b) To fix minor exposure issues, there are many solutions depending on the software you're using. Even the simplest software usually offers an exposure or contrast slider that can be tweaked. If you want to focus your corrections on a specific area of the canvas, use the selection tools to capture the area that needs correction. If you're using software with more advanced capabilities, you can use the curves adjustment menu to remove the darkest darks, dim the lightest lights, or lift the low midtones. Click and drag on the curved line on the curves graph to make these adjustments. It can be raised, lowered, or shortened from the left and right sides of the graph.

 c) Unifying the directional lighting can be done in several ways. If your software has dodging and burning brushes, they're a great way to swiftly add more nuanced shadows and highlights, especially when working with grayscale images. If you don't have this functionality, turn to layer blend modes. Drop two new layers over your merged image. Set the lower of the two to the multiply layer blend mode. Set the upper of the two to the color dodge/add blend mode. Using soft airbrushes at low opacity, brush in your shadows and highlights. If you don't have access to layer blend modes, use layer lock/alpha lock and airbrushes set to low opacity and low flow. Work in thin layers, being careful not to lose your textures as you paint over them.

7. If there is anything you'd like to add to the costume (for instance, the hand has been shifted from the original pose in order to hold the parasol), it's easiest to do when the image is in grayscale. Paint or paste in any new decorative items. Be sure to think about the ways in which the new items interact with the clothes. For instance, both the added collar and the added bow were given cast shadows on the blouse to help them appear anchored instead of appearing to float over the shirt.

8. Prior to moving to color, be sure your image contains little to no solid black or solid white. These colors do not play well with overlay coloring, so knock blacks down to a soft charcoal and dim your solid whites to a pale gray. You can do this with paintbrushes or by adjusting your image in one of the menus described above.

9. Once the image is patched and corrected, it's time to start reintroducing color. Drop a new layer over all existing layers and set it to the overlay or color layer blend mode.

10. Begin laying color over your grayscale image. Getting the color right will take a little trial and error, as the colors will usually read as more saturated and light on the overlay than they do in the color well. If your paint job is complex, be sure to swatch colors that you use on a palette layer that isn't set to a layer blend mode, as the visible colors on your overlay layer do not correspond with the colors that created them. (If you forget to do this and desperately need to reload a color, turn the layer blend mode to normal, swatch the color, then return the layer blend mode to overlay.)

Figure 8.25 The costume rendering is easy to correct for value adjustments and lighting conditions when the image is desaturated. This is also the best time to paint in additional elements, like bows and trim, prior to adding color. (Author's own)

Figure 8.26 The costume rendering is finished by painting color into the clothing, skin, and hair using a layer blend mode like overlay or color. (Author's own)

11. It can help land your character in the void if you paint in a light shadow where the character's feet hit the ground. When determining the placement, size, and sharpness of your shadow, take the lighting on the performer's clothing and face into account.

12. Take your last looks by flipping the canvas horizontally to check for balance errors, then (time permitting) close the document for at least a few hours before reviewing and submitting it. You can grow accustomed to mistakes, and

sometimes stepping away from the work is the only way to spot them.

Stylistically, you can decide that you want to create renderings that deliberately break the rules of perspective, scale, and human posing. These intentionally broken renderings can be emotionally charged and interesting, but difficult for technicians to parse and misleading to directors, who may expect to see a similarly abstracted costume on stage. Finding the balance between artistic expression and effective communication is key for any costumer with a rendering practice.

Further Resources

helpx.adobe.com/uk/photoshop/using/default-keyboard-shortcuts.html

www.nytimes.com/2019/04/25/lens/sarah-lewis-racial-bias-photography.html

CHAPTER 9

Living with Digital Painting

Advantages and Disadvantages of Digital Painting

Having covered the mechanics of building a computer setup, a physical studio, and a digital painting practice, it seems a good time to generally review the advantages and disadvantages of going "all in" on digital rendering. If you are reading this text prior to engaging with digital painting, this list should help you determine how much to invest in this process as you convert your practice and what to be aware of that may be different than working in traditional media.

Advantages

- **Undo:** Perhaps the best feature of digital versus traditional media rendering is the Undo command. Being able to try something, dislike it, and remove it from your canvas is a revelation for artists, and frees you up to make bolder, riskier rendering choices. Consider whether your confidence as a painter or renderer hinders your ability to express your design ideas. Digital rendering may help to build your confidence simply by allowing you to take steps backward as you paint.
- **Long-term cost:** While it is expensive to set up your digital rendering studio, the long-term cost versus traditional media supplies can be advantageous, especially considering that good digital rendering software will provide an entire art supply store's worth of options to you. Your markers won't dry out, you won't need fresh paper for each project, and you won't be restocking your brushes. Consider how much you spend on art supplies and balance this cost against how often you would need to replace your hardware, the cost of your software, and how much you intend to spend on peripherals.
- **Media variety:** Rather than buying art supplies piecemeal, good digital rendering software will provide you with an entire art supply store. Consider that a good selection of art markers can cost upwards of $400. Multiply digital rendering's color range by its potential media options and you get nearly endless choices.

You can also blend media that wouldn't necessarily blend in traditional media work, like oil paint and colored pencils.
- **Flexibility:** Non-destructive editing using masks and iterative saving compound the freedom of the Undo command. Iterative saving allows you to return to earlier versions of your work, and editing tools allow you to change body shapes, colors, atmospheric effects, and more, even after your renderings are finished. Additionally, there are other freedoms to consider: ease of file sharing, portability, media options, scale of media, and more.
- **Industry standards:** Digital rendering is swiftly becoming industry-standard due to its ease of sharing and flexibility. This toolset doesn't seem to be a momentary trend; instead, it's the way the industry is trending. It's also a crucial skillset for associate and assistant work.
- **Rapid sharing:** Finishing a rendering, scanning a rendering, and color correcting a rendering before uploading to a file sharing service isn't necessary with digital painting. Finished digital paintings can be uploaded immediately.
- **No precious paper:** A traditional media rendering has a preciousness to it. There is only one source copy, so it has to be handled with care and respect. This is not necessary with digital renderings. New copies can be made, allowing for shops to notate, sketch, and drag the renderings everywhere without fear of damaging the source material.
- **Clean, compact workspace:** Traditional media require dedicated space, and that space must be able to get messy. Splashes of watercolor, blobs of acrylic paint, smears of graphite, and glue residue are often the accretion of a traditional media workspace. While some artists relish the mess as part of their process, others don't have the space to easily allow for this type of material overflow. Digital painting studios are clean and can be quite compact, depending on your computer and peripheral setup. It is also worth mentioning that while many of the art supplies used in theatrical rendering work are low toxicity, not all of them are, and digital paints can be used without proper ventilation!

DOI: 10.4324/9781003212836-9

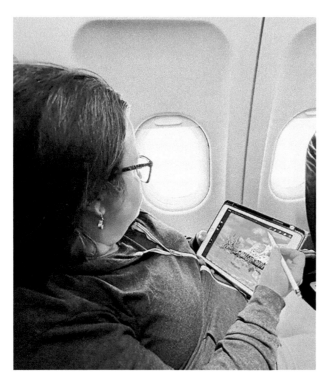

Figure 9.1 Designer Jenni Propst rendering at 30,000 feet. (Jenni Propst)

Disadvantages

- **Startup costs:** As we've mentioned, there is a front-loaded cost to begin rendering digitally. Perhaps you already have an iPad Pro and an Apple Pencil: you're lucky, and your investment might be simply purchasing Procreate. Maybe you already have a decent computer and only need to invest in a Huion pen tablet to give digital rendering a try. This won't be the case for everyone, and the initial outlay for hardware and software can be steep. It can also be difficult to gauge how much to invest if you're new to digital painting; what if you invest too little and the consequential challenges (lag time, poor performance) are too frustrating to truly evaluate the tools? What if you invest too much, only to learn it's really not for you? If you are brand new to the practice, please look over the recommendations in Chapter 3 to figure out the most cost-effective build for your studio. It's also extremely helpful to get your hands on the software and hardware you intend to purchase before investing in it, even if it's just playing on a device at your local retail store.
- **Electricity:** If you want to do all of your work in a charming, off-the-grid cabin, digital rendering is not for you. Unfortunately, electricity is not optional for this medium and none of the devices that can do this work hold a charge for more than a few hours.

- **Internet:** While it is possible to use digital painting tools offline, internet access is helpful and sometimes necessary. You will need access to cloud-based products, you will want to search for reference images, and you will need to download hardware and software updates. Internet access is fairly crucial to our industry in general, and digital painting is no exception.
- **Eye strain:** Sedentary work is a larger issue for rendering-heavy projects, whether they are digital or analog. Eye strain is a unique danger to digital painters due to the time spent staring at backlit displays. Be sure to look over the recommendations in Chapter 2 to protect yourself against eye strain and repetitive stress injuries as you work.
- **Data loss and storage:** Digital media can vanish unexpectedly due to user errors, hardware failure, or software issues. To avoid catastrophic losses, constant vigilance and backups are required. This can also require additional storage on internal hard drives, external hard drives, or cloud storage services. These practices can add additional time, responsibilities, and cost for the digital painter.
- **Hardware and software upgrades:** An expensive digital painting setup will not last forever. As hardware improves beyond the model you have in your hands, you may find your device unable to keep up with the demands of your software or your operating system. Some hardware choices are more obsolescence-proof than others; a pen tablet paired with a home-built gaming desktop will outlast almost anything else because the computer's individual components can be upgraded. Devices like the iPad will last for years, but will eventually need to be replaced when the operating system fails to be compatible with your older model, when the touchscreen sensitivity begins to degrade, or when the apps you use to render no longer work with your device. Consider replacement and upgrade costs into your decision-making when setting up your digital painting studio.

Living with Your Sketchbook

Some digital painting options allow you to take your studio everywhere with you. This can be both an advantage and a disadvantage, depending on how good you are at maintaining work–life boundaries! The digital studio can be as small as a touchscreen tablet, meaning it can be part of an everyday carry. If you go this route, think of it as having a powerful sketchbook in your pocket at all times. Use downtime to sketch from life in order to build familiarity with your tools and keep your drawing skills sharp. Sketching beats doomscrolling through social media or news feeds on your phone.

If you have never been the type of artist with a sketchbook practice, here are a few suggestions for bringing digital sketchbooking into your life. Using a digital tablet to interact with the world around you can add to your skills, visual imagination, and library of images when you're working toward a design.

- Schedule a 5- or 10-minute observational drawing into your daily routine, and try to draw at the same time every day. Think of a time you already have as sedentary: your morning coffee, the last moments in bed before going to sleep for the evening, or the time you spend eating your lunch. Choose something you see and make an observational sketch. This practice can be a meditation: don't judge your work or progress. Simply be in the moment and capture what you see. Setting a timer can help keep this practice from ballooning out to compromise your schedule, so set boundaries if you need them. Make sure to date the drawings as you finish them.
- Import photos you have taken and make palette breakdowns. Sample the most prevalent colors and arrange them according to how heavily they're used in the composition. This can build your eye for color selection, use of neutrals, and lighting conditions.
- Make simple rotation drawings. Make a quick observational sketch, then try to rotate the object in your mind and draw it from different views and angles.
- Dedicate some downtime to plein air drawing, or the practice of drawing on-site instead of from reference photos. Go someplace peaceful and beautiful, like a park, a museum, or a corner of wilderness you love. Bring your tablet and make a painting of what you see.
- Collect photos and images of things that inspire you. When you have a few minutes, use digital painting software to collage these images into mood or vision boards. This can help to develop your visual taste and it can be a great source of inspiration to revisit these collages when you're feeling creatively blocked.
- Think about a way to engage with drawing or painting that isn't tied to your profession. In other words, what art could you make for fun? Do you want to paint a collection of old-fashioned botanical illustrations based on the plants you see in your neighborhood? Fan art for your favorite podcast? A set of family portraits, including the pets? Art cards for your favorite activism causes? Big splashy wet-color messes that capture your emotional responses to different days? Not everything you make has to be tied to your income, and you will love the medium more if you engage with it from a place of personal exploration. (It can be exhausting to spend personal time painting during heavy rendering projects, so make sure to balance your time thoughtfully.)

Figure 9.2 Podcast fan art can be a great creative outlet and it can give you the opportunity to draw things you might never have the chance to draw in your theatrical design work, like bioluminescent sharks. It can also help to drive new viewers to your social media feeds. (Author's own)

The Future of Digital Painting

The development of digital tools is happening at such an incredible speed, this section may date itself prior to publication. Still, I believe it is valuable to look at some of the hottest topics on the horizon, especially for rising designers who are new to these practices and the industry so they can make strong choices about which avenues to pursue in their own training.

Artificial Intelligence and Art

It is undeniable that artificial intelligence image generators are now a part of the visual landscape. These tools have emerged relatively recently and exploded in popularity. First available only to beta testers and invitation holders, image generators are now available to most smartphone users through various apps like Lensa. Even Adobe has adopted AI, using AI-powered tools for powerful, one-click image revisions.

Rather than building images using brushstrokes or lines, these tools generate images based on text input from users. The possibilities are fairly staggering and already occurring: furniture designed by description instead of by engineers, Polaroid-style snapshots of punk nightclubs that never existed, elaborate dreamscapes, company logos, highly custom stock photography,

and selfies that identify the cultural heritage of the user are all examples of how this software is being used.

The issue of authorship is driving the contentiousness around AI-generated artwork flooding the market. AI artwork learns what artwork looks like by evaluating the photos, art, and images that have already been shared online, but often without the permission of the original creator. Using this information, much of which is copyrighted by its creators, AI can interpret the visual structure of these images into "new" content. Debates are raging across social media about the ethics of this practice: does it create valuable access to visual creation for people who have no training or does it threaten to leave trained artists unemployed as users turn to AI for swiftly built visuals? Is it stealing from artists (some artists have even spotted their signatures on AI-generated work) when their work is re-interpreted by AI, or is it closer to a remix, thus falling under fair use? Does the debate around AI mirror that around photography when it was first developed, fanning worries that easier access to accurate imagery will further displace artists?

Time will continue to develop the various nuances of these arguments, but it's clear that these tools will not be disappearing. Rather than wishing AI generators would disappear, artists make a stronger case for hiring humans by showcasing what AI can't do (yet): collaborate, make iterative changes, and be imperfect. Also, AI is still pretty terrible at generating hands.

Three-Dimensional Rendering

More and more industries that hire artists are requiring not only two-dimensional painting skills, but three-dimensional image construction. Working digitally to create 3D objects and environments that can be animated, immersive, printed in 3D, or explored via gaming is an incredibly valuable skillset that has not been fully embraced by the theatrical industry. 3D visualization technology is more often used by lighting designers than the designers who traditionally create painted renderings. Fashion technology is allowing draping over 3D forms, and people are utilizing this technology to generate highly unique pattern pieces draped over three-dimensionally sculpted forms.

Digital painters who want to pivot into adjacent fields or simply get ahead of the curve on theatrical design expectations should begin exploring the three-dimensional painting frontier. For the most up-to-date information about which software is being favored in various industries, check current job postings. There are a wealth of free resources for learning these tools (see the next section about learning resources), and at least one of the industry-standard pieces of software, Blender, is free and open source.

Further Resources

No single text can address every question or every tech support issue you'll encounter in your digital painting journey. The aim of this text has been to frame digital painting tools in the context of theatrical design, not to exhaustively teach any specific software. Lucky for you, there is a wealth of free resources to help you learn specific software, trouble-shoot technical issues, and continue expanding your skills.

Software Learning Resources

Sometimes, the most difficult thing to learn about new software is where to start. Hopefully, some of the terms used in this text have helped you to navigate your software. When in doubt, run an online search of any term or phrase used in this book plus the name of your software to get very specific, updated guidance on how to achieve the effect described in the text. For instance, if you are using Clip Studio and want to know how to make a new layer, simply search "Clip Studio how to make a new layer," and the internet will provide an overwhelming number of videos, how-to pages, and forums to answer your question.

If you want a more structured approach to learning your software, there are great formalized resources available to you. If you're a US resident, check out your local public library's website to see if they subscribe to LinkedIn Learning. This tool offers tens of thousands of structured tutorials for different types of software, and all you need is your library card. You can walk yourself into multiple software platforms from the beginning, following a basics or essentials course, or you can dive into more advanced skills.

If you are a university student, you'll have even more resources at your disposal. Check in with your campus library and/or your campus library's website to see if there are informal learning opportunities, training, or affiliated student organizations available to you. Many campus libraries offer maker spaces that include use of drawing tablets, so this could be a great way to get your hands on a variety of technologies. The only frustrating element of using campus technology is you generally cannot do anything to customize the software (downloading fonts, setting preferences) that will last beyond a single session.

If you are out of school and looking for a structured learning environment, check to see if there are relevant classes offered by your local community college. Since the pandemic, many larger universities are also offering online courses, some of which are synchronous with scheduled meeting times, and some of which are completely asynchronous but still provide access to an instructor. These options can be cost-effective ways to learn from an expert if you are uncomfortable with self-teaching or working

exclusively with online modules. LinkedIn Learning, available for public library cardholders in the United States, also provides structured asynchronous lessons in a host of software platforms.

It almost goes without saying that YouTube is a phenomenal, free resource for learning. Searching for what you need on YouTube can be overwhelming, but if you start to curate playlists and follow specific artists whose tutorials work for you, you can narrow it down to the information most useful to you. YouTube is a wonderful informal learning environment where you can watch a quick two-minute video explaining a concept, or sit down with a two-hour live painting demonstration. Watching other artists paint is an unparalleled way to expand your own artistic vocabulary.

Troubleshooting

It's inevitable that you will run into technical difficulties as a digital painter. No matter how experienced you are, there are times when the command you usually use refuses to work, or when something goes horrifically wrong during an intense crunch time. Don't worry: the internet is open 24/7 and has all of the answers you'll need.

When you're having an issue, it helps to phrase it as plainly as possible when searching for solutions. For instance, let's say you need to use puppet warp in Adobe Photoshop, but it is grayed out on your menu. Run an online search for "Photoshop CC22 vX.X puppet warp grayed out." Adding a lot of grammatical extras as though you are speaking your problem to another human being can muddle results. If you don't get results in the search that apply directly to your problem, read the first few results and try to determine why you are being offered these search results. There may be a clue about how to reword your request to improve your results, such as a specific bit of jargon. It's also critical to search for answers specific to your operating system and your version of the software. It's good to think of listing your search terms from large to small: software>version year>version number>tool>issue.

Software support forums will likely top your search results. Official software support forums are a great place to go for answers because they're generally monitored by representatives of the software company. When other users have encountered the same issue you've encountered, they've posted and their issue has been addressed, either by a representative of the software or by a knowledgeable member of the software community. Some forums highlight helpful or correct answers in order to guide you to the most helpful advice. Unofficial forums can also be helpful, but the more obscure the forum, the more likely that it's a niche hotbed for socialization and not an active support community. For instance, sites like Reddit generally provide quick responses from a wide array of professionals, and sometimes the Subreddit Guidelines or sticky posts will answer your question before you even begin to engage with the community. Smaller, more off-the-beaten-path forums may not be well moderated and may contain dilute information. No matter how desperate you are, remember to never give your personal computing information or remote control of your desktop to another community member.

If a search fails to solve your issue, you can try posting to the official software support forum and hope for an answer. This answer may not come quickly, and the software company will likely try to make sure you haven't missed a duplicate post before allowing you to post your question. You can also try third-party forums like Reddit or Discord groups, but be mindful of your security: never give anyone remote access to your desktop, passwords, or personal information. Most major software and hardware companies also offer online help and phone support. If all else fails, get on the phone with the professionals and they will likely solve your problem quickly.

Learning how to troubleshoot software and hardware issues is essential to working with digital tools in a full-time capacity. Freelancers and artists rarely have an IT department to rely upon, and even when we do, they're likely not trained in the specifics of the software platform in use. It's also important to understand your limits and know when a problem, especially a hardware problem, is beyond your ability to tackle. If you've never opened up a CPU before, doing so under the pressure of a deadline may not be the best time to try it, and you may risk voiding your warranty. Once DIY options are exhausted, you may have to call a professional for help.

It is good common sense to only take your hardware to the company that produced it, not to third-party repair people. For instance, if you have an iPad on the fritz, it's better to schedule an appointment at an Apple store than take it to the kiosk at the mall offering iPad repairs. Third-party repairs can invalidate warranties and pose security threats. Depending on where you live, this may mean putting your device in the mail and losing access to it for several days, even weeks. Consider it a small price to pay in exchange for peace of mind. Reputable companies will often replace what they cannot repair, sometimes even when parts of the device have expired warranties. No matter what avenue you choose for repair work, be sure that your device is entirely backed up, preferably to two locations, before bringing it in for service.

Index

Page numbers in *italics* refer to figures. Page numbers in **bold** refer to tables.

20-20-20 method 8

acrylic painting 72–74
actions (photo bashing) 154, 155
additive color 22
add/subtract (selection) 153
adjustment layers 28, 42–43, 49, 121, 152–153, 160, 162
Adobe Creative Cloud 17, 24, 25, 54
Adobe Fresco 12, 17, *17*, 54, 98, 125, 126; brushes 17, 60–61, *61*; color well *22*; layer blending modes 34; menu bar 27; mixer brushes in 69, 74; multitouch gestures 28; text tools 136; watercolor live brushes in 60, *61*, 70
Adobe Illustrator 126, *126*, 127, 129
Adobe Photoshop 16–17, *16*, 21, 26, 105, 140, 146, *147*; actions 154, 155; batching 155; blend if 152–153, *153*; burn tool 35; cache presets 29; color range 22; color well *22*; dark mode *9*, *16*; drawing straight lines in 107; file types 25, 26; guides 58; layer blending modes 34; layer composites 43; layer structure for costume rendering in *95*; markers *68*; menu bar 27; mixer brushes in 69, 74; navigator 28; presets 26; properties menu 28; render clouds filter 115; smart objects 158; soft proofing 23, 24, *24*; templates 27; text tools 136; warning for non-printable color selections 23, *23*; watermark layers 137
airbrush 51, 98, 101, 103, 163
AirDrop 26
alcohol brush 70, 104
alcohol technique (watercolor) 70
algorithmic watermarks 137
alpha lock *see* layer locks
American Optometric Association 8
American Public Health Association 9
anchor points 25, 58, 92, *92*, 151, *151*
Android tablets 11, 12
angle jitter 52, *53*
antivirus software 15

Anything Goes 118, *119*
Apple iOS 15
Apple MacOS 15
Apple Pencil 13, 17, 54, 126, 142
archiving/archives 13, 15, 16, 30, 31, 59, 83, 140, 148, 156
artificial intelligence (AI) 167–168
Art Markers pack for Adobe (Webster) 69 *see* markers
assisted perspective drawing tool 18, 106–107, 114
asymmetrical composition 77
atmospheric perspective 156, *156*, 160, 162
authorship 168
AutoCAD 25, 140
automatic selection tool *see* magic wand tool
auto-saves 30

background: costume rendering *67*, 94, 135, *136*; and layers 33; scenic 118; toned 62
backups, data 13, 15–16, 31
Baroque painting 77, *77*
bash models *see* white models
basic warp 89
batch processing of images 154, 155
Beat Bugs 134
Benson, Logan 150
Benton, Thomas Hart 76
bevel and emboss tool 105, 136
Billions, Oakley 110–112, *110*, *111*, *112*
Bird, Brad 111
Bitmap color mode 23
black (photography) 149
blend if feature (Adobe Photoshop) 152–153, *153*
blur filters 77, 154, *154*; *see also* Gaussian blur
Bosch, Hieronymus 76
boulders 106–107
bounding box 109
brick wall 107–108, *108*

brush(es) *10*, 97, 126, *142–143*; brush settings menu 28, 52–54, 57; building 54–61; charcoal 65, *66*; construction, basic mechanics of 54; flow 51; Kyle 17, 54, 65, 126; live 17, 60–61, *61*, 70; load 51; mechanics 50–61; mixer brushes 69, *69*, 74; mode 52; opacity 50, *50*, 51; organization of 61–62; presets 26, 54, 56, 57, 105; settings 28, 52–54, 57; size 50, *50*, 51; smoothing/stabilization 51, *52*, 66; smudging 64, 65, 80, 101; swatch 54, *62*; symmetry tool 52, *52*; tip shape 52; toolbar brush settings 51–52; vector 25, 61; *see also specific entries*
Budincich, Andja 7
bullet lists 7
burlap 102
Burton, Tim 76

Cabaret 143
cache 15, 28–29
CAD 118
calendar 7
callout boxes 133
canvas 20; rotating 67; shift 59; splitting 52
Carracci, Annibale *78*
Casperson, Gigi *9*
cellulosic fibers 99–100
cel-shading 44–45, *45*
chairs 8
chalk and pastels 65, *67*
charcoal 65, *66*
chiaroscuro 79
chiffon 101
Cinderella 136
Cinderella: The Remix 116
Cintiq 11
Cirillo, Francesco 7
classical painting 77; color 78–79, *79*; composition 77–78, *77*, *78*; light and shade 79–80, *80*, *81*; underpainting 78, *78*
clipping masks 31, 32, 98, 102, 121, 153, 161
Clip Studio 18, *18*; color well *22*; mechanically aided perspective drawing in 84; menu bar 27; navigator 28; text tools 136
clock 6
clone brushes 66, 160, 163
cloud brush 157
cloud services 140–141
cloud storage 13, 15–16, 30, 31, 139; drive etiquette 140; drive organization 139–140
CMYK (Cyan Magenta Yellow Black) color mode 22, 23, 24, 25, 64, 137
CNC (Computerized Numerical Control) machines 128
cold press watercolor paper 138
collaboration 2; and cloud storage 13, 30, 139–141; and layers 31, 33, 44; and Pantone swatch book 24
collages 113, 141, 155, 162, 167

color 3, 64, 78–79, *79*; base colors 94, 109; calibration 24, 137–138; choice, precision of 3; CMYK color mode 22, 23, 24, 25, 64, 137; coloring costume renderings 94–98; conversion 23–24; digital color theory 21–24; discoloration of fabric 103; local 79, *79*; paper 138; in photo bashing 163, *164*; and printing 137–138; RGB color modes 22–23, 24, 25; scenic design 114–115; skin 94, 95, *96*; and underpainting 78
color (layer blend mode) 42, *43*, 163
color accuracy (dE) 138
color blindness, people with 24, *24*
color burn (layer blend mode) 35, *36*
color dodge (layer blend mode) 38, *38*, 163
color dynamics, brush 53, *53*, 54
colored pencils 65–66, *67*
colorimeters 138
coloring outside the lines, prevention of 33, 69, 153
color libraries 28
color palettes 51, *51*, 66, 69, 78, 79, *79*, 80, *82*, 96, 130
color picker 22, 34, 51, 66, 69, 79, 80, 95, 118, 124, 130
color swatches 24, 28, 69, 115, *156*
color temperature 79, *79*, 138, *154*, 156, 162
color well 22, *22*, 28, 69, 72
composition (classical painting) 77–78, *77*, *78*
computer(s) 13; display 9–10, 14; graphics card 14, 15; hard drive 13, 15; multiple monitors 14; operating system 15, 30; performance of 13, 21; portable 14; ports 14; replacement 16; system memory (RAM) 14; video memory (VRAM) 14
concept art brushes 104, 109
Conlee, Austin Blake *5*, *74*, *136*
connected drawing tablets 11; advantages of 11–12; disadvantages of 12
control source, brush 54
copyright 130, 148, 159, 168
Corel Painter 18; cache presets 29; mixer brushes in 69, 74
costume design 118; Filipovich, Ali (interview) 125–129, *126*, *127*, *128*; hair 121; insets 118, 121, *121*; notation of fitting photos 124–125, *124*, *125*; proportion 122, *122*; resizing of garment 122; skin tone 121; Teague, Erik (interview) 141–145, *142*, *143*, *144*; technical drawings 118, 119–120, *119*, *120*; visualization of light 122–124, *123*
costume rendering: and adjustment layers 42; chalk pastels *67*; coloring 94–98; croquis library 88–89; digital graphite *67*; digital sketching *64*; fabric 99–104, *99*, *101*, *103*; *Frozen* 76; gouache *72*; hair painting 94, 96–98, *97*; landmark lines 90–91, *90*, 92; layer blend mode 35–43; layers 31, 44, 84–85, *85*, 94, *95*; life drawing 87; and light 80; live brushes (Fresco) *61*; markers *68*; mixed media 74–75; notation 135, *136*; oil painting *74*; photomontage 162, *163*, *164*; sketching clothing using proportional measurements 91–93, *92*, *93*; skin color 95, *96*; tattoos 98, *98*; templates 26–27; thumbnail sketching *86*
costume shop technicians 119, 141
coverstock 62

Index

Creative Commons 148
Cunning Little Vixen, The 98
Curious Incident of the Dog in the Night-Time, The 47
curl scale 96
curves adjustment layer 49, 159, 163
custom fabric printing 129–130
cutting mat 6
cutting tools 6

darken (layer blend mode) 34, *36*
darker color (layer blend mode) 35, *37*
dark mode (display) 9, *9, 16*, 28
data loss 166
DeBlois, Dean 111
dedicated graphics card 14
depth of field 148–149, *148*
desert scenic drop (photo bashing) 159–162, *159, 160, 161*
design rendering: classical painting in digital world 77–80; coloring costume renderings 94–98; color palette 80, *82*; human figure 84–93; perspective in 83–84, *83, 84*; reference imagery 80, 82–83, *82*; surfaces 98–110
Dharma Trading Co. 100
difference (layer blend mode) 40, *41*
digital art supplies 50; brush mechanics 50–61; digital dry media 64–69; digital paper 62–64; digital wet media 69–74; Gillmore, Jean (interview) 75–76; mixed media 74–75, *74–75*; and traditional media 61–75, *63*
digital color theory 21–22; color conversion and soft proofing 23–24; color well 22, *22*; RGB and CMYK color modes 22–23
digital dry media 64; chalk and pastels 65, *67*; charcoal 65, *66*; colored pencils 65–66, *67*; digital pen and ink 66–67; erasers 64; finishing, over printing paper 138; markers 67, *68*, 69; pencils 64, *64*; smudging brushes 64
digital painting/rendering 1, 2, *2*, 3, 75–76, 125, 141–142; advantages of 165; artificial intelligence 167–168; disadvantages of 166; features of 3; sketchbook 166–167; software learning resources 168–169; three-dimensional (3D) rendering 168; troubleshooting 169
digital paper 62–64, 65
digital wet media 69; brushes 70–71, *71*; finishing, over printing paper 138; gouache 72–73, *72, 73*; mixer brushes 69, *69*, 74; oil and acrylic painting 72–74, *74*
digital workspace 20, 64; common file types 24–26, **25**; eliminating digital distractions 29; interface colors 28; layouts, saving 28; libraries 29; memory cache 28–29; menus and palettes 27–28; presets 26; saving your work 29–31; shortcuts and hotkeys 28; software 20–24; templates 26–27; undo settings 29
directional lighting *47*, 48–49, *48, 49*, 80, 122–124, 163
Discord 4, 169
display 14; and color 21; dark mode 9, *9, 16*, 28; night shift in 10; and studio lighting 9–10

dissolve (layer blend mode) 34, *36*
distance jitter 53
distort tool 106, 156
distort wave filter 105, *105*
distressing 104; distressed fabric 103–104, *103*; of paint elevations *104*
divide (layer blend mode) 41, *42*
Divine Proportion *see* Golden Spiral
documentation, theatrical 131; common items to include in 131; costume rendering notation 135, *136*; paint elevation/ properties rendering notation 133; projection/integrated media design storyboards notation 133; scenic rendering notation 131–132, *131*; text 136; watermark 136–137, *137*
dodge and burn brushes 155, 156, 160, 163
dots per inch (DPI) *see* pixels per inch (PPI)
Dragon Vein 77
dramatic lighting 42, 43, 81
drive etiquette 140
drive organization 139–140
Dropbox 30, 140–141
Dr. Seuss 76
dry brush technique (watercolor) 70
DSLR camera 149, 150
duplication of repeating elements (photo bashing) 158

edges 56; in digital water color 70–71; Fresco live brushes 60; in photo bashing 151, *151*, 157, 159, 160
editing research 113
EMR stylus 13
erasers 64, 65, 69, 108, 119; hard round 64; rough-edged 65, 103; soft round 56, 157
ergonomics 7–10
Every Tool's a Hammer (Savage) 7
exclusion (layer blend mode) 41, *41*
exercise regimen 8
exposure (photography) 149, *149*
exposure/contrast slider 163
external cleaning of hardware 16
eye strain 8, 166

fabric(s) 99; bias 99; CNC (Computerized Numerical Control) machines 128; custom fabric printing 129–130; discoloration of 103; distressed 103–104, *103*; fiber 99–100; fullness, drawing 102–103, *103*; grain 56, *56*, 99; knit 99, *99*; physics 102; scatter print 55, *55*; selvedge 99; studies 100–102, *101*; swatches 100, 129, 130, *157*; waste 129; woven 99, *99*
factory reset (hardware) 16
Fann, Hattie *126*
fashion croquis 122, *122*, 135
Faustus 134
faux fur 101
Favorites (brush category) 61

feathering 56, 66, 153

fiber (fabric) 99–100

file(s): digital painting 20–21, 137; names 30, 140; organization 30–31; sharing 165; types 24–26, **25**, 137

Filipovich, Ali *7*, 125–129, *126*, *127*, *128*

fill tool *see* paint bucket tool/fill tool

film speed 149

filters 147, 153–154; artistic 153; blur 77, 154, *154*; distort wave 105, *105*; Gaussian blur 47, *48*, 49, 102, 115, 116, 154, *154*, 156, 160; liquify 154, 162; perspective 153–154, 160, 161; render clouds 115

firewall software 15

fitting photos, notation of 124–125, *124*, *125*

flat wash technique (watercolor) 70

flip horizontal 78, 156, 159, 164

floor: distressing *104*; repeating patterns *60*

flow (brush) 51

fluorescent light 9

foundation makeup 95

freehand selection (lasso) tool 56, 60, 69, 72, 86, 89, 100, 101, 106–107, 109, 115, 121, 123, 151, *151*, 162

Frozen (film) 76

F-stop 148–149, *148*

fullness in fabric 102–103, *103*

Galaxy Jacket project *127*

gamma 138

gamut 138

Gaussian blur 47, *48*, 49, 102, 115, 116, 154, *154*, 156, 160

geometric marquee tools 150

geometric selection tool 107

Gerber AccuMark *126*

gesture drawings 65, *66*

Gilbert, Melissa *18*

Gillmore, Jean 75–76

glazing 72

glitter fabric 102

glowing effects 46–47, *46*, *47*

Godspell 136

Golden Spiral 77, *77*

Google Android 15

Google Drive 30, 140, 141

gouache 72–73, *72*, *73*

gouache brushes 72, 73, 109, 123

GPU *see* graphics card

gradient tool 147, 162

graduated wash technique (watercolor) 70

graffiti 108–109

grain: fabric 56, *56*, 99, *99*; paper 62

graphics card 14, 15

grayscale color 23

grayscale layer masks 34

grayscale/mixed opacity brush 56–57, *57*

greenery 109–110, *109*, *110*, *154*

Griffiths, Aidan *74*

Gypsy 120

hair 121; curl scale 96; in life drawing sketch 88, 89; painting 94, 96–98, *97*; in technical drawing 119

hairline 88, 89, 90, 96, 119, 162

Hansel and Gretel 142

hard drive 13, 15, 30, 31

hard light (layer blend mode) 39, *39*

hard mix (layer blend mode) 40, *41*

hard round brush 50, *50*, 51

hard round eraser 64

hard surfaces 104; masonry 106–109, *108*; rocks and boulders 104–106, *106*, *107*; wood 104–106, *105–106*

hardware 10–11, 166; computer 13–15; connected drawing tablets 11–12; device replacement 16; maintenance 15–16; selection based on software system requirements 15; standalone drawing tablets 11, 12–13; stylus and surface 13; troubleshooting 169; upgrades 166

haze effects 115, *116*

heal brush 160, 163

HEIC file 26

Herald, Tyler *47*, *131*

highlights 33, 43, 49, 65; costume rendering 94, 123; fabric 100–101, 102, 103; hair painting 96; masonry 108; photo bashing 155, 160, 163; rocks 106; scenic design 114; and skin tones 95, *96*

Homan, Alyssa *6*

hotkeys 28, 29, 153

hot press watercolor paper 138, 139

hue (layer blend mode) 41

Hughes, M.K. *136*

Huion 11

human figure(s) 84, 156; layers and costume renderings 84–85, *85*; re-posing 89–93, *90*; in scenic rendering 132, *132*; sketching from life drawing photo 87–89, *87*, *88*; thumbnail sketching 85–87

iCloud 18, 30

image adjustment tools 153, *154*

image morgue 83, 123

image repair tools 147

impasto 72

ink 66–67

inking brushes 45, 70, 92, 98, 101, 102, 107

inkjet printer 62, 64, 139

input device 10–11; connected drawing tablets 11–12; standalone drawing tablets 11, 12–13; stylus and surface 13

insets 118, 121, *121*

integrated graphics 14

intellectual property 136–137
interface colors 28
internet access 166
inverse (selection) 153
iPad 11, 12, 14, 17, 125, 155, 166; cache 29; iPad Pro 12, *17*, 126; paper-feel screen protectors for 13
ISO 149
iterative saving 30, 31, 165

jitter, brush 52–53, *53*, 54, 110
Jones, Newman *120*
JPG/JPEG (Joint Photographic Experts Group) file 24, **25**, 43, 124, 140
Junie B. Jones 126

Klimt, Gustav 76
knit fabrics 99, *99*
Kodak 149

lab color 23
La Bohème 144–145
landmark lines 90–91, *90*, 92
large format printers 137, 138, 139
laser printer 62, 64, 126, 139
lasso tool *see* freehand selection (lasso) tool
layer control menu 28
layer effects 147
layer locks 31, *31*, 69, 72, 102, 103, 108, 109, 110, 153, 162, 163
layer masks 31, 34, 69, 147, 152–153, *152*, 160
layers 32–33, *32*, 80, 83; adjustment layers 28, 42–43, 49, 121, 152–153, 160, 162; and background 33; cel-shading 44–45, *45*; clipping masks 31, 32, 98, 102, 121, 153, 161; and collaboration 31, 44; costume rendering 84–85, *85*, 94, *95*; directional lighting *47*, 48–49, *48*, *49*; glowing effects 46–47, *46*, *47*; grouping 44, *44*, 162; layer blend modes 34–35, *35–43*, 38–42, 44–45, *45*, 52, 62, *74*, 78, 94, 98, 101, 115, 116, 121, 155, 161, 162, 163; layer composites 43–44; merging 44; naming 33, 44; opacity of 85; organization of 33; tattoos 98, *98*; turning off 31
layer style 34
lb number (paper) 138
library(ies) 29, 98, 118; brush 104; color 28; croquis 88–89
life drawing 65, 91; croquis library 88–89; figures, dressing 93; photo, sketching from 87–89, *87*, *88*; reference images 87; side-by-side 87, *87*; tracing 87, *87*, 88, *88*
lighten (layer blend mode) 35, *37*
lighten color (layer blend mode) 38, *38*
lighting, studio 5, 9–10
light/lighting 79–80, *80*, *81*; and color 21, 79, *79*; directional *47*, 48–49, *48*, *49*, 80, 122–124, 163; dramatic 42, 43, *81*; and fabric 100, 101, 102; glowing effects 46–47, *46*, *47*; and hair painting 96; and photo bashing 156, 160, 161, 162, 163; and photography 150; storyboard model 117; textured *60*;

visualization, in costume renderings 122–124, *123*; visualization, in scenic renderings 115–116, *116*
linear burn (layer blend mode) 35, *37*
linear dodge/add (layer blend mode) 38, *38*, 115, 121, 163
linear light (layer blend mode) 40, *40*
line of dialogue 132
linework/line art 33, 44, 66–67, *67*, 94, 98, 107
LinkedIn Learning 4, 168, 169
liquify filter 154, 162
lists 7
Little Mermaid, The 63
live brushes (Fresco) 17, 60–61, *61*, 70
load, brush 51
local color 79, *79*
loose sketching 65
lossless compression 24
lossy compression 24
Loupedeck pads 155
luminosity (layer blend mode) 42, *43*

Macbeth 113
McElcheran, Sarah *47*
MacPaint 1
macros 154–155
magic wand tool 123, 151–152, *151*, 153, 157
magnetic disk drive 13
magnetic selection tool 151, *151*
makeup 95, 98, *98*
malicious software 15
marching ants selection mask 69, 153
markers 66, 67, *68*, 69
masonry 106–109, *108*
mechanical perspective aids 83–84, *84*
media license information 133
mentoring 124, *125*
menus 27–28
metal ruler 6
Microsoft OneDrive 30, 140
Microsoft Surface tablets 11, 12
Microsoft Windows 15
Milan, Aly *126*
mist effect 157–158, *158*
mixer brushes 69, *69*, 74, 126
monitor calibration tool 24
Monté, Keyon *67*, *75*, *80*
multiply (layer blend mode) 34–35, *36*, 94, 98, 109, 115, 121, 161, 162, 163
multitouch gestures 27, 28
music 6, 145

natural light 9
nibs, stylus 13

night shift in displays 10
Niikura, Maki *158*
noise (image) 154
normal (layer blend mode) 34, *36*, 80, 163
notation: costume rendering 135, *136*; fitting photos 124–125, *124*, *125*; layers 94; paint elevations 133, *133*, *136*; projection/integrated media design storyboards 133; scenic rendering 131–132, *131*; stage properties rendering 133, *134*; storyboards 118
notebook computers 14
numbering of costume renderings 135

oil painting 72–74, *74*; brushes 60–61, *61*, 72, 126; and light 79; of rocks 106
opera 6, 144–145
operating system (OS) 15, 30
outsourcing 6, 54
overlay (layer blend mode) 38–39, *39*, 62, 101, 106, 109, 115, 116, 121, 163

page bleed 21
paint bucket tool/fill tool 60, 72, 147
paint elevations 109, *132*, *136*; distressing *104*; notation 133, *133*, *136*; scenic design 118, *118*
painting navigation palette 28
palettes 27–28; color palettes 51, *51*, 66, 69, 78, 79, *79*, 80, *82*, 96, 130; scenic 118
Palmer, Zyunia *128*
Pantone swatch book 24, 115
paper: choice, for printing 138–139; color 138; digital 62–64, *65*; lb number 138; size of 20–21, **20**; tooth 62, 138
patterns: digital patterning *vs.* analog patterning 129; and fabric grain 56, *56*; layers 94; liquify filter 154; making 126–127, *126*, 128; pieces, complex 127; repeating 54, 57–58, *58*, 59–60, *59*, *60*, 130
PDF (Portable Document Format) file 24–25, **25**, 43, 136, 137, 140
pen, digital 66–67
pencils 64, *64*, 85; colored 65–66, *67*; white colored 62
pen computers 11, 12
pen display tablets 11, *11*
pen tablets 11, 12, 28, 62
peripheral ports 14
perspective drawing 18, 83–84, 114; manual perspective grids 84, *84*; masonry 106; mechanical perspective aids 83–84, *84*
perspective filters 153–154, 160, 161
perspective grids 18, 83, *83*, 84, *84*, 156
perspective tool 106, 130
Peter and the Starcatcher 116
photo bashing 27, 74, 106, 109, 115, 146, *146*; desert scenic drop 159–162, *159*, *160*, *161*; and digital painting, hybrid between *158*; filters and adjustments 153–154, *154*; image for use in 147–148, *147*; macros, actions, and batch processing

154–155; masks 152–153, *152*; selection tools 150–152, *150*, *151*; techniques 155–158; tools 147–150
photography: correction tools 147; vocabulary 148–150
photomontage 146, 162–164
picture plane 32, 77, 79
pin light (layer blend mode) 40, *40*
pixels per inch (PPI) 20–21, *21*, 26, 137
planks 105–106, *106*
plant surfaces 109–110, *109*, *110*
plotters 20, 128, 137, 138, 139
PNG (Portable Network Graphics) file 24, **25**, 84
podcast fan art *167*
polygonal lasso tool 49, 107–109, 116, 151, *151*
polygon shape tool 84
Pomodoro Technique 7
portable computers 14
ports, computer 14
posters 108–109
posture, work 7–8, *8*
Powers, Kimberly *63*, *104*, *114*, *134*
presets 26, 29, 54, 56, 57, 105
pressure sensitivity 10, 11
Pretorius, Loryn 98
Princess Plays, The 146
printers 6; and CMYK color mode 23; and custom fabric printing 129; inkjet 62, 64, 139; large format 137, 138, 139; laser 62, 64, 139; owning, pros/cons of 139; and page bleed 21; and paper size 20; types of 139
printing 137; color accuracy 137–138; document setup for 137; paper choice for 138–139
privacy, and studio workspace 5
processed wood 104
Procreate 12, 17–18, 25, 54, 69, 142; color well *22*; document setup interface *21*; drawing straight lines in 107; layer blending modes 34; layer structure for costume rendering in *95*; mechanically aided perspective drawing in 84, *84*; menu bar 27; multitouch gestures 28; presets 26; templates 27; text tools 136, 142; thumbnail sketching *86*; undo feature in 30; user interface *17*
production 113; costume design 118–124; custom fabric printing 129–130; digital swatches 130, *130*; editing research 113; printing 137–139; scenic design 113–118; shared drives and collaboration 139–141; theatrical documentation 131–137
PRO (Procreate) file 25, **25**
projection/integrated media design 21, 133, *134*
projection lines 120
proportion: and costume design 89, 122, *122*, 135, *135*, 162; human figures 85–87; life drawing 87, *87*; sketching clothing using proportional measurements 91–93, *92*, *93*
Propst, Jenni *2*, *166*
protein fibers 100
PSB file (Adobe Photoshop) 24

PSD file (Adobe Photoshop) 24, 25, **25**, 26
PSDT file (Adobe Photoshop) 24, 27, 105
Puget Systems 15
puppet warp 86, 89

rake brushes 109
Ramsey, Peter 111
raster images 25–26
RAW format 150
raw wood 104
realism 109–110, *110*, 122, *122*, 156
rectangular selection/marquee tool 59, 86, 105, 119, *150*
Reddit 4, 169
reference imagery 28, 80, 82, *82*, 91, 92, 106, 107, 156; creating 82–83; fabrics 100, 103; finding 82; hair painting 96; image morgue 83; life drawing 87; lighting 123; for photo bashing 159; plant surfaces 109, 110; scenic design 115; size and quality of 83; and skin colors 95, *96*; technical drawing 120
Renaissance painting 77, *77*
render clouds filter 115
Rent 103
repeating patterns 54, 57–58, *58*, 59–60, *59*, *60*, 130; canvas shift 59; guidelines 58–59; uses of *60*
repetitive stress injury 8, 166
re-posing of figure 86, 89; anchor points 92, *92*; feet 91, *91*; landmark lines 90–91, *90*, *92*; sketching clothing using proportional measurements 91–93, *92*, *93*; working from proximal joints to distal joints *90*
research boards 113, *113*
resolution: display 14; document 20–21, *21*, 137; image 147–148, *147*
RGB (Red Green Blue) color mode 22–23, 24, 25
Rio (film) 76
rocks 106–107, *106*, *107*
Romeo & Juliet & Zombies (R&J&Z) 126, *126*
Rose Brand 100
rough models *see* white models
round brushes 43, 50, *50*, 51, *51*, 100, 101, 102, 121, 123
Royale, The 104
Ruggaber, Brian *118*, *133*
Rule of Thirds 77
Rusalka 131

salt brush 70, 104
salt technique (watercolor) 70
Sargent, John Singer 76
satin 100
saturation (layer blend mode) 41, *42*
Savage, Adam 7
saving your work 29–30; auto-saves 30; file names 30, 140; file organization 30–31; iterative saving 30, 31, 165; location 30
scale: brush, and scatter print 55, *55*; curl scale 96; in photo

bashing 156, 159, 161; properties rendering 133; scale figure 132; scenic rendering 131
scanners 62
scatter brushes 54–56, *55*
scatter control (brush) 53, *53*
scene number 118, 132, 135
scenic design 113–114; developing a sketch from white model 114–115, *115*; paint elevations 118, *118*; rendering *vs.* modeling 114, *114*; storyboards 117–118, *117*; visualization of light 115–116, *116*
scenic rendering: and adjustment layers 42; *Curious Incident of the Dog in the Night-Time, The 47*; human figures in 132, *132*; and layers 31, 44; notation included in 131–132, *131*; *Violet 81*
scheduling 7
screen (layer blend mode) 35, *37*
screen space 27
Searle, Ronald 76
selection tools 17, 43, 56, 58, 59, 66, 72, 86, 89, *93*, 102, 122, 147, 150–152, *150*, *151*, 155, 156, 157, 158, 163
Sense and Sensibility 120
sensitivity: brush 62; pressure 10, 11; tablet screen 62; tilt 10, 11, 64
sequins 102
shade 79–80, *80*, *81*
shadows 33, 122–123; cel-shading 45; charcoal for 65; fabric 100, 101, 102, 103; hair painting 96; layers, for costume renderings 94; masonry 108–109; multiply (layer blend mode) 35; in photo bashing 155, 156, 162, 163, 164; rocks 106; scenic design 114; and skin tones 95, *96*
Shape Dynamics menu 52
shortcut keys 10, 28
shutter speed *149*
Simmers, Bill *126*
Sinnott, Ethan *116*, *117*, *134*
size jitter 52, *53*
sketchbook 166–167
sketching: clothing, using proportional measurements 91–93, *92*, *93*; digital 64, *64*, 87; from life drawing photo 87–89, *87*, *88*; loose sketching 65; perspective 84, *84*; sketch in from white model 114–115, *115*; thumbnail 85–87
SketchUp 114
skew tool 130, 156
skin: colors, choosing 94, 95, *96*; tattoos 98, *98*; tone 95, *96*, 98, 121
smart objects 43, 153, 158
smoothing/stabilization, brush 51, *52*, 66
smooth pen tool 119
smudging brushes 64, 65, 80, 101
snapping 58, 59
Snyders, Frans *79*
soft light (layer blend mode) 39, *39*
soft proofing 23–24, *24*
soft round brush 43, 50, 51, 100, 101, 102, 123

soft round eraser 56, 157

soft surfaces 99–104, *99, 101, 103*

software 16–18, 20, 165, 166; digital color theory 21–24; digital pattern making 128; file types 24–26; formatting digital painting file 20–21; interface color 28; learning resources 168–169; memory cache 28–29; menus and palettes 27–28; presets and templates 26–27; shortcuts and hotkeys 28; support forums 169; troubleshooting 169; upgrades 166; *see also specific entries*

solid state drive (SSD) 13

sound devices 6

space management 127–128

spacing, brush 52, *53*

spatter brush 49, 70, 102, 104, 109

spatter technique (watercolor) 70

special effects 94, 147

special needs, person with 122

spectrophotometer 138

square brush 108

stage properties rendering, notation for 133, *134*

stains in fabric 103–104

"Stalagmites and Stalactites" (Filipovich) *128*

stamping brush 105, 110

standalone drawing tablets 11, 12; advantages of 12; disadvantages of 12–13

still life objects, painting 51, *51*

Still Life with Flowers, Grapes, and Small Game Birds (Snyders) *79*

stock photographs 148, 159

storage (studio) 6

storage, data 13, 15–16, 30, 31, 139–140, 166

story artists 110–112, *110, 111, 112*

storyboards 43, 110, *110*, 112; projection/integrated media design, notation 133; scenic 117–118, *117*

straight lines, drawing 107

streaky brush 101, 108

studio: hardware 10–16; software 16–18; time management in 7; workspace 5–10, *5, 6, 7, 9, 10*

stylus 10, 11, 13, 60, 65, 66, 70, 142

subtract (layer blend mode) 41, *42*

subtractive color 23

sunrise effect 115–116

sunset effect 115–116

surfaces 98; hard 104–109, *105, 106, 107, 108*; plant 109–110, *109, 110*; soft 99–104, *99, 101, 103*

swatches: brush 54, *62*; color 24, 28, 69, 115, *156*; fabric 100, 129, 130, *130, 157*

symmetrical composition 77

symmetry tool 52, *52*, 119, 120

synthetic fibers 100

Syracuse Stage *63*

system memory (RAM) 14

system refresh (hardware) 16

tablets 10, 14, 21, 166, 167; connected drawing tablets 11–12; "Do Not Disturb" mode 29; operating system 15; pen tablets 11, 12, 28, 62; standalone drawing tablets 11, 12–13

Tao Wang *81, 116, 146*

taper control (brush) 52

tattoos 98, *98*

Teague, Erik 85, *103*, 141–145, *142, 143, 144*

technical drawings 118, 119–120, *119, 120*, 141

templates 26–27, 31, 137; broad-use 27; specific-use 27

text 26, 136, 142, 147

texture(s) 56; brush 53–54; hair 96, *97*, 121; light *60*, 115; plant surfaces 109; rock 106–107; textured background *67*

three-dimensional (3D) rendering 168

Threepenny Opera, The 144, *144*

thumbnail sketching 85–87

TIF/TIFF (Tag Image File Format) file 24, **25**

tilt, brush 54

tilt sensitivity 10, 11, 64

time lapse videos (Procreate) 25

time limits, setting 7

time management 7

time off 7

timer 6–7, 8, 167

title blocks 26–27, 94, 131, *131*, 135, *136*, 155

tone (color) 138

toned paper 62, 64, 65, 66

toolbar 27

toolbar brush settings 51–52

tooth, paper 62, 138

tracing 83, 84–85, 129; fabric 100; life drawing 87, *87*, 88, *88*; technical drawing 119; thumbnail sketching 85

transform tools 108–109

trash can (recycle bin) 6

trees 104, 109, *109*, 158; bark 106; tree stamping 105, *105*; woodgrain 105–106, *105*

troubleshooting 168

true black 42, 48, 78, 80, 96, 149

true white 42, 48, 78, 80, 149

Twitch 4

two-color wash technique (watercolor) 70

Two-Plus-One backup method 15

type tools 147

underpainting 78, *78*

undo command 4, 29, 30, 34, 70, 85, 97, 109, 125, 165

updates (hardware) 16

Urinetown 74

UV light 9

values 23, 62, 73, *78*, 79–80, *81*, 110, *110*, 149

vector brushes 25, 61

vector images 25–26, 44

vector shapes tool 147
Vectorworks 25, 114, 118, 140
velvet 100
Venus Adorned by the Graces (Carracci) *78*
video card *see* graphics card
video memory (VRAM) 14
video ports 14
Violet 81
vivid light (layer blend mode) 39, *40*

Wacom 11, 12, 154–155
warping tools 56, 86, 89, 106, 115, 120, 122, 130, 147, 155, 156, 157, 162, 163
watercolor 3, 4, 70–71, *71*, 139; brushes 60, *61*, 65, 70, 104, 109; cold press *vs.* hot press paper 138; exercises 71; and light 79, *81*
watermark 136–137, *137*
Wayback Machine 83
Webster, Kyle 17, 54, 65, 69
wet on dry technique (watercolor) 70
wet on wet technique (watercolor) 70
white (photography) 149

white colored pencils 62
white gel pens 62
white models 114–115, *115*
white point 138
wig designers 98
Windows Surface Pro 12
wood 104–106, *105*
woodgrain 105–106, *105*
work posture 7–8, *8*
workspace, studio 5–7, *5, 6, 7, 9, 10*, 165; ergonomics and arrangement 7–10; lighting 5, 9–10; music/sound devices 6; printer 6; privacy 5; storage and organization 6; work surfaces 5
work surfaces 5
woven fabrics 99, *99*

XPPen 11

yardage, digital 130
YouTube 4, 169

zero jitter 52

*For Product Safety Concerns and Information please contact
our EU representative GPSR@taylorandfrancis.com Taylor & Francis
Verlag GmbH, Kaufingerstraße 24, 80331 München, Germany*

T - #0311 - 160425 - C188 - 280/210/9 - PB - 9781032076928 - Gloss Lamination